SHADOWS, SPECTERS, SHARDS

University of Minnesota Press / Minneapolis London

SHADOWS, SPECTERS, SHARDS

Making History in Avant-Garde Film

Jeffrey Skoller

The University of Minnesota Press acknowledges the work of Edward Dimendberg, editorial consultant, on this project.

Published by the University of Minnesota Press
111 Third Avenue South, Suite 290
Minneapolis, MN 55401–2520
http://www.upress.umn.edu

Library of Congress Cataloging-in-Publication Data

Skoller, Jeffrey.
 Shadows, specters, shards : making history in avant-garde film / Jeffrey Skoller.
 p. cm.
 Filmography: p.
 Includes bibliographical references and index.
 ISBN 0-8166-4231-1 (hc : alk. paper) — ISBN 0-8166-4232-X (pb : alk. paper)
 1. Historical films—History and criticism. 2. Experimental films—History and criticism. I. Title.
PN1995.9.H5S46 2005
791.43'658—dc22 2005010522

Printed in the United States of America on acid-free paper

The University of Minnesota is an equal-opportunity educator and employer.

12 11 10 09 08 07 06 05 10 9 8 7 6 5 4 3 2 1

To *the coming community*

Contents

Acknowledgments

First, I must acknowledge that amorphous and constantly transforming entity called the international experimental film community. Its idealism, energy, and constant production of astounding works of art—against all odds—has sustained my artistic and intellectual life for more than twenty years. This study is my contribution to that community's continuing legacy. I hope I have helped to show just how vital a world it continues to be.

I would like to thank, too, all the filmmakers I have written about here. In particular I thank Eleanor Antin, Craig Baldwin, Zoe Beloff, James Benning, Charles Burnett, Abigail Child, Daniel Eisenberg, Ernie Gehr, Patricio Guzmán, Ken Jacobs, Joel Katz, Leandro Katz, Jesse Lerner, Mark Rappaport, Abraham Ravett, and Tony Sinden. I am grateful to many for their friendship and personal encouragement, and for taking the time to share their ideas with me. I am indebted to all for making their work available on request. What I got right in this study is due to their articulate work and the generosity of their thought, which guided me through the often uncharted territory of their films.

I also thank Ed Dimendberg, who saw the potential in my manuscript and called it to the attention of the University of Minnesota Press. I thank my editor, Douglas Armato, and his assistant, Gretchen Asmussen, for their help and support throughout the production of this book. Thanks also to the two anonymous reviewers for their enthusiasm and insightful critiques and suggestions.

Earlier versions of parts of this manuscript have been previously published in *Discourse: A Journal for Theoretical Studies in Media and Culture, Film Quarterly,* and *Afterimage: The Journal of Media Arts and Cultural Criticism.* I thank the editors I worked with at these publications, including Marcus Bullock, Ann Martin, Michael

Starenko, and Karen Van Meenen. I am grateful to these journals for permission to reprint this material here. Thanks go to Dominic Angerame at Canyon Cinema Inc. in San Francisco, M. M. Serra at the New York Filmmakers Co-op, First Run/Icarus Films, and Third World Newsreel for facilitating my access to the films for study and photo stills.

Many people helped with the preparation of the manuscript; in particular I thank Henrietta Zelinski, SAIC research librarian extraordinaire, and Kris Andrews for his digital prowess. I thank Catherine Greenblatt for her close reading of the manuscript and astute editorial consultations. I am fortunate to have so many wonderful colleagues at the School of the Art Institute of Chicago. I especially thank dean Carol Becker for all manner of personal inspiration and institutional support.

This book is the result of accumulative reflections on art, cinema, history, politics, and philosophy that evolved over a decade. Coming to film criticism as a visual artist was a big shift for me, and I had much to learn. I thank Chuck Kleinhans for helping me to trespass those borders. My most constant intellectual companion during the writing of this text has been Scott Durham, and I thank him for so generously sharing many of his ideas with me—they have become integral to many parts of this text.

I am grateful to all the people who commented on portions of the manuscript and to those with whom I had many clarifying conversations. All have had a profound impact on my thinking and the development of this text: Lincoln Shlensky, Gregg Bordowitz, Dan Eisenberg, Ellen Rothenberg, Greg Sholette, Michael André Berstein, Mimi White, Tom Gunning, Leandro Katz, Jack Walsh, Martha Wallner, Joel Katz, Steve Fagin, Tiffany Holmes, Rachel Weiss, Lisa Cartwright, Patty Zimmerman, Leo Charney, Lydia Matthews, Mark Bartlett, Debbie Gould, Laurie Palmer, John Corbett, Terri Kapsalis, Michael Rowe, Susan Greene, Amanda Berger, Larry and Matthew Skoller, and Leslie Salzinger, whose astonishing appearance, seemingly out of nowhere, during the final moments of revision showed me how to finish.

Finally, my parents. Donald Skoller first showed me the excitement of cinema and insisted on the practice of radical openness when approaching any work of art. The influence of his thinking permeates this work, as does that of Eleanor Honig Skoller, who patiently read and commented—more than once—on every word that follows. She is the one who taught me how to read and write, and continues to.

Figure 1. *Signal—Germany on the Air* (Ernie Gehr, 1982–85). Photograph courtesy of Ernie Gehr.

Introduction

When we are in earnest, we discover our conviction that we have experienced infinitely more than we know about.

—WALTER BENJAMIN

The Cinematograph is an invention without a future.

—LOUIS LUMIÈRE

The film begins with images of a contemporary city street intersection. Nothing special is occurring. Daily life is seen in the passing of cars and trucks; people are crossing the streets. There are the hazy sunshine and deep shadows of a summer afternoon. In the long static shots I begin to see signs in the shop windows, a clock. The ambient sound of the street confirms the prosaic quality of the scene. This could be a city in almost any affluent country. The camera begins to cut to other shots revealing different points of the intersection. Each shot is separated from the next with several clear frames creating short flashes of white light making each shot discrete while creating a sense of the whole intersection. It is so mundane that I begin to look more thoughtfully to understand why the filmmaker is focusing so intently on this particular intersection. As the shots continue to jump-cut around the street, I notice that the signs are all in German. It becomes clear that I am seeing a street in Berlin. The movement around the intersection continues in a circular fashion. Germany. The present. Thought begins. At times the jump-cutting exploration continues at other similarly nondescript locations in the city. At one point there is an empty sandlot in which a hastily built sign announces that this is the site of what were once the torture chambers of the Nazi

Gestapo. At first it is confusing because it resembles a sign that might indicate the construction of something rather than calling attention to something that is not there. In the same casual manner of the shots of other street corners, the camera cuts to still another street. The shots are not composed to reveal the hierarchy of a point of view but are created to allow viewers to find their own way through the images. At another moment the camera explores a point at which a street and some railroad tracks intersect. There are parked train cars. In one shot the camera holds on a lone boxcar. I have seen old photographs of people being loaded into such cars. The camera cuts back to what seems like the original intersection. I recognize it, but now it seems different, inflected with a strange foreboding. Nothing has occurred in the frame, but I experience the sensation of a memory of something having occurred right here on these streets. But it is not clear exactly what, or if the memory is my own. In the slow movement around these streets, the past begins to shake out of mundane images of a present-day street corner in a city that stood at the center of some of the twentieth century's most catastrophic and transforming events.

Using an opposite strategy from that of traditional films about historical events that overflow the screen with the signifiers of periodized catastrophe or an emotional accounting of events that safely place the past elsewhere, this film, *Signal—Germany on the Air,* by Ernie Gehr (1982–85), through a refusal to re-create or represent, evokes a past that only exists in the present. As I watch, I am aware of the real time of the film moving through the gate of the projector, which also places me in the present, heightening my awareness of the act of seeing and thinking. Out of this form of extreme attention, the film becomes an experience of history, not as re-creation but as a force that acts on my body and mind. The experience of *Signal—Germany on the Air* opens me up to consider new possibilities for how cinema might be used to enlarge our culture's conception of what it is to think historically. The film embodies the ambition of an avant-garde cinema willing to take up some of the most challenging questions about the passage of time and the ways our culture uses visual images to understand the events of our past in the present.

In *Shadows, Specters, Shards: Making History in Avant-Garde Film,* I look at the ways in which a range of contemporary avant-garde filmmakers, largely from the United States and Europe, have explored the possibilities of thinking about history through cinema at the end of the twentieth century. While, for the most part, avant-garde and experimental films are seen to exist at the margins of—usually in reaction to, or as a laboratory for—dominant industry forms of cinema, less evident are their connections to contemporary intellectual thought, which reflect the epistemological shifts in historiography during the last half of that century. This is in contrast to a dominant cinema that uses the technologies of the photographic to re-create indexical signs of the past, thus placing the notion of historical knowledge largely in the realm of what can be seen, told, and re-created. Such a cinema uses its vast image and sound-making technologies to give us images of events that in the past could only be imagined: from point-of-view shots in the hold of a slave ship during the Middle

Passage to ground zero of the atomic explosion at Hiroshima.[1] This kind of emphasis on the specularization of the past has been central to cinema's power and authority as a historiographic medium. Such a literalization of the past through the re-creation of historical events works to separate the past from the present, constructing a gap between then and now by placing each at a safe distance from the other. As the historiographer Michel de Certeau describes:

> Even though [traditional] historiography postulates a continuity (a genealogy), a solidarity (an affliction), and a complicity (a sympathy) between its agents and its objects, it nevertheless distinguishes a *difference* between them, a difference established out of a will to objectivity. The space it organizes is divided and hierarchical. (*Heterologies*, 4)

Such divided narrative constructions produce specific boundaries that often close off past from present, limiting the complex ways different moments of time commingle, inscribe, and inflect each other. As de Certeau suggests, the imposed break between past and present, the hallmark of traditional historical forms, hides the process of its own production. These narratives emphasize the empirical quality of what still exists, such as artifacts and documents, to objectify and thus give authority to the interpretive—narrativized—account of the event by the historian or filmmaker. Furthermore, the objectification of narrative accounts can also be seen as a formal structure that serves to hide the very material elements of the constructed nature of historical knowledge.

In contrast, the avant-garde films I discuss take up an opposite strategy. They work to undermine such gaps between past and present by using a range of cinematic strategies to consider elements of the past that are unseen, unspeakable, ephemeral, and defy representations not necessarily verifiable through normal empirical means. At the same time, these films often foreground the constructed nature of narrative forms and the materiality of the film medium, both being integral parts of the meaning-making process. In conventional historiography, these formal elements are often understood to be the very aspects of a text that limit access to an "objective truth" in the recounting of an event. In these films, by contrast, their formal and aesthetic aspects are foregrounded to become the generative element that releases history as a force acting on the present.

My focus in this book is figured in the three images of its title: "shards," "specters," and "shadows." Each emphasizes that which exceeds the empirical and representable of history; each figure points to the limits of what can be seen and known. Shadows, specters, and shards signal the aspects of historical knowledge that are occluded, incomplete, and intuited. Although many of the films I write about use traditional visual elements and techniques of the historical film such as documents, artifacts, testimonies, and re-creations to represent past moments in their most visible and material forms, they also work to make us aware of the nonvisible elements that also surround their images. As we will see, such invisible elements supplement the actual image with

a surplus of meanings that deepen and give poetic dimension to history. These spectral presences, which are often sensed but remain unapprehendable, are nevertheless part of the energy of the past and exert themselves as a force on the present. The recognition of such unseen forces creates an awareness of other temporalities in which linear chronologies are called into question in favor of other temporal structures such as simultaneity and virtuality.

The figure of the shard acknowledges the constructed nature of the histories and cinematic objects that make up these films. History creates narrative out of the shattered fragments of what is left of an event after it has occurred. Similarly, films reconstruct time from a series of discrete shots, each an incomplete fragment severed from ongoing time. Both history and cinema are structured by what is missing and by the resulting gaps and elisions that can only be imagined or inferred. Conventional histories and films often work to hide the fragmented nature of their narratives through elaborate formal means that create seamless movements through time. These avant-garde films, on the other hand, work to emphasize the fragment as a central element of historical and cinematic thinking. Meaning accrues through the constellation of bits and pieces and the spaces between them, rather than the illusory totality of a seamless whole. As cinematic figures, shadows, specters, and shards refer to the ephemeralities of moving images, and paradoxically to the ways the very indexicality of film images can open onto what is nonvisual. Thus in naming this book *Shadows, Specters, and Shards,* I point to the unique combination of film's immateriality and the very material force of its affective impact on the body and mind that renders cinema such a powerful medium for the making of history. At the same time, this combination also provides a profound metaphor for the ways history functions personally and collectively.

These films implicitly, and often explicitly, take up the question that is at the center of postmodern historiographic concerns: the recognition that there are historical events that by their nature defy representability but nevertheless play an important part in the ways we understand the present. Even more importantly, what in past events continues to inhere in the dynamics of the present invisibly, but no less crucially, remains a spectral presence—apparition-like—within the dynamic of the present. This approach toward history as spectral force, writes the sociologist Avery F. Gordon, "captures perfectly the paradox of tracking through time and across all those forces that which makes its mark by being there and not being there at the same time" (*Ghostly Matters,* 6). The acknowledgment of such forces has been a major epistemological development within postmodern historiography, raising questions about the limits of what can be represented. These kinds of questions have given rise to particular formal and ethical problems for the creation of complex histories using cinema.

Shadows, Specters, Shards identifies and reads a subgenre within contemporary avant-garde and experimental filmmaking that has taken up the problem of historical representation in light of the postmodern turn. Like many other interdisciplinary forms of postmodern cultural study, this subgenre at once critiques the formal social science discipline of historiography and revitalizes it by complicating the relationships between

aesthetic and historiographic practices. I argue that the most innovative approaches to thinking and representing historiographic temporality in cinema are coming out of such aesthetically based cinematic practices rather than those that are sociologically bound—the social documentary and social realist dramatic films—which often replicate older conventional narrative forms of historiography. At the same time, avant-garde film reflects many of the shifts in the way time is narrated in our society, often reflecting changes in social formation and the nature of events that become historicized. To show how they do what I am claiming they do, I relate these cinematic practices to several contemporary discourses outside of media studies that take up questions of historiography in our culture. These include theoretical and critical work from the disciplines of history, philosophy, and literary and visual studies. This establishes a relationship between avant-garde film practice, usually understood within film studies to be largely formalist or poetic, and the larger intellectual and social discourses within the study of culture. In doing this, I argue, historiographic practices within avant-garde cinema are essentially interdisciplinary. The lines between what is seen as the traditional discipline of historical scholarship and poetic or aesthetic approaches to representations of past events are not antithetical but are in fact deeply interrelated and thoroughly dependent on one another.

Theoretical Armatures: Allegory and Time-Images

What links the formal approaches of all the films in the book are the ways in which pressure is placed on the present to exceed itself. As we will see, each film uses different methods of working with film images from the past in ways that cause them to open onto the present and vice versa. This creates other kinds of temporal relationships between past and present, allowing new possibilities for narrating the past that go beyond theatrical re-creation. Such cinematic approaches also have their theoretical counterparts, and throughout the book I use such theories to elucidate my readings of the films. In keeping with the idea of bringing past and present into dialogue with each other, I have brought together two major ideas from opposite ends of the twentieth century. One is an approach to history, Walter Benjamin's "historical materialism" and the activity of "allegoresis," and the other is an approach to cinema, Gilles Deleuze's taxonomy of the "time-image."

Benjamin's notion of history is useful because of the way he creates a distinction between traditional historicism as the construction of an "eternal image of the past . . . 'the way it really was'" and a notion of historical materialism in which the experience of the past is produced as something unique by the conditions of the present. As he writes: "History is the subject of a structure whose site is not homogenous, empty time, but time filled by the presence of the 'now' (Jetztzeit)" (*Illuminations*, 261). In this conception, "each 'now' is the now of a particular recognizability" (*The Arcades Project*, [N3,1], 463). For Benjamin, the past does not exist independently of the present as a force of nature, but rather relationally as the continuous construction and

reconstruction of a transforming present through an engagement with the material elements of the past as they exist in the present—objects, images, narratives, documents, detritus. For Benjamin, history is the active work of truthmaking. As he writes: "Truth is charged to the bursting point with time" ([N3,1], 463).

Nearly all the films I have written about can be described in Benjaminian terms as allegorical, creating the conditions for the active reading of events and objects from the past in relation to the conditions of the present. The allegorist attempts to make sense out of the fragmented, fractured, and decontextualized remains of the past by creating forms through which they might come to have meaning. This kind of "making sense" can be seen as a form of experimentation in which meaning is never something given, but something that is aimed at through active and creative engagement, the outcome of which is never guaranteed. Similarly each of these experimental films produces the textual conditions for such active forms of cinematic interrogation and spectatorship. Throughout the book, allegorists are figured in different ways: as collectors of discarded filmstrips and cine-archaeologists trying to make sense of fragmented, decontextualized shards of film (*Dal polo all'equatore* [From Pole to Equator], Yervant Gianikian and Angela Ricci Lucchi [1986]); as seers rendering palpable that which is not readily visible to the eye (*Signal—Germany on the Air*); and as cine-hysterics creating wild, paranoid visions of history based on rereadings of images found in dustbins (*Tribulation 99: Alien Anomalies under America*, Craig Baldwin [1991]). There are also the cine-dreamers, using utopian revolutions that failed in one context to imagine their success in another (*Utopia*, James Benning [1998]). We see witnesses attempting to place into language personal experiences of overwhelming events that they themselves can hardly make sense of (*The March*, Abraham Ravett [1999]). Still others use past events to reclaim the idealism of one era as the potential for another (*Chile, la memoria obstinada* [*Chile, the Obstinate Memory*] [1997]). In all cases the filmmakers appear as allegorists engaging both rational and nonrational forms of knowledge and experience to create what Benjamin called "profane illumination." Profane illumination arises from directing attention to aspects of daily life that have "a materialistic, anthropological inspiration" (*Reflections*, 179) and can produce an awareness of the transformative potential of the present. With this notion, Benjamin explored the possibilities that profound and enlightening experiences can be had in the everyday world, not just in the officially sanctioned contexts for enlightenment such as churches, museums, or symphony halls. As with the concept of profane illumination, so these films get at an experience of the present in which the past becomes legible in the interconnection between the material world of everyday life, its objects and places, and the unseen and inexplicable forces of subjective and unconscious desire. This includes dreams, memories, and altered states of perception that impact the present and, as such, are powerful components in the field of social production.

For Benjamin, the surrealist vision provides the aesthetic link to his philosophical strategies for an awakening to the "now of recognizability" (*The Arcades Project*, [N3a,3], 464). Like Benjamin, the surrealists trafficked in the shock of the discontinuities of

daily life in which conscious and unconscious worlds blur, disrupt, and confuse. The colliding montages of such fragmented worlds are seen in the modern city, the non-rational juxtapositions of the images and ideas of mass culture and the resurrection of discarded objects made new as they become connected to the construction of new works of art. As André Breton wrote, surrealism arises from "a desire to deepen the foundations of the real, to bring about an even clearer and at the same time ever more passionate consciousness of the world perceived by the senses" (*What Is Surrealism?* 49). The artwork releases sensuous and intellectual shocks of awareness as the past comes to have meaning for the present by speaking to its concerns. It is in this sense that aesthetic experience becomes generative of new potentials for how to think the past—not as an overarching narrative of something at a distance but as part of the experience of an always transforming present. The allegorical work of these films, then, creates the possibility for viewers to actively produce links between past, present, and future, between what can be seen or only evoked and what can be explained or only signaled.

In concrete cinematic terms, these kinds of temporal relationships can be productively understood within the Deleuzian description of the "time-image." Based on his philosophical studies of time and thought, Deleuze's "cinema books" *Cinema 1: The Movement-Image* and *Cinema 2: The Time-Image* are among the most sustained descriptions of the ways time can be rendered cinematically that I have encountered, and give a new language with which to write about cinematic time. Deleuze has not produced a theory of film signification. Rather, through close observation of temporal formations in cinema, he has produced a philosophical context and a taxonomy of the different constructions of cinematic movement and time, and the ways cinema evokes and creates images of the shifting structures of thought in an evolving society. Most important for a study of avant-garde film is his emphasis on the experiential aspects of cinema as an aesthetic encounter with duration that generates a complex web of shifting ideas about what constitutes the present. Like much avant-garde film, Deleuze's ideas at once challenge older conceptions of the movement of time and reveal new potentials for cinema as a means of thinking in time. In earlier forms of radical critique, film images are regarded as distorted or false representations of the world whose dangers lie in cinema's seductive powers that tap (unknowingly) into the deepest parts of our unconscious and so must be regarded with suspicion. Deleuze instead focuses on the generative possibilities of aesthetic practice that can create new relationships between objects, ideas, temporalities, and spaces that are both actual and speculative. For Deleuze, the movement of time is always the potential for transformation and new thought. This idea of creative thought and invention links Deleuzian philosophy with the most radical experimental impulses in avant-garde film practice in which clichéd constructions of time and narrative give way to new experiences of the cinematic.

Like Benjamin's notion of history as a continuously transforming set of relations within time, Deleuze maintains that cinematographic images are signs whose meanings are constantly in flux because they exist in time, rather than being fixed and immobile,

as presupposed by many traditional theories of cinematic representation. Deleuze argues against the notion of the film image as merely a simulated sign for something that exists in the world. Like many of the avant-garde films discussed in this book, and following Deleuze's thought, I move away from discourses about the ways films represent the world and toward ones in which film images *create* worlds. In Deleuzian terms, "time-images" are direct images of time, comprising the interchange of the actual, what is represented, and the virtual, that which exceeds the image and can only be thought or sensed—both of which the body and mind experience as the sensation of being in time. Deleuze stresses the direct experience of duration as that which "goes beyond the purely empirical succession of time—past, present and future." Rather than being chronological, duration is "a coexistence of distinct durations or of levels of duration; a single event can belong to several levels" (*Cinema 2,* xii). As the work of materialist avant-garde film makes us acutely aware, what the "image represents is not the image itself." Rather, as Deleuze continues, "the image itself is the system of the relationships between its elements, that is, a set of relationships of time from which the variable present only flows" (xii).

In this conception, *the image is in time as opposed to time being in the image.* Time-images can evoke temporalities that are not necessarily actualized in the image itself, but, as we will see, they "make perceptible . . . [more complicated relationships of time] which cannot be seen in the represented object and do not allow themselves to be reduced to the present" (*Cinema 2,* xii). It is not only a result of what is represented that opens the image beyond itself; it is also the bodily and affective experience of real-time duration. Such direct images of time access virtual temporalities through memory, desire, and bodily sensation—the experience of the body adjusting its metabolism to the velocity of high-speed movement or the stasis of real time passing with little apparent change, for example. But most crucially for this study, it is the experience of thought through the lapses and disruptions in the flow of time that occur in gaps between nonlinking images that evoke the unseeable, the forgotten, and the spectral qualities of history. This is what is occurs in Gehr's *Signal—Germany on the Air,* in which actual images of present-day Berlin release the virtuality of Berlin's past as a coexisting force in the experience of the image.

Central to films such as *Signal—Germany on the Air* and others throughout the book is that the meaning of an image changes over time. This happens not only through the experience of the image's duration on-screen but also in the ways in which images change as they, along with the viewer, travel through time from one historical moment to another. As Deleuze suggests, films do not just present images; they surround them with a world—a world moving in time and in perpetual flux. Cinematic images register constant change, from the movements of the camera and the profilmic objects in motion to the movement from one shot to the next. Time passes. Movement is constant. Both image and world impact each other as forces making the meanings of images as fixed representations impossible. It is in this sense that I use the term "image" throughout. To quote Henri Bergson, from whom Deleuze derives many

of his ideas about the movement of time, an image is "a certain existence which is more than that which the idealist calls *representation,* but less than that which the realist calls a *thing*—an existence placed halfway between the 'thing' and 'representation'" (*Matter and Memory,* 9). As Bergson indicates, the image being "halfway between thing and representation" is what gives cinema the complex layered quality as something that indexically simulates the visible world *and* also has the potential to open beyond itself. These films work to place images into the flow of time and thus are dynamic. Each film is at once static object and ephemeral force in the continuously transforming ways they make meaning. And so these films are not so much representations of history as they are the stuff of history.[2]

The Writing of History

My central argument in this study starts from the claim that, at the end of the twentieth century, with the growth of image culture, still and moving pictures are among the most important ways our society comes to understand its past. During the twentieth century, narrativized imagery and other visual objects such as documents and artifacts have gradually come to coexist with the written forms that carry society's authoritative historiographic record. In this sense, photography, film, and television have become the major ways in which we contextualize our past in relation to the present. For the most part, however, the dominant forms of visual history continue to find their authority in a series of self-validating institutions and discourses such as college history curricula and textbooks, and state-supported exhibitions in "official" museums of natural and national histories. This form of visual history perpetuates itself through its disciplinarity, which validates its system of truth, producing rules that determine what can be considered valid data and knowledge. The dominant form of historiography is an epistemology with distinct ideological and political implications used to produce social, political, and cultural consensus from the point of view of those producing such histories.

In contrast, an "antihistoricist" stance rejects the idea of history as an unchanging immanence and sees it, rather, as a production of discourse that is always in flux: what is important and useful as history is always changing. In other words, what is understood as history is a series of naturalized discursive practices constructed within a social formation that gives some texts and representations value and others not. In an attempt to distinguish between traditional history and what he calls "effective history," Michel Foucault writes:

> The forces operating in history are not controlled by destiny or regulative mechanisms, but respond to haphazard conflicts. They do not manifest the successive forms of a primordial intention and their attraction is not that of a conclusion, for they always appear through the singular randomness of events. ("Nietzsche, Genealogy, History," 154–55)

In this critique, history becomes as much a discourse of what is not articulated as history as what is. Historicism thus does not work with "real events" of the past but constructs in the present an image of a past that functions in relation to specific contemporary social and political needs. From this point of view, history becomes a discursive construction connecting the past to the present through the process of narrative formalization, which is a multilayered discourse concerning modes of representation.

When examined closely, the act of narrativization itself can be seen to dissolve the distinction between realistic and imaginary discourses that produce similar meanings, creating what Roland Barthes calls a "reality effect." He writes, "In 'objective' history, the 'real' is never anything but an unformulated signified, sheltered behind the apparent omnipotence of the referent" ("The Discourse of History," 139). Here Barthes, in the language of semiology, distinguishes between the meaning that is created by the language used and the event being referred to. This shows how the function of narrative does not represent the real but rather constitutes a spectacle of language that stands in as an authority for the real. History, then, is no longer simply the narrativizing of events but is also a metanarrative in which the act of creating the narrative is indissolubly intertwined with the knowledge that is constituted through it.

Similarly for historiographer and narratologist Hayden White, narrative discourse is central to relationships between events, their documentation, and how we come to understand them as history; hence he regards historiography as the study of a series of formal problems of narrative and emplotment that are more of a literary nature than one of science. To understand how historical knowledge is produced, White examines history as a literary artifact in which, like all forms of narrative, history is not merely a neutral discursive form but rather entails ontological and epistemic choices with distinct ideological and even specifically political implications. White, like Barthes, describes narrative as the central organizing principle for "translating knowing into telling . . . fashioning human experience into a form assimilable to structures of meaning . . . [like stories told, which come to be seen as] generally human rather than culture-specific" (*The Content of the Form*, 1). This is to say, the drive to make random experience coherent is the universal basis of narrative formalization. These formal structures are the elements that make representations culturally and temporally specific. Fiction and history are genres that signify in the same manner, producing the effects of a self-contained verisimilitude. Both serve to make the narrative structures of events appear to be natural and objective. If the narrative modes of representation seem so natural to human consciousness, these emplotted narratives become transparent, and their true ideological nature becomes less visible and is more indicative of present perceptions than of the actuality of past events.

At issue here are questions of the dynamics of narrative and the ways in which different formal modes of representation produce historical knowledge. This is what links historical representation with formal and aesthetic discourses of representation. From this position, the narration of history is an interdisciplinary enterprise, one in which there is movement across different temporalities, as in the relationship between

the space of memory, the place of the present, and often the objects that stand in between. At the same time, there is also movement across the different domains of knowledge that produce the representations of such relationships.

Avant-Garde Film Practice: Classifications

With a few exceptions, the films that I discuss here come out of the artisan tradition of experimental film production, linking them to earlier modernist formal explorations of the medium's materiality. The artisanal mode of film production, in which most aspects of production from scripting to cinematography, sound recording, optical printing, and editing are usually performed by the filmmaker, is understood to be the most direct relationship an artist can have to this highly technological medium. This individual mode of production not only emerged from economic necessity but, by the 1960s, was also often articulated as a political and aesthetic stance intended as an implicit critique of the industrial modes of film production. Many avant-garde film artists proclaimed themselves *filmmakers* rather than directors or producers, thus emphasizing their relationship to the entire process of film production. This was understood in direct contrast to the impersonal and often alienated Taylorist modes of production within the film industry, in which production is segmented and individual aspects have little relation to the whole. Similarly the distribution and exhibition of these films have been organized largely by the filmmakers themselves or by artist-run, not-for-profit production, distribution, or exhibition collectives and organizations. This mode of production reflects another defining principle of modernist avant-gardism, that of its aspiration for autonomy from critical and economic institutionalization. Central to this idea is that individually authored and independently produced media can be seen as an authentic popular-culture form offering an alternative and antidote to the consumerist media of the for-profit mass-culture industry. The desire for viable forms of cultural production that are autonomous from both the art world and the mass-culture industry continues to be seen as a primary signifier of contemporary avant-garde media practices.

The larger question of the classification of the films I have written about is a vexing one. The terms "avant-garde" and "experimental," which I often use interchangeably to categorize and historically situate these films, have always been problematic or inadequate at best. The complicated definition of avant-garde practice as it emerged as a modernist stance refers to an art that aspires to be an implicit or explicit critique of, and resistance to, the pervasiveness of dominant cultural forms and ideologies. In one aspect, such a critique is structured by the notion of withdrawal from the dominant social order with the ideal of developing institutional autonomy and counter-hegemonic discourses that exist as a parallel to mainstream culture. As counterculture, this offers an alternative to dominant aesthetic and political assumptions about the nature of art and its role in the production of consciousness in society. In another aspect, there is the acknowledgment of the impossibility of such autonomy since

artistic practice is understood as an effect of historically determined social processes; therefore, avant-garde art is understood as interventionist, existing to confront and transform the dominant culture by putting aesthetic practice at the service of social and political change. Both aspects are structured by the notion of an artistic vanguard leading the way by social critique and aesthetic innovation toward a progressive rethinking of the relationship of art to the social order.

"Experimental film" implies an emphasis on process over mastery. Fundamental to the notion of "experiment" is the possibility of innovation and progress as an artistic ideal. Its scientific cast refers to artistic production as a process of invention by working with the formal and material means of making meaning. Many have expressed (with some justification), however, discomfort with the term "experimental film," which, as P. Adams Sitney writes, "implies a tentative and secondary relationship to a more stable cinema" (*Visionary Film,* viii). Nonetheless, the term "experimental" does acknowledge the need for constant critique and aesthetic transformation to better express the realities of the dynamic social discourse of the society of which artistic practice is a part. In both cases these utopian impulses give avant-garde and experimental film its enduring value—as a kind of nonaligned movement—existing as a passionate intersection between the film industry, cultural activism, the art world, and academia. As an ideal, avant-garde film is a cosmopolitan movement, at once marginalized and dependent on these more visible fields, but exerting the force of limitless possibility on them. It is with these utopian implications that I use both terms throughout. By focusing on an advanced media practice such as avant-garde film, I am able to raise questions about the basic assumptions of the narrative constructions of history in general, and specifically as a cinematic genre. At the same time, I show how the formal and aesthetic experimentation in these films has created new cinematic forms and discussions that have profoundly impacted cinematic practice.

In looking at the evolution of avant-garde film practice since 1980, it can be seen that in addition to the maintenance of many older modernist ideals such as medium specificity and formalist exploration of a unique personal vision, avant-garde filmmakers are integrating such exploration with other noncinematic and nonvisual disciplines such as sociology, anthropology, critical theory, philosophy, and historiography. The movement toward other intellectual discourses outside fine art is not only a product of the post-1970s avant-garde cinema's relation to academic film studies—from which much of that generation of avant-garde filmmakers emerged—but an indication of the exhaustion of the emphasis on formalist investigation that was at the center of art world discourses. At the same time, the exploration of aesthetic and artisanal uses of media as a tool for political activism also expanded the conception of experimental cinema as part of the turn within avant-garde film toward a cinema of eclecticism, further blurring distinctions between high art and mass culture, pure aesthetic exploration and social and political investigation. This conception of postmodern avant-garde cinema aspires to be interdisciplinary in both theory and practice and moves away from the refinement of style as a goal or an indication of personal mastery. Rather,

it appropriates and hybridizes a myriad of media styles and intellectual discourses to engage in cultural exploration through cinematic and aesthetic means. Thus, instead of the different schools or tendencies with which critics have defined and identified filmmakers in earlier periods, such as visionary, lyrical, surrealist, structural, and so on,[3] recent avant-garde cinema can be seen to embody a new aesthetic pluralism—both in concern and in style. Many of its artists understand themselves to be part of the rich tradition of an earlier film avant-garde but are also doing primary cultural studies research and aspire to use their work as part of their political activism. This can be seen especially with the emergence of avant-garde feminist, gay, lesbian, multicultural, and postcolonial cinemas since 1980. Such work has extended the notion of personal expression as a form of modernist mythopoetic universalism toward the investigation of personal identity as socially constructed and historically situated. The emphasis on the constructed nature of identity and personal subject position in society in recent avant-garde media has given voice to marginalized cultural and personal memory that was often ignored by earlier critical histories of avant-garde film. The more recent efforts by critics and scholars to focus on such work as a kind of revisionist history have done much to create a larger and more complex notion of a contemporary countercinema. As many of the most recent critical historical studies of contemporary experimental media convincingly show, these works not only integrate artistic traditions from other cultures but also reveal suppressed or lost histories of oppression and resistance.[4]

Less attention, however, has been paid to the examination of recent works that have continued the formal and materialist explorations that were hallmarks of the modernist avant-garde movements and the ways they have engaged contemporary cultural discourse. It is here that my study might add to creating a fuller picture of the wide range of practices and concerns that have taken place in the last twenty years. As a way of examining the movement from modernist practices generally associated with avant-garde filmmaking until 1980, toward ones that go beyond purely aesthetic discourses to make connections between larger areas of cultural study and the hybridized aesthetics of contemporary media art, my study identifies what I consider to be a major preoccupation within this avant-garde cinema tradition during the last twenty-five years—the representation of history in cinema. The modernist avant-garde cinema saw itself in utopian terms as the shock of the new and was obsessed with the experience of the present. A postmodern avant-garde cinema can be seen to be preoccupied with the problem of how to think the past and how to represent it. This is especially so in an era in which the notion of the grand narrative of history is continuously being called into question. While the destabilizing of naturalized narrative forms is a hallmark of postmodernist thought, it has also been central to the modernist avant-garde film in its ongoing challenge to the linearity of temporal representation and narrative emplotment structures. As will become clearer, the defining lines between modernism and its post- are unstable and often blurred. To take on historiographic narrative, then, is at once a continuation of such modernist avant-garde preoccupations and an engagement with postmodern critical questions.

Film Theories: Avant-Garde Political Modernism

As a matter of theory and practice, the historical context for many of the works studied here has emerged from earlier political modernisms, most specifically strategies of aesthetic anti-illusionism that emerged from the European and North American avant-garde cinemas in the 1960s and 1970s. This aspect of political modernism was a search for a politically committed cinema in which the imperative to explore and develop radical aesthetic forms is an integral part of a progressive media culture. At its center is the critique of cinematic illusionism that is equated with intellectual and physiological manipulation of the viewer consciously and unconsciously reinforcing dominant ideologies. As a counterstrategy, this is an aesthetic of reflexive dis-illusion to demystify the transparency of dominant film forms by foregrounding the material and semiological elements of the apparatus. In his influential 1976 essay "The Two Avant-Gardes," Peter Wollen identified two major approaches to such cinematic materialism within avant-garde film practice.[5] The first is understood as neo-Brechtian, associated with the European art cinema of Godard, Straub and Huillet, and others. In the spirit of Brechtian epic theatre, such film practices work to confront the audience with the historical significance of the specific social and political conditions of a film's existence. The film is no longer simply an entertainment or aesthetic object but a tool through which audiences might acquire knowledge about the society in which they live. Brecht's theory of alienation not only "turns the spectator into an observer, but arouses his capacity for action, [and] forces him to take decisions" (Brecht, *Brecht on Theatre,* 37). In such a cinema, the Brechtian "alienation effect" encourages active critical thinking about the ways meaning is made in cinema as an integral part of spectatorship. Spectatorship is based on the linking of the cinematic experience to the social forces in which it is produced, as opposed to traditional cinema, which relies on passive spectatorship and the suspension of disbelief to separate the cinematic experience from the lived reality of the viewer. The second tendency Wollen identifies is associated with North American and British structural/materialist filmmaking, which emerged from art world contexts of abstract expressionism and minimalism. Like painting and sculpture, film is experienced as an object in itself and not simply a transparent medium that represents things other than itself. By foregrounding the process of signification through its material elements— film stock, light, duration, and hardware—such films expose the indexical qualities of the film medium as a phenomenon of its highly developed illusionistic nature. Film's illusionism creates the impression that the film image is an actual trace of real events rather than a system of signifying signs.[6]

One of the most sustained (and crucial for my discussion) articulations of these ideas within the avant-garde film context is the theory and practice of the British structural/materialist filmmakers, Peter Gidal and Malcolm Le Grice in particular, who during the 1970s tried to repoliticize the idea of an avant-garde film by arguing for a practice "which attempts to be non-illusionist . . . [and] that results in demystification or attempted demystification of the film process" (Gidal, *Structural Film Anthology,* 1).

Structural/materialist film distinguished itself from other forms of filmmaking as a radically anti-illusionist film practice designed to expose the highly ideological telos of the motion picture apparatus. Structural/materialist filmmaking also critiqued other forms of experimental film such as visionary and other countercinemas exemplified by the American avant-garde. As Gidal defined structural/materialist films, there is an

> attempted avoidance of empiricism, and the mystic romanticism of higher sensibility individualism. This romantic base of much American Structural film has been eluci-dated by P. A. Sitney. Visionary film is precisely the post-Blakean mire that Structural/Materialist film confronts. (14)

Structural/materialist filmmaking as articulated by Gidal in his manifesto "Theory and Definition of Structural/Materialist Film" is perhaps one of the most polemical (and also most prescriptive) articulations of the potential for avant-garde filmmaking as a radically anticapitalist political film practice since Dziga Vertov's manifestos of the 1920s.[7] In his manifesto, Gidal argues for an anti-illusionist form of filmmaking in which the display of representational and, therefore, illusionist content is replaced by the process of filmic material producing its own trace as light, movement, and dura-tion. As Gidal writes:

> In Structural/Materialist film, the in/film (not in frame) and film/viewer material relations, and the relations of the film's structure, are primary to any representational content. The structuring aspects and the attempt to decipher the structure and antic-ipate/recorrect it, to clarify and analyze the production-process of the specific image at any specific moment, are the root concern of Structural/Materialist film. (*Struc-tural Film Anthology*, 1)

For Gidal, filmic representation is overdetermined by the dominant ideology of cap-italist modes of production because the ideology is reproduced, reinforced, and nat-uralized within the historical relationship between the image and viewer in films that do not negate the transparency of their own illusionistic processes. This, according to Gidal, can only be accomplished by breaking not only with the dominant conventions of cinematic meaning making but finally with representation itself. This position led to a stripping away of the possibility of any kind of representational content to the basic elements of cinema: light, movement, and duration. As a result, the kinds of images that were rendered were usually abstract, minimal, and silent. This had a rela-tion to minimalist aesthetics in the art of the time, but rather than seeing this strip-ping away as a form of ascesis to get to the essence of the aesthetic experience or as a way of transcending the object's materiality toward an intangible sublime, structural/materialist anti-illusionism was understood as a sort of cinematic hygiene in which the politically regressive elements of cinematic representation were excised from the viewing experience. As Gidal declared:

I have vehemently refused . . . to allow images of women into my films at all, since I do not see how those images can be separated from the dominant meanings. . . . I do not see how . . . there is any possibility of using the image of a naked woman . . . other than in an absolutely sexist and politically repressive patriarchal way. ("Technology and Ideology," 169)

This kind of reductio ad absurdum creates a rhetoric of the impossibility of a countercinema, except as a process of negation, since any kind of image can be read only as a dominant media image. Furthermore, not only was this an aesthetic endgame in which the filmmaker had fewer and fewer elements to work with as a form for expression, but it rendered film a medium in which making any kind of cinematic political intervention using representational images a virtual impossibility. While the process of negation that Gidal uses can be seen as idealistic and even utopian in Theodor Adorno's sense of the transformative power of negation, it was also highly restrictive, moralistic, and even an authoritarian form of cultural ultraleftism.[8] By 1980 this strategy of negation produced an aesthetic and political dead end. While such films are interesting as polemic, when there is nothing to see, hardly anyone will watch.

While the reductive nature of structural/materialist practice appeared to close off new aesthetic possibilities for a socially engaged experimental film practice, the rigor and radical aspirations of its polemics produced some of the most challenging works of cinema made in North America, Europe, and Latin America during the postwar period.[9] But as my study shows, the legacy of this work continues to define the edges of what radical film art might be. As will become clear, the filmmakers I have written about have deeply internalized the theory and practice of this earlier materialist avant-garde but have revitalized it by turning toward the larger problems of signification as part of the process of demystification. In doing so, the films bring together Wollen's two avant-gardes as they work to combine both neo-Brechtian signifying approaches that can take up historical and social issues in direct terms while at the same time using the elements of film's material and formal processes to foreground the dynamic experiential aspects of meaning making through cinema.

The Postmedium Condition

The idea of the reduced field of signification and the assertion of the materiality of "film as film" as a progressive political strategy reinforced a politics of authenticity in which the medium can only function counterhegemonically when it is revealed to be irreducible only to itself. This reflexivity lies at the core of political modernism in avant-garde film. The importance of identifying an essential "nature" of a medium—that what the artwork expresses uniquely lies in the particularity of the medium used—has been a hallmark of modernist art in general. This notion has been particularly important to the development of cinema, in which claims for its legitimization as a new art form lay in defining and accessing a "pure cinema" as distinct from the

other arts. The idea that there is a true "nature of cinema" that can be uncovered and made manifest has been a primary discourse in the development of cinema. While this rather reductivist notion of medium has been a dominant trope, it is only part of a larger dialectic, the other side of which is an understanding of cinema as a prototypical post-modernist form and part of what the art historian Rosalind Krauss has called the emergence of a "postmedium condition" in modern art. In this formulation, cinema can never be seen as having its essence in a single medium, since part of its fascination is with its constant technological evolution, sound, color, wide-screen, video, digital imaging, and so on, along with its integration with other forms such as music, theater, literature, sculpture, science, journalism, anthropology. In this sense, cinema extends the notion of medium as "essence" toward an acknowledgment of the "differential condition of film: its inextricable relation between simultaneity and sequence, its layering of sound or text over image" (Krauss, *A Voyage on the North Sea,* 45). For many avant-garde filmmakers, the film medium has created a forked practice in which the experimentation with pure medium—"film as film"—is constantly being challenged by film's ability to become more than simply itself. Such a paradox has been of major importance to the vitality of avant-garde film of the last twenty years, forcing filmmakers to look elsewhere for other theoretical models for what a formally subversive cinema practice might be. In addition to such theoretical reconsiderations, within film practice, the constantly changing conditions of independent film production after 1980 have also caused a reconsideration about what it means to continue to work with the film medium itself.

The question of maintaining medium specificity has become a strategic issue for many experimental filmmakers who have turned their focus to the past as a way of examining and evaluating the accumulation of a century of film images. For the first time in the history of the art form, filmmakers have an archive to sift through, analyze, and appropriate, allowing them to create their own metahistories. The history of world film culture has been a short but dense one that has permeated the consciousness of much of the planet, allowing cinema to become—like literature—a way of apprehending the world itself. Working with this past as a form of historiography is pivotal to any notion of a postmodern cinema. A work such as Jean-Luc Godard's videotape *Histoire(s) du cinéma* (France, 1989–98) is a metahistory of cinema that attempts to create a history of the twentieth century that is inextricable from the history of cinema. Godard indicates the passage away from cinema toward electronic media by making his history of cinema on video, perhaps showing that for him, it is only through the advent of a new medium like video that the cinema can begin to be understood. With the emergence of low-cost, high-quality digital imaging and editing technologies in the 1990s, the post-cinema era has arrived. The slow but steady phasing out of different elements of the film medium—from the discontinuation of production of film stocks and motion picture hardware to the closing of film laboratories and venues that exhibit small-format films, particularly Super-8 mm and 16 mm—is making it clear that the photographic motion picture is an art form that begins and ends in the twentieth century.

For this study, however, unlike Godard, I look exclusively at the ways artists are continuing to use the film medium, its history, and cultural contexts in order to free themselves from the complicating and rapidly transforming contexts of new media technology and the particular discourses that surround them. Avant-garde filmmakers, who have had to deal in a material way with the end of their chosen medium, have discovered for themselves just how profoundly the question of pastness and its representation is tied to their situation as artists. Just as they must find innovative ways to use a now nearly impossible medium to express their ideas, so they must find cinematic forms that are adequate to represent the history of their times. It is my contention that the simultaneous grappling with the history of their chosen medium in relation to the larger historical events they explore inflects the larger discussions of historical representation in complex ways that also illuminate current discussions of newness and medium specificity in art. To make the question of medium even more complex, since the late 1980s, the exorbitant costs of photographic film production, fewer sources of funding, and the changing ways in which media art is exhibited are among the practical reasons that film artists have been forced to reconsider their own cultural relevance and what it means to work in a medium that is not only gradually becoming anachronistic but also disappearing altogether. Hence the use of the photographic film medium itself has become a question in the face of emerging technologies, particularly as electronic and digital imaging becomes the main medium through which contemporary culture represents itself. To continue to work with film, then, is to understand oneself as a "postmedium" artist working in an art form in which there is no longer an essential "nature of the medium." The filmmaker who continues to work with motion picture film has the unique experience of using a medium that was long seen as the newest of aesthetic technologies and the cutting edge of cultural expression but is now becoming the anachronistic embodiment of a passing era. In this sense, to work with motion picture film has in itself become an act of reflection and reconsideration about relationships between pasts and futures.

In the face of new media such as digital video and computer imaging, the motion picture image no longer signifies the "now" of technological progress and cultural expression; like the image of the railroad train in relation to the jet plane, film is now often seen as a periodized technology whose images signify an earlier moment in the development of the melding of modern technology and aesthetic expression. A reconsideration of the question of "newness" in relation to aesthetic exploration has become almost inherent to artists continuing to work with film.

The question of abandoning older forms and technologies for newly emergent ones in the hope of finding ways to more effectively express the present moment has also been a cornerstone in the ethos of aesthetic modernism. To continue to work in a technologically outmoded medium like photographic film when there are new technologies to do the same things more easily and quickly (this aspect of techno-progress is central to the transition from analog to digital modes of production) is not necessarily an indication of aesthetic conservatism. Rather, it opens up the possibility of a

cinematic practice in which the medium itself becomes a basis on which to question the possibility of newness in the first place. Theodor Adorno writes:

> The cult of the new, and thus the idea of modernity, is a rebellion against the fact that there is no longer anything new. . . . The new, sought for its own sake, a kind of laboratory product, petrified into a conceptual scheme, becomes in its sudden apparition a compulsive return of the old, not unlike that in traumatic neuroses. To the dazzled vision the veil of temporal succession is rent to reveal the archetypes of perpetual sameness. (*Minima Moralia,* 235–36)

As Adorno bitterly suggests, the constant focus on the promise of the new as a signifier of progress can become a form of displacement, making it harder to recognize the ways a less-spectacular status quo is maintained despite the gleam of something like a new technology that in its sparkle can be imbued with nearly any promise. In relation to representations of the past, the seductiveness of the new can also close off access to the ways the past inheres in the present both ideologically and aesthetically. In the current period, with its explosion of new imaging technologies, there is the uncanny sense that with each new invention the wheel is being reinvented, because, in aesthetic terms, the new is never really new, for if it were, it wouldn't be recognizable. The reality is that artists are generally compelled to return to already existing ideas, paradigms, and forms as the basis for approaching new technologies, often without consciously knowing they are doing so. In this way, aesthetic conventions become naturalized forms of representation, often unquestioned and uncritically employed as a mark of the new.[10] To work with motion picture film, then, becomes an act of looking retrospectively at what the medium created, its impact on society and what remains of its history—the artifacts and the discourses generated to understand what it means to look forward. This, by default, turns experimental filmmakers—whether consciously or not—into historiographers of their own practice.

As I argue in these pages, some of the most challenging and innovative cinematic work of the last twenty-five years has addressed the problems of historical narration. I have tried to identify and describe some of the strategies that several contemporary avant-garde filmmakers have developed to create a kind of poetics of new formal strategies for representing the past. At the same time, I want to show how the tradition of aesthetic practice of avant-garde cinema as a form of intervention in cultural politics continues to be a vital tradition in cinema. Contrary to the view that aesthetic practices are apolitical and disconnected from the social and intellectual debates that rage in our society, I show that the aesthetic practices of many avant-garde films stand at the center of such debates and are made not only to critique the inadequacies of dominant cultural representations but to create constructive and dynamic alternatives.

Furthermore, in the spirit of the positive and generative aspects of contemporary avant-garde practices, I show how the turn toward the exploration of historical narrative has been a way out of much of the reductivist and minimalist aesthetics of political

modernism, which, as discussed earlier, appeared to be on the verge of turning away from the rich possibilities for film as a signifying practice. Avant-garde filmmakers continue to take up complicated and difficult material by confronting their concerns head on, rather than marking their difficulties by surrendering to the silence of the seeming impossibility of representation. Contrary to Adorno's prediction that the "coming extinction of art is prefigured in the increasing impossibility of representing historical events" (*Minima Moralia,* 143), I have tried to make the case that this so-called increasing impossibility has revitalized a moribund formalism through the desire to confront the limits of representability by reintroducing the signifying practices of representation, thus creating a new set of problems that are at once aesthetic, ethical, and political.

A Spoonful of Sugar: History as Popular Entertainment

Something must also be said about the use of history in mainstream film and television, since it has been identified as a major subgenre within film studies and reflects the importance of the film medium in the making of history.[11] These studies are generally critical of the ways in which the dominant cinema represents popular history, blurring the lines between entertainment and education. Because of this, most studies are preoccupied with historical narratives in the Hollywood feature film, for example, *Glory* by Edward Zwick (1989), *JFK* by Oliver Stone (1991), the television drama *Holocaust* by Marvin J. Chomsky (1978), *Roots* by David Wolper (1977), and mainstream documentaries such as *Eyes on the Prize* by Henry Hampton (1987–90) and *Who Killed Vincent Chin* by Christine Choy and Renee Tajima-Pena (1988), as well as numerous others, to the exclusion of more-marginal works. Their focus is on deconstructing the usually unquestioned authority of the represented, which is even more naturalized by the indexical quality of the cinematographic visual, making relationships between reality and its image even more transparent than in written histories. Other studies rehearse older high/low culture debates that argue for or against mass-media simplification of the complexities of historical events through their adaptation to melodramatic forms, making them more palatable to garner larger audiences who will learn about such events. The debate over the success of a mass-media entertainment such as *Schindler's List* by Steven Spielberg (1993) versus a history like *Shoah* by Claude Lanzmann (France, 1986) whose strategies work to represent such an event in its narrative complexities is paradigmatic.[12]

While much of this criticism speaks to the inadequacy and lack of sophistication of many dominant forms of cinematic historical texts, mainstream academic media studies have paid little attention to alternative practices. For the most part, within media studies, avant-garde cinema has been distinguished from dominant film as its exception, rather than being in an integrated or symbiotic relationship to the more widely seen forms of media. This state of affairs now seems more pronounced than

ever and mirrors the increasing hegemony that the commercial "culture industry" has on contemporary media culture in general. Unfortunately the sense that alternative media practices lack social or political relevance because of their marginalization and invisibility to wide audiences and can therefore be ignored by scholars has become a self-fulfilling prophecy. The value of dressing up complex historical events in popular entertainment forms to make them easily consumable by mass audiences is often rationalized as being problematic, but still better than no history at all. Such rationalizations are infantilizing and reconstitute the simplistic binaries between "high versus low" and elitist versus popular cultural practices. In the context of contemporary media studies, however, the sense that the cultural relevance of counterpractices is lacking often comes from a larger political confusion in distinguishing between notions of (1) industrially manufactured mass culture that gathers cultural importance largely as a result of its broad means of dissemination, (2) a popular culture that grows out of the expression of a specific community, and (3) other modes of media production that neither intentionally represent the expression of any specific community nor are produced out of a profit motive. The latter—such as the personal, experimental, and activist—is generally understood to be counterhegemonic, at least in intent. The social impact of such work is less readily causal or predictable, making it harder to argue for its cultural relevance, and thus is easier to ignore. Although these questions are complicated and beyond the scope of this discussion, my work here asserts the importance of alternative and counterpractices by looking at the highly sophisticated forms of historiographic representation addressed by the aesthetic practices of the experimental avant-garde cinema.

Eurocentric Histories: "Shoah-Business"

I see this book as a cine-poetics focusing on formal and narrative strategies of the films, as well as on their epistemological implications for the histories that they investigate. I am not trying to create an overview of the important histories of the twentieth century as represented through avant-garde film. Responsibility, however, must be taken for the history that is produced from the constellation of events that the films take up. Because many of the films are European and American, the structuring historical event for much late-twentieth-century Euro-American art is World War II, of which the Shoah is its most distilled trauma. Since 1945 those events have come to be understood as singular in the ways they produced a geopolitical, philosophical, and aesthetic rupture in the narratives of the progressive European universalist Enlightenment project, the ramifications of which continue to be felt today. Why Europe at mid-twentieth century, the world's most affluent, educated, and scientifically advanced society, seemed to mobilize its knowledge and technology for the industrial mass deportation and extermination of millions of Jews and other minorities is a question that strikes at the heart of Western modernity. As Jean-François Lyotard argues:

> The project of modernity (the realization of universality) has not been forsaken or forgotten but destroyed, "liquidated." There are several modes of destruction, several names that are symbols for them. "Auschwitz" can be taken as a paradigmatic name for the tragic "incompletion" of modernity. (*The Postmodern Explained*, 18)

The unanswerability of Auschwitz as the brutal culmination of two thousand years of European culture is, as Giorgio Agamben writes, "indeed, the very aporia of historical knowledge: a non-coincidence between facts and truth, between verification and comprehension" (*Remnants of Auschwitz*, 12). As both philosophers suggest, the figure of Auschwitz indicates that what was liquidated along with millions of human beings was a narrative of modernity as the progressive forward movement of knowledge and civilization. Such narratives constituted an idea of humanity as a whole entity, of which each element, valued equally and understood to be an integral part of another, would become manifest as truth. As Agamben suggests, however, history itself as the empirical verification of such a truth no longer coincides (if it ever did) with the facts of what occurred at Auschwitz. The sign of Auschwitz continues to haunt the intellectual worlds of Europe and America as a *post*modern condition in which there is no progressive thread of knowledge, no consensus about the nature of events—what they mean or why they occurred. What remains are fragments, fissures, and gaps that create a field of indeterminate and contested meanings, opacities, and eventually silence, since there can be no representational consensus about exactly what occurred. What we are left with are fragments and signs that something happened, without a clear narrative sense of what they refer to.

The necessity for Europe to reinvent itself politically in light of the war was no less crucial to artists who understood the need to reinvent new aesthetics that could adequately engage the complexity of the events that occurred. For these reasons, the Shoah has become such a profound challenge for avant-garde artists in all art forms. That the Shoah becomes the central event in this study has less to do with making claims for its being the ultimate horror in the history of twentieth-century catastrophe—one has only to think of Armenia, Hiroshima and Nagasaki, Vietnam, Cambodia, Somalia, or the global impact of 9/11—than engaging the aesthetic figuration of the Shoah as an extraordinary intersection between the philosophical, ethical, historical, and aesthetic issues that so much late-twentieth-century art confronts with an almost unique obsession.

There is another reason for making the Shoah a central theme in a book about avant-garde film. While an intellectual and emotional obsession for many artists, the Jewish catastrophe has become something of a growth industry for Hollywood and international film and television corporations. This so-called Shoah-business, with its vast marketing and distribution networks, creates a yearly outpouring of gut-wrenching and eye-popping historical melodramas that threaten to obscure other cinematic approaches to these histories. The overwrought and often exploitative forms of dramatic re-creation are becoming the master narratives of the Shoah, saturating the

public with the singularity of their form.[13] Ironically, as the Hollywood "Holocaust films" have become a more established genre, their narrative forms have become more standardized in their linearity, drawing lines separating past and present more deeply than ever. Compare this to a much earlier film, *The Pawnbroker* by Sidney Lumet (1965), with its complex flashbacks between past and present to show connections between the trauma of the main character's past experience as a Jew in Nazi-occupied Europe in the 1930s and the present of his life in the nonwhite ghettos of New York City in the 1960s. By contrast, in Spielberg's *Schindler's List* (1993) and *The Pianist* by Roman Polanski (2002), the films' beginnings depict an untroubled everyday life of middle-class European Jews, devolving into a catastrophic middle act and concluding with redemptive endings in which the implications of the events depicted have little bearing on the present viewing of the films.

While these films use the vast technologies of modern cinema to enclose the past in itself through ultrarealistic re-creation in order to speculate on what occurred, the films I explore—*Urban Peasants, Signal—Germany on the Air, Cooperation of Parts, Persistence, Un vivant qui passe,* and *The March*—are largely concerned with the present, which is used to open onto the past. In these works, the emphasis is on process rather than presentation. The gesture in these films is to create a process for working with images and sound materials as an event in the present in order to produce a relation to past events. Conjuring, evoking, and active listening and watching are the keys to the past. The developing relation between the present and past becomes a form of knowledge rather than a re-created spectacle.

The continuously reverberating fallout of the events of World War II also powerfully links to other prewar and postwar histories. European decolonization and the global impact of non-Western independence struggles in Asia, Africa, and Latin America are at the center of much geopolitical history in the postwar period. These postcolonial movements were attempts to create new and often profoundly idealistic social and political formations. The successes and especially the failures of the revolutionary political struggles in Latin America during the 1960s, 1970s, and 1980s provide complex histories, raising questions for the future, that have made it necessary for filmmakers of the Americas to find new cinematic forms. What the legacies of these struggles have come to mean for the present are contemplated in the films *El día que me quieras, Chile, la memoria obstinada, Tribulation 99: Alien Anomalies under America,* and *Utopia.* Similarly, I have juxtaposed discussions of films about the Shoah and Latin American struggles for independence with prewar legacies of European colonialism, as in *Dal polo all'equatore,* a film that examines early-twentieth-century imagery of the colonized third world, and the legacies of African American history as evoked in present-day Los Angeles in *Killer of Sheep.*

Theorizing about changing strategies for the representation of contemporary history, Hayden White argues in his essay "The Modernist Event" that the magnitude and complexity of many twentieth-century events, such as the two world wars, pollution of the ecosphere, nuclear war, mass deportations, and the like, are specific to

the century. Such convulsive experiences are difficult to describe and impossible to explain by means of traditional modes of narration and emplotment. He thinks, moreover, that the magnitude of such occurrences makes it impossible for any objective account or rational explanation based solely on the facts to be sufficient to represent their complexity. So large and unwieldy are these events that they actually begin to defy explanation, resist representation, and refuse consensus about their meanings or even about what happened. The thought that one could simply "understand"—implying mastery over events and contexts—becomes illusory. For White, the modernist event blurs the solid distinctions between founding presuppositions of Western realism, especially the opposition between fact and fiction. Hence representational modes based on such solid distinctions are no longer functional or meaningful. He shows how modernist artists in art, literature, and cinema in the twentieth century begin to adapt their formal and aesthetic strategies to represent such events. That both artists and historians are forced to create new forms to represent the events they are trying to describe is central to the works I study here. The desire on the part of experimental filmmakers to invent new forms to represent the past is not simply an Oedipal anxiety of influence overthrowing the old, but a necessity when engaging a medium that provides unique possibilities for representing time.[14] This is especially crucial if established forms of narration are found to be inadequate to represent modern historical events.

Histories, Theories, Images, and Sounds: A Montage

That history is not simply a story of events unfolding but rather a set of *relations* between events, memories, temporalities, geographies, cultures, and objects that move outward beyond the events themselves, creating new forms of knowledge, is also a major idea explored in *Shadows, Specters, Shards*. In cinema, of course, this is known as *montage,* a formal system in which ideas are produced through assemblages of dissimilar images and sounds that collide or sit uncomfortably in relation to each other. Through such uneasy relations, they produce new ideas in the mind of the viewer that don't necessarily exist in the images themselves. The importance of montage lies in the ways it foregrounds the constructed nature of the meanings between things. As Eisenstein suggested, montage does not show facts but creates comparisons between elements. Similarly this book is a literary work of montage. Following the cine-montagists themselves, who invented bold new forms of thinking through seemingly disparate spatial and temporal relationships, in this introduction, I too use similar strategies, making new combinations and connections between the practice of history and the aesthetic practices of experimental filmmaking. Taken as a cumulative whole, this book formulates a cine-poetics of history as a complex matrix of nonlinear assemblages of different historical events, associative geographic and cultural connections, the analysis of diverse styles and formal strategies used in the films, and an often contradictory range of theoretical ideas considering the movement of time. The attempt is to show how the promise of modern cinematic form as a new way of experiencing time at the

beginning of the twentieth century becomes the embodiment of a new, more complex way of thinking historically at the century's end.

But despite the use of such complicated and heady formulations throughout, this study is not a theoretical work. I am not interested in using the films to illustrate the theoretical texts I am working with, or to validate the films through the authority of such academic theory. Rather, I have created a series of close readings of a body of difficult films of which little or nothing has been written. I have also chosen to make extended readings of a few films, to show through my own process of writing the ways in which contemporary avant-garde film can be highly dynamic and generative of ideas, rather than describing many films in small detail simply to make a case for a historical trend or to demonstrate a theoretical point. I have let the films themselves take the lead in opening onto a whole range of philosophical questions, making it necessary to use theoretical texts such as Benjamin's and Deleuze's to give me the language with which to write about them. Here I am not so much interested in using one to illustrate or explicate the other as to see how they illuminate each other, and the exciting ways similar kinds of questions are taken up by filmmakers and theorists and are shaped by written language, in one case, and, in the other, cinematic images and sounds. At the heart of this is a notion of interdisciplinarity in which visual and aesthetic modes of thought are brought together with more analytical and linguistic ones. What is most exciting is that we can see how a relatively new medium like film can take its place alongside older forms of thinking. I show in my analysis of these films how Deleuze's claim that cinema is a form of thinking through images is generative of new and different possibilities for experiencing ideas. In the short history of cinema, its intellectual and formal advancements have been staggering. That such a young art form can take its place next to an ancient discipline like philosophy and then illuminate it in such unique and productive ways is clearly at the center of Deleuze's own cinema project.

Rather than making this study chronologically based or encyclopedic—that is, surveying all the works that have taken up historical issues in the history of avant-garde cinema—I have divided the book thematically. In each chapter, I have identified a different theoretical problem that filmmakers have engaged with through practice. I have made close readings of films that I take to either be paradigmatic attempts to engage the problem of that chapter or have articulated specific issues in the most complex or compelling of ways. I am interested less in scholarly comprehensiveness than in bringing to critical light films about which little or nothing has been written. Creating interest in these works is an important part of this project. Of course, many other extremely important films and filmmakers could easily have been included here, but in many cases I found that they do not fit within the specific contexts I have created, or have already been written about extensively. Where I felt I had nothing new to add to the discussion of these films, I have left their consideration to others. But most importantly, my choices reflect my own own aesthetics, cultural interests, and ideological positions.[15]

Chapter 1, "Shards," takes up the representation of history through the use of artifacts of cinema's own past. The works discussed take film material shot in one moment of time to reexamine or rework it from the point of view of the present. These film materials are taken from the global archive of film images that has emerged over the last century. Such images are often seen by the filmmakers as document, evidence, or the raw material with which to understand another era in relation to how such images are discovered and understood in the present. Each film can be characterized as Benjaminian, being self-consciously allegorical in the ways it appropriates images from the past and rereads them as a reflection on the present. Using Benjamin's own practices of allegoresis and historical materialism, I show their parallels with contemporary avant-garde cinema. Three major films are examined, each one made in a different decade, and each using what, according to my readings, are Benjaminian processes to allegorize a past in relation to specific cultural and political issues in the present. In *Eureka* Ernie Gehr wordlessly creates the experience of simultaneous coexistence of multiple temporal moments by showing the ways in which the mechanical reproducibility of film can produce an image of the past and the present within the same image. *Dal polo all'equatore* (From Pole to Equator) is a study of archival images of the European colonial past that challenges our sense of the pastness of the colonial gaze. While this film skates the line between eroticizing such images and creating a critique of them, I argue that the film produces what cultural theorist Kobena Mercer has called "the experience of aesthetic ambivalence" to produce a complex critical reflexivity often absent in historical documents. My reading of *Tribulation 99: Alien Anomalies under America* by Craig Baldwin takes up relationships between popular-culture narratives and how we come to understand historical events surrounding past anti-imperialist independence struggles in Latin America. Through imaginative, parodic play with popular tropes of political conspiracy narrative and religious mythologies, *Tribulation 99* calls attention to the ways in which narrative forms themselves structure and transform the meanings of a vast range of imagery and cinematic genres. Baldwin constructs these, layer upon layer, until finally, like a house of cards, they collapse under their own weight of signification and produce an entropic image of history in which any idea of the coherent narrative of events blows apart. *Tribulation 99* is an allegory for the process of narrative itself and calls into question the notion of an inherent meaning in any image, revealing meaning itself to be an *effect* of the endless machinic generation of narrative forms.

These films are miniature time machines that move us through the temporal strata of their imagery, revealing each moment of time as a relation to another. In doing so, the films render the complexity of time with a uniquely cinematic texture, making knowledge at once sensual and intellectual. Through the intervention of these contemporary filmmakers, the cine-allegory reactivates once-forgotten imagery to produce an image of the past's future in the present.

Chapter 2, "Shadows," considers constructions of linearity, causality, and inevitability as formal tropes of historical narrative that are often used to create order and

rationale out of the random and unpredictable nature of events. These tropes often work to create a single trajectory for the unfolding of events at the expense of what is more accurately a tangled web of relations and circumstances that surround events. While often elegant in its narration and accessible in its logic explaining why events occurred in the way they did, such history can work to simplify and distort our conceptions of the past.

The Man without a World by Eleanor Antin, *Urban Peasants* by Ken Jacobs, and *Cooperation of Parts* by Daniel Eisenberg explore fragments of Jewish life and culture obscured by the catastrophe of the Shoah. I examine these films in relation to the theoretical concept of sideshadowing as elaborated by the literary scholar Michael André Bernstein. With his trope of the sideshadow, Bernstein considers the possibilities of creating historical narratives in which the multiple possibilities for the outcome of historical events can coexist alongside the actual outcome of events. By critiquing older narrative tropes of historical writing such as backshadowing and foreshadowing as producing the sense of inevitability or causality in what are actually random events, sideshadowing opens the possibility for narrative forms that can render events in all their complexity rather than as binaristic narratives of cause and effect—so often moralistic and dehumanizing. In contrast, Bernstein's concept of sideshadowing allows us to think about the notion of counterhistory as a strategy to undermine such causal tropes of historical time. Sideshadowing builds counternarratives into the central narrative to offer events and ideas that are to be engaged with as significant and raise the notion of multiple contingencies and possible alternatives for understanding events in a story. When this is done, the idea is suggested that although things turned out one way, they could also have turned out some other way. Bernstein formulates sideshadowing as a strategy to subvert the linearizing of historical narratives:

> Sideshadowing's attention to the unfulfilled or unrealized possibilities of the past is a way of disrupting the affirmations of a triumphalist, unidirectional view of history in which whatever perished is condemned because it has been found wanting by some irresistible historico-logical dynamic. (*Foregone Conclusions*, 3)

While sideshadowing does not deny the reality or historicity of an event, it creates an awareness of the indeterminacy of relations between events. There is no inevitable outcome to anything, because so many things are happening simultaneously.

As Bernstein suggests, to sideshadow is also to look at what did not happen, as well as what did, what might have happened but didn't, and also what *else* happened. When sideshadowed possibilities become part of the narrative, they give the sense that although history turned out one way, the outcome of an event is rarely inevitable.[16]

In *The Man without a World*, *Urban Peasants*, and *Cooperation of Parts*, Antin, Jacobs, and Eisenberg focus on Jewish lives and cultural histories that continued in the midst of the Jewish catastrophe in Europe, and more importantly those that continued after. They signal that the Nazis' genocidal campaign was not completely

successful in destroying all traces of European Jewish culture. These films work to resist the totalizing narratives of annihilation by casting a particularly bright light on lives lived, despite the darkness of the Shoah. As we will see, these films offer counterhistories to narratives of inevitability and inexorability that surround the Shoah. I show how they work to cast a sideshadow on the dominant narrative of twentieth-century Jewish life as catastrophe. These films create multiple contingencies and possible alternatives for understanding such events.

Chapter 3, "Virtualities," takes us deeper into an image of history as the coexistence of multiple temporalities, and the interplay of the actual and virtual qualities of history in avant-garde film. While the linear movement of time from past into present is the central temporal structure of traditional historical narrative, I have taken up several films that rethink relationships between past, present, and future as a coexistence in time. Events that occur in one moment in time are perceived to inhere in another and produce very different conceptions of what the nature of past(s) and present(s) are. The films *Allemagne année 90 neuf zéro* (*Germany Year 90 Nine Zero*) by Jean-Luc Godard (France, 1991) and *Persistence* by Daniel Eisenberg (1997) take up the fall of the Berlin Wall in 1989 as a nodal point for the shifts in twentieth-century geopolitics and explore their consequences for historical representations of modern European society and culture. Here Deleuze's "crystalline regime" of the "time-image" in modern cinema becomes a productive way to understand how cinematic forms for representing time emerged out of the social and historical shifts of the postwar period in which the events of one moment in time continue to inhere powerfully in the present, often making the dynamics of what is past and present indistinguishable. Because of the complexity of such historical shifts, thinkers and artists like Godard, Deleuze, and Eisenberg must search out new ways to narrate these events that linear temporalities can no longer explain. Central to Deleuze's definition of the "crystal time-image" is the Bergsonian conception of duration in which the past and future are not simply on a continuum but integral to the present.[17] As Deleuze writes of Bergson's theses on time: "The past co-exists with the present that it has been . . . at each moment time splits itself into present and past, present that passes and past which is preserved" (*Cinema 2*, 82). Hence the crystal image is one that is "present and past, still present and already past, at once and the same time" (79). In such images there is an indistinguishability between the actual and virtual temporalities within an image. The actual is the present of what is seen in the image, and the virtual is the past and future that coexist in the actual image of the present. The films examined in this section use highly formal cinematic techniques of montage (Godard and Child) and the long take (Eisenberg and Benning) to produce complex images of time that are dynamic relationships between real time passing in the present and the spectral time of the past. Such direct images of time allow the actual and virtual of history to emerge from the film images and become indistinguishable, creating new possibilities for understanding momentous events such as the end of the Cold War.

The role of the virtual in art is central to Deleuze's interest in cinema. Contrary to much critical theory, for Deleuze, virtuality is not a negation of the real that in its simulation causes it to recede from reach or leads to distorted relationships with reality. Rather, pure virtuality is understood as a field of liberated potential that does not have to be actualized (since the actual and virtual are complementary but mutually exclusive), on which the unthought can be approached and experimented with. Since this conception of the virtual is based not necessarily on what is possible but rather on the generative, imaginative, and speculative potential for change over time, it becomes just as important to produce the dynamic of an event or situation as it does a chronology. Like Bernstein's conception of sideshadowing, the reverberation between the virtual and the actual of the time-image allows us to consider all the possibilities not only for what is or might have been but perhaps for what is yet to come. The idea of pure virtuality as a crucial part of what we get from history is considered in my readings of the films *B/Side* (1996) by Abigail Child and *Utopia* by James Benning.

B/Side looks at an event in the history of the housing struggles in New York City in which the poor and homeless fight to maintain a community for themselves in the face of urban gentrification. Despite the actuality of their failed struggle, Child also allows us to see their community as a site of pure potential, where even in its failure to keep itself intact in the face of the overwhelming influence of economic interests and state power, we are able to experience the vitality of what was, what might have been, and perhaps what one day could be.

Similarly Benning's *Utopia* is a gesture toward the success that remains unrealized in the history of Che Guevara's failed last revolutionary campaign in Bolivia. By performing the Dadaist act of lifting the sound track from another film and placing it into his own, Benning transposes the narrative of Guevara's final days in the mountains of South America to the borderlands of Southern California. In doing so, Benning not only revivifies for the present the idealism of Che's failed campaign some thirty-five years earlier but also opens onto the virtuality of that failure, its success in another place and time. Surely the possibility of a new revolution at the U.S.-Mexico border region is not (yet) a possibility, but by placing the hero of Latin American liberation struggles there, a force of new relations between time and space and the actual and virtual is created, liberating the idea of the potential in history.

What makes these histories important departures from conventional historicism is the incorporation of what is imagined or remains unrealized in a given historical moment but returns as potential within these works of art. To consider the virtual as part of the process of making history is to embrace what is usually understood as the antithesis of historicism: invention. Like Benjamin's allegory, the political implications for such active approaches to the making of history are powerful. Here, in perhaps the most radical refiguring of the relationships between historicism and artistic expression, the historian has moved from the role of documenter of events that happened, to the role of agent provocateur, the inventor or the sower of seeds (Deleuze) of potential

histories for a future, the outcome of which is not yet known. Both Benning and Child are at once documenting histories and inventing ones that have not yet occurred, further blurring the distinctions between history and personal expression.

Chapter 4, "Specters," takes up two central questions that challenge both postmodern historiography and art practices. Are there events that by their nature defy representability, and conversely, what of past events continues to inhere in representations of the present? All the works discussed in this chapter explore the ways in which the past defies closure, unsettling traditional notions of the separation between past and present. More poetically, these films acknowledge the ways in which the past remains a spectral presence—revealing itself both in language and in objects—to become a force within the dynamic of the present. Similarly, they touch on the reality of events that in their transformative enormity and horror exceed our ability to fully understand what occurred, challenging the possibility of representation. The acknowledgment of such gaps in our collective and personal comprehension makes more complex our idea of history because the relationship between history and an understanding of the meaning of events referred to is no longer necessarily a given.

Essential to these films is the problem of collective and personal trauma that often makes attempts to integrate the limit experiences of catastrophic events into coherent narratives difficult or impossible. As the scholar Cathy Caruth suggests in her formulation of trauma, it is not a problem of "having too little or indirect access to an experience that places its truth in question . . . but paradoxically enough, [it is] its very overwhelming immediacy, that produces its belated uncertainty" (*Trauma*, 6). The belated experience of trauma in a different time and place from its occurrence produces an aura of untimeliness around events that often defy verifiability and narrative wholeness that allows for an event's representability as truth. Such a history can, Caruth continues, "be grasped only in the very inaccessibility of its occurrence" (8).

The ramifications of these issues have had an enormous impact on contemporary artistic practice as artists have begun to acknowledge the inaccessibility of many aspects of history. This has made it necessary for them to develop aesthetic forms that can adequately engage those experiences that resist empirical verification and factual coherence but still have profound impact on the present. Artists have had to pay attention to other aspects of histories, examining the textures of the present, such as place and language, structures of feeling, psychological states, and personal obsessions, to gain access to elements of those that are beyond their own direct experience or the murkiness of the recounted experiences of others. The films I address here take up these questions not only as problems of form but also as an exploration of the ethics of representing such difficult histories.[18] These ethics concern the transformation of such events into aesthetic objects that might only diminish or distort their meaning, reducing them to kitsch spectacles or the redemptive aestheticism of much historical art. They transform such limit subjects into those beautiful and horrible stories that seem to make sense and which, for a moment, reorder the universe and make us feel better about ourselves and our civilization. The difficulty of such problems logically

mitigate toward an ethic of silence as the only state in which the ability to fully imagine the unimaginable in all its depth can take place. Those artists, however, for whom silence is an unacceptable solution, are forced to transgress limits and develop an equally complex ethics of representation as part of an attempt to speak into such silence.

Throughout the chapter, I use psychoanalytic concepts of trauma in the work of Shoshana Felman and Dore Laub, as well as that of Cathy Caruth, and the philosophical thought of Giorgio Agamben and Jean-François Lyotard to speak about the ways in which limit experiences in historical events produce a crisis for witnessing, memory, language, and image, and therefore a crisis of representation. I consider the films *Signal—Germany on the Air* by Ernie Gehr and *Killer of Sheep* by Charles Burnett, both of which use the textures of place as a way to evoke the past of two different catastrophes. In *Signal—Germany on the Air,* Gehr explores the most mundane elements of present-day Berlin—passing cars and buses, street signs, vacant lots, people walking on the streets—to evoke the silent specters of the Jewish catastrophe during World War II. Shamanistically, the repetition of shots attunes the viewer to the tiniest details in the images while creating a space of thought in relation to vision that unsettles temporal verisimilitude in the viewer, making images of Berlin untimely, suspended between the past and present. I have paired *Signal* with a film that comes out of a very different history. Although Burnett's *Killer of Sheep* (1977) is a dramatic narrative, it also explores the prosaics of place, this time in the African American ghettos of contemporary Los Angeles. I suggest that Burnett's use of the formal technique of the long take and disjointed narratives in *Killer of Sheep* evokes the unseen catastrophe of the American legacy of slavery. He creates an image of a community haunted by the trauma of such a past and how these specters continue to inhere in the present of the African American experience. Through Burnett's attention to the rhythms of the present and the delicacy with which he works with images of people, the ways they interact with each other, and the spaces they move through, the film powerfully evokes the sense of the belated experience of a traumatic past that crosses generations without ever referencing the event itself.

Also in this chapter I explore the spoken word as a literalization of the attempt to transgress the silence that surrounds traumatized histories of catastrophic events. In *The March* by Abraham Ravett and *Un vivant qui passe* (*A Visitor from the Living*) by Claude Lanzmann, we watch the testimonies of two very different personal experiences of the Nazi treatment of Jews in concentration camps during World War II. While the use of the sync-sound talking-head interview is often excoriated as the most banal and least imaginative of documentary film techniques, I argue for a cinema of testimony as a deeply cinematic form of historiography. In *The March* we see and hear Fela Ravett, the mother of the filmmaker, in her yearly attempts to remember how she survived the forced "death march" evacuation of Auschwitz in the winter of 1945; in *Un vivant qui passe,* we have the testimony of Maurice Rossel, an inspector of German internment camps for the International Red Cross Committee. He insists that he saw no evidence of the mistreatment or murder of prisoners during his visits to the

concentration camps at Auschwitz and Theresienstadt. In these films, one can distinguish between the journalistic interview, in which answers to specific questions often are an authorizing element in a preconceived narrative in the conventional historical documentary, and a cinema of testimony, which focuses on the act of testimony as the belated experience in the present of a historical event. In these films, the viewer becomes part of a process of witnessing that begins with the subjects attempting to place into language their direct experiences. Their testimony takes place as part of an interaction with a listener who becomes a crucial participant in the event, also experiencing it as an occurrence of the present. Finally the viewer bears witness to the generating of new knowledge of the events of both the past and the present as part of the process of the interaction between the listener and the one testifying. In the filmed images, we witness the force of the past as it impacts the testifier, on whom memory becomes a physical experience visible in his or her changing expressions and body movements. We hear the ways in which language is used to clarify and just as often used to evade. We see and hear the return of the traumatic event as a phenomenon of the present with all the gaps from what is forgotten, ill remembered, or so painful that it cannot be put into words. Rather than the testimony of personal experience being the ultimate confirmation of the veracity of an event, we see the ways in which the testimony calls into question direct experience as the most reliable form of historical evidence. The very intensity of the experience of traumatic events often makes testimony incomprehensible or reveals disconnected bits and pieces of events or distorted perceptions. As we will see in the testimony of Fela Ravett in *The March,* even she could not believe her own experiences. This sense of unbelievability is what the psychiatrist Dori Laub calls "the collapse of witnessing," creating "an event without witnesses" in which the events seem incomprehensible (Felman and Laub, *Testimony,* 80).

In *The March* and *Un vivant qui passe* the dynamics between witness and listener are a central element. The filmmakers include their own behavior and responses to the witnesses, revealing their active participation in the creation of the testimonies, and gradually become part of the belated experience of the trauma caused by the war. As they allow themselves to become part of the process, we see the filmmakers becoming more and more emotionally unsettled in their relentless insistence on knowing what happened. Through their deepening involvement with the testimonies of the witnesses, we begin to understand the ways in which traumatic histories are transmitted across generations, through families and nations.

Chapter 5, "Obsessive Returns," continues to examine narratives of loss as a problem for history in contexts beyond Europe and America. *El día que me quieras* by Leandro Katz and *Chile, la memoria obstinada* by Patricio Guzmán take up the fate of radical utopian social experiments in the wake of the historical traumas of failed Latin American anti-imperialist struggles during the last half of the twentieth century. Crucial to these films is the necessity for creating histories that can at once illuminate the historical question of why they failed while reclaiming the lost idealism that fueled such movements in their times.

Using Freudian notions of the "work of mourning" and "the uncanny," I explore the ways these films use the process of filmmaking to work through the trauma of a lost historical moment to reclaim the cultural memory of idealistic struggles for social transformation and of innumerable dead. In the face of defeat, what can be salvaged as a workable legacy for the next generation can be seen to be a historiographic problem.

Making these films becomes a labor of mourning as each filmmaker works through the loss of his idealistic past through the act of an elegiac return to the site of a failed revolutionary struggle. Rather than being analytic or chronological histories, these films are elegiac and contemplative unearthings of the past. The attempt by the filmmakers and people in the films is to relinquish the sense of loss and failure that keeps returning with every thought of the past. As the theorist Eric L. Santner (whose groundbreaking work on film and mourning I use through out this chapter) writes, "To relinquish something requires a space in which its elegiac procedures can unfold" (*Stranded Objects*, 151). Filmmaking makes a place for the labors of constructing an aesthetic object that can make complex relationships between past and present, and creates just such a space for the psychically liberating work of mourning.

Rather than the singularity of approach in the testimony film, *El día que me quieras* and *Chile, la memoria obstinada* are complex collages weaving together different kinds of materials and formal approaches to the exploration of the past. The making of each film involves the labor of returning to the sites of past events to contemplate what has changed, what remains the same, and what can be felt. There are the archaeological activities of excavating and examining lost photographs, films, documents, names, and narratives. There is the search to find people long silent and to create the opportunity for them to speak of their experiences. Both films create situations that re-create past moments as a way to conjure memory.

El día que me quieras is an investigation of the circumstances surrounding the famous last photograph of the corpse of Che Guevara, murdered by his captors during his final guerrilla campaign in Bolivia. In the film, Katz returns to Latin America to learn how and where the photograph was taken, by whom, and the kinds of impact it has had. *El día* becomes a meditation on the power of the photograph, and through it the film mourns the passing of the age of Latin American revolution in which the youthful romanticism of love, social justice, and revolutionary transformation seemed synonymous. In the film, the image of the dead Che embodies the lost romance of third-world liberation struggles and the intertwined reality of violence and death that surrounded it. Similarly in *Chile, la memoria obstinada*, Guzmán returns to his native Chile after twenty-five years of exile to show his famous film *The Battle of Chile*, which documents the struggle and coup d'état of the democratically elected Marxist president Salvador Allende in the early 1970s. Guzmán's return to Chile to show his film becomes a catalyst that raises the specters of idealism and traumatic violence of the coup and its aftermath both for his own generation, who lived through it, and for the next, who grew up during the repressive years of the ensuing dictatorship with little

knowledge of what had happened and why. In *Chile, la memoria obstinada,* the country is transformed into a haunted house, an uncanny world that is at once familiar—easily recognizable as daily life—and strange, as the unseen specters of the horrors and the unsettled ghosts of those murdered and disappeared hover over all. As the two generations of Chileans begin to recall their experiences and talk about their lives in the aftermath of the coup, there is a sense of the possibility of release from the belated trauma that keeps returning and is silently structuring their lives.

Throughout these last two chapters, I show the ways in which each filmmaker uses the film medium in an attempt to find a new ethics of recorded image and speech that can acknowledge the risks of representing histories such as American slavery, the European Shoah, and the Chilean coup while confronting the transhistorical enormity of their impact. Despite the acknowledgment of the gaps between event, memory, and words spoken, artists and historians continue to try to speak into the silence and emptiness of those gaps. In the end it is the task of the artist and thinker, who must always take the risk of failure, to try to say something into the nothing.

What distinguishes these experimental approaches from most of the mass-produced spectacles of catastrophic historical events we have become so familiar with is that they are no longer guided simply by the naive promise of a better world that will come if we surround ourselves with constant reminders of our crimes. Rather, these films create an ethics surrounding the use of memory and experience that insists that our understanding of the past, each time it returns, continues to deepen and become more complex. It is an ethics that insists that history cannot be disconnected from our experience of the present and gives us the agency to intervene in that present in order to actively imagine our future.

1. Shards: Allegory as Historical Procedure

Method of this project: [literary] montage. I needn't *say* anything. Merely show. I shall purloin no valuables, appropriate no ingenious formulations. But the rags, the refuse—these I will not inventory but allow, in the only way possible, to come into their own: by making use of them.

—WALTER BENJAMIN, *The Arcades Project*

Will it ultimately reach the clear surface of my consciousness, this memory, this old, dead moment which the magnetism of an identical moment has traveled so far to importune, to disturb, to raise up out of the very depths of my being? I cannot tell. Now I feel nothing; it has stopped, has perhaps sunk back into its darkness, from which who can say whether it will rise again?

—MARCEL PROUST, *Swann's Way*

Switches on tape recorder. KRAPP: Just been listening to that stupid bastard I took myself for thirty years ago, hard to believe I was ever as bad as that. Thank God that's all done with anyway. (*Pause*) The eyes she had! (*Broods, realizes he is recording silence, switches off. Broods. Finally*) Everything there, everything, all the—(*Realizes this is not being recorded, switches on.*)

—SAMUEL BECKETT, *Krapp's Last Tape*

The incorporation of recorded sounds and images into artworks has shifted the ways in which artists have understood the movement of time and the uses of memory. In these works, physical objects—specifically audiotape and motion picture film—produce new perceptions of the relationship between the past and present and the construction of history. I briefly trace a shift from an interplay between the ephemeral

1

and subjective apprehension of the past as suggested by Proust's notion of involuntary memory in *À la recherche du temps perdu* (In Search of Lost Time) to one complicated by an engagement with a moment that has been turned into an object by being recorded and stored in one moment in time and then experienced at another. This is just what occurs in the films *Eureka* by Ernie Gehr (1974) and *Dal polo all'equatore* by Yervant Gianikian and Angela Ricci Lucchi (Italy, 1986).

Samuel Beckett's play *Krapp's Last Tape* (1957), which features the tape recorder as mechanical repository of memory, stands in between Proust's literary representation of involuntary memory and Gehr's use of actual cinematic artifacts to create a historical memory as a multiplicity of temporal moments experienced simultaneously and linking past and present. Further, Walter Benjamin's theory of allegory, placed in relation to these works, suggests possibilities for ways in which objects, once thought meaningless as a result of the passage of time, can be reactivated to produce new meanings in another moment. Allegory, as Benjamin maintained, opened the possibility for a new historical practice that comes out of a relationship between subjective memory and the interpretation of the physical apprehension of objects in the present. In his conception of historiography, the past is understood through a doubled reading in which the meaning of an event is created as a relation between its occurrence in the past and its significance to the present. The use of physical objects—the detritus, documents, and artifacts that remain—works to embody such a relation as they signify the shifting meanings and value that an object had in the past *and* has in the present. This was Benjamin's conception of how to move the emphasis of historiography away from representational reflectionism or the individual psychological identification with past people and events toward an active process of understanding the past in terms of the present situation, which is always in transformation. Benjamin's idea was to move away from a totalizing representation of history as it progressively moves into the present. This notion of history as active process rather than an epistemology engages history as a creative force that holds the possibility for political and aesthetic intervention in the present.

In both Proust's early-twentieth-century novel *À la recherche du temps perdu* and Beckett's midcentury play *Krapp's Last Tape,* the main characters are artists who at the end of their lives are examining their pasts to understand the relationships between the passage of time and their creative processes. For Proust, memory is an experience that happens to one. It is an uncontrollable operation in which the power ("magnetism") of a "dead moment" may or may not travel up to consciousness. How, when, and why this occurs, one cannot control. Proustian involuntary memory is a chance experience that is plastic and can be shaped in any way necessary to produce an aesthetic experience of the present. Such memory as a referent for the real is tenuous at best and only gains substance when re-created through aestheticized means—for Proust's Marcel, the process of writing *is* the "search for lost time." For Krapp, however, an artist who lives in an age of the mechanical reproducibility of moments in time through photographic and audiographic devices, memory becomes an object

that can be reproduced and made to occur at any time and at will. In the tape record-
ings of his own voice, Krapp hears himself in past moments. He switches on the past
to be replayed exactly as it was the moment it was recorded. Krapp is forced to move
between an indexical imprint of a past moment as it was occurring and his own per-
ceptions and understanding of it in the present. Throughout the play, Krapp switches
on his tape recorder, listens, turns it off, rewinds the tape, and listens again. Through
the accumulation of recorded tapes over the years, he is able to move voluntarily
across time, selecting memories at will

For Krapp, memory is not an autonomic experience that is attracted to the mag-
netic field of the present, as Proust suggests in the epigraph at the beginning of this
chapter. Rather, memory is substance, endless ribbons of ferrous-oxide-coated tape
that bursts into voice when Krapp commands his machine to move the tape across
the electromagnetic sound heads of the tape recorder. Unlike the narrator in *Swann's
Way*, who encounters memory in the smell and taste of a bone china teacup and
sculpted "scallop shell-like petites madeleines," Krapp is first encountered sitting at a
table with old cardboard boxes and recording tape hanging out of them like so much
debris that has been thrown out. Krapp himself is in the middle of it all, a human
ruin, disheveled, unshaven, clothes in tatters. He eats a banana, throws the peel on
the floor. This is not a room; it is a garbage dump. Like a garbage collector, Beckett's
Krapp can be seen as the embodiment of Walter Benjamin's figure of "the ragpicker"
(which Benjamin found in Baudelaire), who is the most provocative figure of human
misery:

> "Ragtag" [*Lumpenproletarier*] in a double sense: clothed in rags and occupied with
> rags. "Here we have a man whose job it is to pick up the day's rubbish. . . . He col-
> lects and catalogues everything. . . . He goes through the archives of debauchery, and
> the jumbled array of refuse. He makes a selection, an intelligent choice; like a miser
> hoarding treasure, he collects the garbage that will become objects of utility or plea-
> sure when refurbished by industrial magic." (*The Arcades Project*, [J68,4], 349)

Mechanical Memory

In the play, Krapp begins to pick through the boxes, looking for tape spools through
which he can resurrect a past. This garbage constitutes Krapp's memory. Nothing else
exists except Krapp's deteriorating body and his boxes of tapes. Only when he picks a
tape, plays it, and the recorder revivifies it is there something else—another moment
of time.

The spools of tape are transformed from so much garbage to a time machine
in which the past moment, recorded on the tape, is superimposed on the present
moment. The present multiplies. No longer is the inert tape a metaphor for the lin-
ear passage of time—beginning at the head of the tape, ending at its tail—rather, the
past of its recording and the moment of its being listened to come together to form a

present that is at once made up of discrete elements *and* their composite. In the following scene, Krapp puts on a tape, switches on the machine, and listens to himself speaking thirty years earlier:

> Just been listening to an old year, passages at random. I did not check in the book, but it must be at least ten or twelve years ago. . . . Hard to believe I was that young whelp. The voice! Jesus! And the Aspirations! (*Brief laugh in which Krapp joins*) And the Resolutions! (*Brief laugh in which Krapp joins*). (*Krapp's Last Tape*, 15–16)

Here we watch Krapp in the present, listening to his voice from thirty years earlier, commenting about a tape he made twelve years before that. The tape has produced a juxtaposition of three moments in time simultaneously. This is produced not by the subjectivity of a chance memory à la Proust but through the intervention of a mechanical object. Although Krapp's interpretation of what he hears is as subjective as Marcel's interpretation of a memory that he involuntarily recalls, Krapp's ability to hear and rehear—endlessly—exactly what he said thirty years ago makes his memory at once involuntary (Krapp has to hear whatever is on the tape, like it or not) and ephemeral, but also connected to the world of material referents. While in the tape recorder and playing, the spool of tape is part of a machine that produces meaning and has value. But the moment Krapp rips the tape from the recorder and throws it to the floor to join the banana peel, the tape spool returns to its status as detritus. The spool becomes indistinguishable from any other one, and its value indiscernible from anything else around it.

In the shift from the chance operation of involuntary memory to mechanically reproduced memory, Beckett is able to produce a life history as a scene of multiple temporal moments simultaneously. The past and present are not a progressive movement from one to another but coexist as a constellation of moments that together constitute the present. As the play unfolds, we experience the present of Krapp listening to his tapes, the present of the moment of the tape's recording, and the present of the play's performance.

Krapp's Last Tape shows not only how mechanical reproduction changes spatial and temporal possibilities for relationships between past and present but also how objects shift in meaning and use value from one moment to the next. As we will see, mechanical reproduction produces an object of memory and also a commodity whose use value shifts in its passage from blank tape or film to valued archival material to useless garbage.

Benjamin (as does Beckett) asks his readers to contemplate the possibility that the relationship between past and present can be revealed in objects whose value as commodity and meaning in the present moment have been lost, but then found once again in the dialectical relationship between what meaning the object held in the past (when it had commodity value) and the contemplation of why it has lost its value in the present. A renewed interest comes from the relationship between the different meanings

the object had in the past and the ones it has in the present. That is to say, an object's present meaning is produced through a superimposition of the different meanings of the same object from two different points in time. This allows the reading of an object as simultaneously past and present and is what Benjamin defined as "allegorical representation."

In *The Arcades Project*, Benjamin tries to develop a mode of historiographic imagination in which the archaeological examination of antiquated, discarded, or forgotten objects can become the means for finding historical truth through the process of understanding why and how they lost value through the passage of time. Benjamin suggests that to explore what an object from the past means in the present is to turn that object into a text that has at its center an imagining subject who finds new possibilities for its meaning. Like the shifting meanings of commodities in relation to their changing value over time, the subject's changing position over time also transforms the meaning of the object. For modern artists, the use of discarded, mechanically recorded images and sounds has allegorical possibility because they remain unchanged while the original context for their existence passes out of visibility. The temporal untranslatability of the object becomes the embodiment of present meanings and is generative of new possibilities for significance. In his exploration of the antiquated objects that he found for sale in the twentieth-century replicas of nineteenth-century Paris arcades, Benjamin wrote of these objects as being meaningful and at the same time having no meaning at all.

In *The Arcades Project*, Benjamin demonstrates this process of allegorizing objects of the past as an activity of working through the conceptual problems of integrating the changing meanings of an object as it passes through time. He describes this as a creative act that is embodied in the complex figure of the *brooder*, who like the allegorist is someone

> who has arrived at the solution of a great problem but then has forgotten it. And now he broods—not so much over the matter itself as over his past reflections on it. The brooder's thinking therefore bears the imprint of memory. . . . The brooder's memory ranges over the indiscriminate mass of dead lore . . . like the jumble of arbitrarily cut pieces from which a puzzle is assembled. (*The Arcades Project*, [J79a,1; J80,2], 367–68)

The brooder sifts through the random detritus of the past, tormented by his own inability to remember what any of it means. He attempts to decipher dead knowledge, now fragmented and meaningless, with little value to the present and with no guarantee that the bits and pieces will add up to anything. Nonetheless, the brooder is still intent on the activity of making some structure of meaning out of its chaotic mess.

The relationship between the figure of the brooder and the artist who works with found, discarded objects, trying to reactivate their meaning for the present, becomes irresistible. Identifying the political potential of art in his own time, Benjamin makes the case for surrealism as the embodiment of the generative and even revolutionary

possibilities within aesthetic practice. Writing about André Breton and the French surrealists, Benjamin claims that they were

> the first to perceive the revolutionary energies that appear in the "outmoded" in the first iron constructions, the first factory buildings, the earliest photos, the objects that have begun to become extinct. . . . No one before these visionaries and augurs perceived how destitution—not only social but architectonic, the poverty of interiors, enslaved and enslaving objects—can suddenly be transformed into revolutionary nihilism. (*Reflections*, 181)

Benjamin argues for the deeply political nature of an art practice like surrealism as a field on which irrational and noncontiguous connections between decaying, valueless objects and transforming historical conditions release energies that spark new forms of awareness.[1]

Although not usually associated with traditional surrealist cinema, the films I discuss in this chapter, particularly *Eureka, Dal polo all'equatore* (From Pole to Equator), and *Tribulation 99: Alien Anomalies under America*, show how certain avant-garde film practices parallel Benjamin's conception of surrealist allegory. Each of these films is the result of the artist's active and creative engagement with the cinematic materials from the past that have lost the value they had in the period when they were made. As brooders and cine-ragpickers, the filmmakers engage lost images, contemplating the strips of film with the hope that they can once again come to have meaning for the present. As the films aesthetically activate these images, they begin to signify from both moments in time—often simultaneously. For Benjamin and these contemporary filmmakers, this aesthetic activity of rereading, rethinking, and reworking such material holds the possibility not only for a new way of exploring the past but also for a politically engaged artistic practice.

The invention of the motion picture at the end of the nineteenth century created the possibility of recording moving photographic images from which identical reproductions can be created, allowing them to exist indefinitely and in many different places at the same time. As film has reached the end of its first century of existence, early motion pictures can begin to be seen as a form of fossil or ruin that, like Benjamin's arcades or Beckett's audiotapes, is ripe to be read allegorically, in that films can produce a simultaneous relationship between the moment of filming and a later moment in which they are viewed. At the end of the twentieth century, it is no coincidence that works of cinema begin to appear that use the discarded and lost cinematic objects from the early part of the century. These contemporary works of cinema use mechanically reproduced images from another time, which, when projected for those who have no connection to that time, produce new possibilities for a *re-membering* of the past in the present. The artist is able to reinscribe new meanings onto old, once-discarded images by producing two simultaneous images out of one. Of the allegorist, Benjamin writes:

Through the disorderly fund which his knowledge places at his disposal, the allegorist rummages here and there for a particular piece, holds it next to some other piece, and tests to see if it fits together—that meaning with this image or this image with that meaning. The result can never be known before-hand, for there is no natural mediation between the two. (*The Arcades Project*, [J80,2; J80a,1], 368)

The allegorical use of archival and discarded film in the so-called found-footage film has been a central genre of cinematic exploration for the American avant-garde in the postwar period. Practiced by many of its most important filmmakers, much of this work consists in the reediting of such material, making new films out of old footage, or incorporating the old findings into the filmmakers' own material shot in the present.

The American surrealist and collagist Joseph Cornell worked closely with several of the most important figures of the postwar avant-garde and, according to P. Adams Sitney, "exerted a considerable influence on" Ken Jacobs, Jack Smith, and Jonas Mekas, as well as Stan Brakhage and Larry Jordan, both of whom were also involved in the production of some of Cornell's films (*Visionary Film*, 347). Cornell's first found-footage film, *Rose Hobart* (1939), uses footage from the Hollywood tropical adventure film *East of Borneo* by George Melford (1931), starring the actress Rose Hobart. Cornell focuses on Hobart's expressions and gestures in relation to the exotic jungle environment. That Cornell later added *Tristes Tropiques* to the film's title—a clear reference to Claude Lévi-Strauss's 1955 book of the same name—gives the remade film an even stronger allegorical bent.[2] Other major figures who began working with found film materials that can be linked to this tradition include Bruce Conner (*A Movie* [1958], *Cosmic Ray* [1961], *Report* [1963–67], *Crossroads* [1976]) and Jack Smith (*No President* [1968]). Like Cornell, Smith and Conner were collagists, known largely for their work in other media, who came to use film as a way to engage elements of mass culture. Smith, a performance artist and central figure of the postwar New York avant-garde theater, appropriated elements of Hollywood B films to create alter egos and to worship his personal movie star idols Yvonne De Carlo and Maria Montez. In *No President* Smith used a found documentary on the life of Wendell Willkie in an extraordinary allegory for the tumultuous 1968 U.S. presidential election.[3] Beginning in the late 1950s, Bruce Conner, a San Francisco–based collage artist associated with the West Coast beat arts scene, began using found materials from dramatic films, newsreels, documentaries, and industrial educational films to create a series of short montage films that recontextualize film footage to create bleakly ironic allegories of the emerging militarist and consumer culture of postwar America. Ken Jacobs has been known primarily as a filmmaker with a large and tremendously variegated body of work. He began collaborating with Jack Smith, who was the featured performer in Jacobs's early films such as *Little Stabs of Happiness* (1959–63), *Blonde Cobra* (1959–63) and *Star Spangled to Death* (1957–2003). In another area of his work, Jacobs's use of found film emphasizes the reexamination and reworking of footage from early cinema to reveal other possibilities for

perceiving the footage (see chapter 2 for my detailed reading of his *Urban Peasants*). For example, refilming Buster Keaton's short film *Cops* (1922), Jacobs masks off certain sections of the film frame, drawing attention to other areas of the image that generally go unnoticed. He works to reveal other possibilities for perceiving the footage. As he writes of his own film, *Keaton's Cops*:

> We become conscious of a painterly screen alive with many shapes in many tones, playing back and forth between the 2D screen-plane and representation of a 3D movie-world, at the same time that we notice objects and activities (Keaton sets his comedy amidst actual street traffic) normally kept from mind by the movie star–centered movie story.[4]

Similarly, in one of his most influential films, *Tom, Tom, the Piper's Son* (1969), Jacobs uses a ten-minute found film of the same name from 1905, which has been attributed to D. W. Griffith's cameraman Billy Bitzer. Rephotographing each frame separately, Jacobs extends the film to over ten times its original length, making his version 110 minutes long. Beginning by presenting the film as it originally appeared, Jacobs then repeats it, showing different permutations of the original, this time emphasizing the material and nonrepresentational elements that make up the image. By enlarging aspects of the frame, allowing the film to lose its registration in the gate of the projector, and slowing down its movement, Jacobs turns the rephotographed film into an exercise in the dissolution of narrative emplotment of the film's images to reveal other possibilities for cine-narrative based on the abstract and purely temporal elements of the cinematic experience. As Jacobs has written of his film:

> I wanted to show the actual present of film, just begin to indicate its energy. . . . I wanted to "bring to the surface" . . . that multi-rhythmic collision-contesting of dark and light two-dimensional force-areas struggling edge to edge for identity and shape . . . to get into the amoebic grain pattern itself—a chemical dispersion pattern unique to each frame, each cold still . . . stirred to life by a successive 16–24 f.p.s. pattering on our retinas. (New York Filmmakers Cooperative, *Catalogue 7*, 270–71)

Eureka

Starting his work as a filmmaker in the late 1960s, Ernie Gehr began making films that, like those of Ken Jacobs, were rigorously materialist in the ways they explored the elements of the film medium and its apparatus—the camera, lens, light, film stock, and the illusion of movement. In a search to find an ontological basis for how meaning is made in cinema, Gehr engaged the cinematic apparatus, not simply as a tool to represent something else, but to look at how the medium is activated by the world around it. Like *Tom, Tom, the Piper's Son*, Gehr's early films such as *Reverberation* (1969), *History* (1970), and *Serene Velocity* (1970) explore the more sensual aspects of the cinematic

experience by moving away from the purely representational possibilities of the medium to explore the energy of light from the projector, the power of the illusion of perceived motion, and the granularity of the photographic emulsion. Unlike Jacobs's films, however, Gehr's early films may seem more visceral than intellectual, working toward the possibility of creating an ecstatic or sublime experience of the pure materiality of the medium. The works in this period by both Jacobs and Gehr can also be seen as an integral part of the minimalist anti-illusionist aesthetics that were central to modernist art practices in the painting, sculpture, dance, music, and theater of the late sixties.[5]

Nearly all of Gehr's films evoke a consideration of the past as integral to the movement of time, particularly in his films that document the changing urban landscape of New York City and San Francisco, such as *Reverberation, Still* (1971–74), and *Side/ Walk/Shuttle* (1991). With *Eureka* (1974), a new strain in Gehr's work can be identified in which his exploration of the material elements of the cinematic continues, but alongside the simultaneous exploration of the representation of specific historical events and their temporalities. Along with *Eureka,* his films *Untitled, Part One* (1981), *Signal— Germany on the Air* (1982–85), *This Side of Paradise* (1991), *Cotton Candy* (digital video, 2001), and *Passage* (2003) can be included in this group, each of which takes up specific events or identifiable historical moments. (See chapter 4 for my reading of *Signal— Germany on the Air.*)

Eureka employs many of the same elements as *Tom, Tom, the Piper's Son.* Both use a short film from the earliest period of cinema; both films are rephotographed, and through this, their durations are extended. But the effects of the two films differ in crucial ways. *Tom, Tom* works to reveal new aspects of the footage by abstracting it. Jacobs creates an entirely new set of images that are no longer representational, focusing the viewer on the most physical aspects of the footage: its grain, black-and-white tonal range, graphic elements, and movement through the projector. *Eureka,* on the other hand, is allegorical. It maintains the representational elements of the original imagery, which is seen throughout the film. But because it is slowed down, the meanings of the representations can be read multiply, between past and present, both as a historical artifact and as a commentary on the present. In this sense *Eureka* can be seen as an emblematic work of a new form of cinematic *brooding*.

The film uses found footage from an extinct genre of early cinema known as *actualities* (Figure 2). They were nondramatic films that often depicted exotic and rarely seen phenomena from all over the world as recorded by the motion picture camera. These protodocumentaries were popular commodities—and profitable for their producers—that were used as both entertainments and propaganda. Shown widely at the turn of the century in theaters and amusement arcades, actualities had a dual attraction as a demonstration of the new technology of cinema and a chance for viewers to see places, objects, and events they had never before seen.[6] The creation of *Eureka* came about when Gehr found such a film in a box of discarded 16 mm films. He recalls that the unattributed reel of film was undated and untitled, and suspects it was shot between 1903 and 1905; he calls it "The Market Street Film."[7] In this film, a

camera was mounted on the front of a streetcar, and filming commenced as the trol-
ley trundled down Market Street in San Francisco until it reached the car's terminus,
the Embarcadero ferry launch on the shore of San Francisco Bay. The original strip of
film that Gehr used was about five minutes long when projected at eighteen frames
per second. As the car moves forward toward its destination, we see a view of the daily
life of San Francisco's main area of commerce before the great earthquake of 1906.
The film presents a deep-focus image of the length of the entire street. Our gaze is
directed into the illusionistic depth of the screen as the car and camera move along
the length of the street (Figure 3). As in quattrocento perspective in Renaissance paint-
ing, the viewer, through the lens of the camera, is placed at the center of the image. The
vanishing point of this two-dimensional image is the center of the screen. In the orig-
inal footage, the view of San Francisco is seen as an integrated whole connecting the
mode of representation produced by the trolley and camera with the activity of what
was then a modern urban marketplace. As the camera glides smoothly along the trolley
rails, we see a vision of urban modernity in the image of well-dressed men and women
moving along the sidewalks and going in and out of stores. The emergence of the
mechanical age is visible in the mixture of the horse and wagon with cars and trucks.

Figure 2. *Eureka* (Ernie Gehr, 1974). Photograph courtesy of Ernie Gehr.

In this footage, the camera itself embodies the shift from the nineteenth-century urban flaneur to a mechanical eye that produces infinitely reproducible "virtual" gazes for anyone with the money to buy a movie ticket. In the Benjaminian archetype, the flaneur is the seemingly unencumbered bohemian poet wandering through the spaces of the cityscape observing the goings on and turning them into poetry or paintings. "In the *flâneur* the intelligentsia pays a visit to the market-place, ostensibly to look around, yet in reality to find a buyer" (*Reflections,* 156). For Benjamin, the flaneur is at once the unencumbered observer and an integral part of the commodification of the culture he observes, as he tries to find a way to turn his observations into a salable commodity. Significant to a notion of twentieth-century flanerie are the cinematic and televisual apparatuses and the commodification of a nonambulatory "virtual" movement in which, instead of walking, the flaneur pays to sit in a seat as the cinematic images move him or her through the city.

In the original Market Street footage of *Eureka,* we see elements of both nineteenth- and twentieth-century flanerie. The camera-trolley takes on the role of the nineteenth-century urban flaneur in what appears to be an unmotivated stroll down an urban street (but is actually highly motivated in direction and function). It is also producing a

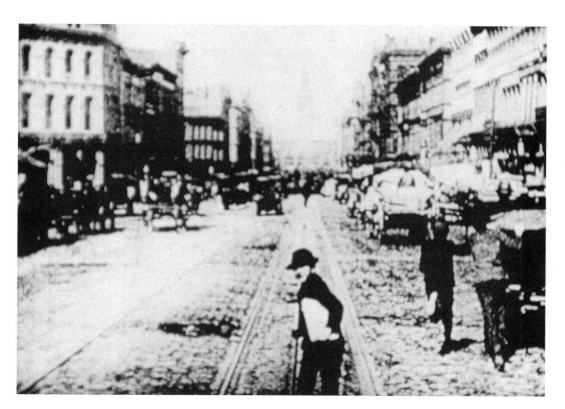

Figure 3. *Eureka.* Photograph courtesy of Ernie Gehr.

commodity: the film, which will later be sold as a demonstration of the new mechanical apparatuses of the trolley car and motion picture camera. The footage is also an example of what Anne Friedberg has called a *mobilized virtual gaze* that repositions spectatorship in ways unique to the twentieth century. She has suggested that this kind of "flâneurie of cinema spectatorship offers a spatially mobilized visuality . . . [and] a temporal mobility" (*Window Shopping*, 3). That is, no longer bound by the limits of physical space and real time, the cinema viewer can visually wander through any space, in any time, at any time. In *Eureka,* this temporal mobility allows us to see in the present not only what San Francisco's Market Street looked like in the past but also Gehr's allegorizing intervention in the footage as he produces a direct superimposition of past and present.

If the authorless footage produced by the fixed camera on the streetcar is a kind of cyborgian flaneur, producing a commodified, recorded memory, then Gehr embodies the figure of the brooder and allegorist, who seventy years later, while sifting through the detritus of early film footage, looks for the possibility of new meanings for this footage in the present. In *Eureka,* Gehr uses the reproducibility of the film image to rephotograph each frame several times, extending the strip of film—and the trip down Market Street—from six to thirty minutes. Gehr slows down the movement of the image, rephotographing each frame four to eight times. Impressionistically, rather than systematically, slowing down the movement of some frames more than others, Gehr subtly emphasizes movements and relationships between elements in the frame as they interest him. He creates something that looks like a choreographed dance between the objects in the frame and an archaeological analysis of a found object. Like Krapp, who listens to a single section of tape and then rewinds it and listens to it again and again, Gehr wishes to examine the image in each frame—as projected—as a way to explore lost time. As he slows down the movement, viewers are able to see the micro-events occurring around the camera in ways that were not obvious before. Moreover, through this slowing down, we are also aware of the original strip of film, which allows us to examine images of an array of periodized objects such as cars, horses, and wagons, men, women, and children, all in the clothes of that time. As Benjamin suggests in "The Work of Art in the Age of Mechanical Reproduction":

> The enlargement of a snapshot does not simply render more precise what in any case was visible, though unclear: it reveals entirely new structural formations of the subject. So, too, slow motion not only presents familiar qualities of movement, but reveals in them entirely unknown ones. (*Illuminations,* 236)

At the same time, the slowness produces a gap between past and present in which we are able to see the distance between then and now. As Gehr explains:

> Working with the energy of film implies working with the present, the moment in which the film is being projected on the screen. But the image takes you back in time to something that isn't there any longer. (J. Skoller, "Sublime Intensity," 19)

The foregrounding of the present moment of the viewer's gaze through the slowing down of the image denaturalizes it and pulls the viewer out of the image of the past and into an acute sense of the present, which is the experience of the strip of film moving through the projector. This produces at once a reflexive experience of real time and one that is an image of time. Gehr, however, has complicated this idea even further by producing an actual image—the actual being the experience of a virtual image of the past in the present. As Gehr says of *Eureka:*

> The slowing down, it's a tension for me between still photographs and movement. It's almost like robotic movement. It's still and it's moving, it's still and it's moving. . . . It's on the verge of existence and nonexistence in a way. It's an era that is a century old, and no matter how much I slow it down, it's not there, it's not on the screen. There are just these fragile indications, light and shadows, these splatterings of grain that give you some photo-memory of what was once there. (J. Skoller, "Sublime Intensity," 19)

The start-and-stop pulsing from the slowing down of the image also produces another form of movement on the screen in addition to the forward movement of the camera-trolley. The gentle start-stop pulse also shifts our gaze from illusionistic depth to the material surface of the screen.

The trace of daily life from a day in 1905 is also moving across the screen in concert with the camera moving into the frame. One becomes aware of this simultaneous movement into the screen and across it, as a moment during the industrial revolution in which the intersection between human beings and the machines they have created appears to diverge. Each seems to have a life of its own. The relation between man and machine is key to Gehr's work, and to this film in particular. Gehr has said that his own work to some degree has proceeded from

> acknowledging existence; not just the existence of people, which of course is very important, but also the existence of objects, including cinematic phenomena: the character of film, the ribbon of film that carries all these images, the character of the projector, the energy it sprouts out. (J. Skoller, "Sublime Intensity," 18)

This is a robotic flaneur with its camera-trolley eye moving unswervingly and observing the chaotic swarming of human beings, horses and wagons, cars and trucks, all of which are moving in all directions, forward and backward and in and out of the frame. This contrast reveals the entropic nature of urban society. It is a symphony of graphic movement, and only the machines—like the streetcar locked firmly in its tracks and the movie camera with its film locked in the camera gate, with loops properly formed, moving at approximately eighteen frames per second—seem able to bring order to this image. *Eureka* affirms Benjamin's supposition that "evidently a different nature opens itself to the camera than opens to the naked eye—if only because an

unconsciously penetrated space is substituted for a space consciously explored by man" (*Illuminations*, 236–37).

What is seen by the repeat printing of each frame, which produces the slowing stop-start motion of each one, is of a "different nature," creating an image of time not seen by the naked eye. There is a sense of being able to observe something for a moment that is normally unseen. What has become inert through the passage of time springs to action through Gehr's intervention. This is an experiential dynamic in which the image seems to come to life as if from a cryogenic stillness. This stillness into movement reveals an essential quality of cinema's illusionism. In a persistence of vision as successive still frames hold on the retina, the stillness of each frame, a frozen moment of time, thaws.[8] In *Eureka* the frozen moment of each frame becomes an image of the dead. When it moves, the image is momentarily reanimated and produces an image of the present. The people are moving mechanically, reanimated for a moment in the present, then freezing again, mortified, returning to the past. Gehr's frame-by-frame reprinting process short-circuits the phi phenomenon (the other physiological phenomenon of the human brain that creates the illusion of the continuous movement of successive still frames).[9] By repeating each frame, Gehr makes that sense of temporal elision impossible and opens the gap between the past of the original film and the present of Gehr's rephotography. What is so moving about this experience is not so much the reanimation of a past moment but the awareness of temporal space that opens between the past and present moment of our viewing.

Eureka is a film without sound. The images move on the screen as silent apparitions embodied in the light, but with no solidity. The people and objects in the image, long dead or destroyed, hover silently in the present, the full color palette of their past now limited only to pure white, translucent grays, and inky blacks—a soundless trace of lives lived. As Benjamin wrote, "Living means leaving traces" (*Charles Baudelaire,* 169). For the viewer in the theater watching *Eureka,* soundlessness *is* the sound of the trace. At the same time we see the deterioration of the original strip of film. Scratches, gouges, and dirt particles interrupt the image. We see firsthand the effect of time as it has corroded the original film strip. The scratches on the film imply past projections, suggesting past moments when people gathered together to watch these same frames pass in front of the light of the projector. This history (deterioration) of the original film strip has been preserved, revealing it as a document and archive of the film's existence. In the presence of the strip of film, the slow changes that occur can work to challenge our attention; the length of time it takes to watch the film at once produces boredom—real time passing—and the hallucinatory sensation of obsessive visuality in which one feels an amplified awareness of the act of perception. Such sensation is a heightened sense of the present moment, which is placed in a dialectical relationship with the elemental pastness of the original strip of film. The binaries past/present, still/ motion, life/death, and thought/sensation become blurred in the experience of *Eureka.*

The possibility that actively thinking the present through an object from the past will produce new meanings of the present is most important to Benjaminian allegory.

Rather than using antiquated objects to produce a mythic present, giving the illusion of a redeemed past, as in messianic notions of history, the materiality of the object in decay produces the present as a cumulative ruin.

Eureka is allegorical in that it represents neither past nor present but is rather a field on which references to both moments in time can be produced by the viewer. Even without knowing the specific street shown in the film, it is possible for one to sense in the image that the relationship between what was new in 1905—the motion picture camera, the moving trolley car, the chaotic bustle of the modern urban street— expresses a utopian desire to embrace modernity as something progressive. This desire is embodied in the turn-of-the-century city represented through the progressing image of the camera-trolley moving—inexorably—forward. This movement forward might be seen as the figuration of redemptive history, a transcendental infinity embedded in the vanishing point deep in the image. In Gehr's rephotographing of the footage, however, the illusion of eternal progress is belied by the actual surface of the deteriorated image, which alludes to the dystopian reality of the highly technological urban present with its crumbling infrastructures and gross economic imbalances. Not only does this kind of visual allegorization reveal the coexistence of the past in the present, but in other terms, it releases what was *virtual* in the present of that past—the unrealized collective fantasy of the *potential* of urban modernity as the fulfillment of an earlier utopian desire. The perception of the coexistence of an *actual* and *virtual* within the same image is how Gilles Deleuze has defined the cinematic "time-image":

> The image has to be present and past, still present and already past, at once, and at the same time. . . . The past does not follow the present that is no longer, it coexists with the present it was. The present is the actual image and *its* contemporaneous past is the virtual image, the image in the mirror. (*Cinema 2,* 79)

Because the film image is the movement of time, Deleuzian time-images not only contain the visible imprint of the past as a series of successions into the present but also function as images of the present of that past which existed as virtual—as a force or even potential—and inheres in the present of the image of that past. In the rephotographing and slowing down of the *actual image* of the decayed film strip of a long-past moment, *Eureka* produces a gap between the two moments in time from which its *virtual image* is sensed rather than seen. This kind of time-image creates the possibility for an allegorical reading that not only constructs the past in terms of the needs of the present or finds the past in the present but also allows the use of what was potential—that which remains unrealized in one moment—to coexist in relation to what is actual in another moment.

The film's title itself, it could be said, refers to yet another relationship between the actual and the virtual "Eureka" was exclaimed by the prospectors who found gold in the California gold rush that led to the growth of the city of San Francisco, and by extension, the actualization of the image of the street through which the camera-trolley

moves (Figure 4). Gehr has created an aesthetic object in which one can experience the possibility of an image that exists simultaneously in the past and the present *and* in relation to the actual and virtual of the composite image he creates. *Eureka* is a time-image that embodies Benjamin's notion of history as wreckage by showing us the present in the deteriorated image of the past's ruined promise for the future. At the same time, in Deleuzian terms, it releases as its virtual image the not yet realized utopian promise of modernity that the past held for the present.

Dal polo all'equatore

The 1986 film *Dal polo all'equatore* (From Pole to Equator) by Yervant Gianikian and Angela Ricci Lucchi also uses images from early cinema actualities as allegory. *Dal polo,* however, looks at ways in which early filmmakers produced the image of the racial and ethnic "other" of European colonial adventurism and occupation. Although some of the formal strategies used to allegorize such long-discarded film footage—optically step printing each frame to slow it down—are similar to those in Gehr's *Eureka, Dal polo* is a much more historically ambitious and politically problematic work. Unlike

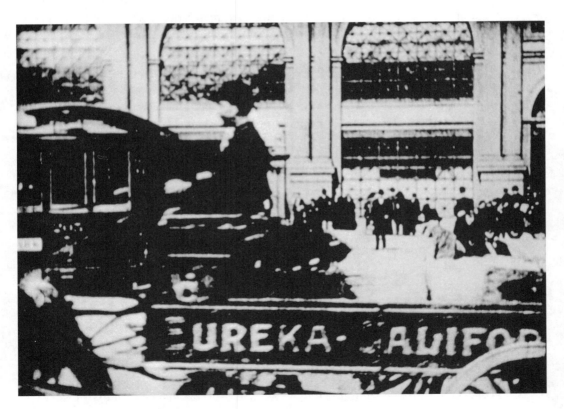

Figure 4. *Eureka.* Photograph courtesy of Ernie Gehr.

Eureka, which uses a single shot to make the entire film, *Dal polo* is a montage film of hundreds of shots from different sources edited together to make a single historical allegory. The filmmakers found the original footage in an Italian film lab. The footage comes from a "found" film of the same name, as well as other footage from an archive of the early Italian cinematographer and film collector Luca Comerio.[10] Not a well-known figure in the history of Italian cinema, Comerio is described by Gianikian as a "pioneer of Italian cinema and the cameraman of the King" (MacDonald, *A Critical Cinema* 3, 279). The footage for *Dal polo* was shot between 1899 and 1920. The subject matter of the footage is largely images of colonial ethnography and conquest: safaris, big-game hunting from polar bears to hippopotamuses, military parades, indigenous ceremonies, missionaries "teaching" native children, theatrical spectacles using indigenous people and animals, and carnage from military campaigns. The original silent film, also called *Dal polo all'equatore,* has no exact date. Based on Comerio's found letters to Mussolini while the filmmaker was trying to secure a job at "the new Institute Luce, the institute for Italian fascist documentary," Gianikian places the film in the late 1920s at the end of Comerio's career (279). The original film comprises four sections and is 57 minutes long, nearly half the length of the subsequent 1986 version, which comprises ten sections and is 101 minutes long. In their version, Gianikian and Ricci Lucchi have used three sections of the original version, and the remaining seven sections were found in Comerio's archive. The new film is a multifaceted historical project. It is at once an archaeology, recovering lost documents from an early period of Italian cinema, and an experimental form of historiography, using changing notions of the spectacle of an exoticized other as the basis for an allegorized historical narrative of European colonial conquest.

The major formal intervention in *Dal polo* is that of slowing down the image through rephotographing each original film frame several times. As in *Eureka,* this technique allows the viewer to see each frame for a longer period and emphasizes its material reality as a photographic image degraded by the passage of time. Both films work to denaturalize the indexical quality of the image as recorded reality, which, given the feeling of unmediated immediacy and the signifying power that these images have, is difficult to do. The multiple printing of each frame emphasizes surface scratches, missing and faded emulsion, mold that has grown on the image, and remnants of color tinting. The slowing down of the movement also works to distance the images from their original intention as commodifiable spectacles of an exoticized other and allows them to be examined as an artifact or document of colonialist cinema. Also like *Eureka, Dal polo* produces a new image that creates an awareness of the multiple temporalities of its production. Here one is able to see an image of the original exposure made by Comerio's camera and the image that has been made from Gianikian and Ricci Lucchi's rephotography. As Scott MacDonald writes about the film:

> The result transforms the original material . . . so that viewers not only see the original imagery and its original intent (to testify to the superiority of white, European

civilization) but *see through* the imagery to the human beings looking back at these cameras from within their own complex cultures. (*A Critical Cinema 3*, 275)

Here MacDonald implies that the film creates a critique of the earlier images through a rehumanizing of the people filmed by allowing the viewer to see their images more slowly. It is not, however, that one is able to see through one image to another as if there were a true nature of the people photographed that was contained in the image to be seen under the right circumstances; rather, the slowing down retards the movement of the spectacle allowing space for thinking about what is being seen. There are time and space—distance—in the viewing to consider the image's allusiveness and for the possibility of forming an allegorical reading based on the present moment in which one watches the images. As Deleuze suggests, "The cinema does not just present images, it surrounds them with a world" (*Cinema 2*, 68). That is to say, the images are not autonomous from the historical moment in which they are seen. Rather, they are magnetic, pulling the world of the present around them as an integral part of how they are understood. This recalls Benjamin's notion of the "dialectical image" as a productive way of thinking about what happens to archaic images in the context of the present. He writes, "For while the relation of the present to the past is a purely temporal, continuous one, the relation of what-has-been to the now is dialectical: is not progression but image, suddenly emergent" (*The Arcades Project*, [N2a,3], 462). What is understood in these images is not merely based on what is seen *in* the image but is part of a dialectic that also includes what is known by the viewer and brought to the image, something that is always in flux and transforming. In his refutation of the notion of "timeless truth," Benjamin continues, "Truth is not—as Marxism would have it—a merely contingent function of knowing, but is bound to a nucleus of time lying hidden within the knower and the known" ([N3,2], 463). *Dal polo* does not emphasize the arrest and fixing of the image in a specific constellation of meanings; rather, the film opens the image up to transformations of its meanings by releasing them into the flow of time.

Through the process of reprinting, the image is marked by the present—literally shining the light of the optical printer in the present onto the film strip from the past—to produce an image of both past and present. Neither moment in time is obliterated by the other, but forms the possibility of a tension between the two. As Benjamin suggests, "To thinking belongs the movement as well as the arrest of thoughts. Where thinking comes to a standstill in a constellation saturated with tensions—there the dialectical image appears" (*The Arcades Project*, [N10a,3], 475). Benjamin's notion of historical materialism is a process that "blasts" the object of history out of the linear progression of pastness into the present through the recognition of its pressure on the present. *Dal polo* is a film that could have been made only at the moment when the image of the colonial past is seen as a catastrophic inheritance of the present. This is the moment when Comerio's images come to have significance and can be seen "as an image flashing upon the now of its recognizability" ([N9,7], 473). For Benjamin, the

object pulled from the context of its pastness and placed in confrontation with the present becomes an image in which the forces and interests of history permeate the object and can be read.

At an earlier moment in time, Comerio's original film had been seen as insignificant and had been rejected by the Cinematheque in Milan when Comerio's nephew offered it for sale. In 1981 Gianikian and Ricci Lucchi found Comerio's original film in a closet in an old film lab in Milan. In the postcolonial context of the 1980s, they began their project by analyzing the frames of Comerio's film and were

> irritated and disturbed by Comerio's sanctification of imperialism, colonialism and war. We wanted to make a film on the violence of colonialism as it plays itself out in different situations and spheres. . . . We are interested in an ethical sense of vision. A project is usually born from our reading film images. (MacDonald, *A Critical Cinema 3*, 276, 281)

In doing this, the filmmakers reedit the footage to make new relationships that reflect their contemporary critique of such sanctification. In their film, they order the images so that they become a veritable condensed catalog of European colonialist violence and objectification. The film begins with a long sequence in which, like the original footage in *Eureka,* the camera is mounted on the side of a train as it moves through the countryside, presumably carrying it and everything else that is on board off to discover other worlds. The slowed-down and tinted image emphasizes the dreamlike quality of being transported into the unknown. Like the condensation in dreams, the film cuts to a ship in the Arctic in the emptiness of vast icescapes and then, just as suddenly, cuts to the Caucasus, India, Siam, Africa, and so on. Throughout we see the slaughter of whatever is encountered, mainly animals on land and at sea. In most cases the filmmakers use shot–reverse shot cutting between white hunters with rifles, looking. In the reverse shot an animal is killed. The hunter sees and then kills polar bears, walruses, wildebeests, zebras, hippos, gazelles, lions. The film emphasizes the gaze of the hunters in relation to their uninhibited display of power and brutality. The use of shot–reverse shot in these cases becomes part of a circle of gazes in relation to the domination of the animals and of the indigenous people as well, who are often seen looking on while assisting the hunters. This circle of looks implicates the camera, filmmaker, and viewer in a web of brutalization that goes beyond the killing to the act of seeing. The slowing down of the image forces the viewer to contemplate the act of seeing as an integral part—both literally and metaphorically—of the act of killing (Figure 5).

The catalog continues with images of coercive subjugation of native people by white colonialists. We see native people in colonial military uniforms marching in formation, sherpas carrying supplies and weapons, and missionary nuns training native children to sing and march in line. Often these images are placed in relation to shots of "uncolonialized" people unaware that they are being filmed in the act of performing their daily activities or religious customs. The placement of the shots in relation

to one another emphasizes the judgmental quality of the camera's gaze, through which composition sexualizes and exoticizes the subjects' often semiclothed bodies. At times colonists interact with them, usually to ridicule their behavior and customs.

Cinematically, the slowing down of the images foregrounds their graphic qualities and allows the viewer to examine the process of colonization and acculturation by showing in detail how people were placed into rigid formations such as queues or military lineups and made to march. The slowed-down image and its graphic quality emphasize how people were placed in matching uniforms, stripping them of their culturally specific dress. In one scene, we see the orderly rows of small black schoolchildren, all with shaved heads and white smocks, gesturing in unison to a missionary nun standing over them (Figure 6). The high-contrast black-and-white film renders them as graphic contrasts moving across the flat surface of the screen and turns them into objects of some grand plan—as if they were pieces of a large board game. By the end, the film takes on a fablelike quality of inevitability as this cataloging of violence begins to show images of the Europeans turning on themselves. We see the high-tech warfare of the battlefields and trenches of World War I. These are scenes of soldiers marching through fields and snowdrifts. We see images of endless dead bodies strewn

Figure 5. *Dal polo all'equatore* (Yervant Gianikian and Angela Ricci Lucchi, 1986).

Figure 6.
Dal polo all'equatore.

about the fields and bodies piled up around trenches. Here the chickens have come home to roost. We see the Europeans in massive military formations, fighting one another. Uniformed soldiers and their generals stare into the camera and salute. The last two images of the film emphasize the Europeans' specious victory over nature: an aerial shot of sheep herded into formation spelling out in Italian "Long Live the King!" and then a scene of a bourgeois family in their garden standing around a table laughing as they cajole a dog to attack a rabbit that one of the men is holding up by the ears. The shot is rephotographed so that the film strip is sliding through the gate of the optical printer, showing the repetition of each frame rather than continuous motion, creating a sense of the endless repetition of violence, aggression, and domination. The members of the group are seen looking on in passive pleasure as the rabbit is being terrorized by the dog. This short coda, which is quite different from the main body of the film in both the content of the image and the way it is rephotographed, can be seen as a summary of the act of looking that has gone on throughout the film by the cinematographer and the viewers, implicating and warning the viewers of their own (passive) role in perpetuating the spectacle of violence. This coda is a dialectical image, a metaphor for the activity of watching this film, as it brings together an image of the past domination as spectacle with the viewer's experience as spectator in the present.

In a critique of the film, Catherine Russell, in her important book on experimental film ethnography, argues, however, that *Dal polo's*

> lack of any information, narration, or titles . . . is an important means of deflecting the scientism of conventional ethnographic practices. . . . [This, however, reduces the film] to sheer image and spectacle [which] always runs the risk of aestheticization, of turning the Other into a consumable image [and so] fails to realize the dialectical potential of the archive. (*Experimental Ethnography,* 61–62)

Russell points out that, except for the opening titles, which are a poetic dedication to "Comerio, pioneer of documentary cinema who died in 1940 in a state of amnesia," *Dal polo all'equatore* eschews the contextualization of other kinds of information about the footage—for example, who is in the image, where or when the images were shot. The film contains no voice-over narration or intertitles giving information about the images or other interventions such as an authorial analysis about ways to read these images, what they mean, or how they functioned in the past and in the present. The images are not, according to Russell, "rendered textual, [they are] merely ephemeral and mysterious . . . as a form of nostalgia that incorporates, rather than allegorizes, the gaze of imperialism" (60). She contends that without verbal and textual intervention on the part of the filmmakers, their interventions—the reordering of the images, the slowing down of the image movement, the restoration of the film's original color tinting and the added music track—"engage in deliberate aestheticization of the colonial image bank . . . to create a sensual, affective viewing experience . . . that privileges the pleasure of the image over its role in constructing history and memory" (60). In this critique, Russell privileges language over image as the basis for creating an allegorical critical analysis of images, as if a "sensual affective viewing experience" can result only in a manipulated seduction, simply privileging pleasure. Here Russell tends to perpetuate the old and ultimately moralistic mind/body binary in which the rationalist function of critical analysis can take place only within the logos of language and textuality. For her, the sensual pleasures of sight and sound are to be regarded as seductive and passive. This leaves out the possibility that sensual pleasure can also heighten awareness and produce thoughts and emotions as part of a process of critical thinking. Although Russell rightly points out that "we have to make a . . . distinction between an aestheticization of otherness and a politics of representation" (189), she presumes a dichotomy between the aesthetic and the analytic. By insisting on such a split, Russell limits notions of critical thinking to linguistic forms of intervention. This ultimately reduces and may even obscure the possibility of multiple strategies for generating critical cultural discourse in a medium like film—in which affect and sensation are central to meaning making. I argue that *Dal polo* is indeed an allegorical film, but it allegorizes using purely imagistic means, directly confronting the sensuous possibilities of the visual. While *Dal polo* uses similar formal strategies to refigure the images as do the earlier "structural films," it goes a step further. The film heightens the signification of the content through what the cultural theorist Kobena Mercer has called "the experience of aesthetic ambivalence" ("Skin Head Sex Thing," 169) to produce an even more complex critical reflexivity that takes into account not only the intention of the author but also the affect and shifting subject position of the viewer.

With his notion of ambivalence, Mercer offers another, more nuanced critical model for spectatorship that takes into account those aspects of aesthetic experience that generate multiple and often contradictory thoughts and emotions that relate not only to the object viewed but to the larger subjective experience of both the artist and

the viewer. In his essay "Skin Head Sex Thing: Racial Difference and the Homoerotic Imaginary," discussing the nude photographs of black men in the photographer Robert Mapplethorpe's controversial series *Black Book,* Mercer contends "that the articulation of ambivalence in Mapplethorpe's work can be seen as a subversive deconstruction of the hidden racial and gendered axioms of the nude in dominant traditions of representation" (181). By emphasizing the viewer's position as subject in relation to the photographs, the images of black men in highly aestheticized poses produce multiple and contradictory readings depending on who is viewing. On the one hand, the images produce an ambivalence as historical signifiers of high art—they are part of a tradition of highly aestheticized nude portraiture shown in art museums and galleries, as well as in their appropriation in commercial art and advertising. On the other, these are signifiers of low culture, which includes the degraded forms of racist stereotyping of exoticized images of sexual otherness associated with pornography and the lower classes to which the image of the black male has traditionally been relegated. In the photographs, Mapplethorpe reverses and blurs these distinctions by elevating the images "onto the pedestal of the transcendental Western aesthetic ideal" (188). Mercer maintains that it is through a complex structure of feeling—that of ambivalence—that "far from reinforcing the fixed beliefs of the white supremacist imaginary, such a deconstructive move begins to undermine the foundational myths of the pedestal itself" (188). Mercer himself speaks as a gay black man who experiences the feeling of ambivalence, looking at images that are horrifying in the ways they work to stereotype black male sexuality but at the same time are sexually stimulating images of a homoerotic ideal. He maintains that the production of this ambivalence also creates a Benjaminian "shock effect" prompted by the "promiscuous textual intercourse between elements drawn from opposite ends of the hierarchy of cultural value" (189).

In *Dal polo,* the deliberate aestheticizing of the images of exoticized "other" bodies and places from the Comerio footage—wordless and left free of commentary—can also produce a "shock effect" on the contemporary viewer. The privileging of the visual, and with it, the cinephilic pleasure of the intense beauty of the slowed, color-tinted, grainy, and degraded film images in relation to their horrifyingly stereotypical content, is precisely what produces a critical ambivalence toward both the aestheticizing nature of the film image and the fascination with the othering it produces. *Dal polo* raises, in some viewers, the possibility for contradictory impulses, that of a desire for a sublime experience of the "pure image" and the realization that one may be finding pleasure in the dehumanizing representations in such imagery. The film, then, creates a dialectical relationship between a fascination with the possibility of a wordless sublime of its images, something so characteristic of the modernist aspiration of pure vision, and a sense of uneasiness—if not outright revulsion—in the face of such racist signifiers. The desire for the sensual gaze opens the viewer to the push and pull of the body, to the sensuality of the cinematic. For the critical viewer, the self-consciousness that he or she may be experiencing pleasure from such horribly stereotypical imagery implicates the viewer in the questionable morality of such images and opens the

possibility for critical awareness. It is in this sense that the beauty of these reprocessed images sets up a condition of ambivalence in the viewer.

The film sets up the conditions for the viewer to share the same fascination for such exoticized imagery and to occupy the position of the gaze of the colonial filmmaker. While the viewer is looking at the same images as the earlier filmmaker, however, he or she is not living and thinking with the same worldview. The political struggles against racism and colonial domination throughout the last fifty years have challenged many of the earlier discourses around colonial and racial representation. Arguably, this has made it harder for contemporary viewers to look at such imagery without it being surrounded by a greater critical awareness of how such imagery may be distorting and degrading. The film produces anxiety because the viewer inhabits two contradictory subject positions at once. The possibility that the viewer can make use of the image to substitute his or her own fascination with that of the filmmaker's can be seen as a form of fetishism. The racist image becomes a fetishistic disavowal of the viewer's anxiety over his or her own pleasure in the objectified, sexualized, or racialized other. In *Dal polo,* the viewer is able to do this through the objectivizing gaze of the original filmmaker, which is safely located in another time. While, as Mercer suggests, calling something fetishistic "implies a negative judgment, unavoidably moralistic" (179), he also argues for "fetishism's 'shocking' undecidability" (190), which works to unfix over-determined relationships between subject and object and also the limiting binarisms of good versus bad images of otherness. As Mercer has suggested of the Mapplethorpe photographs—which I think can be read in relation to the treated colonial images of *Dal polo*—such a contradictory position "destabilizes the ideological fixity" of the viewer and "begins to reveal the political unconscious of white ethnicity" (189), at once affirming and denying racial difference in the contradictory experience of the images. The question of whether or not the intense signifying of such images without verbal contextualizing undermines or reinforces racial stereotyping is undecidable. By removing the fixity of contextualization of language from these "difficult" images, they become unruly and indeterminate. This is the power and danger in Gianikian and Ricci Lucchi's experiment, since "indeterminacy means that multiaccentual or polyvalent signs have no necessary belonging and can be articulated and appropriated" for any ideological purpose (191). This moves the responsibility of enunciation away from the author to the viewer, and depending on the social identity of the viewer, the images are read variously.[11]

As becomes clear, allegorization happens not only through the author's intervention but also as an act of spectatorship. The entire film is an allegory for the present since the images can only be read from the shifting subject position of the viewer—filling the images with his or her knowledge and experience. Throwing the allegorizing impulse onto the viewer may create the risk of a so-called wrong reading, as Russell fears, but it also opens the possibility for new and more-complex relationships between the past and present that are not just limited to the temporal location of the filmmakers.

In this way *Dal polo* moves beyond the presumption of the indexicality of the film

image, that one can see through the image to reveal "the real" behind its spectacle, thus finding a truth that could redeem such repulsive images. Instead the film moves toward a different means of critique using what can be seen as a critically engaged confrontation with the image, since meaning is

> not something that occurs "inside" the text (as if cultural texts were hermetically sealed or self-sufficient), but as something that is experienced across the relations between authors, texts, and readers, relations that are always contingent, context-bound and historically specific. (Mercer, "Skin Head Sex Thing," 169–70)

Rather than perpetuating the notion of the fixed, autonomous text that can be critiqued only by linguistic intervention, correcting a misguided reading with the presumption of a singularly correct way to understand such images, *Dal polo* is unsettling, throwing its images and the viewer into the movement of history with its ever-changing discourses, and their social, political, and aesthetic contexts. The experience of the film produces a complex structure of ambivalence from which we are never free. Such ambivalence unsettles the viewer, not allowing us to stop questioning our relation to the imagery and the meanings of what is being seen. It causes us to question not only our own experience but also the experiences of others: other viewers, the filmmakers, the societies of the past and the present. In *Dal polo*, one is never allowed the complacency of the enlightened reading that allows the viewer to occupy a historically or morally superior position to our past.

Tribulation 99: Alien Anomalies under America

Using literary tropes as deconstructive methods for critiquing of images from the past has been a major strategy of contemporary film and video artists, who are returning to the archive to explore past film images of the colonial other in light of the recent explorations of postcolonial history, theory, and culture. As in *Dal polo*, much of this work examines and rereads lost or ignored representations and artifacts of the colonial past through contemporary political discourse. These works use a range of allegorizing strategies to reveal the deeply embedded ideology of Euro-American cultural and racial supremacy contained within them. The aim is to show how such distorted and racially biased imagery has become naturalized as a part of our collective and individual psyches and to produce alternative critical readings. Three paradigmatic films are *The Gringo in Mañanaland* by Dee Dee Halleck (1995), *Corporation with a Movie Camera* by Joel Katz (1992), and *Ruins* by Jesse Lerner (1998). In these works, the filmmakers use tropes of authenticity and personal experience as a strategy to question the reality and accuracy of such naturalized imagery to reveal the ideological distortions of these representations. Such works create a rhetoric of distorted history versus true history by creating true/false dichotomies between the self-serving ideology of the original films and what is understood by the filmmakers to be a more accurate image

of that past. Central to these strategies is the notion that a true or more authentic image of history exists outside competing ideological constructs and can emerge through the representation of the *authentic* experience of the oppressed other. In contrast to such works is *Tribulation 99: Alien Anomalies under America* by Craig Baldwin (1991), which, in an opposite strategy, questions the idea that there can be a historical real in any image and that history is a series of transforming narrative constructions competing for hegemony as historical reality. Baldwin is concerned not only with revealing a real behind such distorted imagery but also with examining the forms that are used to narrativize them.

Each of these films can be seen as allegorical in the ways it uses literary tropes and devices such as irony, parody, satire, and revisionist historical narratives to reinscribe new ways of understanding such images in the present. Lerner's *Ruins* deconstructs old educational films about the Mayan ruins of Mexico in which American and European anthropologists and art historians are seen and heard interpreting the meanings of the ruins. The film parodies the ways that anthropologists produce a sense of authority and facticity by using discourses from their academic disciplines to objectively naturalize what the film argues is merely a class- and culturally biased reading of these artifacts. To deconstruct this material, Lerner creates a fictional Spanish-speaking character dressed in traditional Mexican costume to answer and correct the white anthropologist's culturally biased interpretations. Lerner invokes the discourse of authenticity by creating an aestheticized, fictional rhetoric of racial and national authenticity to expose the fiction of the earlier film's linguistic and visual authority. Openly creating his own fiction, Lerner uses an actress who replies in Spanish as a sign of legitimacy in the face of the English-speaking foreigner. Lerner uses the fiction of authenticity to question the pseudoscientific authority of the white anthropologists by showing that their conclusions were erroneous because of their cultural biases. If *Ruins* takes up and critiques the use of film images within academic discourses, then similarly Katz's *Corporation with a Movie Camera* catalogs the different possibilities for allegorized critiques of industrial film images produced by U.S. corporations. *Corporation* attempts to show the ways such companies used the industrial film "genre" as a way to promote imperialist corporate expansionism. As Katz writes:

> The moment in history when the movie camera made its debut—the industrial revolution just settling in for the long haul, Colonialism's grasp at its height—determined that the camera's gaze was generally understood to be synonymous with that of the white male from the industrialized nation. ("From Archive to Archiveology," 100)

The cinematic detritus left by such relationships has been used as a major form of evidence in recent studies of the concurrent development of the motion picture apparatus and the industrial revolution, both of which were an integral part of colonialist expansion.[12] These ruins of once-commodifiable images are being taken up again for study. As a way to promote the reuse of such material, Rick Prelinger, a film archivist

who specializes in the preservation and sale of what he has termed "ephemeral films" (in which he includes advertising, educational, and industrial films) writes:

> Produced for specific purposes at specific times, and rarely just to entertain, ephemeral films illuminate almost every aspect of twentieth-century life, culture and industry. History as evidence and intention both reside in these often obscure and unintentionally humorous documents. As artifacts of past efforts to sell, convince, train, educate (and often miseducate), ephemeral films record continuing efforts to manufacture and maintain social control. ("Archival Footage")

In *Corporation,* Katz shows how the films were used both to promote investment in the corporations that were expanding their businesses into underdeveloped countries and to create the new markets for the products that came from such places. He focuses on bananas as an example of these early corporate advertising campaigns. The United Fruit Company used film to advertise the virtues of the banana as the company developed its huge banana plantations in Central America. *Corporation* contains clips of these films, with titles such as *Bananaland* (1928) and *Journey to Bananaland* (1953). The former, intended for corporate investors, shows the development and productivity of the plantations, and the latter persuades the U.S. consumer to buy the product. In his film, Katz shows how often the same footage is used, recontextualized by a different narrative for each purpose. Like the ones seen in *Ruins,* most of the films were produced from the 1920s through the 1950s and Katz parodies them by re-creating the unselfconsciously used "voice-of-god" narrators and by using actors in period costume to reenact scenes in exaggerated ways that expose their overtly imperialist ideologies.

In other sections of *Corporation,* Katz uses the first-person "I" and lyric poetry to again invoke the discourse of authenticity as a way to allegorize images of a colonial past. He shows contemporary Latin American and Afro-Caribbean poets reciting testimonial poems (often performed in Spanish), which claim the colonial past, as seen in the archival films, to be part of their own distorted cultural inheritance. The poems authorize Katz's present-day reinterpretations of the images from the earlier films. The poets speak back to the images by proclaiming solidarity with the voiceless victims of the barbarity of the colonial past. Their performances are meant to redeem this distorted past, giving posthumous voice to their ancestors by reinscribing the meanings of the images through their own knowledge and interpretations in the present. Like Lerner's use of a Spanish-speaking actress, Katz's use of the ethnic identity of the poets authorizes the truth value of their texts as a rhetorical trope giving the sense that theirs is a more authentic interpretation of the images. In these performances, Katz also invokes the authority of their high-culture aesthetics as poets. Both strategies work to produce a corrective rereading of the images. Katz juxtaposes the crude, ignorant representations of other cultures by corporate-produced industrial propaganda films with their vulgar and racist stereotyping (the low) with the literary language of lyric poetry

and its deliberately aestheticized use of metaphor, distilled language, and the earnest self-consciousness of the subjective "I" of the lyric poem (the high). In these ways, Katz and Lerner create the impression that the performers are producing a truer narrative of past events than those created in the archival films.

More overtly historiographic in intent, Dee Dee Halleck's *The Gringo in Mañanaland* uses the history of popular cinema as a way to understand the popular image of the colonized other of Latin America. The tape is a montage of dozens of clips from mostly North American films of different genres—Hollywood dramas, comedies, musicals, cartoons, newsreels, industrial and educational films—from all periods of film history. While the history is more impressionistic than chronological or analytic in the scholarly sense, the film was created out of a much larger project, which was the making of a database of images of Latin America: "Over seven thousand films were identified from over sixty archives. From the entire list approximately six hundred films and film segments were chosen for video transfer. It was from these selections *The Gringo in Mañanaland* was created."[13] Again the authority of this critique is produced through the discourse of personal experience—this time the filmmaker's own—as she frames the film by her testimony of her own misrecognition between her lived perceptions of Latin America and the movie images she saw as a child. The videotape begins with Halleck speaking directly to the camera:

> When I was twelve years old, my father got a job at a nickel mine in Cuba. It was 1952, the open-air company theater showed Hollywood films, many were about Latin America some were even about Cuba. *The Cuba in the movies wasn't the Cuba where I lived.* This film is a look at that other Latin America, the place in the movies. It's still there, at the movies, in our schoolrooms, on our TV sets, in our heads.[14]

This introduction sets up the following images from the past as allegories for the ways in which North America thinks about Latin America in the present. *The Gringo in Mañanaland* is a catalog of evidence of distorted views, the critique of which is authorized by filmmaker's experience (the real) versus the ideological desire of those who made the films (the distorted). The film is a kind of cine-bibliography of short archival clips organized around a series of intertitles that thematize them in relation to possible narratives of the imperialist project: "Arrival," "The Past," "Paradise," "Ambition," "Technology," and so on. Once allegorized in this way, the film no longer needs the benefit of ongoing textual narration or systematic explication. The filmmaker seemingly causes the "archive to expose its own secrets and agenda, propelling the film into a meta-level of inquiry on history and representation" (Katz, "From Archive to Archivology," 102), as if the "true meaning" of such images lay in waiting to be coaxed forth. The intertitles from the earlier film, which were made to read one way, in this new context are read in an opposite way. We see an intertitle from a film about the United Fruit Company that reads: "The United Fruit Co. with its Yankee enterprise has transformed trackless wastes into a veritable Garden of Eden." Around the intertitle are

images of untouched jungle being cut down, as well as ones of Fred Astaire in the film *Yolanda and the Thief* (1945) dancing around a woman as he strips her of the scarves that clothe her. The film goes on to ironically juxtapose images of Carmen Miranda dancing with bananas from Busby Berkeley's *The Gang's All Here* (1943) and U.S. Boy Scouts eating bananas from an educational film about the nutritional value of bananas, with newsreel images of the nearly slavelike working conditions on Central American banana plantations.

Ruins, *Corporation,* and *Gringo* all use renarrativization as an allegorizing device to "see through" the images in order to reveal their underlying ideological formulations. Through their allegorization, the images are now revealed as a symptom of distorted ideas rather than indications of a captured reality as the original films laid claim. But paradoxically, these cine-allegories still depend on a notion of an underlying truth of a historical past hidden behind the distorted spectacle of the image, replacing past truth claims with new ones. This implies that there *is* a "real" to these found images that can be uncovered and represented properly—or, more accurately, closer to the desire of the filmmakers.

In contrast, *Tribulation 99: Alien Anomalies under America* by Craig Baldwin (1991) begins with the idea that in an image-saturated postmodern culture, the real of the image has receded so far into representation that it is no longer grounded in a notion of an originary reality. That is to say, in *Tribulation 99,* the film image is not simply an indexical sign of a real event but an image of an image of an image, ad infinitum. The media theorist Jean Baudrillard has distinguished between representation and simulation, suggesting that "whereas representation attempts to absorb simulation by interpreting it as a false representation, simulation envelops the whole edifice of representation itself as a simulacrum" (*Simulacra and Simulation,* 6). He identifies "successive phases of the image" as it moves from representation to simulation. These might also be seen in relation to the movement of archival film images used in the four films discussed here as a way of distinguishing shifting notions of allegorization in the postmodern. The image

> —masks and denatures a profound reality. . . . it is an evil appearance—it is the order of malfeasance [e.g., the original films from which the images were taken];
> —masks the absence of a profound reality. . . . It plays at being an appearance—it is of the order of sorcery [e.g., *Ruins, Gringo,* and *Corporation,* which attempt to expose and uncover "false representations" of the original films];
> —has no relation to any reality whatsoever; it is its own pure simulacrum. It is no longer the order of appearances, but of simulation [e.g., *Tribulation 99*]. (6)

In *Tribulation 99,* Baldwin gives up the idea of such true versus false representation and takes up the problem of simulation as the realm of pure sign. He no longer sees the archival image as simply referencing an original event, but suggests that these images stand in relation to other images. Rather than trying to see through the image

to some essential truth, Baldwin transforms the archival imagery into pure simulacra, obscuring—as much as he can—any notion of the truth of the event through the overlaying of narrative upon narrative. This too is a cinema of revelation, but rather than presuming that there is a historical truth to be uncovered and redeemed, this is the revelation of the machinelike workings of historical narrative construction (Figure 7).

As in Halleck's *The Gringo in Mañanaland,* in *Tribulation 99,* Baldwin allegorizes the past by mixing archival newsreel and documentary footage (which are often the same in both films), as well as all manner of "ephemeral" films with dramatic films, cartoons, and television shows from different periods throughout the history of cinema and television. Unlike Halleck, however, Baldwin refuses citation, thus cutting the images off from historical reference. He neither gives the titles or dates of the footage nor invokes any discourse of authority in relation to an authentic term for how these images might be "correctly" read. Rather, the images can be seen as sheets of images moving by so quickly that they become a surface of textures, historical figurations, and references that, at times, signify something recognizable to the viewer and, at other times, are a blur of unrecognizable or misrecognized signifiers. Most often, one

Figure 7. *Tribulation 99: Alien Anomalies under America* (Craig Baldwin, 1991). Future U.S. president Ronald Reagan sells "Faultless Starch" on a TV commercial. Photograph courtesy of Craig Baldwin.

is able to read the genre from which the images come even without knowing the specific film or period in which it was made.

The freewheeling use of such film footage, which allows signification to occur on many levels, links Baldwin as much to the earlier ironic, Dadaesque, and morally ambivalent films of fellow West Coast filmmakers of the sixties and seventies such as Bruce Conner and Robert Nelson as to the more politically engaged didactic rereadings of such footage of his contemporaries Halleck, Lerner, and Katz. Like *Tribulation 99,* many of Conner's most overtly political films also use found footage to obliquely comment on the excesses of American conformism, imperialism, and violence. Like Conner, Baldwin uses a mixture of black humor and paranoid fantasy to allegorize the detritus of popular imagery, revealing the darker side of such excess. *Tribulation 99,* however, as are Baldwin's other films, such as *RocketKitKongoKit* (1986), *¡O No Coronado!* (1992), *Sonic Outlaws* (1995), and *Specters of the Spectrum* (2000), is clearly critical of specific political positions and often expresses solidarity with others. On the other hand, Conner's films, such as *A Movie* (1958), *Cosmic Ray* (1961), *Report* (1963–67), *Marilyn Times Five* (1968), and *Crossroads* (1976), and Nelson's films *Oh Dem Watermelons* (1965) and *Bleu Shut* (1970) often express political ambivalence by ironically aestheticizing and making dark humor from some of the most horrific imagery, such as the atomic bomb blast in *Crossroads* or stereotypes of African Americans in *Oh Dem Watermelons.* Unlike Conner or Nelson, Baldwin also articulates his practice as a filmmaker in more overtly political and pedagogical terms in which making art is also a form of cultural activism. As he says in an interview:

> I hate to describe myself as a moralist, but there really is this drive behind the film, not only to make something that's beautiful-slash-ugly, but also to raise consciousness. That's my missionary zeal or whatever. Filmmakers are driven to develop strategies to get information across. If you can do it visually, so much the better. . . . What I try to do is not only talk about the development of the problem but the intellectual process of the filmmaking. . . . That's not some a priori, top-down, overdetermined, overproduced thing. It's an authentic response from the margin. But it also has the critique, which is more trenchant, because it uses the very images against themselves. (Lu, "Situationist 99")

Tribulation 99 operates on the presumption that in this era of media saturation, meanings from the formal elements of film genres are gleaned by the viewer more quickly than any specific content. The popularity of *Tribulation 99* outside the United States seems to be an indication that the ability to recognize film and television genre forms typically transcends content specificity. Over these images, Baldwin creates a narrative, fashioning it out of multiple narratives, referencing other literary genres such as conspiracy narratives, religious mythology of the apocalypse, and science fiction.

Using the history of U.S. imperialism in Latin America, particularly the Cold War period, which, already represented on film, is historicized in a multitude of ways,

each with its own emplotting of events, Baldwin's appropriation of these films becomes an extremely productive stage for critiquing the U.S. government's Cold War claims of Soviet-sponsored domino theories of communist infiltration of Latin America. Structuring the film in a series of ninety-nine "rants," each with its own emplotted event, Baldwin parodies such institutionalized government conspiracy theories by threading them through contemporary apocalyptic conspiracy theories about aliens from outer space taking over the planet, and apocalyptic religious doomsday predictions made popular by religious and right-wing fringe groups. In *Tribulation 99*'s reductio-ad-absurdum emplotment, in which every unexplainable event now connects to every other, the history of Latin American anti-imperialist and revolutionary independence movements is recast as the "Quetzal Conspiracy," an invasion from outer space leading inescapably to apocalypse. This is led by space aliens who have taken human form to infiltrate civilization, destroy the human race, and take over the earth (Figure 8). In this parody, using an *Invasion of the Body Snatchers* scenario, all the leaders of twentieth-century Latin American independence movements from Arbenz and Allende to Castro and the Sandinistas are actually humanoids made by the space aliens to carry out the goals of the unseen alien force. All mysterious political conspiracies from the Kennedy assassination to Watergate become interconnected and explained by the alien invasion of Earth. The film is a vast catalog—using both visual evidence and a barrage

Figure 8. *Tribulation 99: Alien Anomalies under America*. Rant 27, "The Gathering Storm": Cuba, ground zero of the "Quetzal Conspiracy," leading inescapably to global apocalypse. Photograph courtesy of Craig Baldwin.

of verbal facts and statistics—of evidence of this invasion. We learn that some U.S. leaders who supported moderation or peaceful coexistence with such movements have been taken over by the space aliens. The name "the New Jewel Movement of Grenada" proves that the socialist leader Maurice Bishop was actually an "Atlantean plant" of a "rampaging gang of psychic vampires," since the movement's very name is a reference to the "evil power crystals," the energy source of the alien invaders' flying saucers (Figure 9). The truth is revealed about why the CIA's Operation Mongoose failed to assassinate Cuban leader Fidel Castro when the manic narrator—an actor playing the character of a retired air force colonel—explains that "after thirty-three assassination attempts entailing two thousand people and fifty million dollars, they are horrified to realize that you can't kill something that is not alive."[15] This is contextualized by images from James Bond movies mixed with newsreel images of recognizable figures such as CIA operative E. Howard Hunt and Castro himself until all lines between historical fact and fictional fantasy are blurred. Thus the blurring becomes an allegory for what Baldwin and others often see as the conspiratorial hysteria of much U.S. foreign policy. Like historical writing, Baldwin's fiction can only be rendered through emplotment. As Hayden White suggests:

> Every narrative discourse consists, not of one single code monolithically utilized, but a complex set of codes the interweaving of which by the author—for the production of a story infinitely rich in suggestion and variety of affect, not to mention attitude towards and subliminal evaluation of its subject matter—attests to his talents as an artist, as master rather than servant of the codes available for his use. (*The Content of the Form*, 41–42)

In *Tribulation 99*, Baldwin foregrounds the aesthetic nature of historical narrative and his own creative virtuosity by showing the multiple possibilities for making stories out of events, by the endless montaging not only of "found" images but also of "found" narratives from every genre. By inducing the viewer to read form before content, Baldwin reduces the authority of the empirical truth value of the images to tropes of genre. In this way, the film itself becomes a metacommentary on the history of narrative figuration in cinema. White theorizes:

> If there is any logic presiding over the transition from the level of fact or event in the discourse to that of narrative, it is the logic of figuration itself, which is to say tropology. This transition is effected by a displacement of the facts onto the ground of literary fictions or, what amounts to the same thing, the projection onto the facts of the plot structure of one or another of the genres of literary figuration. (*The Content of the Form*, 47)

In *Tribulation 99* the dialectical image occurs in a battle of genre forms that are smashed together through image montage and image-sound juxtaposition, creating a kind of

Figure 9. *Tribulation 99: Alien Anomalies under America*. Rant 6, "The Isle of Doom": (*top*) Grenadian socialist leader Maurice Bishop, actually an "Atlantean plant," and (*bottom*) part of a rampaging gang of psychic vampires. Photograph courtesy of Craig Baldwin.

delirious overflow of signifiers of historical figuration from past and present. In doing so, the film reverses the relationship of narrative form to content of traditional historiography in which the truth effect of events that actually happened obscures the artifice with which an event is explained. For example, it is true that John F. Kennedy was assassinated. How or why is solely a product of competing narratives. In elaborating the ways this truth effect is produced, White shows that traditional historians must make what amounts to a leap of faith that what is created as historical narrative

> is less a product of the historian's poetic talents, as the narrative account of imaginary events is conceived to be, than it is a necessary result of a proper application of historical "method." The form of the discourse, the narrative, adds nothing to the content of the representation; rather it is a simulacrum of the structure and processes of real events. (*The Content of the Form*, 27)

Instead, it can be argued that *Tribulation 99* attempts to expose the process of the narrative figuration of historical accounts that are normally hidden in traditional historical narratives. Here the film takes on a formal reflexivity that links it to earlier political modernist strategies in which "the reflexive structure of the text . . . is mapped onto a series of formal negations organized according to the opposition of modernism to realism" (Rodowick, *Crisis,* 52). This form of reflexive materialism within avant-garde film has for the most part been defined by focusing the viewer's awareness of the materiality of the medium's artifice as theorized and practiced most thoroughly by British and American structural/materialist filmmakers.[16] *Tribulation 99,* however, can also be seen to embody the Brechtian project of epic theater, which, in a counterconstruction of materialist film practice, attempts to bring together both an awareness of material artifice *and* the historical aspects of specific social and political conditions.[17] Like Brecht's epic theater, *Tribulation 99* uses recognizable historical events to provoke the viewer to think about the rhetoric behind U.S. policy toward Latin America. At the same time, Baldwin calls into question traditional forms of such critique by getting rid of many of the hallmarks of historical writing such as dates and other contextualizing references, which can be organized in any way to validate or criticize policy. This makes it impossible to produce the sense of authority provided by the discourse of scientific historical inquiry. Baldwin deliberately trades the scientific discourse of historiography for the aestheticism of the novel through the imaginative mixing of different narrative tropes in a single overarching plotline. By pitting his artistic text against the scientific, Baldwin, in White's terms, "directs attention as much to the virtuosity involved in its production as to the 'information' conveyed in the various codes employed in its composition" (*The Content of the Form*, 42). By doing so, he shows that historical events represented in his film have meaning only in relation to the forms in which they are narrativized. Also, by using so many different narrative scenarios, he shows how any event can be understood according to any ideological need. Any event can be connected to any other, as long as the events can be emplotted in a way that

the "real events display the coherence, integrity, fullness and closure of an image of life that is and can only be imaginary" (24).

Tribulation 99, as do nearly all of Baldwin's films, displays the excess of a desire for narrative fullness and closure. The events on which Baldwin's films are based are all *supersaturated* by emplotment, and as such, the multiplicity of possible narratives precipitates out of the transparency of the truth effect of historiographic discourse, producing a sense of swoon, of being overwhelmed by the sheer buildup of images, information, scenarios, and possible scenarios that characterize the "society of the spectacle."[18] In the end, the buildup of multiple scenarios begins to produce what becomes narrative entropy, in which narrative chaos ensues. As a strategy, this can be seen as a kind of "alienation effect," which is an attempt to break the viewer's habituated acceptance of linear cine-narrative transparency as he or she is forced to confront the constructed nature of historical narrative in which lines between fact and fiction are inevitably blurred in the search for a consistent coherency of the events.

The film itself begins to fly apart as it arrives at its final moments. Rant 98, "The Final Deluge," can be seen as a metaphor for what the film has done with historicity itself as it describes the last moments of civilization, when the buildup of plutonium "by-products [like narrative emplotments?] reaches critical mass, the dam melts down, the isthmus is flooded. The Atlantic and Pacific merge, radically altering prevailing ocean currents. Hot radioactive water is swept into polar seas. The ice caps melt, engulfing the continents." In *Tribulation 99,* Baldwin treats historical narrative itself as ruin, its own authority undermined by the pure accumulation of possible formulations or rationalizations, each vying for hegemony. Out of this multiplicity of single scenarios, we experience a function of narrative that is "not to represent, but to constitute a spectacle." According to Roland Barthes, "Narrative does not show, does not imitate. . . . 'What takes place' in a narrative is from the referential (reality) point of view literally nothing; 'what happens' is language alone " (*Image, Music, Text,* 123–24). What links *Tribulation 99* to earlier materialist avant-garde film practices is how it strips away the transparency of illusionist authority to reveal the process of representation and signification. In the case of structural/materialist film, there is a stripping away to the very material of the apparatus—light, duration, film stock, apparent motion, et cetera. These elements are often foregrounded in *Tribulation 99* through the use of generational degradation of the film strips, which become copies of copies, or the repetitive use of images, light flares, flash frames, black frames, and other techniques. But its most subversive action is in the delirious play of multiple signifiers as a strategy to strip away the reality effect of historical narrative to its pure textuality.

This is not to say that the film is without its political urgency or that it has traded an awareness of pure textuality for the agency of historical knowledge. Behind the layers of ironic parody can be found a coherent critique of the contradictory and often incoherent U.S. foreign policy in Latin America. *Tribulation 99* also shows how fear and paranoia can be mobilized for political ends through the complex and contradictory narrativizing of actual events in the world. What makes the film so effective as a

metahistory of U.S. foreign policy toward Latin America is the recognition of the ways in which citizens can become disempowered and reduced to mere spectators rather than knowledgeable members of a society who are able to participate in the creation of a policy that represents their wishes. As satire, *Tribulation 99* shows how the confused (or bemused) cynicism around politically charged events becomes possible as such events are narrated by the media and government and are then appropriated and commodified for any purpose from mass-media entertainment to religious and political indoctrination. At the same time, the film acknowledges the uselessness of history with its cause-and-effect constructions that explain everything and question nothing. Like much postmodern narrative, *Tribulation 99* emphasizes the play of the signifier—one among many. With its overflow of images, this is a maximalist strategy, as opposed to the minimalist stripping away of signifiers as in earlier forms of political modernism.[19]

On the face of it, there is a great aesthetic distance between a film like *Eureka,* whose emphasis on the materiality of the cinematographic trace produces a silent evocation of two simultaneous moments in time, and *Tribulation 99*'s self-conscious and multiple recontexualizing of historical events through the juxtaposition of literary trope and image. But like all forms of historical allegory, the films discussed here, *Eureka, Dal polo,* and *Tribulation 99,* all begin with the idea that historical representation is essentially an aesthetic activity, if one sees allegorizing as an active and creative transformation of temporal relationships. While Benjamin advocated allegory as an essential part of his notion of historical materialism, he also warned of the dangers of aestheticizing politics, which can only "culminate in one thing: war" (*Illuminations,* 241). This has been and continues to be demonstrated in the commercial and propagandistic uses of film. With this danger in mind, I have argued here that these artists have taken on the challenge of reclaiming the aesthetics inherent to the allegorizing of cinema's mechanical memory in order to produce new possibilities, new knowledge, and a critical awareness through the act of reimaging, or, more accurately, the act of reimagining.

2. Shadows: Historical Temporalities 1

Going down that street ten thousand times in a lifetime . . .

. . . or perhaps never at all . . .

—DANIEL EISENBERG, *Cooperation of Parts*

Our desire to understand the confusing and chaotic nature of historical events often gives rise to narrative forms and their conventions. They are created to give a sense of coherence or a rationale that helps explain why events occur in the ways they do. Notions of inevitability, predictability, and causality are central to such conventions and become binding agents that seem to cement fragments of events into seamless, whole stories that satisfy our apparent need for closure.

This is a literary as well as an ideological problem, for as much as anything else, the narrative representation of history consists of a set of forms that are created to adhere to certain ideological and philosophical precepts. Such forms run throughout the cultural representations that we use to structure events for specific meaning. For example, in Judeo-Christian theology, messianic notions of events are central to the way in which redemption structures and overdetermines the lives of the people and societies that adhere to these religions. In secular Enlightenment philosophies, ideas of progressive intellectual and scientific development posit a progressive present in which an ever-growing body of knowledge redeems the ignorance of the past. Even Marxist scientific materialism posits a similar progressivist but scientized history based on causality. All of them, despite their manifest differences, cast inevitability as the major structuring device for narration.

If narrative meaning results in the creation of formal structures that shape relationships between events, then the most creatively rendered relationships generally

produce the most convincing accounts whether they are based on events that actually occurred or were imagined. Although it is simplistic to see history as merely creative construction or vice versa, similar kinds of formal structures and systems of identification are often at play in the narrative arts and scholarly research. In this sense we can see the narration of history as having an analogous relation to fictional forms—the novel in particular. As these forms structure our perception of events that occur in the world as well as in the imagination, the question arises for both reader and writer: How does one distinguish between history and fiction?

The ideology of linearity insists that one event seamlessly slides into another as if preordained. In the continuity conventions in cinema, narrative form inscribes the appearance of seamless causality in which each shot is cut to flow invisibly into the next. In the cinema of continuity, conventions such as the eye line match, angle of action, and the match cut were created to give time the illusion of a continuous verisimilitude. For example, the five or six discrete shots that make up walking through a door seem like one continuous action, making the last shot the inevitable conclusion to the first.

In relation to how we understand the progression of historical events in the conventional novel, and by extension in conventional film narrative, the role of foreshadowing is significant, for it is often the most transparent and manipulative. According to literary theorist Michael André Bernstein, foreshadowing is the built-in evidence of an inevitable conclusion to the story being read. From the beginning of such narratives, the reader or viewer starts to see signs that will lead directly to the "fate" of the character at the end. The reader and author are locked in a bond, being able to foresee the fate of the character long before the character himself does. The implication is that if the character were more aware, he too would be able to read the inevitable writing on the wall. Foreshadowing often removes the sense of the eventness of a situation in flux, the outcome of which is not inherently guaranteed. Foreshadowing creates a reading of an event that gives an impression that all events have causal relations to one another by "naturalizing" what is described through the seamless elision of one narrative event into another. For instance, in representations of catastrophe, foreshadowing creates an air of inevitability: there was nothing that could have been done. Given the "players" in the "drama," it could only have ended in disaster. Moreover, the implication of inevitability limits the sense of the possibility of individual or group agency in a given situation. The singularity of such a narrative trajectory can also work to discourage readers and viewers from actively engaging with the complexity of possible outcomes as events unfold in a given history. Such a sense of possibility is essential to any notion of individual or collective agency shaping representations of one's own present in relation to events of the past. Aesthetically, foreshadowing also limits narrative possibilities, since the formation of a story becomes a map highlighting a single path leading to its conclusion. It forecloses the possibility of creating or experiencing other routes. At the same time, foreshadowing relies on the emotional

power of the knowledge of impending catastrophe; any other intellectual or emotional engagement a person might have when confronting a life situation is precluded.

Another aspect of foreshadowing is backshadowing. Backshadowing takes place when prior knowledge of a situation's outcome is shared by both the reader or viewer and the author. In this construct, all actions and events move inexorably to a result that is already known. Moreover, the emotional power of the narrative is based on what the reader or viewer already knows, not on what is being learned. This shared knowledge removes the possibility in the reader's mind of other ways a character might respond or other ways an event could turn out in the face of how ultimately it did. By making our knowledge of their doom the only source of judgment and concern, it strips their lives of any significance. As Bernstein writes, for example:

> The cruelty of backshadowing can be illustrated concisely by realizing that it regards as pointless the lives of countless numbers of people over hundreds of years like the Polish or Austro-German Jews who contributed to the building and maintenance of the synagogues that were eventually razed by the Nazis. Each present, and each separate life, has its own distinct value that later events cannot wholly take away. (*Foregone Conclusions,* 41)

As Bernstein argues, when the narratives of characters' lives, whether fictional or real, are structured by foreshadowing and backshadowing, both reader and author sit in judgment of the characters and the meaning of their existence. These ordering devices structure our perception of the movement of time in relation to concepts of inevitability and causality that seep into the way we understand events in the world. Insidiously, they become naturalized as the way we understand the history of our own lives.

With an awareness of these shadowing conventions, it is interesting to see how intellectually manipulative these formal devices are and how they raise ethical questions about narrative form. Yet for the last several hundred years, the ability to foreshadow in the most intense and subtle ways has been a sign of literary skill. This remains true even today, especially in mass-culture cinema, where the pleasures of "Hitchcockian" suspense are often created through narrative foreshadowing understood to be the highest form of cinematic narrative sophistication. Here the fate of the character is foreshadowed through small clues given to the audience long before the character has any sense of what will happen. The feeling of knowing, but not being able to affect the outcome of the character's fate, casts the sense of inevitability over the story's outcome.

As a counter to such narratives of linearity and inevitability, Bernstein and other literary theorists have pointed to a form they have termed *sideshadowing.* To sideshadow in historical narrative is to illuminate other aspects that existed simultaneously as part of the main trajectory of an event, showing the density in the dynamics of that history. As Bernstein writes:

Against foreshadowing, sideshadowing champions the incommensurability of the concrete moment and refuses the tyranny of all synthetic master-schemes; it rejects the conviction that a particular code, law or pattern exists, waiting to be uncovered beneath the heterogeneity of human existence. (3–4)

Sideshadowing strategies take into account the reality of counternarratives that exist within historical events and can open such narratives to multiple contingencies that surround an event. Sideshadowing suggests that although things turned out one way, they could also have turned out some other way, expanding the complexity and nuance of events. Sideshadowing is generative of alternatives for the understanding of events as a result of the multiple factors that surround them. Such a strategy allows us to

recognize that a whole orchestration of complex sentiments and concepts might be occurring, not as it were, archaeologically *beneath* the surface ones as their foundation, but instead topographically *alongside of,* and temporally *concurrent with,* the one we notice and upon which our attention and interpretive acumen are focused. (6–7)

While sideshadowing does not deny the reality or historicity of events, it creates an awareness of the indeterminacy of relations between them. There is no inevitable outcome to anything, because so many things are happening simultaneously. Because multiple possibilities open the way for different ways of interpreting an event, sideshadowing displaces the question of the truth of an event—which can always be called into question—onto the ethics of the event's representation.[1]

In an event as monumentally catastrophic as the Jewish Shoah, the backshadowed knowledge of the destruction of an entire community can take on an air of inexorability when the narrative of such total loss is not surrounded by other possibilities and knowledge. Such a singular narrative of destruction can produce a sense of fate and inevitability, foreclosing on the sense that the lives of those lost were also filled with a cultural richness and sense of individual possibility that existed alongside the destruction. The three films that frame this chapter can be seen as narratives casting sideshadows that throw into relief aspects of Jewish life that are often overpowered by the searing brightness of the Shoah.

The Man without a World

Eleanor Antin's *The Man without a World* (1991) is a film of a film made to evoke an absence, as a means to "see" what is no longer there (Figure 10). It is an act on the part of an artist to engage with a past that no longer physically exists except through representations of that world. The film, a 16 mm, black-and-white, silent feature, is part of Antin's work as a conceptual and performance artist spanning three decades. One of the most influential figures of the multimedia art movements of the 1960s and 1970s, Antin has long ago left the specificity of a single medium and moves easily between

different ones, including drawing, photography, film, video, performance, and writing. Her use of a specific medium arises from the issues and ideas of a given piece. This makes her practice distinct from that of a film director, who engages all ideas through the discourse of cinema. This nomadic relation to different kinds of media places Antin in the margins of specific media discourses and perhaps opens areas of investigation unnoticed by artists whose primary relation to ideas is through their single chosen medium. Her wide-ranging body of work focuses on the use of historical narratives and the appropriation of past events and figures to look at how aesthetic and social conventions are constructed temporally. About her work, Antin states, "I see time as epoch and genre rather than as an unfolding process" (Levin, *Beyond Modernism,* 107). As a feminist artist, Antin is particularly interested in looking at how the image of women and their position in history is constructed through genre and other narrative forms that become naturalized as fact, reality, and even social policy. The activity of taking such histories apart, reformulating them, and reinscribing them, with her own ideas and images is an attempt to destabilize representations of women's histories that have become naturalized in specific forms. This can be understood as an empowering act of appropriation that often leads her to new ways of thinking about her position in contemporary society. Antin's recent work consists of re-creating

Figure 10. *The Man without a World* (Eleanor Antin, 1991). The Eastern European Jewish shtetl: a film of a film evoking a world no longer there. Photograph courtesy of Eleanor Antin.

historical moments and then inserting herself into those temporal scenes by taking on the role of an amalgamated character or a figure from that period. For three weeks in 1980, Antin created the character Eleanora Antinova and lived in a hotel in New York City as this once celebrated but now retired black ballerina of Diaghilev's Ballets Russes, darkening her skin color, dressing as Antinova, adopting the aristocratic trappings of this persona, and giving public performances and lectures in character. Through the process of transforming herself into a range of women characters of different races, ethnicities, and professions from various moments in time, Antin combines her own imaginings with historical research. In this way, she is able to experience in the present how gender functions as a phenomenon of history, which she sees at once as fact and fiction. For example, in the 1977 piece *The Angel of Mercy*, Antin becomes nurse Eleanor Antin, RN, to evoke and comment on the stylistic, social, political, and moral climate of Victorian England. Using re-creations of nineteenth-century *tableaux vivants*, theatrical styles, and early photographic and cinematographic techniques that give the appearance of historically authentic documents of the period, Antin places the objectivity of historical perception in doubt. Her nineteenth-century photographs, impressive as they are in their apparent authenticity, are simulations. As Antin writes, "It is not the real thing which suggests the real in art, it is rather the slight disparity, the unexpected even, that will give the appearance of truth" (Levin, *Beyond Modernism*, 113).

During the 1990s, Antin focused on Jewish history, especially pre–World War II Yiddish culture both as it was lived in Eastern Europe and its immigrant culture in the United States.[2] Starting from the position that history is more genre construction than event, in 1991 Antin became Yevgeny Antinov, the Polish Jewish film director of *The Man without a World*. As opening titles indicate, *The Man without a World* is the recently found "lost" film of this forgotten Yiddish film director. As Antinov, Antin has inserted herself into the discourse of creative artifact as history. From this vantage point, she can reimage a now-extinct world by creating a fiction and turning it into a historical artifact, this time to explore the Yiddish cinema and Jewish shtetl life before World War II. In this elegant gesture, Antin uses the events of World War II, a lost era of film history, the extinct culture of the shtetl, and pure fiction to fashion the parts of this "history" that are important to her.

Set in a shtetl in prewar Poland, the film centers on Zevi, a young man with pretensions to being a poet, who yearns for the cosmopolitan artist's life in Warsaw. Inspired by the arrival of a band of traveling Gypsy performers—replete with a ballerina (recalling an earlier Antin character), magician, and strongman—Zevi abandons his family and girlfriend to be near the performers. He starts frequenting a local bar, where he writes and recites symbolist poetry and argues politics and philosophy with the local "intellectuals," who, like Zevi, have pretensions to being socialists, anarchists, and Zionists (Figure 11). The film moves from scenes of general daily shtetl life to scenes in the bar to Zevi's home, where we meet his loving girlfriend, his tortured mother, and his sister, who goes crazy as a result of being raped by Polish peasants. Throughout,

Zevi is torn between being a "good Jewish boy," living the responsible life, and going off to Warsaw with the Gypsies to live the life of a poet. In the end, his mother dies of suffering—"Jewish mother" style. His sister dies after religious fanatics exorcise a *dybbuk* that has possessed her, and finally Zevi agrees to do the right thing and marry his now-pregnant girlfriend. His wife's rejected suitor crashes the wedding, killing several of Zevi's best friends. Zevi, in a fit of rage, kills the suitor and is forced to leave the shtetl to avoid arrest. The film ends with Zevi going off—without his pregnant wife—with the Gypsies to Warsaw as Death follows close behind.

The narrative of the film is closer to an armature that supports images and situations that interest Antin than it is a story which is complex in its psychological or plot development. Rather, like dreams, the narrative is based on condensation—of different stories, myths, characters, and situations. Here Antin creates a montage of Jewish cultural traits and archetypes. These come from an amalgam of sources, from mystical Yiddish folktales to more-realistic stories about the difficulties of Jewish life in Eastern Europe. Antin was influenced by stories of the great Jewish writers such as Babel and Singer, by the Yiddish cinema itself, and by received images from her own family history. The film is based on desire and loss by the artist, whose own relationship as a first-generation Jewish American to this vanished world seems to take precedence over issues of strict historical accuracy.

Figure 11. *The Man without a World*. Moishe's Café, where intellectuals gather to solve the world's problems, recite poetry, and see modern dance. Photograph courtesy of Eleanor Antin.

In the film, Antin has rendered visible through representations of representations a compendium of Yiddish cultural archetypes and stereotypes that Antin—not Antinov—knows are doomed to oblivion, since she is making the film in the present. The film also comments on the immediate past of European modernist culture, incorporating a kind of social history of the different strains of pre–World War II intellectual, political, and artistic ideas into the narrative. At the same time, the film incorporates contemporary notions of appropriation and simulation embodied by Antin's project itself. This is all woven together as a pretext for Antin's real agenda, which is to revive the "lost" cultural archetypes of the now-extinct *Yiddishkeit* culture of Eastern Europe: the romantic and lost poet who wants to get out of the small, oppressive town, the Gypsy artists, the revolutionists, the Jewish mother, the fair maiden at once committed to and oppressed by her family, the Rabbi, the *dybbuk,* the anti-Semitic Polish rapists, and more broadly the village people, the towns, cities, a culture (art, literature, theater, and cinema), a way of life, a language—all of which have been eradicated as they existed before World II. What is left is a memory trace that, as time goes on, becomes more distanced and sentimentalized. The title *The Man without a World* itself not only speaks to Zevi's alienation from his own culture as a result of his intellectual and artistic aspirations but also foreshadows the end of both these worlds in the decade to come.

Because Antin's film engages social, cinematic, and art history from several different vantage points, the film becomes an interesting source in which to look at the phenomenon of narrative backshadowing, foreshadowing, and sideshadowing. For better or worse, they are all rolled into one postmodern extravaganza that is at once an embodiment of the perniciousness of backshadowing and points to a possible solution to its linearities.

Though the Shoah is never mentioned, the end titles of the film speak to the end of this "world," through reference to Jewish deportation out of the region. These titles return the film to historical context, validating what we are already thinking about throughout the film. Still, the entire narrative of the film is backshadowed by the viewer's knowledge of the events of World War II. The viewer's prior knowledge of what happened to the people portrayed in the film works to disarm any critical judgment of the characters and makes possible a sympathetic and sentimentalized view of this world, since, as we watch, we know it is already doomed. In this sense, *The Man without a World* is a world of ghosts. The film opens with a figure who comes to be known as Death and conjures up the world we are about to experience simply by snapping his finger. These are no longer real people who have all the complexity of human beings. Rather, they are cultural archetypes and victims with whose ultimate fate we sympathize and, from a vantage point of distance in time, mourn. Our sympathy has its price: in the end, none of the villagers' actions have any consequence because of this impending doom, and thus their humanity is reduced. Antin is more interested in her desires for what this lost world represents to her personally and poetically in the present than rendering the "archaeologically" correct image of it. Her shtetl is the

wellspring of the elements of a secular, cultural Judaism that the now-assimilated and educated American Jew can still embrace. Antin's shtetl is a world of argument, family, art, politics, and religion. This is a world poised at the intersection between traditional ethnic folk life and modernity. It has an innocence and purity that are no longer easily questioned because it was destroyed from outside rather than from within. While few of the characters in the film are particularly interesting, and many can even be seen as simply embarrassing Jewish caricatures, especially as portrayed in the nonnaturalistic acting style of the silent film—which can make the viewer even more aware of their stereotypical nature—the backshadowed knowledge of their eventual doom disarms a critical view and transforms what might be seen as embarrassment into sentimentality.

Since this world is gone for good, its memory can be used to support any polemic or need one might have. As contemporary societies become more homogenized and ethnic groups assimilate, the negative aspects of the ethnic past begin to recede as sources of embarrassment and anger and yield to sentimentality and nostalgia. Time and the safety of this assimilation seem to smooth the edges of the spectacle of ethnicity; for example, Old World customs, food, accents, dress, rituals, social styles, which were once the mark of ignorance and backwardness, become the embodiment of one's heart and soul forfeited in the process of assimilation. For example, the embarrassed, neurotic descriptions of copious quantities of pot roast and chopped liver, forced on Neil by his aunt in Philip Roth's depiction of Jewish life in the 1960 *Goodbye, Columbus* (3–4), have given way to sentimental and loving meditations on the smells of onions, whitefish, and red herring in a delicatessen, which now connect Roth to the lost history of European Jewish life in his 1993 novel *Operation Shylock: A Confession,* written some thirty-five years later (378–79). This phenomenon is particularly true of second- and third-generation immigrants who, in the context of a highly assimilated culture, are now looking for some connection to their ethnic past, with hopes of finding cultural authenticity in the midst of the contemporary hybrid culture of the United States. They and we attempt to reach out to a past that in its ephemerality and idealized representations can be appropriated in any way needed.

The Man without a World creates an emotional intensity through the foreshadowing elements in the story. The film is filled with death and loss that carves a path straight to Zevi's and the whole village's ultimate doom. The film begins with the embodiment of Death popping into the frame—mystically and cinematically—with a wave of a finger, creating the drama as if this were a world of the dead. This foreshadows the loss and death that will befall the characters in the film and ultimately the whole culture, making the cataclysm of the Final Solution seem inexorable. Throughout the work, we see foreshadows of the "end": the rape of the young woman by the Polish peasants; the takeover of the bakery by a non-Jew, implying that there is a law that has been passed banning Jews from owning bakeries. These are images from the pogroms that beset these communities, which today we see as a foreshadowing of the Shoah itself. In the last shot of the film, as the remaining artists leave for Warsaw, they are followed down the road by Death.

The sideshadow in the film is, in fact, the history of cinema, which opens up other possibilities for representing a historical moment. Rather than making a naturalized fictional representation of the lost shtetl world (à la the movie *Yentl* by Barbra Streisand [1983]), Antin has made a fictionalized representation of a film that *might have been made* representing that world. *The Man without a World* is a simulation of a silent-era Yiddish film: a film of a film, as it were. Antin has gone back to a secondary historical moment—a moment in the history of cinema. She then places this film in a real historical context. The opening titles (white letters moving across a black background in a vertical crawl) inscribe the film not only in the history of cinema but also in the political history of the Soviet Union. We are told that this is a lost work by the great Yiddish director Yevgeny Antinov, which was recently discovered in Soviet archives during perestroika. These opening titles become a fictional "factual" introduction to frame the fiction. As images, the titles also work to further blur genres. The self-conscious use of the convention of white letters moving across a black field at the beginning and end have all the qualities of the authoritative voice of scholarship. The titles "frame" the experience of the film not only as an entertainment but also as an educational documentary film that shows a historical document and artifact of a culture destroyed. This is consistent with popular Holocaust literature in which the fictional story is usually given a historical immediacy and validation through a historically based introduction. By inserting it into a political history, whether real or not, Antin makes us understand that in its time, the film we are about to see was simply an entertainment. But now, because of the forces of history, the film is more meaningful than that. It is now an artifact—a shard from a lost world. For Antin, this creates an even larger field on which to sideshadow. This simulated artifact not only interrogates the history of a people and the loss of their culture but also gives us a way into the history of the representation of that culture. As an artistic action, Antin's work raises many questions and issues having to do with the lines between the real and the image and how they become inseparable: an image at times can come to have more reality and presence than the object it is representing. This is particularly true of representations of a world—such as the *shtetlekh*—that has been eradicated.

How, then, does one represent a world that no longer exists, a world that cannot be returned to in order to find evidence, ruins, survivors, and the like? How do we know what that world was except through the representations that were made of it? Antin's knowledge of shtetl life does not come from real experience but rather comes from copies of copies. So to make a film of a film that came out of that world, which portrayed that world, is an act of disillusion in the sense that the artist is revealing the source of the representation as opposed to creating a seamless illusion of a "real" world. This places Antin right in the middle of contemporary postmodern art discourses about issues of appropriation and the originality of objects and images.

Rosalind Krauss, in her description of the artist Sherrie Levine's pirated photo print series of Edward Weston's photographs, in which she simply rephotographed his images in violation of Weston's copyright, points out:

Weston's "originals" are already taken from models provided by others; they are given in that long series of Greek kouroi by which the nude male torso has long ago been processed and multiplied within our culture. Levine's act of "theft," which takes place, so to speak, in front of the surface of Weston's print, opens the print from behind to the series of models from which it, in turn, has stolen, of which it is itself the reproduction. (27)

Krauss goes on to place Levine in the discourse of copy that has been developed by writers, among them Roland Barthes, who in *S/Z* characterizes the realist as not a copyist from nature but rather a "pasticher," or someone who makes copies of copies. Barthes explains:

> To depict is to . . . refer not from a language to a referent, but from one code to another. Thus realism . . . consists not in copying the real but in copying a (depicted) copy of the real. . . . (Through secondary mimesis [realism] copies what is already a copy.) (*S/Z*, 55)

Similarly, Antin approaches her subject through opening the back door of cinematic representation, more specifically through the appropriation of its own history. *The Man without a World* is a black-and-white "silent film" (with only a music sound track) from 1928 made in 1991. Antin has explained that at the time she began researching the film, many of the "lost" original Yiddish films were being rediscovered and restored.[3] As a result, she was able to study the mise-en-scène as well as the cinematic and dramatic styles of the original films in order to make her filmic simulation in the style of that period. Here Antin's copy of a copy raises interesting questions about what happens to the experience of the original work in the face of its more recent double. Like a clone, what is the difference between two different objects if they are made from the same material? This creates an interesting twist to Walter Benjamin's claims of "the withering of the aura" of the original work of art through the infinite reproducibility of the photographic. As Benjamin in his complex argument suggests, the auratic is a play between the experience of an object as authentic and "the unique phenomenon of a distance, however close it may be" (*Illuminations,* 222).[4] In his argument, the development of mechanically reproduced art (photography and film) fulfilled the desire to bring what was once experienced at a distance "'closer' spatially and humanly" (223). A medium like cinema, which could be reproduced and thus shown anywhere, anytime, fulfilled that possibility. The original films that *The Man without a World* is based on were made as infinitely reproducible vernacular entertainments and were rarely thought of as unique works of high art such as serious theater or painting. But despite their mechanical reproducibility, as they have moved through time and taken on the "shine" of the histories that surround them, they have also come to have an auratic sense of a "unique phenomenon of a distance" of an authentic and unique work of art.[5] Ironically, rather than destroying the auratic quality of

the original film, a remake or simulation such as Antin's confirms it. *The Man without a World* plays with the auratic quality of early silent film in the present: a unique document of a past moment experienced as something at a distance. To follow Benjamin's thinking, *The Man without a World,* which is a copy of a copy, now becomes the object that fulfills a desire to bring the past closer.

After a century of film culture, the aura that Benjamin saw in oil painting really was not obliterated by photographic reproducibility but rather shifted and broadened to include the new arts of cinema and photography. Rather than making a new print of a lost "real" Yiddish film, using the reproducibility inherent to the cinematographic medium, Antin uses the "aura" of the now lost or rarely seen early silent film as a mirror to her own film. In doing this, she engages the history and loss of the relatively unknown Yiddish cinema as a further reflection on lost Yiddish culture in general. The film becomes a series of doublings that frame the experience of those watching and thinking about the film. As in photorealist painting, part of the experience is the knowledge that the hand-painted work looks so much like a photograph. One marvels at the incredible technique of the painter, and at the same time one wonders why one would make a painting look like the photograph on which it was based. A critical distance to the representation of the scene in the painting is created around technique and the relation between photographic-chemical or (non-natural) impression and handmade (or natural) expression.

In *The Man without a World,* the filmmaker uses modern technology to re-create the look of the early silent cinema. The image is slightly sped up to give the feeling that the film was shot at silent speed (18 frames per second) and is now being projected at the modern speed for sound film (24 fps). Antin eschews contemporary continuity conventions of shot–reverse shot and long, medium, and close-up shot combinations. The acting is nonnaturalistic, invoking commonly held notions of silent film acting with its emphasis on gesture and tableau. In fact, the whole film is nonrealist. On the one hand, the mise-en-scène is theatrical rather than natural, with sets recalling the German expressionist cinema of the 1920s. On the other, there are scenes that portray the difficulties of shtetl life. We see the poverty, the authoritarian control by both Polish law—as in the scene where a policeman accepts graft money to allow Jewish businesses to run smoothly—and Jewish law, where the father decides for the daughter whom she will marry. But at the same time, Antin also freely moves the narrative between the verisimilitude of this story line and sequences that are clearly fantasy and even supernatural. For example, ghosts rise from the grave in the cemetery to mourn the newly dead, and most spectacularly, a rabbi exorcises a *dybbuk* from the body of Zevi's sister Soorelah (Figure 12). But what is consistent is the visual style of the film and its disciplined adherence to the look of the earlier cinema on which it is modeled.

Yet despite the faithfulness of this simulation, there is still some slight disparity that is hard to pinpoint. Perhaps it is the texture of the film: not as much silver in today's film stock as in that of the 1920s, which gave early black-and-white film its luminosity. Once or twice there is a modern camera technique or contemporary

element in the story or a modern gesture or expression in the actors' faces. But what is missing is precisely the aura of the original. *The Man without a World* is at once an original and its copy. Our awareness of the slippage between the two frames the film. This frame creates a crack in the seamlessness of the film's historicity and opens the possibility for other ways of thinking about the events surrounding the story of the film. This perhaps widens the scope of our own relation to this past, making us conscious of the plasticity of events and how we understand them.

As our European past recedes, and because European Jewish culture was so effectively destroyed, new generations of American Jews are losing much of the substantive knowledge of the vibrant and rich culture of their European Jewish ancestry—their language, literature, and other arts, and the way they lived their lives in the cities and villages. Because of its catastrophic qualities and potential for spectacular representation, the Shoah has become, almost by default, the central image of that European Jewish past, often at the expense of any knowledge of other events or elements of that Jewish culture. It has locked Jewish history into a contradictory rebus in which the Shoah is a culmination of European Jewish history, which, as Bernstein points out, is conceived of as being "simultaneously unimaginable *and* inevitable" (23). This has allowed the crime that is the Shoah to be appropriated by many for a myriad of

Figure 12. *The Man without a World.* The rebbe exorcises a *dybbuk* that possesses Sooreleh after she was raped in the pogrom. Photograph courtesy of Eleanor Antin.

politically and personally self-serving needs, particularly from the safety and affluence of postwar assimilation.

What places *The Man without a World* among the most engaging and thought-provoking instances of postmodern art making is that it is itself made up of a series of sideshadows. Here foreshadowing is just one of many sideshadows. By creating this film of a film, Antin has found a form to explore an amalgam of revisionist history, myth and archetype, self-reflexivity and the artist's own subjective desire. The value of sideshadowing can be seen in Antin's relationship to the European Jewish past, which through her own lively and imaginative engagement opens that lost world onto the present as a culture that continues to be generative of many of its values and ideas despite its actual nonexistence.

Urban Peasants

Central to Bernstein's conception of sideshadowing within historical narrative is its ability to take into consideration what did *not* happen as a result of the murderous destruction as well as what did happen.

> Rather than casting doubt on the event-ness of history, sideshadowing helps us reckon the human cost of an occurrence by reminding us of all that its coming-into-existence made impossible. The non-lives of the sideshadowed events that never happened are a part of the emotional/intellectual legacy and aura of each actually occurring event, inflecting it in distinct ways, as, for example, the extinction of the culture that sustained Yiddish as a spoken and literary language has profoundly changed the way in which Jewish life has been represented since 1945. (*Foregone Conclusions*, 14–15)

Not to take into account the *what-might-have-been* of what was lost or not to consider what was continuing in Jewish life despite the catastrophe of World War II condemns those lost to a narrative of inevitable doom and produces a limiting sense of nostalgia for what was by removing the necessity to imagine the what-could-be.

What about the Jews who "got away"? How are we to consider those Jews who during the darkest moments of the Shoah were living lives elsewhere? There actually was a Jewish quotidian during that period. To highlight this fact is to sideshadow the annihilation occurring at the same time in Europe. The integration of these lived lives and ongoing communities into the history of the Shoah is essential to producing a more complex and polysemous conception of Jewish history in the twentieth century. This sideshadowed history would be one that does not reinforce the backshadowed histories of inevitability and singularity that seem to so infect current understandings of the Jewish position in the world and continue to be appropriated for political and ideological ends.[6]

Ken Jacobs's *Urban Peasants* (1975) is a film and sound work that casts a sidelight

on those Jews who had left the ghettos and shtetls of Eastern Europe for the urban centers of the United States before the Nazi destruction of their European communities. In an ironic and affectionate way, *Urban Peasants* shows not only what was lost of the traditional Jewish life through assimilation but also the ways Jewish life continued elsewhere despite what was occurring in Europe. *Urban Peasants* is a sideshadow on the narrative of annihilation and its claims of inevitability by showing the prosaics of other Jewish lives through the use of home movies and other found objects. These artifacts of everyday Jewish life speak to the idea of a quotidian existence in the midst of catastrophe.

Ken Jacobs, a central figure of the American avant-garde cinema, demonstrates an extraordinary sensitivity to the importance of reviving lost or ignored histories in the bits and pieces of film, what Benjamin might call the debris of cinema. Very much in the manner of Benjamin's ragpicker, rummaging through the waste bins of New York City, the archives of early cinema, or the attics and basements of relatives, Jacobs finds lost and discarded images and sounds that have outlived their original use value or were never seen to have value when they were made in the first place. Rummaging through such material, Jacobs may try to see what the film strip "re-members," or he points to what is missed in the frame as the images move through the projector at normal speed. Reviving such material, bringing it to the light of the projector, Jacobs at times simply shows it exactly as he found it in the manner of the Duchampian readymade.[7] In other works in his vast oeuvre, Jacobs "broods" over such found cinematic detritus in a manner similar to Gehr's *Eureka,* rephotographing the material to render visible aspects of the cinematic image that are often obscured by their orginal contexts and forms.[8] In still other works, Jacobs has invented alternate projection methods to explore new ways of perceiving these found-film artifacts. These new methods include experimenting with 3-D viewing techniques and projection performances using multiple and, at times, custom-built projectors, adding additional shutters to create astounding new films from older ones.[9] Like Antin's, Jacobs's body of work is vast and varied, moving easily between different forms and media such as film, video, installation, and performance. Also like Antin, Jacobs was born and raised in the immigrant Jewish ghettos of Brooklyn and the fading influence of the decimated Eastern European Yiddish world, but also in the vitality of European modernist culture and the sensibilities of the hybrid cosmopolitanism of midcentury New York City. Steeped in this cultural in-between, the past and present can be seen to be deeply connected to these artists' aesthetic desire to bring them together as a central impulse and formal strategy in their art, linking them to an earlier era of prewar European modernist Jewish culture and to figures like Benjamin, Kafka, and others. Jacobs has made several works that document or attempt to bring into view the lost and dying worlds of Eastern Europe and the New York City of his childhood including *Urban Peasants,* which I will discuss in detail, *New York Ghetto Fishmarket, 1903* (1992), *Orchard Street* (1956), and *The Sky Socialist* (1964–65/1988), among others. His vast knowledge

of early Yiddish cinema has also made him an important resource in the study and restoration of that once-lost body of work.[10]

In the manner of the readymade, *Urban Peasants* is a fifty-minute image triptych in which Jacobs brings together disparate found sound and image elements. It begins in the dark of the movie theater with a seven-minute selection from an old language instruction record called "Instant Yiddish." In typical fashion for such language instruction tapes, a woman with a distinctly American accent says a phrase in English, and then the phrase is repeated in Yiddish by a man, with all the cadences and inflections of a "native" speaker, after which the woman's voice repeats it again in Yiddish. There then follows a space of silence for the listener to repeat the phrase in Yiddish. The lesson begins with the male voice intoning, "Situation Three: When you go to a hotel." The woman says, "Where is a good hotel?" "Wo ist a gutte hotel?" the man repeats. The lesson continues in this manner:

> I want a room;
> For one person;
> For two persons;
> For a week;
> I don't like it;
> Show me another room;
> Hot water;
> A towel;
> Soap;
> Send breakfast to room 702 please;
> I want five airmail stamps for the United States.[11]

It is not clear from the tape when this language lesson was made. From the perspective of the post-Shoah era of Jewish history, as one listens, multiple possibilities for how to think about this recording as a historical document begin to emerge, and each possibility inflects an implicit and explicit meaning of these words.

Based on the questions asked, one can imagine a Yiddish-speaking tourist from the United States visiting a Yiddish-speaking city or town in which there are hotels with Yiddish-speaking proprietors. Perhaps before World War II there were such places to visit. Indeed, there were such hotels in Poland and in cities in other Eastern European countries with large Jewish populations. Could such a language recording have been made after the war? Doubtful. The language lesson becomes a macabre foreshadowing of the destruction of the thriving Yiddish culture of Eastern Europe. At the same time, from our position in the postwar present, such questions produce an ironic backshadowing of the idea that there could be a Yiddish-speaking hotel to check into. As the critic J. Hoberman observes of the film, "The assumption is mind-blowing: Where in the world, with the possible exception of Birobidzhan, would one ever need

to call room service in Yiddish?" (*Vulgar Modernism,* 189). Here this irony produces a dramatic sense of the stakes of the destruction that took place: a culture so destroyed that there is no longer a place or context to use a language to ask the most basic questions or to care for the most basic needs of daily life.

Urban Peasants sets into play complex temporalities as well as geographic relationships in the history of prewar, wartime, and postwar Jewish life between Europe and the United States. Each possibility for how the phrases in the language lesson are understood is structured by our backshadowed, foreshadowed, and sideshadowed knowledge of events. As a result, language itself becomes allegorical and doubled in its meanings; words and phrases such as "soap," "Help," "I don't understand," "I have lost my passport," "What is going on?" and "dead-end" take on a grisly double meaning because the listener cannot help but allegorize the meaning of such words as a code for the fate met by the people who used this language. These kinds of backshadowed meanings are obvious enough, calling forth images of Gestapo roundups, mass deportations, and gas chambers more easily than the image of an elegant hotel in the tourist section of Jewish Warsaw. The irony is that in our historical imagination, we have endless images of death camps and mass deportations, but the mundane image of a Yiddish-speaking hotel is barely imaginable. As we have seen in earlier discussions, the meanings of found material can easily become allegorical for present knowledge. Jacobs, however, creates an even more complex set of relations in *Urban Peasants*. Foregrounding the mundane quality of the words in the lessons produces the deepest sense of what is lost: the days of the week, questions about a room with a bath. Such prosaic words and phrases emphasize the disruption of the everyday for the Jews of Europe. They bring home the realization that the Yiddish language itself no longer signifies the expression of quotidian needs but rather its impossibility for those who happened to speak the language.

The language lesson temporarily ends, and the film images begin. As we sit in silence, we see black-and-white home movies of what appears to be a petit bourgeois immigrant family mugging for the camera on the streets of Brooklyn, New York. Much of the filming is taking place in front of a butcher shop with both English and Yiddish writing on the windows (Figure 13). One distinguishes a family structure comprising several generations of people; from their dress, they are in various states of assimilation. Life is on the street: they meet and socialize in front of the shop as the kids run around on the sidewalks and play on the stoops. Elderly men and women are still wearing clothes from the "old country," the middle-aged men are wearing conservative suits and ties, and young adult women are wearing quite fashionable urban garb, all of which set the film in the late 1930s or early 1940s, in the midst of the Nazi extermination in Europe. Finally there are children and infants in play clothes and dress clothes and infants in strollers. The camera work is the stuff of the amateur home movie: shaky, awkward pans, often out of focus and overexposed, making the images highly poetic and movingly nostalgic. The people being filmed gesticulate awkwardly

for the camera, smiling, posing, walking directly toward the camera until they nearly bump into it. These are motion pictures, after all, and one must move rather than simply stand still in front of the camera! The images of the family were recorded by Jacobs's wife's aunt Stella Weiss. Jacobs states in the film's description: "The title [*Urban Peasants*] is no put-down. Brooklyn was a place made up of many little villages; an East European shtetl is pictured here, all in the space of a storefront. Aunt Stella's camera rolls are joined intact (not in chronological order)" (New York Filmmakers Cooperative, Catalog 7). As Jacobs's title and the images show, these are people caught in a transitional moment between the traditional life of the Eastern European shtetl and the modern urban "new world." The multiple generations of this family are, for the moment, still intact, but the growing cultural gap between generations is painfully clear. The older ones look uneasy and exposed on the concrete sidewalks, and we see them doing their best to conduct a Passover seder in the cramped kitchen of a tenement apartment. The variation of the exposure often gives the images a washed-out, ethereal quality. At times it is hard to tell if we are seeing these people in the past or

Figure 13. *Urban Peasants* (Ken Jacobs, 1975). Members of Stella Weiss's family, Brooklyn, New York.

the present. These are images of the elderly who are at once ghosts and survivors, remnants of a destroyed world. But their strength is implicit in the herculean act of having moved their families out of Europe.

For the younger ones, being on the American city street is more natural. Their sense of safety is palpable as they joke around with each other and tease their children. At the seder, the youngsters are barely paying attention. Jacobs seems to heighten the sense of distance in their rural-to-urban transition in one sequence where the family is picnicking in the country. The image becomes sepia-toned, lending the quasi-pastoral image of the urban park a greater sense of nostalgia. There are images of weddings, of polished silverware laid out on a table, a shot of an airplane flying by, a father teaching his son to box. The images of this family are suffused with an innocence and hopefulness. The children look healthy and energetic; the young men and women are good looking and well dressed. Despite the ugliness of the neighborhood there is a sense that these people are safe and able to pursue their dreams. There is even a movie camera to document the family's upwardly mobile rise as Americans. After about forty-five minutes of these random images from unedited camera rolls, the film ends, and the audience is back in the dark.

The language lesson with the English-speaking woman and Yiddish-speaking man resumes: "Situation 8: When you are in trouble." Here the words seem more threatening, their allegorical qualities even harder to miss. Among the words recited are the following:

"Help."
"Police."
"Look out."
"Wait a minute."
"Stop."
"Don't bother me."
"What is going on."
"I don't understand."
"Danger."
"Please call a doctor."
"Take me to the hospital."
"Dead end."
"My passport."
"I am disappointed."
"I am an American."
"Everything is all right."

Beyond the irony that there is no longer a place to travel to speak Yiddish as a tourist, the question of safety and danger, the historical palpability of this for all Jewish communities, is central to *Urban Peasants*. Jacobs counters the happy images in Brooklyn

with this dark list of Yiddish words, which as allegory speak to the concurrent experience of the European Jews at the time the footage was shot and also to what kinds of troubles even American Jews might have when traveling abroad. The experience of sitting in the dark, listening to these words in English and Yiddish, evokes narratives that express the deep anxiety of assimilationist transformation and its limits. "Wait a minute, stop. What is going on? I don't understand. Danger. Dead end. I am disappointed. My passport. I am an American. Everything is all right." Hearing both voices, one speaking in English and the other in Yiddish, breaks open the progressive narratives of assimilation, revealing ghosts of the past speaking from a lost world and the repressed sense of never being safe as a Jew, even given the confidence in America as a place where Jews can be safely hyphenated. Or can they? The three sentences, heard as the piece ends, "I am disappointed. I am an American. Everything is all right," express not just an anxiety but also a wariness about the American dream of melting pot assimilation.

As we watch these seemingly carefree images of the family clowning around with each other, showing off their new clothes and car, it is clear that the lives of these New Yorkers and their Eastern European counterparts were nearly incommensurable and cannot easily be compared. The viewer's backshadowed awareness of the fate of the counterparts of this now American Jewish family creates a sense of unease and outrage that somehow even implicates these people in the fate of European Jews. These images as contextualized by the language lesson can raise moral questions about what Jews in the United States knew about what was going on in Europe and what was or was not done to save them. At the same time, to burden them with such questions simply because they are Jewish is employing the same historical logic used in Europe to expel, deport, and exterminate them simply for being Jewish.

Urban Peasants raises an extraordinarily complex series of issues about Jewish history that continue into the present. These counterimages show that history did not stop, nor did the variegated quality of Jewish life end in the midst of the Nazi effort to obliterate it. Stella Weiss's images of Brooklyn's "urban shtetl" show a world that seems rather colorless, and its people unexceptional, doing little of significance or interest (Figure 14). But it is precisely the prosaic quality of the images that creates the sense of historical contingency within Jewish life at that time. A "prosaics of the quotidian" is what makes *Urban Peasants* so powerful as a work of history. Of such a prosaics, Bernstein writes:

> It means learning to value the contingencies and multiple paths leading from each concrete moment of lived experience, and recognizing the importance of those moments not for their place in an already determined larger pattern but as significant in their own right. (70–71)

The sense of dailiness is what is usually ignored in the intensity of the Jewish catastrophe, and Jacobs's foregrounding of the prosaic quality of the imagery in *Urban*

Peasants casts a sideshadow on that history. The illumination of such countermoments—especially the most mundane—can suggest the possibility for a future within a history that indicates few such possibilities.

In *Urban Peasants,* Jacobs doesn't ignore the catastrophe. It is, of course, contained in the film's sound track as the backshadowed knowledge of what happened to the Yiddish speakers of Europe. But he sideshadows it with the everyday life of Jewish émigrés who were lucky enough to get out of Europe and whose lives continue. With this seemingly simple gesture of placing the found sound track and images next to each other, Jacobs indicates the enormity of genocide: the loss of the general usefulness of a language on the one hand, and an image of lives continuing on the other. The film is not only a work of mourning; because we are also shown Jewish lives continuing despite the catastrophe, it can also be seen as an act of defiance. In 1977, Jacobs insisted on showing the film every day in West Germany as part of the Documenta 6 art exhibit in Kassel. As Hoberman suggests, the film becomes "a profoundly moving—and enraged—gesture" (*Bridge of Light,* 347). The gesture of placing these found sound and image artifacts next to each other creates a topos of geographies and temporalities that puts into play a wide range of conflicting and conflicted emotions for American Jews and others about the relationship between their prosperous and

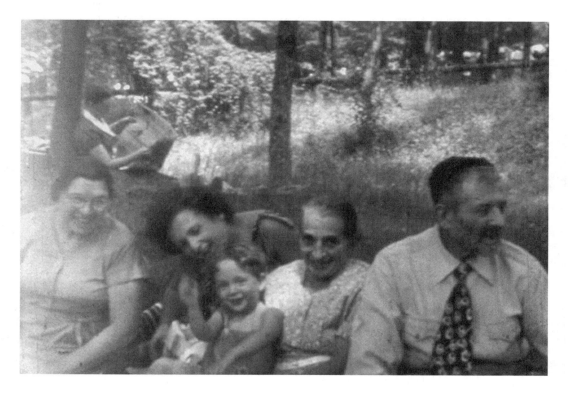

Figure 14. *Urban Peasants.* Photograph courtesy of Ken Jacobs.

relatively safe existence in America and the fate of their European counterparts. *Urban Peasants* creates a history of a situation in the Jewish Diaspora at mid-twentieth century that is based neither on causal rationale nor on inevitable occurrences. From nostalgia for a lost world to anger about its decimation, from the guilt of surviving to hopes that America will be embracing, such ambivalence about how to think about the history of European Jewish destruction continues to inhere in Jewish American relationships to the Jewish Diaspora today.[12]

Cooperation of Parts

Films end, but wars don't. Daniel Eisenberg, the son of Holocaust survivors, returns, in his film *Cooperation of Parts* (16 mm, 40 minutes, 1987), to the scene of present-day Europe to explore relationships between his present and his parents' past. While *The Man without a World* self-consciously appropriates an early film genre, and *Urban Peasants* uses artifacts from the past as readymades to produce sideshadows that interrupt the narratives of inexorability that surround the Shoah, Eisenberg's film engages traditions of the autobiographical and diary film to explore relationships between personal identity and history. In the period after 1980, these sub-genres have become central strategies to the postmodern avant-garde film as a way to engage the complex relationships between social history and personal experience. Uses of postmodern forms such as pastiche and parody, the appropriation of found materials, and explorations of identity construction have enabled filmmakers to move beyond the hermeticism of earlier forms such as the lyrical film poem and purely formalist practices of the structural film. This has helped filmmakers link personal and subjective vision more directly to larger cultural formations and discourses.[13]

Eisenberg's film uses his own experience of coming to know his family's history as another sideshadow of the Shoah to show how the force of a catastrophic history continues into the present although the event itself ended long ago. *Cooperation of Parts* shows how historical events can never be contained by the singularity of inevitability but rather are inflected by chance and the personal and political choices that are constantly being made. The importance that Eisenberg places on this notion of contingency in history is exemplifed in the film's fragmented and open form.

In *Cooperation of Parts* there are no endings or beginnings; there are only fragments of images and sound. These are bits and pieces of a trip, of events, moments, architecture, proverbs, thoughts. Eisenberg, born in Israel in the early 1950s and raised in the United States, visits northern Europe. Starting in France, he travels to Berlin, then to Warsaw and Radom, Poland, the birthplaces of his mother and father, and to Auschwitz and Dachau, where they were interned during the war.

In *The Arrival of a Train at La Ciotat Station* (Lumière brothers, 1895), a film that marks the beginning of cinema and imminently of the twentieth century, we see a train pulling into the station and coming to a stop. Utopian in its vision, like all arrivals it is a hopeful moment: people disembark from the train, greet one another. There is a

sense of possibility. Newness seems to abound in this short strip of film as one experiences the excitement of the new technologies of transportation and the new imaging device that creates this moment. The motion picture camera and motorized transportation are both central to the development of the twentieth century. Now, nearly a century later, the film *Cooperation of Parts,* made in 1987, starts with the train *leaving* the station and begins what is at once a personal pilgrimage and a homecoming. The camera is now on board the train—camera and train have become one, gliding over the well-used rails of twentieth-century Europe. This time the view is decidedly dystopian; the close-ups of the rails and blurred trees, photographed from inside the car, backshadow a century of deportations, emigrations, and dislocations. The image of the railroad no longer signifies the possibility of beginnings, the opening up of new sights and ways of living, as it did at the turn of the century; it now contains the ominous quality of endings and severings. On board and returning to the site of his parents' early life, Eisenberg questions his own identity in relation to this place, which might have been his own world. His return to Europe is a sideshadow on the Shoah. His parents' miraculous survival of the extermination camps, their postwar meeting, marriage, and the creation of a family—Eisenberg's very existence—all are contingent to the Nazi narrative of Jewish genocide. This child was never supposed to be born, and this film never made. As Mark McElhatten writes: "Eisenberg marvels at the very fact that he exists at all. Seeing himself as a statistical oddity in light of the numbers exterminated and the numbers that survived, 'by all rights or reason I should not exist'" (31).

The problem of how to construct an identity in the context of a European culture that Eisenberg is inextricably a part of, but which also tried to annihilate his family and people, permeates his experience. It is central to the film. It is the sense of being in between, at once inside and outside.

So I wind up asking the same question my mother asks, "Why me?"

Like a shock wave felt through several generations, It's a typology, a magnetized personality.

A personality characterized mainly by suspicion, mistrust, an uncanny ability to read the subtext.

This personality is the one that draws negativity to its self; never a nation, never an idea.

What happens if I discover who I am, what then? (Eisenberg, filmscript, 49)

This is Eisenberg's burden. Having been born into a catastrophe that was not his own, as if he were exposed to radioactive material, his parents' catastrophe becomes his, and he has little choice in the matter and even less context. He is forced to live in the shadow of events and experiences that not only were never his but are never rendered clearly for him, spoken of only in hushed tones and disconnected stories. Alone, he is left to sift through the fragments of past events that are never fully explained or

articulated. It is in this uneasiness that the war nevertheless continues beyond its end, which Eisenberg explores through image and sound fragments. As he states:

> The fragment contains within it an implied reference to something that was once whole. It suggests damage and violence, time and distance. These qualities I found were integral to my *own* constitution and it was with the making of *Cooperation of Parts* that this became clear. (61)

The filmmaker returns to the scene as both a ghost and a living embodiment of history, using the motion picture camera as a kind of conjuring tool to evoke that history, as if it lay dormant in the ground, in the architecture, the fence posts of the death camps, and the railroad tracks (Figure 15). We see ephemeral reflections of people in windows looking out—-but at what? We see the edge of the mass graves at Dachau, statues and frescoes in buildings pockmarked by bullets. The camera is never able to fix on a single image, as if the ground is solid one moment and then liquefied the next. What we see are image shards, off-kilter compositions, wisps of light. Is the filmmaker's eye searching for evidence, for meaning? But of what? At Auschwitz the camera pans over

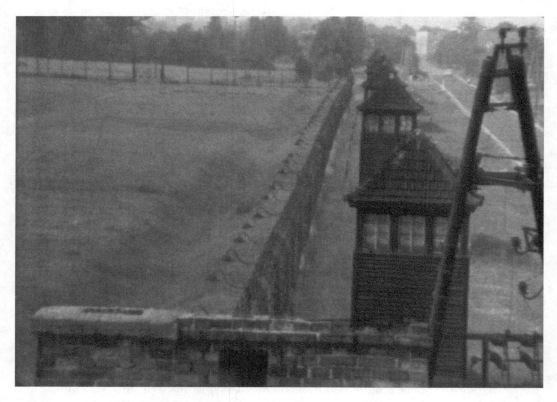

Figure 15. *Cooperation of Parts* (Daniel Eisenberg, 1987). Auschwitz: the filmmaker returns to the scene as both a ghost and a living embodiment of history. Photograph courtesy of Daniel Eisenberg.

the camp's grounds, moves obsessively through the empty bunkhouses. It peers into the now-clean crematorium ovens, examines artifacts left by the prisoners; it inspects in close-up the dirt roads and pathways of the camp. Is he looking for some proof of, or key to, their meaning, or perhaps some kind of elision between past and present? But the images are dumb; they reveal little except for the limits of what can be known through vision. The promise of the motion picture camera as a tool that could reveal the world beyond the limitations of the acculturated human eye has been a central trope of the modernist avant-garde from Vertov in the 1920s to Stan Brakhage in the 1960s.[14] As embodied by Brakhage and Bruce Baillie, first-person camera work in the American avant-garde was understood to be revelatory, making visible the most subjective impulses of the filmmaker.[15] But for a postmodern filmmaker like Eisenberg, the camera is used to reveal the limits of what can be seen and known. His use of the handheld camera seems to have an affinity with the first-person camera work of the lyrical cinema. But Eisenberg's use of the handheld camera has a different agenda. He is interested not so much in visionary revelation as in revealing the limits of the specular and the empirical. For Eisenberg, the idea that an image of a place could reveal the secrets of an event or that his subjectivity could clarify the silent history of a landscape is an impossibility. In *Cooperation of Parts,* Eisenberg and his camera bear witness to what can never be completely known or understood. At Auschwitz what he finds are questions and more questions. At times Eisenberg tries to give the image primacy over language, but it is never enough. The inadequacy of the image and the specular leads Eisenberg to language, and this turn to language is what ultimately separates this work from the modernist tradition of the lyrical personal film.[16]

The voice-over returns, constantly probing, by turns confused, speculative, judgmental, philosophically self-aware, and even childlike:

> Momentary flashes of awareness, gradually replaced by a continuum of . . . the mines, the forests, the factories. . . . Which were your accomplices? Sometimes you tire of explaining so you find yourself saying, "Examples are everywhere . . .
>
> Everything reminds me of you . . ."
>
> I asked simple questions, responses were measured.
> *What were they looking at?*
> *Why couldn't they go?*
> *How was it that you were there?* (Eisenberg, 45)

At these moments of incommensurability between the images and his questions, the filmmaker always returns to language for grounding, through his use of short proverbs taken from Yiddish lore and the words of some contemporary thinkers and writers, some remembered from childhood. They too are fragmented, at times synecdochical, and appear throughout the film both as spoken text and as written text to be seen and read. These proverbs can be analytical tools but more often than not are of little help. Here are several examples:

Words have no boundaries.

Hunger teaches a man many things.

As long as language lives, the nation is not dead.

Forgive others easily, but never yourself.

Pray that you may never have to endure all that you can learn to bear.

A charred place smells a long time.

If you wish to know a man, give him authority. (47)

Cooperation of Parts is a son's journey to war, a war into which he was born. He is part of a series of events that were as random and unpredictable as who survived the war and who did not. In the film's final scenes, we are in the courtyard of the apartment where Eisenberg's mother once lived in Radom, Poland. The courtyard is filled with children playing, skipping rope, running around. Clothes hang on the line; the mortar is crumbling from the building's walls. The camera watches the children closely: their feet, elbows, how they touch each other. Again only fragments—the camera moves on ground that is not solid (Figure 16). Where are we located in time? Is this moment the past? The present? A memory? A dream? A wish? And whose moment is it? The final shot is a subjective camera moving down a Radom street; the compositions are

It was through her, not through her conscious intention that these things passed.

Figure 16. *Cooperation of Parts*. Photograph courtesy of Daniel Eisenberg.

again fragmented, off center. The final title appears: "Going down that street ten thousand times in a lifetime . . . or perhaps never at all."

Eisenberg sideshadows his own life, imagining this courtyard as his own. Here he experiences the contingency of his own history. Could he have just as easily been brought up in this courtyard as in the United States, or could he have never lived at all? The film continues to liberate the history of the Shoah from the dehumanizing effects of singular and inexorable history. Placing the imaginings of what might have or what could have happened alongside the reality of what did doesn't lessen the horror of what happened to the people who lived in this apartment building forty years earlier. But having the what-might-have-been coexist with the what-did-happen releases the victims from a helpless sense of their history as destiny to be passively lived with and begins to untangle the idea of fate from history. It asserts the sense that history is actively worked on and worked through and not simply given. What makes a work like *Cooperation of Parts* so valuable is the way it unbinds the events referenced throughout the film from any kind of backshadowed narration in which the filmmaker's existence, as the child of Holocaust survivors, can be understood as the closure to, or redemption of, the horror of that event. In this film there is no linear trajectory that moves to a simplistic impression of closure to events as do more conventional cinematic "Holocaust histories" such as *Schindler's List*. In that paradigmatic film, like *The Wizard of Oz* in negative, we are brought from the black-and-white "film-stocked" nightmare of the carnage of northern Europe into bright daylight, now in full color, to the final redemption of Eretz Israel, where we find the remnants of the real "Schindler Jews" being led to a grave by the actors who played them in the drama. Together they are placing stones on the real Schindler's grave. Schindler has died, his Jews survived, we have survived, the film ends. The Holocaust ends. They have become one and the same. By contrast, in *Cooperation of Parts,* there are no cathartic moments of revelation or transformation to give closure to the narrative. Though the film recounts personal experience and at times is even autobiographical, Eisenberg is never content simply to become the traumatized subject at the center of a drama of victimhood. He never uses the work as a confessional to give authority to his experience—as if the testimony of personal experience was somehow more authentic and less mediated or stylized than any other narrative form. Nor does this film function as a kind of therapeutic device for the self-healing of the artist's personal wounds. Here we have a functional creative artist who is exploring and thinking through multiple positions in the world he was born into.[17]

But this is not life we are experiencing. This film is a creative act that makes an opening to challenge our notion of what the result of the Shoah has been. In this sense, *Cooperation of Parts* is all sideshadow. What we can experience is the process of exploration, expedition, and struggle to construct an identity, replete with all the gaps of knowledge and comprehension, with all the unknowables and the breakdown of meaning. At the same time, we experience the process and problems of representing such a thing. Throughout the film, one can see the process of the filmmaker trying to

construct workable narratives for representing his experience, his parents' experience, a European Jewish experience. But he doesn't stop there. This is too simple; it leaves out too many complexities and contradictions. Rather than creating the illusion of coherence by employing narrative devices that produce an ordered and rational comprehensibility of information and events leading to specific conclusions, Eisenberg creates multiple pasts and presents, through layers of fragmented images, sounds, voices, and scenarios. The relationship between meanings generated and the truth of those meanings is constantly being placed in question. The filmmaker Trinh T. Minh-ha has referred to the space between truth and meaning as the "interval":

> Truth and meaning: the two are likely to be equated with one another. Yet what is put forth as truth is often nothing more than *a* meaning. And what persists between the meaning of something and its truth is the interval, a break without which meaning would be fixed and truth congealed. ("Documentary," 77)

Finally, although *Cooperation of Parts* has elements of the historical documentary and the lyrical autobiographical film, it is first and foremost an aesthetic work. It is an experience that sensitizes the viewer to the possibilities of the past by producing a history that insists on an engagement with the complexities of randomness, contradiction, and contingency. This work is permeable; there are spaces for multiple readings, interpretations, and even incomprehensibility. The viewer is able to think through what is seen and heard in the text and relate that to what he or she knows or has experienced. Perhaps most importantly, time is not simply a representational element, pretending to move into the past through theatrical means, for example, with the use of periodizing mise-en-scène or black-and-white film stocks. Here time is a material element, the duration spent with an image, time spent thinking and listening. These are actually physical processes. The film uses its duration to generate its own present/its presence. And ours. The film becomes a space for contemplation. The viewer is not hauled into the screen as if it were a time capsule and taken into a new time zone. Rather, there is the screen/film, and there is the viewer. It is this space between—also an interval—that allows the viewer to experience himself or herself in relation to the images and words, and even (or especially) to experience the silences and ruptures of meaning, where one is able to contemplate the sense of loss and the implications of what a Holocaust might mean, and the limits of what can be understood. Unlike *Schindler's List,* which is structured around themes of transformation and redemption (by the end of the film, Schindler is transformed, "his Jews" are redeemed through their survival, the audience is redeemed by watching the film, and Spielberg is both redeemed and transformed by rediscovering himself as a serious artist and a Jew), no transformation occurs at the end of *Cooperation of Parts.* Eisenberg doesn't find his true identity, nor does he come to understand his parents' experience better, nor does he put it all behind him. What one is left with is the process of an attempt. Eisenberg *attempts* to engage with past events, with the possibility of constructing an identity in

relation to what remains unknowable. Throughout the film, he is at once representing this process and resisting its representation. In the fragmentation that occurs through this contradiction, one begins to understand the complexity of his position and, like Eisenberg himself, begins to ask questions (Figure 17).

Like *The Man without a World* and *Urban Peasants, Cooperation of Parts* suggests a different kind of formal and conceptual possibility for using cinema to interrogate such a complex, multidimensional event as the catastrophe of the Shoah. I have used the notion of the sideshadow to explore these films because it is a narrative technique and because it illuminates the complex and layered images of the past these filmmakers have created. But even more importantly, it suggests an ethics for representing the past that breaks with conventional linear, causal narrative forms. Sideshowing is a means to create a space in which people, cultures, and events can be contemplated in all their humanity by opening up possibilities for seeing complexities.

Sixty years after World War II, if learning about the Shoah is to become an integral part of the socialization process in our society, then there also needs to be an ethics of representation for that event. Such an ethics would include a way of producing art from catastrophe that does not dehumanize the living victims, the memory of the dead,

Figure 17. *Cooperation of Parts.* "A charred place smells a long time." Photograph courtesy of Daniel Eisenberg.

and the people who are experiencing the work of art. To do this, then, that work will necessarily be an experience that *is* difficult, challenging, and contains the complexity of catastrophe. Like the most radical of postmodern art, these films challenge the modernist aura of authenticity, originality, and essential meanings, calling into question narratives that are linear, universalized, or triumphalist versions of history. These films are interventions into the "voice-over" of "official" history and culture, which speaks *at* us, representing power and authority. The sideshadows of *The Man without a World, Urban Peasants,* and *Cooperation of Parts* illuminate more-contemporary notions of historical multiplicity that ask us to consider that the past is filled with contingencies, marginalia, and imaginings, and that these are integral to any image of an event like the Shoah. These are historical films that, while honoring the specificity of the Shoah's occurrence, point beyond its singularity by making us think beyond hierarchies of horror and suffering to consider a more nuanced notion of lives lived as part of those histories.

3. Virtualities: Historical Temporalities 2

Each Epoch not only dreams the next, but also, in dreaming strives toward the moment of waking.

— WALTER BENJAMIN, "Paris, Capital of the Nineteenth Century"

The only danger in all of this is that the virtual could be confused with the possible. The possible is opposed to the real; the process undergone by the possible is therefore a "realization." By contrast, the virtual is not opposed to the real; it possesses a full reality by itself.

— GILLES DELEUZE, *Difference and Repetition*

Allemagne année 90 neuf zéro

If the rubble-strewn cities of Europe were the mise-en-scène for the postwar cinema of neorealism, with its melodramatic examinations of the brutality of fascism, then the empty space left by the removal of the Berlin Wall in 1989 is the image of an emerging post–Cold War cinema. Through the use of the same modern technology with which Europe destroyed itself, the Germans (and their country's occupiers) rebuilt West Germany after World War II, thus rendering virtually invisible the convulsive destruction that the war had brought on. Not only had the geography of Europe changed, but many of the cities themselves—monuments to two thousand years of Western culture—had been destroyed, only to be rebuilt as modern urban centers. The Berlin Wall, that one-hundred-plus-mile seam that stretched across Germany, stood as a constant reminder that the war had occurred and still continued now as the geopolitical politics of occupation and domination. The Berlin Wall defined a *west* in

opposition to an *east* necessary for the logic of Cold War domination of Europe by the superpowers.

The removal of the Wall, ushering in a new stage in the globalization of capitalism, presents a new set of questions for historicizing the entire postwar period.[1] Of all the different kinds of films made after the fall of the Berlin Wall (documents, dramas, histories, and commentaries), few attempt to take up the complexity of the meaning of the rise and fall of the Wall in its broader temporal, cultural, and philosophical implications for the representation of European history. Jean-Luc Godard, in *Allemagne année 90 neuf zéro* (*Germany Year 90 Nine Zero*) (France, 1991), uses the fall of the Berlin Wall to question the very possibility of history as a useful discourse to understand what happened and what is continuing to happen. Godard frames the fall of the Wall through the specificity of the medium of cinema to evoke a sense of the passing of a period in European history that at once contains the specific events that occurred and the equally important ephemeralities, multiplicities, and lapses of meaning that can emerge from an event of such magnitude. In this sense *Allemagne année 90 neuf zéro* is a twentieth-century fin de siècle work of art that speaks to something having just passed. For an artist with the imagination of Godard, what has passed is nothing less than the possibilities of the twentieth century, with all its ideals and atrocities. This film is not about creating the sense of the loss of a German identity resulting from the division and reunification of the country. Instead it shows the shards of a European culture that self-destructed. Rather than present narratives that explain the events that led up to the building and dismantling of the Wall, and explications or summaries of what happened in sociological or political terms, as do the dramatic and documentary films that have been made on the subject since 1989,[2] this film chooses a poetic form to create an elegy that expresses the sense of an unrecoverable past. For Godard to speak of the twentieth century is to speak of cinema, and cinema is the central medium for thinking (of) the twentieth century. Throughout his career, one of his major themes has been to find a cinematic form with which to think through the complexity of large historical events as they manifest themselves in the consciousness of postwar, late capitalist European society.

From his first feature film in 1959, the history of cinema has been the surface on which all of Godard's discourses have taken place. The reflexive gesture of a metadiscourse on the medium being used and woven into the body of the work is essential to the critique of contemporary European life that runs through his oeuvre: "From the beginning, Godard has worked within cinema's very flesh, incorporating the images of others with his own; today he incorporates his own with those of others. The result is this art of superimposing two and three images on top of each other so as to make just one" (Leutrat, "The Declension," 30). In doing this, Godard used pop art strategies that created a style by working with specific genres, from the pulp crime thriller to the Hollywood musical, with such a level of self-consciousness that this kind of celebration and critique became "Godardian" and made him one of the most famous figures of the sixties' cultural revolution.

In *Alphaville* (France, 1965), Godard appropriates elements from both the Hollywood detective and sci-fi genres as translated through 1950s French pulp thrillers. Here, Lemmy Caution, played by the American Eddie Constantine, the leftover private eye from films such as *La môme vert-de-gris* (*Poison Ivy*) by Bernard Borderie (France, 1953) and *Vous pigez* by Pierre Chevalier (France, 1955), poses as a reporter to investigate the city of Alphaville, an Orwellian city run by a computer and mad scientists. Alphaville is populated by tranquilized automatons who quietly follow orders from the computer and have no emotional life. Any expression of human tendencies such as rebellion, emotion, or questioning is met with death. Through the use of a high-contrast black-and-white "noir" style, Godard transforms modern Paris into an anonymous postwar "any-city-what-ever,"[3] of neon signs and high-rise buildings and endless highways. Granite-faced Lemmy Caution endlessly wanders the nighttime streets of Alphaville, exploring with us the image of the totalitarian, high-tech Europe, which is a blend of depersonalized late capitalist urban signifiers and post-1956 Soviet-socialist control. He takes photographs of everything, interviews glazed-over Alphavillians, and looks for Alphaville's leader, who is a computer.

By 1991, when Godard once again resurrects Lemmy Caution, the "Godardian" style of the essay of pastiche has entered the language of cinema to the extent that Godard begins to use his own work and the cult of personality around his name and style as a metadiscourse in a similar way that he once used classical Hollywood cinema. Hence he is able to resurrect Lemmy Caution, using Constantine in one of his last performances, for *Allemagne année 90 neuf zéro*. The film becomes at once a meditation on the history of Europe and a home movie in which Godard writes himself into the history of postwar Europe.

In *Allemagne année 90 neuf zéro,* it turns out that Lemmy Caution has quietly been living undercover behind a hair salon in East Berlin. He is discovered by German film historians who have just gained access to the East German archives with the fall of the Wall and the German Democratic Republic's government, which has rendered useless Caution's raison d'être as a spy. Like Wagner's Flying Dutchman, Caution is cast into the ocean of a now-deterritorialized German landscape to wander endlessly without any coherent history or borders to legitimate his occupation as a counterinsurgency spy. He spends the rest of the film wandering through East Berlin and its environs, making his way to the West. This loose narrative of wandering creates a portrait of contemporary Berlin, as his wandering in *Alphaville* did the same in Paris. This wandering character is a means of exploring a physical place that is actually the filmmaker's central concern. To do this, a coherent story line is displaced to the margins of the film. This strategy can be traced to the early neorealist cinema of Roberto Rossellini, namely, his 1946 film *Germany Year Zero,* to which Godard's film is at once an homage and a continuation. Like Rossellini, who went to Berlin to see what was left after World War II, Godard comes to Berlin forty-six years later to see its condition after the Cold War. He resurrects Lemmy Caution as a vehicle for exploration just as Rossellini created Edmund, a German youth who wanders through the bombed-out rubble of a

defeated Berlin. In both films, the narratives are simple, schematic, and at times non-existent, because the ruins of the once-great city are the object of both filmmakers' interests. Both *Germany Year Zero* and *Germany Year 90 Nine Zero* use this wandering character as a way to show Berlin as a deterritorialized world of signifiers of events that have happened in the place through which the wanderer has just passed (Figure 18).

Remarking on the emergence of neorealism in film, Gilles Deleuze points out one of its pivotal aspects:

> The characters were found less and less in sensory-motor "motivating" situations, but rather in a state of strolling, of sauntering or of rambling which defined pure *optical and sound situations.* The action-image tended to shatter, whilst the determinate locations were blurred, letting any-spaces-what-ever rise up where the modern affects of fear, detachment, but also freshness, extreme speed and interminable waiting were developing. (*Cinema 1*, 120–21)

This explains a shift in emphasis from "sensory-motor motivating situations" (in which the physical actions of characters define and are specific to the spaces they are in) to "pure optical and sound situations." (Specific spaces are no longer inherently linked to the actions of characters and plot development. This often blurs lines between the image as a diegetic element and as a document of the place and moment in time where

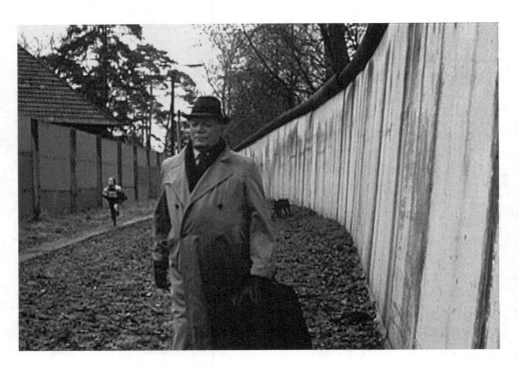

Figure 18. *Allemagne année 90 neuf zéro* (Jean-Luc Godard, 1991).

the camera was filming.) It is on these "any-space-what-evers" that Godard is able to hang a wide range of possibilities for talking about the meaning of the Berlin Wall. Once set up, the narrative detaches from the film like a booster rocket that has launched a space capsule into orbit. In the case of *Allemagne année 90 neuf zéro,* it is a time capsule that contains nothing less than the intellectual and cultural history of Germany. In the problem of how to narrate such a history, Godard takes on cinema as the medium through which all history must speak. The film's opening voice-over speaks critically of the problem of monological historical narration and the ways it closes off the possibilities of multiplicity and the interpenetration of different perspectives and perceptions within time. An unseen voice asks:

> Can we recount time? Time as such in and of itself? No, in truth it would be an insane undertaking. A recital saying, Time passed, flowed, . . . ran its course, and so on. No sane man could sustain such a narration. It is a bit like holding for an hour one single note, one chord, and trying to pass it off as music.[4]

The musical form of the fugue with its fluid interpenetration of contrasting themes, variations, harmonies, and rhythms becomes the formal metaphor for *Allemagne année 90 neuf zéro.* The film is structured as a series of variations, as in a piece of chamber music. Each variation is thematized in an indirect way that alludes to the relationship between a political and cultural past. Variation 1, "The Last Spy," introduces Lemmy Caution. He is an artifact of the history of cinema who is there to find clues to the missing German history. We hear philosophical musings. Are these clues? After all, Germany is the land of philosophy. Hegel is introduced with a quote: "Philosophy begins with the ruin of the actual world." A couple is seen studying Hegel; the man reads in German, the woman in French. They argue, not about his ideas but about the problems of translation between German and French. This suggests a larger problem of translation between borders, between languages, between subjectivities in a unifying post–Cold War Europe. As Frieda Grafe suggests in her essay "Whose History: Jean-Luc Godard between the Media," the problem of translation is that it "is not true to the word, but rather changes or, even worse, distorts the word in order to make it understandable, because when language moves to a different territory, words necessarily take on a different shape" (5). In a unified Europe there is no longer a narrative of nation that can bridge the necessary recontextualization of meaning as ideas move across borders and cultures. Rather than ideas becoming universalized knowledge, they are simply ill-remembered signifiers of a vague memory.

The couple is seen in a library full of books. But the quotations they are reading, their argument over translation, and the books themselves seem simply useless. "It is the silence of these countless books that frightens me," Lemmy Caution at one point muses off camera. While the couple is reading, Godard moves us back to another time: Nazi Germany. Is this what the German world of ideas produced? The past is cinema: footage from the Jewish ghettos, idealized Aryan imagery from German films

of the period. Godard cuts freely between past and present, and the voices of the two philosophers in French and German continue over. We see a tree. The woman's voice-off: "World history is not the place for happiness." These are empty signifiers of the great philosophical traditions of Germany, which are of little meaning in the face of the images of the past. The concentration camp Buchenwald was built around Goethe's tree. An intertitle appears on the screen: "HISTORY OF SOLITUDE." Such images, which may or may not form linkages, can be described in Deleuzian terms as pure time-images. They are not linked narratively through continuity conventions, or by description, or even thematically. Central to the film is the situation of the narrator in the contemporary representation of history. Of the role of narration in history, the film states that it has become "impossible, difficult, lonely . . . absent and present oscillating between two truths, that of document and that of fiction." This oscillation produces new forms of narration that more adequately represent social, political, epistemological, and aesthetic developments in modern society. Deleuze suggests that "the postwar period has greatly increased the situations which we no longer know how to react to, in spaces which we no longer know how to describe" (*Cinema 2,* xi).

In cinematic terms, he has productively described this as a shift from the movement-image to the time-image. The movement-image, largely referring to classical narrative cinema, is an indirect and therefore illusionistic image of time in which constructions of discrete images act on one another to create a durational whole of a scene, sequence, or story. The time-image, on the other hand, is a direct image of time in which each shot is self-contained as a durational whole whose meanings are not necessarily constructed through the movement between shots. With the time-image, each shot works to deframe the previous one, thus producing more fragmented, elliptical relationships between shots. As will be elaborated more fully, the other aspect of the direct time-image reveals the coexistence of a multiplicity of temporalities within the same image. With such image constructions, time is no longer seen as movement, but as a perception, making thought immanent to what is seen. This can create the condition for the image to open onto virtual temporalities that coexist alongside the actual of the image—what is seen. In his attempt to examine history as the interpenetration of different moments, events, and ideas, Godard's famous adage "Not one image after another; rather, one image *plus* another" might be restated as "Not one moment of time after another; rather, one moment of time *plus* another." Like Godard's cinema, Deleuzian philosophy points to the need for rethinking the questions and situations of the post–Cold War reality with a new relation to temporality. Godard's cinematic language of accumulation or one image *plus* another becomes an important model for Deleuze's notions of multiplicity and *becoming* as processes in modern thought. The "irrational cuts" of nonlinked images and sounds make totalizing narratives of nation impossible.

Ultimately, there are no longer any rational cuts but only irrational ones. There is thus no longer association through metaphor or metonymy, but relinkage on the literal

image; there is no longer linkage of associated images, but only relinkages of independent images. (Deleuze, *Cinema 2*, 214)

Deleuze sees this as a central aesthetic characteristic of the cinema of the time-image, in which image fragments never add up to a whole, as was still possible in the cinema of the movement-image. It is the accumulation of images that creates contexts, allowing open readings, both as images on their own and in their juxtaposition.

Allemagne année 90 neuf zéro is a time poem in the steely grays and blues of northern European light. The film picks up again on Lemmy Caution wandering around East Berlin. There is no sunshine. We see a sign marking what was once a Gestapo headquarters. Next to it someone is selling pieces of the Berlin Wall, Nazi memorabilia, and books. History is something to be bought and sold. East Berlin is now seen as a flea market of allusion and references to a past of German culture and ideologies. But it is all inert, eerily silent. Caution wanders around and meets up with Sigmund Freud's Dora; these are "pure optical and sound situations" documenting East Berlin within a disjunctively surreal narrative. Dora turns into Goethe's Charlotte Kestner, and this begins variation 2, "Charlotte in Weimar." Caution and Dora/Charlotte wander through East Berlin encountering German history: Schiller's home, the monument to Pushkin, an image of Kafka, the site of the murder of Rosa Luxemburg, statues from past centuries now worn down and corroded by pollution. Each statue is pure time, at once an artifact of the time when the statue was made and the corrosion of the passage of time in the present. Intercut are other time images: paintings, photographs, and snippets of music from Europe of the eighteenth, nineteenth, and twentieth centuries.

In this constant movement between registers of artifact, document, dramatic sequences, sounds, and musical quotations, Godard constructs history as a playground of the dead. One becomes overwhelmed by the references. What film is that snippet from? What painting is that, what quotation or piece of music? There are references within references, as, for instance, in Liszt's piano transcription of Beethoven's Fifth Symphony. Through this overflow of references, the guarantee of knowledge as a means of understanding becomes impossible. As the endless stream of cultural and historical quotations cascades in front of the viewer, one catches a reference and misses others. Like the scraps of the memory of an education that once constituted a whole nation that no longer exists, these image and sound quotations create an out-of-field echo at once completely foreign and oppressively familiar. Has the filmmaker even remembered them correctly? As a "home movie," the film interrogates Godard's own memory. How does a Swiss national, known internationally as a French *auteur*, remember a Germany through his own figure in relation to a Europe that no longer exists as it did in his childhood? As Frieda Grafe, who quotes Godard, writes:

[Godard] refers to Germany as his *patrie imaginaire,* the source of his imagination, the fertile ground of his mind. "When I think back, it was Germany that formed me

and by which I let myself be formed. By it alone." . . . As a result of the German culture he had absorbed, Godard shares a feeling of guilt. He sees himself in the ranks of a generation of children whose parents allowed Hitler to rise. His reproach is directed at his own parents: they said nothing about it to him after they first kindled his love for Germany. (10)

There is a powerful interplay between the actual mechanics of making representations and the objects that are created. Throughout the film, people are writing, playing music, drawing, taking pictures, and Godard is making a film. There is a sense of endless production and reproduction of the world. For Godard, this is his history, and history is plastic. It is something to be molded, shaped, worked on and through. He always comes back to himself—to cinema and its own plasticity as a means of shaping meaning and time. At times, it is pure surface, one image next to another, a house, a person walking by a lake, the image of a book lying on the ground, a detail from a painting. Not unlike Trinh Minh-ha's description of the "interval" between images described earlier,[5] Deleuze comments on such spaces: "What counts is . . . the *interstice* between images, between two images: a spacing which means that each image is plucked from the void and falls back into it" (*Cinema 2,* 179). This is the opposite of associative montage, where there is a connective tissue between shots that must be ferreted out by the viewer. Rather, Godard is interested in the differentiation between the shots. The interstice is the space *between* shots that holds them apart so there is no chain of interlinked images that form a whole. Rather, as Deleuze insists, it is a form of thought, a virtuality that exists between nonlinking images. For Godard, history is this *and* then that, never something that adds up to one. Deleuze again:

> It is the method of BETWEEN "between two images," which does away with all cinema of the ONE. . . . Between two perceptions, between two visual images, between two sound images, between the sound and the visual: make the indiscernible. . . . The whole undergoes a mutation . . . in order to become the constitutive "and" of things, the constitutive between-two of images. (*Cinema 2,* 180)

Sometimes the film returns to cinematic conventions that create spatial and even narrative verisimilitude. With the use of match-cutting and shot–counter shot, we are moving not only through space but across time (Figure 19). A woman in a museum is looking at a painting of the sea. She raises a camera to her eye and depresses the shutter. The painting turns into an early motion picture of waves in motion. In one shot, Godard has moved through eighteenth- to twentieth-century forms of representation. At other moments there are film images from other periods. Lemmy Caution watches two women get out of a car in front of a hotel. They walk off-screen. We cut to Caution looking at them, and then we get his point of view. All at once it is in another time period and in another film (Murnau) that the two women emerge from the hotel and get into a car. We are in the black-and-white world of prewar cinema

Figure 19. *Allemagne année 90 neuf zéro*. The history of image forms: from painting to photography to film.

linked through the convention of match cutting. Godard has elided prewar and post-war Germany in a single cut.

While all of this may seem unrigorous as historiography, Godard points to the complexity of the way history becomes a series of layerings, overlappings, and super-impositions. It is a model for the representation of history that is geological rather than chronological. It is geological in the sense that moments of time are sedimented and become strata. Deleuze and Félix Guattari write:

> In a geological stratum . . . the first articulation is the process of "sedimentation," which deposits units of cyclic sediment according to a statistical order: flysch, with its succession of sandstone and schist. The second articulation is the "folding" that sets up a stable functional structure and effects the passage from sediment to sedimentary rock. (*A Thousand Plateaus*, 41)

If we use a geological stratum as a model to think about historical genealogy, the past does not fall away to reveal the present as in progressivist modes of historiography. Rather, the past coexists simultaneously with the present as sedimented layers that become enfolded to produce an object. Deleuze and Guattari, using the crystalline stratum as a metaphor for the coexistence of different strata of time, write: "The amorphous milieu, or medium, is exterior to the seed before the crystal has formed; the crystal forms by interiorizing and incorporating masses of amorphous material" (49). The crystal metaphor continues with its translucent multifacets as a metaphor for this coexistence of different planes of time within the cinematic time-image: "What the crystal reveals or makes visible is the hidden ground of time, that is, its differentiation into two flows, that of presents which pass and that of pasts which are preserved" (Deleuze, *Cinema 2*, 99). The crystal is a productive metaphor for describing the poetics of Godard's use of time and the interpenetration of the textures of past and present, image and sound. This notion of geological stratum can be seen not only in temporal relations between shots but also within the composition and mise-en-scène of individual shots. In these instances, history is not extension, one moment moving to the next; often it is depth of field, molded into a single frame. For example, Lemmy Caution is walking down a road. In the distance is an old windmill, a relic from a preindustrial era. Into the frame, a man is pushing a late-model automobile. It won't start and comes to a stop in center frame. At that moment, a Don Quixote–like conquistador figure on horseback comes riding into the frame. The frame is now divided into four planes, each one a different moment of history. Caution asks, "Which way is the West?" Don Quixote rides past the windmill—he has chased it in the past—to do battle with the giant digging machine that is strip-mining a field in the distance. The strip-mining machine might be seen as historical practice itself. It tears away stratified layers of earth, each one a different period of time, keeping the substratum that is of value to the needs of the historian and discarding the detritus that seems insignificant.

As Lemmy Caution continues his wandering, the notion of an East and West Germany begins to elide. No one he asks knows any longer which is what or where. But suddenly and sardonically, Caution is in a different world; the sun is shining, there are joggers, birds singing. It is variation 6, "The Decline of the West." It is night in the city of neon signs, car dealerships, billboards, banks, and endless department stores. Has Caution returned to Alphaville? At the end of this film, the city is still the geological site of Godard's history. But the bleakness of East Berlin, with its historical references and artifacts of a past German nation, seems quaint compared to the foreboding and malevolent tone that Godard creates in the Western city. In this portrait he becomes moralistic and apocalyptic. This is a present in which there are no signs of the past—an eternal present. As Lemmy Caution says, "Here is where the last battle takes place." It is "the battle of money and blood." For Godard, the "blood and soil" movements of the fascists of an earlier time seem to hold little power in the face of a new economic world order where money is conqueror and, as Caution says, produced Auschwitz and Hiroshima. Here image and text relationships become didactic. Over these words, Godard cuts between the ominous images of the Intercontinental World Bank building with hundreds of black crows flying around it, creating an urban version of Van Gogh's last painting before his suicide, *Cornfield with Crows,* and disaster images from Fritz Lang's *Metropolis* (Germany, 1926).

For Godard, the Berlin Wall was at least a reference to a past, as grotesque a failure as it was. It was still a past that was embedded in the present and was embodied by the Wall as a physical limit, reflecting an inside and outside to the state, whether capitalist or socialist. For Godard the Wall indicated the possibility of difference. Things are one way but could be another. But in his image of a world culture of late capitalism, there is no "outerland." There is nothing onto which the present can reflect. The fashion mannequins in the department stores are the statues of modern capitalism, reflecting neither past nor present. One gets the sense that the socialist state of East Germany, with its primitive apparatus for repression, was at least still within history and producing history and in fact needed history to function. It was the repressive present of an East Germany that guaranteed a context for the past and hope for the future. For the world of Western capitalism, with its ever expanding present, there are no longer such needs. The late capitalist state is a machine that crushes difference, temporal or otherwise. To function smoothly on its own, it produces an eternal present.

Allemagne année 90 neuf zéro ends with Lemmy Caution returning to the same sterile and characterless hotel room seen at the beginning of *Alphaville.* There are the same maids and bellhops waiting to serve. Instead of the tranquilizer pills on the night table in *Alphaville,* there is a television on and the sound of the howling wind. Caution removes two thick volumes of the history of the Gestapo from his suitcase and has the maid place them under his mattress to prop up his feet while in bed. As in *Alphaville,* Lemmy Caution asks that the book by the bedside be taken from the room. The maid refuses, saying "No sir, it's the Bible, it's always there." With that, *Allemagne année 90 neuf zéro* simply ends. Unlike in *Alphaville,* there is no longer any outerland

to return to and no place to escape from. Caution's journey has not led anywhere. The signifiers of history, which for the moment remain in East Berlin, will be subsumed by the reunification of Germany, and with it a guarantee of international-style shopping malls and their attached museums. For Godard, this leaves Germany (and by extension Europe) without a past. History, as he says, "is always alone." On both sides of the Wall, we see the failure of the state as the producer of culture, ideas, and history.

In this deformed narrative of nation, even the hope of a rebuilt postwar state-sponsored culture (on both sides of the Wall), with its accompanying state-constructed museums, produced nothing more than an image of itself.[6] Godard raises the question of the appropriation of art and artists by the state. A voice-over says that "artists who painted under orders were the most hypocritical." Velázquez, Giotto, Dürer. Italy, Spain, Germany. "Nothing but state art—art dictated by the state. Always." There is an image of Goebbels over a swastika. The voice continues in the film's first direct mention of Nazism, "that awful Dürer, precursor and predecessor of Nazism, who put nature on canvas and killed it." In the German state's postwar incarnation, it again appropriates art to produce an image of itself as the embodiment of individual freedom.

In 1955 Germany's international arts festival Documenta was established in Kassel. Its first exhibition was a major revival of the modernist "degenerate art" banned under the Nazis in order to return Germany to the artistic mainstream of European culture. In 1959 Documenta 2 introduced American abstract expressionism in Germany (Huyssen, *Twilight Memories,* 201). American abstract expressionism, with its state-sponsored international touring exhibitions, had become an icon for the emerging hegemony of American culture and its notions of freedom of expression in postfascist Europe. In postwar Germany, art was no longer seen simply as individual expression, a manifestation of national cultural identity, but actually became a currency used to reconstruct an image of Germany as a state among states. The implication is that culture in the context of international capital is no longer necessary to the construction of a national identity; rather, it is something to be appropriated as mise-en-scène in the solipsistic dramas of interstate power relations. Hence the subtitle to *Allemagne année 90 neuf zéro:* "Solitudes: A State and Variations." This may be Godard's bleakest work, producing a sense of futility by showing that no amount of human ingenuity or knowledge can stop or prevent this "state machine" from reproducing itself in whatever form necessary.

The Berlin Wall, both in its past physical incarnation and now in its absent presence, is like the Deleuzian crystal, now made grotesquely of concrete, where the past and the present, the virtual and the real, become indistinguishable. Between these "states"—the past of Germany, of World War II, of the Cold War, and the present with its reunification and late capitalist condition—time becomes unstuck. For Godard, there is no chronology, one can no longer think history linearly, space becomes deterritorialized, and distinctions between East and West, past and present, become subsumed by the specter of global capital.

Deleuze, however, attempts to turn the implications of this kind of apocalyptic

vision into possibilities for new ways of thinking that allow for dynamic networks of discursive relations between ideas, territories, and moments of time. Deleuzian thought is one of transformation or, as he describes it, "of becoming." This utopian idea is embodied by an experimental cinema—a plastic grouping of spatial and temporal relations or becomings—in which unimagined events may occur. A film like Godard's *Allemagne année 90 neuf zéro,* then, despite its dark vision of the present, is connected inextricably to Deleuze's vision in that it demands that we think time in its multiplicities rather than in its chronologies and therefore challenges us to think our forms of representations—like history—differently.

Persistence

Berlin: Symphony of a Great City, Walter Ruttmann's 1927 film portrait of early-twentieth-century Berlin, renders that city and urban modernity as the embodiment of human progress. As a modernist work of art, Ruttmann's film eschews nineteenth-century forms of melodramatic narration for the kineticism of the cinematic, creating dynamic portraits of the rush of urban daily life, endless modern buildings, industrial sites, and the ever forward movement of streetcars and high-speed railroads. In this film, Berlin held the promise that twentieth-century modernity would progress inexorably forward into the future. Seventy years later, Daniel Eisenberg's film *Persistence: Film in 24 Absences/Presences/Prospects* (1997) offers a countermeditation on this European city, whose future, as it happened, was very different from that imagined in Ruttmann's hopeful vision. In *Persistence,* Berlin is a city encased in scaffolding, shown as a living ruin. This is the third in a trilogy of films in which Eisenberg has examined the problems of representing European history in the post–World War II period. Like *Cooperation of Parts,* and his film *Displaced Person* (1981), *Persistence* examines the problems of historiographic representation as personal and aesthetic experience.

Elegiac and contemplative, befitting the moment after a major upheaval, *Persistence* was shot in 1991–92 in Berlin just after the reunification of East and West Berlin and the collapse of the Soviet Union. Neither simple historical documentary nor impressionistic portrait, the images in this episodic film essay, as the title suggests, are structured in twenty-four sections that fall under three headings: "Absences," "Presences," and "Prospects." Often these headings are combined to contextualize the same images and sequences, indicating the fluidity of the actual, virtual, and potential within historiographic narrative. The film is a complexly structured amalgam of footage that Eisenberg filmed in and around Berlin during this transitional period of the early nineties, archival footage of the bombed-out city between 1945 and 1947, and other dramatic and documentary footage of the postwar period. Woven throughout this material we hear a range of texts read voice-over, from radio news reports describing the collapse of the Soviet Union and its subsequent withdrawal of troops from Germany, to a series of journal entries written by the filmmaker during this time, as well as ones by the writers Max Frisch, Stig Dagerman, and Janet Flanner, who were in

Berlin at the end of World War II. Unidentified until the end credits, these voice-over excerpts from the writers' journals are juxtaposed with Eisenberg's Berlin footage. Hearing accounts of the confusion and displacement among the rubble of Berlin of 1945 while seeing images of modern-day Berlin with its decaying and still bullet-pocked building facades produces an eerie temporal elision between the two moments. In this way, Eisenberg turns Berlin into a kind of "history machine" in which relationships between events, objects, institutions, and politics, as they move through time, produce assemblages of possible connections between past, present, and future.

Here I am taking this notion of history as a "machinic" assemblage from Deleuze's concept of the "literary machine," an assemblage of formal elements, tropes, and resonances that, as Scott Durham writes, "is not representational but performative: rather than aiming at the representation of a pre-existing truth it seeks the production of certain effects" (*Phantom Communities,* 229). This Deleuzian history machine is constantly producing truth effects that denaturalize or challenge the sense of pastness as a distinct moment from the present. The history machine is not a self-contained totality but a multiplicity: "It functions only in and through the dynamic interaction of detached and heterogeneous elements, whose mobile relations to one another . . . are determined by the imminent functioning of the machine itself" (228–29). Eisenberg uses the unique temporal and spatial plasticity of cinema to produce new assemblages in order to rethink the narrative possibilities of historical representation. In the context of Berlin as a physical site in transition, the film calls into question linear and causal narratives of historical time to suggest a history of superimposition and simultaneity and raises the possibility that, in the filmmaker's words, "what is present now, may also have been present before and what is absent now may be present tomorrow."[7]

As a crossroads between a geopolitical East and West and the epicenter of most of the transformative events of twentieth-century Europe, Berlin is the site that bears the traces of such events from which the materials of German, European, and even global histories of this century are currently being constructed. In *Persistence* Eisenberg focuses on the moment after a major historical event such as Germany's reunification because such transitional moments produce a momentary no-man's-land of not-yet-narrativized events that produce new possibilities for thinking the relationship between past and present. The intense reorganization of the city—the restoration of destroyed buildings, the removal of monuments of the past regime, and the changing uses of institutions—not only creates a new physical landscape that the film imagistically renders palpable, but also shows how such physical changes produce new readings of the events that happened in and around them. Eisenberg uses the presence of what is left after both the war and the reunification to examine how the meanings and uses of such objects and institutions are redefined as time passes (Figure 20).

In *Persistence,* he uses architecture in various states of decay and renovation as a way of visualizing and spatializing the temporal instability between past and present. Rather than using the kineticism of cinematic movement to focus on the present tense, as Ruttmann does in his Berlin, Eisenberg uses the duration of the cinematic image

unfolding in time to produce specters of the past in the present. Early in the film, he presents the Greek ruins on the grounds of the Sans Souci castle on the outskirts of Berlin. These were built as ruins by Fredrick the Great in the eighteenth century as his personal history machine, perhaps to contemplate his own place in time through the evocation of the signs of an imagined past. As a fake ruin, the monument in the film becomes a metaphor for the way objects—in their material existence—can be loosened from what they signify in the present, to become even more complex signifiers of the multiple relationships between different moments in time. Similarly Eisenberg uses film images to create the possibility for one to contemplate the relationships between multiple moments in time, as their meanings (as given in different temporal moments) inflect one another simultaneously.

In *Persistence* Eisenberg also moves beyond the contemplation of images as metaphors for multiple moments in time that exist simultaneously. Rather, he creates direct images of time. The real-time duration of the shot unfolding in the present, the represented temporal moment within the shot, and the virtual moment of the past's present all coexist within the same shot and are often indistinguishable. This can be seen

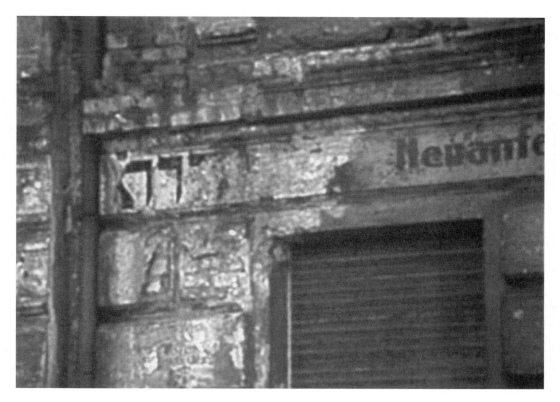

Figure 20. *Persistence: Film in 24 Absences/Presences/Prospects* (Daniel Eisenberg, 1997). An absent presence, 1991. Photograph courtesy of Daniel Eisenberg.

productively in Deleuzian terms as a "crystal image," which describes the phenomenon of a film image that is at once actual *and* virtual. In conventional film constructions of virtuality such as the memory flashback or dream sequence, there is a clear distinction between the movement of the actual to the virtual—when the film's plot moves from the present and *then* to the past. The crystal image instead creates a situation of "an actual image *and* its own virtual image, to the extent that there is no longer any linkage of the real and the imaginary, but *indiscernibility of the two,* a perpetual exchange" (Deleuze, *Cinema 2,* 273). One facet of the image is constantly becoming part of, or is reflecting, the other, producing an ever-widening circuit of associations and events within the image. While the evocative nature of such complex images can produce multifaceted connections in the mind of the viewer, Deleuze also takes seriously the phenomenological qualities of this kind of crystalline description as "the objective characteristic of certain existing images which are by nature double"(69). In this sense, the crystal image is not simply representational in that it stimulates virtual associations among signs, as in montage. Here, it is the direct presentation of time in which all of the image's temporal possibilities are contained within the shot that produces multiple narrative possibilities for the relation between past, present, and future. The crystal image produces an

> indiscernibility of the real and the imaginary . . . go[ing] beyond all psychology of the recollection or dream, and all the physics of action. What we see in the crystal is no longer the empirical progression of time as succession of presents, nor its indirect representation as interval or as whole; it is its direct presentation, its constitutive dividing in two into a present which is passing and a past which is preserved, the strict contemporaneity of the present with the past that it will be, of the past with the present that it has been. (274)

In *Persistence,* in one fixed shot lasting nearly five minutes, we contemplate the side of a tall building somewhere in Berlin, which is inscribed with the remnant outline of a once-attached building. A palimpsest, this ghostly outline indicates the past existence of the missing building, marking the transformation Berlin has undergone. At the same time, it evokes the specter of the catastrophic events of Berlin's recent past. After a time, a modern train moves into the frame in front of the building, and passengers disembark while we see others through the train window sitting and waiting. The train pulls away, revealing the wall and its ghostly outline once again (Figure 21). In this single shot, the present multiplies as we experience several different dimensions of time that coexist simultaneously and define the space of the city in relation to the movement of time: (1) the moment of the existence of the building that is now just an outline; (2) the moment of the filming when the train pulls in; (3) the moment of our watching the cinematic trace of this complex time-image in the movie theater; and (4) the combination of these three aspects to produce an image that is at once actual and virtual. It is the continuous duration of the shot that releases the actual and

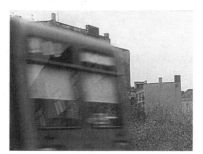

Figure 21. *Persistence: Film in 24 Absences/Presences/Prospects.*
A single shot, in which the present multiplies to reveal the
coexistence of several different dimensions of time defining the space
of the city in relation to the movement of time. Photograph courtesy
of Daniel Eisenberg.

virtual moments of time, creating a temporally faceted image of the space of Berlin. Such an image accurately matches the dynamics of change in a politically volatile city such as Berlin.

In *Persistence* Eisenberg has cinematically constructed the entire city of Berlin as a crystalline sign. In another sequence, nearly hidden behind a complex web of scaffolding, we see the renovation of an immense synagogue. Eisenberg shows these images without commentary, allowing viewers the space to contemplate the remains of this once elegant center of a thriving Jewish community. This actual image of the synagogue produces a pure virtuality: that of the German Jewish community. The silent gaze of the camera is at once of an image of the synagogue in renovation and the reflection of an absent presence. Such reflections can indeed cause reflection: What is the purpose of this renovation? Will it be a museum to show future generations of Germans how this now extinct community lived? Or, more phantasmatically, is it being rebuilt in the hope that Jews might return to Berlin once again, take up use of the synagogue, and further render past events invisible? This exchange between the actual and the virtual in such an image reveals the often confused and unpredictable quality of the historical movement of a city that, in one moment in time, mobilized itself to destroy its Jewish community and then, in another, expresses that loss as a desire for its return. Both are given as thought in relation to the actual of what is seen in the shot.

While the use of static shots of such long duration is a strategy that has been used by many avant-garde filmmakers as a way to produce a contemplative experience of an image in real time, Eisenberg uses such durational images to a different effect. Filmmakers such as Chantal Akerman (*News from Home* [1976], *D'Est* [1993]), Peter Hutton (The *New York Portrait* series [1978–90], *Lodz Symphony* [1991–93]), James Benning (*11 x 14* [1976]), and Michael Snow *La region centrale* [1971]) also use shots of long duration. But they are often less concerned with using the present as a way to evoke the past than they are in heightening the experience of the image in the present through the real-time duration of the shot as it is being projected. In these films, the past is the moment that the shot was made, which stands in a dialectical relation to the present moment of the viewing of the film. The time of the image heightens a sense of the present that is often experienced as a sublime encounter with the act of vision, as in Benning and Hutton. In other cases, the long shot is used to evoke states of consciousness, as in Akerman or Snow. In contrast, Eisenberg uses shots of long duration to produce an image that opens onto multiple temporal moments of the past and present simultaneously, giving rise to virtualities that can occur in the interplay between such moments in the mind of the viewer.

Persistence appears to be an analytic exposition concerned with the ways in which objects, such as a piece of paper, photograph, or roll of film, become a document and how their use value and meaning constantly shift. At the same time, the film is a poetic look at objects that are rendered visible in ways that reveal aspects often ignored by conventional social documentarians and historians. These ways might include an object's

metaphoric possibility, its beauty, or its potential for having new meanings reinscribed onto it. Eisenberg has resurrected images whose value in one context has long passed, and has brought them forth in another, giving them the possibility of a continued presence within new historical discourses. In *Persistence,* history is movement. This movement is the present constantly rethinking its relation to the past; what is understood as a past is constantly changing because of what is happening in the present. This, by necessity, is a rethinking of historical narrative that takes into account the dynamic nature of time—which is always in flux—rather than the traditional forms of historical narrative, which constructs pastness as hidebound, already known and received as "truth."

With the increase in cinematographic documentation of events during the twentieth century, film images have only recently become central to the historiographic process. Which images are preserved as artifacts and documents and which are discarded as useless change over time and context. How this material is understood and used as evidence and knowledge in the representation of events, then, is only now becoming a serious question. Much of the archival footage seen in *Persistence* was shot by the U.S. Army Signal Corps during the occupation of Germany in 1945. Now that Berlin has long since been rebuilt, the military has little use for such footage, and it was scheduled to be destroyed. Going through this material slated for incineration, Eisenberg discovered long, quiet tracking shots of the decimated city rendered in beautiful deep focus with highly saturated color, as well as aerial shots of the city, which looks like an unearthed archaeological site. In other shots, we see the stirrings of the city digging out after weeks of warfare. The occasional tram passes by. Women and children walk through the rubble. Occupation soldiers pose for photographs in front of ruined monuments. Seeing such prosaic shots, one wonders what possible use they had for the military. But placed in this film, they reveal a latent poetry, allowing us to contemplate the fragility of the urban landscape. This city, once the embodiment of progress, has become a wilderness of rubble where neighborhoods in which people spent their entire lives are altered beyond recognition. In the footage, Berliners are trying to resume their former lives despite the utter incongruity between the devastated city and their attempts to carry out the activities of daily life. We see people pushing baby carriages, carrying furniture and bags of food. Women are dressed in urban street clothes, wearing high heels, looking as if they are on their way to some prewar office job as they stumble across mangled iron girders of destroyed buildings. The focus in this image on the incongruities of such wreckage also creates a Deleuzian crystalline image in which "the past does not follow the present that it is no longer, it coexists with the present it was. The present is the actual image, and *its* contemporaneous past is the virtual image, the image in a mirror" (*Cinema 2,* 79). Here the image of the mundane activities and dress of the people becomes the mirror image of the city's quotidian past seen in the midst of the otherworldly present of the city's destruction.

Eisenberg pushes the problem even further by introducing yet another mode of

cinematic discourse—the dramatic film. Intercut throughout *Persistence* are sequences from Roberto Rossellini's neorealist film *Germany Year Zero* (Italy, 1947). This film was shot in the same streets about two years after the archival military footage. Rossellini shows the devastated city as part of a fictional drama depicting Berliners trying to re-construct their daily lives in the wake of the German defeat. The film follows a young boy named Edmund as he walks through the rubble. Between the two types of footage, the viewer's ability to discern what is documentary and what is fictional construction becomes blurred. The fiction of *Germany Year Zero* produces a greater "reality effect"—creating a stronger feeling of historical truth through the viewer's identification with the fictional character and dramatic compositions of Rossellini's camera—than the distanced, surveying camera of the surrealistically beautiful military documents. Perhaps more influential than any other genre of filmmaking in the postwar period, neorealism (Rossellini was one of its central practitioners) raised the possibility of integrating the image of place as it is at the moment of filming with dramatic conceits, calling into question lines between the actual and the simulated. Using *Germany Year Zero* at once as an homage and critique, *Persistence* goes even further to show how the categories of document/staging and past/present are merely rhetorical constructs by using conti-nuity editing conventions to construct artificial relationships between a fictional film like *Germany Year Zero* and the documentary footage shot in the present. As the cam-era explores the ruins of the synagogue, Eisenberg cuts to Edmund walking through an equally devastated building in *Germany Year Zero;* the use of simple match cutting and shot–reverse shot techniques makes the wandering Edmund appear to move through time between 1947 and 1991. We see the same character in the same streets and buildings simultaneously in two moments of time. In this sequence it is the cut, rather than the long take, that opens onto the crystalline description of time by momen-tarily making the actual and virtual indistinct. We see Edmund gazing down a flight of stairs in 1947, and the cut shows us that what he is looking at is the lower level of the synagogue in 1991. The dramatic power of the actor's gaze carries over between the two moments in time.

Along with the shifting meaning and significance of the document, *Persistence* also explores the ways in which institutions that collect and house such documents pro-duce fluid relations between past and present. Museums, archives, libraries, schools, and other institutions are constantly shifting the meanings of the objects stored in them according to the ideologies of those in power or the shifting hegemony of soci-ety itself. Eisenberg shows how this has been an almost constant occurrence in Berlin. In a sequence filmed inside the former Stasi headquarters in what was once East Berlin, we learn from the voice-over that the building once housed an archive for the files on one out of every three citizens of the GDR, and that if laid out side by side the files would extend over two hundred kilometers. The possibility that files documenting each individual's daily activities could be used by the government in any way it wanted kept the East Germans in a constant state of fear. Once the GDR collapsed, this active

tool of governmental control was turned into a museum containing documentary evidence of what are now called "past abuses" of the government's power. Eisenberg is obsessed with the ways in which institutions that were once functional have been redefined as descriptive exhibits of a seemingly inert past.

In yet another sequence, he explores in long, slow pans the human experimentation room in what was the Sachsenhausen concentration camp just outside Berlin. Now it serves as a museum, so that anyone may see the tiled operating tables of the laboratory and the instruments locked in glass cases. Long gone are the bodies on which experiments were performed. The instruments have been washed clean and are neatly displayed as artifacts of a time forever past. A voice-over is heard in the form of a birthday letter from a son to his aged mother who survived such a camp. The son explains that his visit to Sachsenhausen only increased the distance between her experience and his ability to understand it. As the tour of the camp continues, we learn that it had recently been firebombed by a neo-Nazi group protesting contemporary German immigrant policies in the wake of a visit to the camp by the late Israeli prime minister Yitzhak Rabin. The evocation of the web of histories around this site—from scientific laboratory to torture chamber museum to political symbol to protest site—defies any stable meaning of this place as it moves through history.

Along with the activity of reconfiguring relationships between past and present, the film itself is an archive of images of Berlin in 1991. *Persistence* documents objects and sites that are in the process of disappearing forever. Part of the reconfiguring of Berlin as a unified city includes the erasure of much of the evidence of the forced division. Immediately after the reunification, statues, monuments, and military installations were dismantled. The empty areas surrounding the Berlin Wall were rebuilt. The film carefully documents such sites in anticipation of the receding and eventual erasure of the period of the city's division. The film attempts to stand as a counter-memory to the construction of whatever master narrative may emerge in the current German effort to reconstitute its national identity as a single unified nation.

With the film's slow pacing, long static shots of present-day Berlin, and silent views of past archival footage, the experience of watching *Persistence* gives the self-conscious viewer the room to think in relation to the complexity rather than the simplification of the changes that are taking place. Beyond the representations that images contain, in the slow pacing, it is possible for one to develop an attentiveness to aspects of these images not immediately identifiable as meaningful. As the viewer begins to find himself or herself in the act of observing, aspects of the film slowly come to have meaning: its filmic texture, the quality of light, scratches and dirt particles marring the film surface, the way a shadow changes the contours of a building as the sun moves behind a cloud, and how bodies move in space in different moments in time. All of this becomes significant to the viewer's sense of temporal movement. This kind of attention to the subtle processes of cognition and decentered meanings within film images is pivotal to Eisenberg's questioning of the rhetorics of historical

narration and opens the possibility for counterhistories. Thus the film suggests a discourse that moves beyond hollow post–Cold War rhetorics of victories and defeats or accusations and guilt that surround "the German Question" into more constructive perspectives on the integration of the past into a dynamic future.

A question that becomes implicit in the film's reflexive deconstruction of the narrativization of Berlin's postwar history is the filmmaker's own subject position. This question is implicit, largely because there is little overt reference in the film to the author's identity. Because the work is for the most part about the problems of representation, who the filmmaker is and why he traveled from the United States to witness such a transition become absent questions that persist in the film. What does it mean for an American to be engaged in a reformulation of German history? Eisenberg does little within the film to include his own relationship to Berlin. That the author's position must be included in such a project is debatable. In the last ten years, the first-person documentary, in which the filmmaker's own relation to his or her subject is often more foregrounded than the subject itself, has come to be seen as a major solution to the problems of transparent representation. Because the use of the first-person narrative is often reduced to a stylistic trope or structuring device, it has become clear that such narratives can produce a subject as self-consciously constructed as fictional characters, creating yet another level of illusion to sort through. Perhaps Eisenberg's biography—European parents who were Holocaust survivors, and an artist's fellowship to live in Germany for a year—can be significant in explaining the motivation behind this project. But this kind of information simplifies what are more complex questions about modern transnational interrelationships and how major historical events have begun to cut across national boundaries and identities.

After a century of forced displacements, mass deportations, and emigrations of entire communities from one part of the world to another, the question arises: can historical events still be understood as local or even locatable phenomena? Coupled with the rise of high technologies that allow capital, information, and people to move fluidly across national and geographical boundaries, our modern conception of historical narrative becomes spatial. In this sense, the writing of history in relation to geopolitical boundaries becomes largely iconic rather than real. The presupposition that a whole nation's, or culture's history can be written from any totalizing point of view has become harder to maintain. Fredric Jameson sees the breakup of the notion of totalizable history as part of a shift away from temporal constructions of history that culminate in the totality of the present in relation to a remembered past. In place of such totalities, he suggests the notion of "cognitive mapping," which spatializes our conception of events across distinct and noncommunicating sets that no longer add up to a single entity or past. This produces new kinds of problems for how to represent the indeterminability of the individual's relationship to a past. As Jameson writes:

> An aesthetic of cognitive mapping—a pedagogical political culture which seeks to endow the individual subject with some new heightened sense of its place in the global

system—will necessarily have to respect [a] now enormously complex representational dialectic and invent radically new forms in order to do it justice. (*Postmodernism*, 54)

Eisenberg's project in *Persistence* is to do just that. The film's relationship to Germany is complex, crisscrossing personal, political, and cultural histories. There are the Cold War politics that redefined the United States and Germany in the postwar period, the intertwined cultural legacies that have shaped the consciousness of artists and intellectuals in the United States and Europe during the twentieth century, as well as Eisenberg's own European history of familial destruction, displacement, and emigration. The film is a "cognitive map" across discontinuous spaces, cultures, and, most crucially, temporalities. In this sense the film is pedagogical: it creates new kinds of networks to express spatial and temporal relations, teaching us to think of them as multiplicitous rather than sequential.[8]

A work of art such as *Persistence,* a singly authored film made by an American Jew about Berlin, also raises the question of the individual voice speaking in relation to notions of nationality that are changing in the current period of globalization. If globalization is the undoing of national boundaries, creating a hybridization of cultures and identities, it becomes harder for anyone to claim a national history as simply his or her own. The writing of history can no longer be seen as a solely national project when the demarcations between nations and their internal politics are subsumed by the developing global economy and become deeply interconnected with the politics of other nations. How national history relates to the formation of individual identity, and who is authorized to write history or represent events and experiences, can no longer be based only on the preeminence of personal experience and national allegiances. A film like *Persistence* contributes to an opening out of historiography beyond localized accounts and interpretations and continues the process of undermining outmoded notions of a single, unified national identity. It begins to define a postmodern aesthetic practice that no longer depends solely on the fixity of identity, nationality, or even a direct temporal relationship to events in order to authorize the renarration of the past. For a non-German artist like Eisenberg to intervene with his film in this transitional moment is not an act of cultural imperialism; rather, it shows the German project of national reunification to be just one of many narrative constructions of nation—all of which may be equally fictive and rhetorical. Still, Eisenberg holds to the possibility that the film image carries with it its own history and meanings that can be rendered visible as it moves through time. Documenting the present becomes a constant necessity in order to construct an accurate image of the past. In *Persistence,* Eisenberg raises important questions about the relationship between document and history, asking at what points they are different and when they are one and the same. This is an important difference between the interrogation of the image of Berlin's history in *Persistence* and the play of its history in *Allemagne année 90 neuf zéro.* Godard has less interest in the meanings that images may carry over time than in the ways in which they can be inscribed with meaning at any given moment in history.

The final image in *Persistence* is the giant statue of Karl Marx and Friedrich Engels in Marx-Engels Platz, in what was once East Berlin. Filmed from behind the sculpture, tourists are seen photographing each other next to the two huge figures, who seem to be gazing out into the clouds above the industrial landscape of Berlin. Spray-painted on the base of the statue are the words, in German, "Next time everything will be better." Clearly sardonic, but with more than a tinge of hope, this motto seems to be a challenge to continue—despite the past—the struggle for humane social transformation (Figure 22).

B/Side

Many urban artists who lived through the gentrification of the major American cities during the 1980s and struggled to find low-priced work and living space in the midst of skyrocketing rents unwittingly found themselves in coalition and more often in conflict with the urban poor who were being pushed out of their housing and into the streets. In cities like New York and San Francisco, artist colonization of low-income

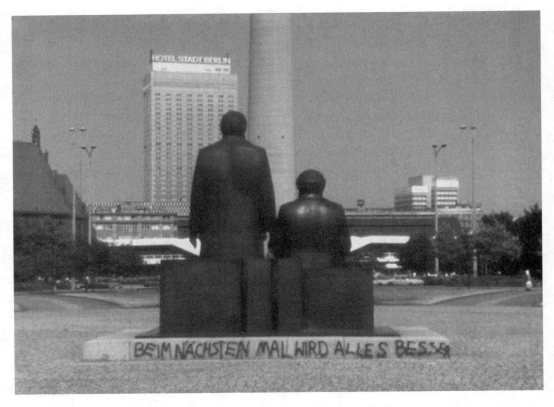

Figure 22. *Persistence: Film in 24 Absences/Presences/Prospects.* "Next time everything will be better." Photograph courtesy of Daniel Eisenberg.

neighborhoods from Manhattan's Lower East Side and Williamsburg, Brooklyn to The Mission District and South of Market in San Francisco began gentrification processes that often ended not only in the displacement of the poor but also in the eventual displacement of the artists themselves. Some of these artists whose work examined questions of the intersection between the personal, the formal, and the socio-logical began to coalesce around the issue of homelessness as a way of bringing together their art practices and social activism. Throughout the eighties there was a wide range of artistic responses to gentrification, from the guerrilla activism of groups such as San Francisco's Urban Rats to institutionalized art world exhibitions such as Martha Rosler's project *If You Lived Here,* sponsored by New York's Dia Foundation.[9]

In this context, there was also a range of film and video responses that empha-sized the personal subject position and viewpoint of the maker versus more conven-tional social documentary traditions of journalistic reportage and analysis. Coming out of the tradition of North American personal and poetic filmmaking, films such as *To a World Not Listening* by David Lee (1980), *Moving In* by Jeffrey Skoller (1981), *The Man Who Envied Women* by Yvonne Rainer (1985), and *Home Less Home* by Bill Brand (1990) are examples of ways in which highly experimental filmmakers took up the issues in the context of larger activist movements. There were also many more video artists and community activist groups who made radically innovative videotapes, including Clayton Patterson's and Paul Garrin's portraits of the Lower East Side hous-ing struggles during the late eighties, and Arlyn Gajilan's *Not Just a Number,* as well as videos made through New York's Educational Video Center.[10] As a political stance, much of this video activism adopted social-realist and agitprop strategies, largely en-gaging in the empirical and sociological exploration of such issues as a way of exposing the politics of urban housing struggles that remain well hidden by dominant political and cultural discourses.

After the impact of such topical work, and despite the fact that many of these struggles for low-income housing failed in the intervening decade, the artist Abigail Child raises these issues again in her film *B/Side* (1996). In this film, Child returns to a past event that took place in the housing struggle in her own neighborhood on the Lower East Side of New York City. Without the immediacy of the need to document and report in the midst of such struggles, she is able to approach these events with-out the urgency or didacticism of the earlier works. Now in more contemplative and impressionistic ways, the film makes a unique contribution, engaging in an active looking at the external environment of the urban homeless. *B/Side* takes this a step further because it also considers the individual inner lives of people living on the streets. This interplay between images of actual life on the street and a more speculative image of the interior worlds of the homeless makes for a complexly constructed and deeply felt work of art that reengages the recurring refrain of the twentieth-century historical avant-garde: the problem of integrating social engagement and innovative aesthetic practice. In an opposite strategy to the antiaesthetic stance of much social-issue art of the last twenty years, which moved away from modernist formal strategies in favor of

more conventional social documentary, journalistic, and theatrical forms, Child aggressively reasserts the aesthetic and speculative processes of art making in the context of a complex social problem. In so doing, she reengages in innovative ways the representations of social injustice that have become mundane by well-worn tropes and rhetorics used for representing such problems within the genre of the social documentary. That is to say, her film is not simply an aestheticizing of social conditions; rather, she uses the emotional power of the aesthetic and formal experience of cinema to engage in renewed ways the ongoing problems of urban homelessness. As in her other films collectively entitled *Is This What You Were Born For?* (1981–87), Child rethinks the radical metric and tonal montage strategies of the modernist filmmakers Dziga Vertov and Peter Kubelka to produce dynamic relationships between image, sound, motion, and texture. The aggressive fragmenting of the image produces new kinds of meanings and connections through the graphic juxtaposition of images and rhythmic velocity. Child emphasizes the plasticity of the cinematic as a means of representing the dynamic quality of a social condition that is in process and in constant transformation.

As a work of history, *B/Side* brings to light a failed attempt by a group of homeless people to create their own countercommunity to solve the immediate problem of safe shelter and to resist the official displacement of the poor in the face of state-supported gentrification. The film takes up the problem of how to create a critical history without either valorizing (uncritically) the victims of such displacements or repeating the sense of helplessness that partisan histories of these kinds of struggles often reinforce. In conventional histories, by focusing only on the actuality of what occurred, the history comes to be just a reliving of such failures. Without including, as part of the history, what was imagined for the community had it been allowed to exist, the impulse behind *why* such a struggle took place can become obscured or written out of the event as it becomes historicized in the present. In this way, the dictum that history is always written by the victors actually takes on a formal significance as a structural element of historical narrative. In contrast, the work of art is able to engage other levels of an event, such as what was immanent in the event or a force of potential that was never actualized. As Scott Durham, in his work on Deleuze and the simulacrum, explains:

> It is the primary vocation of art and philosophy to draw out and amplify the latent potential for difference and metamorphosis within and against even the most stereotypical of repetitions: to transform the experience of repetition into the thought of the future. (*Phantom Communities*, 15)

This suggests that the figuration of an event creates the possibility of opening onto the virtualities that surround the event, either as forces that inflect its outcome or as ideas generated. In this there is no essence of an event. In a work of art there is only the multiplicity of forces that surround it: not just the facts or objects of the event, but the potential, as well. As Deleuze writes: "Multiplicity tolerates no dependence on the

identical in the subject or in the object. The events and singularities of the Idea do not allow any positing of an essence as 'what the thing is'" (*Difference and Repetition,* 191).

B/Side takes place in and around a homeless encampment known as Dinkinsville, which was formed on the Lower East Side of New York City after groups of homeless people who were living in nearby Tompkins Square Park were forcibly evicted by the city in June 1991. Named for then-mayor David Dinkins, the short-lived tent village was formed in one of the many nearby vacant lots. From June to October 1991, when the city bulldozed the encampment out of existence, people built an elaborate village-within-a-village of small wooden shanties and tents. Through the kinetic accumulation of image fragments, Child produces a geography of the neighborhood as a liminal space that exists somewhere between the concrete urban environment and a postapocalyptic landscape in the process of returning to nature where there is no distinction between indoors and outdoors.

Within the rubble of crumbling buildings, trashed cars, and empty lots overgrown by weeds, there is human life. Child films people fixing cars, washing clothes, talking, making love, drinking, playing. Kids are riding bikes; others are selling goods in sidewalk flea markets. Contrary to the standardized liberal-humanist image of poverty as a state that is endured in silent abjection, this film shows the neighborhood to be teeming with life and activity. The film focuses on an unnamed black woman through whom we learn about the complex and layered relationship between the materiality of her outer life on the street and her complex inner world. She is first observed sleeping. She is lying outside, uncovered, and the shadows of tree leaves gently caress her face. Child emphasizes the sensuality of the woman, the light and shadow. As the fragmented montage continues, the quiet and recurring image of the sleeping woman suggests dream states and invites the viewer to contemplate the possibility of an interior world, not as a respite from the harshness of her outer world, but as one that is an integral part of it. Rather than producing a single narrative plot that sorts the daily life of a homeless woman into an easily comprehensible trajectory, Child suggests an array of possible narratives and dramatic events that could be fantasy, dream, or real experience. These are presented in bits and pieces and often simply evaporate into the rush of imagery. Narrative elements here are used not to "sort things out" but rather to suggest just how complex the lived experience of homelessness might be. This radical fragmentation produces a form of speculative knowledge that never allows one to be seduced into the complacency of getting the complete picture or whole story and opens up the possibility of other sorts of knowledge through a kind of perceptual defamiliarization.

Child never allows the complexity of the social problem of homelessness to be shoehorned into the illusionistic verisimilitude of a whole picture or whole story by completing the images with contextualizing voice-overs or interviews. As part of this process, the film eschews language as a means of explaining and encapsulating the images. Still, it is very much a sound film. The sound track is a kind of musique concrète that creates a montage of overlapping urban sounds from the street, snippets

of various kinds of instrumental music and conversation, emphasizing the kaleido-scopic sensorium of the urban body.

At the same time, Child uses her distinctive style of fragmented montage to pro-duce a speculative and multifaceted psychological space of the experience of home-lessness. The film is structured as a fugue between the inquiring gaze of a distanced camera looking in at the social reality of an actual homeless encampment and a por-trait of fictional characters who move in and out of it. This is not simply the mixing of fact and fiction, as in the "docudrama"; rather, Child liberates the virtual from the actual of the indexical descriptions of the neighborhood and encampment. The film shows the multiplicity of forces at play within the actual. In this sense, "the virtual is not opposed to the real, but to the actual. . . . Indeed, the virtual must be defined as strictly part of the real object—as though the object has one part of itself in the virtual into which it plunged as though into an objective dimension" (Deleuze, *Dif-ference and Repetition*, 208–9).

Child creates a virtual portrait of one of its inhabitants in which her inner world of dreams, desire, and memories becomes indistinguishable from the world around her. By speculating on the subjectivity of a woman of color who also appears to be middle-aged, Child further insists on the need to represent female desire and experi-ence, which are at best marginalized or most often simply ignored. As such the film is linked to the tradition of feminist and formally innovative filmmakers such as Maya Deren (*Ritual in Transfigured Time*, 1946) and Chantal Akerman (*Je, tu, il, elle*, Bel-gium, 1974). As do Deren and Akerman, Child integrates fictional characters and narrative events with the quotidian to reveal aspects of women's lives that are less empirically accessible. In this way, *B/Side* moves beyond the representation of people without homes as merely marginal victims of social inequity and political injustice to show them as desiring subjects capable of being part of the world. Here we see how desire can be a productive force, creating the potential for new political configurations and alternative communities.

Child constructs a multiplicity of subjectivities in the unnamed woman charac-ter, who is seen as having a number of possible identities, suggested by a range of pos-sible narrative episodes that suddenly start up and end just as abruptly. In one, she is a working woman dressing up and leaving the encampment, briefcase under her arm, boarding a bus (Figure 23). At other times she is hanging out on the street buying used shoes, washing her feet at a fire hydrant, or taking food handouts from a Salvation Army truck. In another there is some sort of security guard moving through the neigh-borhood and encampment, checking doors and locks and harassing her. There is much innuendo of sexual harassment between the two, which just as easily folds into the possibility of a romantic liaison between them. Child is constantly juxtaposing dehumanizing images of power with other moments of the rehumanizing imagery of everyday life. Color images of the police hassling people, locked doors, bulldozers plow-ing encampments into the ground, and buildings on fire are intercut with black-and-white images of people playing, gardening, and salvaging junk to resell. Sexual desire,

fantasy, and the need for intimacy persist even though they are set against the constantly exposed environment of life out-of-doors. The figures of two women, one black and the other white, keep reappearing throughout and, in turn, are seen playing, fighting, and making love to each other. Just as suddenly the sleeping woman may appear as part of the tryst.

Child uses these narrative fragments to create a highly complex image of the ways a social problem such as homelessness can be understood. In her film, the idea of the truth of this event is no longer solely defined by distinctions such as what "actually" happened and what did not, but rather between what actually happened and all the other forces that remain virtual as part of an ongoing understanding of the event. In *B/Side,* the actuality of the daily life Child documents on the streets and her staged fragments of situations in which the characters might find themselves are freely combined until they become indistinguishable. Deleuze describes the undecidability between what is true, what was actual, and what is potential in an event to be the "powers of the false."

> The actual is cut off from its motor-linkages [the illusionistic verisimilitude of a constructed reality], or the real from its legal connections, and the virtual for its part

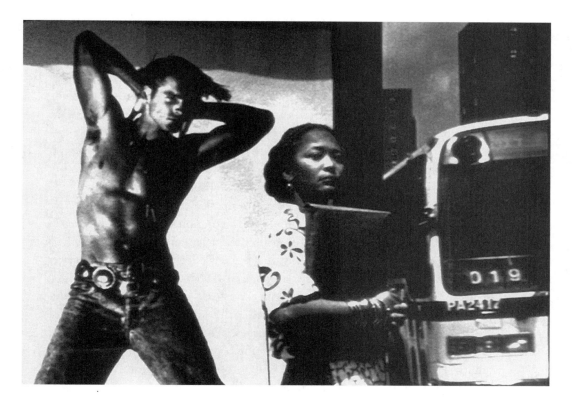

Figure 23. *B/Side* (Abigail Child, 1996). Photograph courtesy of Abigail Child.

detaches itself from its actualizations, starts to be valid for itself. The two modes of existence are now combined in a circuit where the real and the imaginary, the actual and the virtual chase after each other, exchange their roles and become indiscernible. (*Cinema 2*, 127)

By contrast, in the traditional documentary, such "powers of the false" are clearly demarcated through illusionistic means as distinctions between what is actual and imaginary (as in realism). Here claims to truth exist solely within the establishment of a verisimilitude called "the actual" in which narrative truth is authorized by whatever evidence can be established through the use of documents, testimony, and artifacts. This becomes a productive way to distinguish the traditional forms of narrating historical events in cinema from a work like *B/Side*, which allows the indiscernibilty between the actual and virtual to be an integral part of what it is to understand an event.

Such a notion "replaces and supersedes the form of the true, because it poses the simultaneity of incompossible presents, or the coexistence of not-necessarily true pasts" (*Cinema 2*, 131). In this context, Deleuze's use of the term "incompossible" expresses his notion of the coexistence of divergent but equally possible events that are contained within a given narrative.[11] Like the people in *B/Side*, whose lives are in constant flux, the film creates situations in which the viewer's perceptions are also in flux, never allowing them to settle into a singular discourse of true-versus-false reality. *B/Side* uses "the powers of the false" to infect rhetorics of truth claims, so important to the authority of much social documentary, with a myriad of facts, speculations, imaginings, and desires, with all their complexities.

The experience of indiscernibility links *B/Side* to Eisenberg's *Persistence* in the sense that they both embody aspects of Deleuze's crystalline regime. In the case of *Persistence*, it is the temporal demarcation of past and present that becomes indiscernible, releasing "the pure force of time which puts truth into crises" (*Cinema 2*, 130). In *B/Side*, it is the indiscernibility of lines between fact and fiction within an event—the history of Dinkinsville—that also throws truth rhetorics into crises.

Throughout *B/Side*, Child returns to images of the sleeping woman as a narrative sign for the temporal disruptions of the film's fragmentation. The image of sleep is experienced as a temporal release from linearized narration and opens onto the virtual, producing relationships between individual desire, collective memory, and larger notions of history. We begin to see archival footage of what appears to be a colonial past. Images of the tropics, peasants working in cane fields, young girls in school uniforms filing into a school (Figure 24). At times Child juxtaposes similar images of daily life in present-day New York with past images: people dancing in the street and folk dances from past rituals, or the police arresting people and the military rounding up peasants. Through these images, Child is able to suggest a political history that connects with the woman's present circumstance. Through these images of a colonial past, the woman is seen as a subject of history and not simply a victim of her own lack

of agency. In these images made in an earlier time, Child refers to a prior historical situation, but one in which there is still a sense that the fate of an individual could be linked with that of a whole people. In the modern situation, this becomes more difficult. While the conditions of homelessness can certainly be seen in relation to race and class, these categories do not indicate an individual's connection to any kind of a whole. The act of displacement and emigration alluded to in these images begins to signify—politically—the breaking up of social relations in which individuals in a given situation can be defined in relation to a whole people.

In this sense, when Deleuze writes of a modern political cinema in which "the people no longer exist, or not yet . . . the people are missing" (*Cinema 2,* 216), he is referring to a cinema that acknowledges the crisis of postcolonial displacement, which in the case of *B/Side* has resulted in the nameless and faceless image of homelessness. With this film, Child can be seen to have attempted a new kind of political cinema that rethinks its representation not by reinstituting the humanistic idea of a "name to every face" (of which one can be stripped at any time—as in the Shoah, when people were by decree stripped of an individual identity), but rather by instituting one that, as Deleuze suggests, is "contributing to the invention of a people" (*Cinema 2,* 217). That is to say, Child's film acknowledges the potential for people coming together to form new relationships and communities that might reconfigure the notion of loss implied in histories of displacement. Not reflecting but inventing is the fundamental difference between the aesthetic and social science approaches to historiographic representation and opens onto a new idea of what political filmmaking might be. As Deleuze writes:

> Art and especially cinematographic art, must take part in this task: not that of addressing a people, which is presupposed already there. . . . The moment the master, or colonizer, proclaims 'There have never been people here,' the missing people

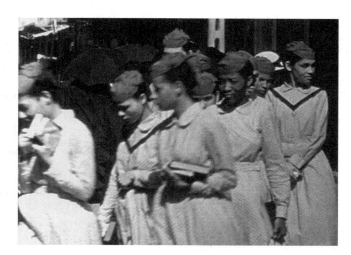

Figure 24. *B/Side.* Photograph courtesy of Abigail Child.

are a becoming, they invent themselves, in shanty towns and camps, or in ghettos, in new conditions of struggle to which a necessarily political art must contribute. (*Cinema 2*, 217)

The fragmented world of *B/Side* deterritorializes the space of the urban environment and creates an image of a people living together without traditional boundaries between what is understood to be private and public space and urban and rural space. This opens the possibility of thinking differently about social configurations that must be constantly and creatively rethought and reinvented. Central to this is the image of the Lower East Side as a space that exists between the highly developed first world as in the concrete urban world of New York City and the underdeveloped third world shown in the archival footage. We see the ruin of the neighborhood not as a dying city but as a living world reemerging through the rubble, and through this the potential of renewal. There are images of people gardening in empty lots, performing domestic tasks—washing their clothes and themselves out in the open. We see people living among the trees and bushes in empty spaces that are transforming into forests. Child places these images next to more idealized images of nonurban environments of the tropics where we see picturesque vistas of palm trees and rural village life, producing a renewed sense of continuity between the woman's fantasy of an idealized past and her present. Thus the film produces readings that also suggest the potential for new kinds of community in the midst of the great economic imbalances of a city like New York. It suggests new possibilities for the notion of *home* in a city in which the privatized, locked-down world of the urban North gives way to more open and collective ways of living. In producing this kind of deterritorialized environment, the film imagines this neighborhood as a settlement in which civilization is not ending but beginning again.

This is not to suggest that Child's film romanticizes the squalor of one of the poorest communities in New York City, or the brutality of urban policies toward the poor. The film ends with shots of the police marching into the area to reclaim it for the city. A bulldozer is seen razing Dinkinsville, returning the once-inhabited encampment to a useless vacant lot. Rather, Child uses the utopian impulse of creative art making to move away from the iconography of hopelessness and impossibility that stands for urban homelessness, most often seen in the liberal imagination. It is an iconography that seems only to make society feel passive in its helplessness to effect social change and to simply feel lucky not to be in the same situation.

While the film shows that the inhabitants of Dinkinsville failed to create an ongoing and more permanent community, its brief existence raises the possibility and shows the need for countercommunities in the face of the enormous powers of the state. *B/Side* narrates the failed events of Dinkinsville in a way that allows the community's success, which remains virtual, to have play. The film helps us to imagine the possibility of turning the abjection of poverty into positive and even innovative forms of community where people are actively engaged in creating their own lives. It not

only shows the potential for the medium of cinema to render social problems in all their complexities but also produces a powerful image of the potential for new forms of community.

Utopia

In *Utopia* (1998), the filmmaker James Benning takes the idea of "potential histories" even further into the realm of the virtual, focusing less on what is possible to actualize than on the complex interplay between events that actually did happen and what can be imagined or desired in relation to them. *Utopia* is a "virtual history" of Che Guevara's guerrilla campaign in the southwestern United States. Like Child in *B/Side,* Benning uses the plasticity of film to create a play of new combinations of sound and image. Simultaneously, through recombination, he constructs history as a complex interplay between "what actually happened" and the virtualities and imaginings to which such events give rise. In *Utopia* Benning places the entire sound track from a 1998 Swiss documentary that recounts the events of Che Guevara's failed 1966–67 Bolivian campaign around his own images of the desert in the southwestern United States. The opening image from *Utopia* is the following intertitle:

> Except for some additional ambience, the entire soundtrack has been taken (without permission) from: documentary *Ernesto Che Guevara, The Bolivian Journal,* a film by Richard Dindo. The images were found in the desert landscape from Death Valley south to and crossing the Mexican border. (Benning, *Fifty Years to Life,* 211)

The Dindo sound track narrates the final year of Che's life, in which he leaves Cuba in 1966 to create a guerrilla movement in Bolivia. Hearing the Dindo sound track over Benning's own lushly textured, static, and largely unpopulated landscapes, one can begin to imagine Guevara and his soldiers, Coco, Rolando, Pombo, Tuma, Tanya, Regis Debray, Willi, and others, crossing beautifully empty desert washes and scrub fields, graveyards and back roads, marching through the growing fields of U.S. agribusiness, the outskirts of the tiny towns in California's Imperial Valley, shooting it out with state troopers while trying to enlist the unseen Mexican migrant workers to fight for their own liberation. Absurd, perhaps, but certainly delicious.

Using Guevara's own posthumously published diary and interviews of surviving Bolivian soldiers and peasants as a voice-over, the sound track recounts the final months of the campaign in which Che's small army is surrounded by the Bolivian army and slowly destroyed. He is finally caught and summarily executed by orders of the Bolivian army and the CIA. From the sound track, we learn of the events of Che's final days; we hear a reading of his personal observations and descriptions of the hardships of guerrilla warfare, his relationships with his men, and encounters with the Bolivian peasantry for whom he claims to be fighting. The diary imparts a sense of how profound his own idealism and commitment to peasant revolution are in the face

of the miscalculation and ultimate hopelessness of his enterprise. Through the interviews and Guevara's own comments, we learn that the guerrillas have little active support from the Bolivian peasantry; his diary entries recount the growing isolation. On one day, Guevara hears on the radio a report of his own death. He acknowledges the loyalty and commitment of his diminishing band of guerrillas. Even after he is captured—wounded and shoeless—hours before his execution, Guevara still articulates his idealism. A young schoolteacher in the village of Higuera, where Guevara was being held, recounts his last hours promising her a better future with modern schools, tractors, and roads. Later that day, October 17, 1967, at one o'clock in the afternoon, Che Guevara was executed. His body would be famously displayed for a press conference, an event explored by Leandro Katz in his film *El día que me quieras,* discussed in chapter 5.

In *Utopia,* the Dindo sound track becomes the voice-over narrative that surrounds a series of static landscape images filmed by Benning himself. The shots are made in the signature visual style of Benning's films, in which each is a compendium of static shots from a fixed position. He uses the uninterrupted shot not only to allow viewers to unhurriedly roam the landscape with their eyes but also to assert the materiality of the film's structure by foregrounding the real-time durational element of cinema. Again to foreground the constructed nature of the film's form, durations of shots are at times predetermined by an external rationale such as the length of a 100-foot (2:45 minutes) or 400-foot (11 minutes) roll of 16 mm film, the length of a text or a song, and so on. By doing this, Benning removes the impressionistic and subjective element of his film's construction while foregrounding aspects of his own subjective eye in the composition of each shot. The films are usually photographed in lush color with very few close-ups. Often there is little or no movement either by the camera or within the frame, which at times can blur the distinction between a still and moving image. In all his films, Benning is deeply interested in the photographic as opposed to the painterly; he rarely uses unusual color and motion manipulation in his film images. His compositions call attention to the flatness of the image and the illusion of perspective through the use of wide-angle lenses, natural light, and the limited depth of field of the 16 mm format. The fixed nature of his shots often emphasizes the edges of the frame by allowing moving objects, such as machines and living creatures, to traverse the screen, at times using natural ambient sound, voices, and other sounds to define off-screen space. Often the shots are self-contained narratives that unfold in real time without the shot–reverse shot or point-of-view angles of the traditional building blocks of narrative form. The fixed camera records an action taking place within the frame, and usually the shot ends when the action is complete.

In *Utopia,* the flatness and slowness of each shot allow the landscape to begin to mingle with the sound-image elements that are placed over the visual image. Here I am using the term "sound image" in the Deleuzian sense of certain relationships between sound and image within modern cinema, in which what is on the sound track has no direct relationship to the film's images, forming two separate narratives,

one on the sound track and another with the images.[12] The time-space continuum of each never coheres into a single image of a history or event. Instead they remain parallel. Holding them apart keeps each open to explore its individual elements as autonomous situations while at the same time pointing to their connection. As Deleuze suggests about such sound and image disparities:

> When the sound image and visual image become heautonomous [i.e., autonomous] they still constitute no less of an audio-visual image, all the purer in that the new correspondence is born from the determinant forms of their non-correspondence: it is the limit of each which connects it to the other. (*Cinema 2*, 261)

The noncorrespondence between the image of an empty and unpopulated Southern California landscape and the graphic descriptions of Guevara's Bolivian diary opens onto the virtuality of a revolutionary struggle where none has taken place. The historical incommensurability of the two moments in time—Bolivia, 1967, and Southern California, 1998—is brought together, creating a cinematic force field that allows for a double action: the description of the horrific actuality of Che's failed campaign continues to have its place in the past, while its success, which still remains virtual, is released to be discovered in other contexts. As with all virtualities, its strength is that it is not bound by the actuality of space, time, or possibility.

Separating sound track from image to create more discursive and complex relationships between the temporality of historical events and landscape has been explored in different ways in Benning's other films, most notably *Landscape/Suicide* (1986), *North on Evers* (1991), and *Deseret* (1995). But rather than using image and sound to reveal incommensurable gaps from which virtual relationships emerge as in Utopia, sound and image are more often bound together in an attempt to inscribe a specific place with historical meaning. An example of this strategy is the historical landscape film *Too Early, Too Late* by Jean-Marie Straub and Danièle Huillet (West Germany and France, 1981), which begins by using a similar strategy of placing voice-over texts describing a history over landscape images in the present. *Too Early, Too Late* comprises two movements. The first explores the rural landscape of the present-day French countryside. The voice-over is a reading of a letter sent by Friedrich Engels to Karl Kautsky, who describes the horrible conditions of the peasants in the countryside on the eve of the French Revolution. The second movement shows a present-day landscape documenting daily life in Egypt. The voice-over text by Mahmoud Hussein analyzes the peasant resistance to the English occupation until the revolution of Neguib in 1952. The film's title refers to the revolutionary failure of the peasants, who in both cases revolted too early and succeeded too late to gain power. In the film, the visual image explores the sites that are being referred to in the texts, and in this way the past events are inscribed into an image of the present. This kind of inscription raises the question of whether or not past events inhere in the landscapes in which we live—even if there is no material evidence of the events themselves. The contrast between

Engels's and Hussein's highly analytical treatises and the poetically lyrical images shows the dialectical relationship between the discourse of history and its relation to nature as something untimely that repels narrativization.

Similar, but even less discursive, is Dindo's own film *Ernesto Che Guevara, the Bolivian Journal,* the film from which the sound track for *Utopia* comes. In this film, Dindo goes to Bolivia and retraces Guevara's footsteps during his guerrilla campaign, using a subjective camera to simulate his march through the mountains. The hand-held, point-of-view camera work simulates what Che must have seen, evoking and authenticating the forbidding environment in which he and his comrades struggled. At the same time, the first-person camera also seems to legitimize the filmmaker's authority as historian, as the film becomes a document of his own struggle to make the film in this difficult terrain. In most cases, however, the image is simply used to illustrate the places that are being spoken and written about. In the case of both *Ernesto Che Guevara, the Bolivian Journal* and *Too Early, Too Late,* the filmmakers employ the indexicality of the cinematographic image to verify their narratives through the image of the places where the events occurred. The images of the landscapes in the present appear to give material substance to the past events being described as a way to reveal them in the present. This can be seen as a quintessentially modernist act of revelation in the sense that the landscape is regarded as a repository of the memory of past events that can be "rendered visible" through aesthetic mediation.

In contrast, *Utopia* makes few claims for a spatial and temporal verisimilitude between its narration and images. Rather than a verisimilitude, the film produces virtualities that have little to do with the possible. History becomes a space of imaginings and desire. In this sense, the film's title, *Utopia,* refers not only to the utopian promise that is embodied by the figure of Che, or the utopian desire of a Southern California filmmaker who longs for social justice, but also to the activity of history that can be something more than creating representations that merely get the "facts" right. In *Utopia,* we are seeing Southern California of the late 1990s, where the crisis of Mexican undocumented workers "illegally" entering the United States to look for work is a direct reflection of the economic underdevelopment and exploitation of Mexican workers in a globalized economic order. The vast emptiness of Benning's border landscape stands as a specter of the uneven development between first- and third-world economies and its draconian effects on the Mexican poor who risk their lives crossing the border to find jobs in the wealthy Southern California service industry as maids, gardeners, busboys, and waitresses, or passing back and forth between the two countries as seasonal laborers.[13] The empty, unpopulated landscape also evokes the invisibility of these people who are hiding from the immigration police and the bandits who prey on them. Their invisibility is also a result of their own displacement from their communities in Mexico and their homelessness in the United States, which makes it nearly impossible for them to become part of new communities as legitimate immigrants. This invisibility further makes it impossible for them to be protected by laws against labor exploitation or to use the social services that their labor is paying

for in the taxes taken from their wages. As part of a final intertitle that ends *Utopia*, we read:

> On August 13, 1998, the severely decomposed bodies of seven undocumented Mexican farm workers were found under a grove of salt cedar trees about seven miles from the main highway north. They had been kept in a "safehouse" in El Centro and then were driven into the desert and abandoned by the *coyotes* they had paid to bring them across. During the past three years more than 100 illegals have been found dead trying to enter the U.S. through the Imperial valley. (Benning, *Fifty Years to Life*, 236)

Deleuze defined the modern cinema in terms of "the breakup of the sensory-motor schema," which gives rise to situations "to which one can no longer react, of environments with which there are now only chance relations, of empty or disconnected [abandoned] any-space-what-evers replacing qualified extended space" (*Cinema 2*, 272). Such films, to continue his formulation, are pure optical-sound situations in which one doesn't quite know how to respond. Watching them, the viewer finds that there are no longer narrative actions to interpret; rather, the viewer becomes a seer of images. Deleuze defines classical political cinema—Eisenstein's *Battleship Potemkin* (1927), for example—as a cinema that can depict a unified people capable of rising up to transform their world. He suggests that in "American and Soviet [classical] cinema, the people are already there, real before being actual, real without being abstract" (216). For Deleuze, the rise of fascism, the tyranny of Stalinism, and the breakup of a notion of a unified American people make it impossible to create an image in which the "masses" can "believe themselves to be either the melting-pot of peoples past or the seed of a people to come." In the modern cinema, the image of "the people" can no longer be constituted as a whole; hence the notion that "the people no longer exist, or not yet" (216). In *Utopia*, Benning's creation of such "pure optical-sound situations" locates the "action" in the mind of viewer, unlinking the indexical from the actual, allowing free play between the viewer's desire and what is seen and heard. In this sense, the film allows the viewer to *think into* the image other possibilities for what could be seen or what must be seen and heard, rather than what could be actualized. This is central to Deleuze's notion of a modern political cinema. He writes: "It is as if modern political cinema were no longer constituted on the basis of a possibility of evolution or revolution, like the classical cinema, but on impossibilities in the style of Kafka: *the intolerable*" (219). For Benning it is the specter of the deaths of hundreds of Mexicans being killed in their search for work—a result of the great disparity of wealth and resources that has become "the intolerable" and gives rise to the hope of the not-yet-realized.

Utopia hauntingly raises the specter of the failed histories of the great struggles of Latin America against colonial and imperial dominance since the conquest of the Americas. The California landscapes that poor Mexicans now move through as "illegal aliens" once actually belonged to Mexico, and by 1998, most of the revolutionary struggles for self-determination throughout the twentieth century had been defeated

either by military might or through corruption or institutionalization. An image of a makeshift graveyard dotted with wooden crosses becomes a figuration for the lost as well as what is not yet realized (Figure 25). Surrounded by the narrative of Guevara's Bolivian diary, the emptiness of the landscape also signifies the unlimited potential for a different meaning and a new history of a future that has not yet been determined for these exploited poor. These multiple and even contradictory ways of thinking about the past both in its actuality and in its virtuality go beyond the idea of historical materialism, in which one finds the past in the present, or even as part of an archaeological or forensic historiography; rather, to consider the virtual allows for elements that are also overtly imaginative, generative of new possibilities.

The film's utopianism also strives to see history as a "resource of hope" for the present, to paraphrase both Raymond Williams and the cultural geographer David Harvey.[14] Such cinema creates images of historical events that produce a space for historical imagining. In his book *Spaces of Hope,* written in 2000, Harvey rightly rethinks the familiar Gramscian adage "pessimism of the intellect and optimism of the will" in light of the current global political situation. He writes: "I believe that in this moment in our history we have something of great import to accomplish by exercising an optimism of the intellect in order to open up ways of thinking that have for too long remained foreclosed" (17).

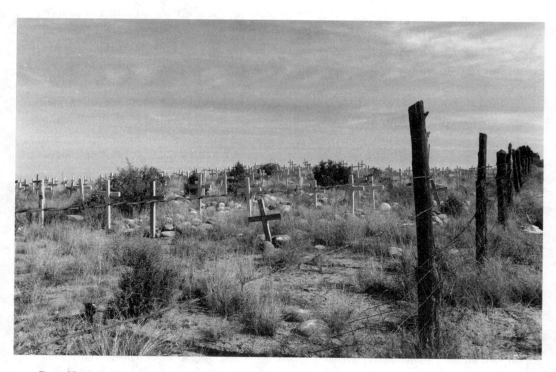

Figure 25. *Utopia* (James Benning, 1998). Photograph courtesy of James Benning.

In *Utopia,* Benning abandons the spatial verisimilitude between events that took place in 1960s Bolivia and the empty spaces of 1990s Southern California as a marker of historical reality and engages in what Harvey refers to in his discussion of utopian social planning as "spatial play" (159). In the case of urban planning and architecture, Harvey sees spatial play as a utopian practice that can open up the possibility for new and productive alternative social formations of urban spaces. He looks at the "relationships proposed between space and time, between geography and history," and characterizes imagined relationships between them as "utopias of spatial form." Spatial play, then, proposes an "infinite array of possible spatial orderings [and] holds out the prospect of an infinite array of possible social worlds" (161). In *Utopia,* Benning engages in a cinematic form of spatial play by placing the specter of Che Guevara's Bolivian revolution in the context of the Southern California landscape as a way to think new possibilities for social transformation no longer bound by the limitations of space and time. All the while, he makes the viewer keenly aware of the incredible difficulties of such an idea through the visual exploration of the specific time and geography in which his virtual revolution took place. In *Utopia* it is not so much that such a revolution seems impossible; rather, it seems ridiculous.

But the ridiculous, absurd, surreal, and impossible are the realm of art, not history. This is central to the utopian aspiration that art could enter the realm of politics and transform not just consciousness but the world. The situationist concept of *détournement* can also be seen as a form of utopian spatial play. It begins as a political act of theft (without permission), or as the Situationist International put it:

> The re-use of pre-existing artistic elements in a new ensemble. . . . The two fundamental laws of *détournement* are the loss of importance of each *detourned* autonomous element . . . and at the same time the organization of another meaningful ensemble that confers on each element its new scope and effect. (Knabb, *Situationist International Anthology,* 55)

The act of *détournement* is at once an act of negation and revitalization. In the most idealistic terms, it devalues the notion of the unique object and says that nothing is so important or sacred that it cannot be appropriated and transformed into something new and relevant to the current political moment. *Detourned* elements taken from anywhere can serve to create new combinations and meanings. This can also be used as a form of civil disobedience, openly violating notions of ownership and copyright laws. In all of these ways, *Utopia* can be seen as an act of *détournement* in the tradition of the politically engaged rhetoric of the situationists. Benning openly announces his expropriation of the Dindo sound track without permission, ironically challenging the producers and distributors to make an issue of his use of their material about the "great Communist" Che. Guy Debord wrote that *détournement* is "the first step toward a *literary communism*" (Knabb, 11). At the same time, Benning is engaging one of the biggest current legal debates in the cultural sphere, the "fair use" of

intellectual property. In *detourning* the sound track of a mediocre historical documentary that in itself has little current political value (since it makes few links to any contemporary political situation in Bolivia or elsewhere), Benning attempts to use the materials in a more clearly relevant and politically partisan manner by connecting them to a current political situation—another basic tenet of situationist *détournement*. This links *Utopia* more directly to other films such as the previously discussed *Tribulation 99* by Craig Baldwin, as well as the situationist René Viénet's *La dialectique peut-elle casser des briques?* (*Can Dialectics Break Bricks?*) (1973), in which he replaces the sound track of *The Crush,* a ninety-minute kung fu film made in Hong Kong, with an altered sound track that became, in its time, an ironic critique of the failed post-1968 left-wing political movements and ideologies. In all three films, the impulse is to engage current political situations by revivifying older material that has little relevance in the present of the new film's production. The desire is to engage historical material and events with current political situations that distinguish this kind of *detourned* material from other examples of films that use appropriated and found materials. For example, as previously discussed, the work of Bruce Conner, Ernie Gehr, and Ken Jacobs uses techniques similar to *détournement,* but to different and less overtly politically charged ends.

Perhaps *Allemagne année 90 neuf zéro, Persistence, B/Side,* and *Utopia* can all be seen as examples of a new kind of political cinema to emerge at the end of the Cold War, when binaristic discourses distinguishing between truth versus fiction no longer carry the same aesthetic and political weight of previous moments. These films challenge many of the concepts and prescriptions for the "proper," politically engaged nonfiction cinema handed down from earlier political modernisms and social realisms. In the current context, such strategies can be seen to give too narrow a vision of historical events that determines only what is right or wrong and what is or is not possible. In contrast, the experimental films I have been exploring perform the important function of creating a distinction between knowledge and thought. "Thinking or thought is defined not by what we know, but by the virtual or what is unthought. To think, Deleuze argues, is not to interpret or to reflect, but to experiment and to create" (Rodowick, *Gilles Deleuze's Time Machine,* 198). To see art as linked to a kind of virtuality—as are politics—is to see both as producing the potential of what is not yet available, that is, a relation of not-yet-realized forces that are placed in motion by the work of art. To struggle with this through cinema within its current cultural and economic confines also offers the utopian possibility of unpredictable *becoming.* In this new political cinema, the past and the present, successes and failures, what actually happened, what might have happened, and what has not yet happened surround each other in a mind-expanding dance of what was, what is, and what if.

4. Specters: The Limits of Representing History

It was terrible. No one can describe it. No one can re-create what happened here. Impossible? And no one can understand it. Even I, here, now. . . . I can't believe I'm here. No, I just can't believe it. It was always this peaceful here. Always. When they burned two thousand people—Jews—every day, it was just as peaceful. No one shouted. Everyone went about his work. It was silent. Peaceful. Just as it is now.

—SIMON SREBNIK, in *Shoah*

So says Shoah survivor Simon Srebnik, standing in a green and lush open field in Chelmno, Poland. The combination of the deadpan look on his face as he is speaking and the inert, pastoral quality of the landscape, both of which seem to be covering up more than we can imagine, makes the possibility of representing what Srebnik experienced as a thirteen-year-old boy seem impossible. As the scene in Claude Lanzmann's film *Shoah* (France, 1986) continues, the camera records the empty field as Srebnik walks silently through it. His seeming inability to put into words the connection between what he is seeing and the memory of what he experienced in the past creates the silence. Clearly the sights and experiences of the Shoah were so dreadful and immense as to make them at once unforgettable and impossible to describe or re-create. To try, as one argument goes, would only be a feeble and impotent attempt that would fall short of what happened, would trivialize the experience of what happened and its implications. The story is always irreducible to events that occurred. On the other hand, the need to tell, to try to explain, to document, lest each of us and the world forget what happened, has been the challenge of many writers and artists. As the Jewish writer and survivor of the camps Raymond Federman contends:

The writer, however, the Jewish writer at any rate, cannot, must not evade his moral responsibilities, we are told, nor can he avoid dealing with his Jewishness. It is demanded of him. And the writer himself feels obligated to tell and retell the sad story, lest we forget. He must become the historian of the Holocaust. He must tell the truth—the "real story." But how? That is the fundamental question that confronts us today. ("Displaced Person," 86)

But how, indeed. As one attempts to represent such an event, its reality becomes harder to imagine rather than less so. It is a contradiction, since to represent such is to make it imaginable, rendering it apprehensible and thereby mitigating its enormity. Can there be events that by their very nature defy all the forms that our culture uses to relate them? Hayden White asks in relation to the study of Nazism and the Final Solution:

Are there limits on the *kind* of story that can responsibly be told about these phenomena? Can these events be responsibly emplotted in *any* of the modes, symbols, plot types, and genres our culture provides for "making sense" of such extreme events in our past? ("Historical Emplotment," 37)

Even aside from the question of Jewish responsibility to tell what happened to European Jewry, the reality of more than fifty million victims—of which, six million Jews were killed in industrial genocide during the years of World War II—created a shift in how the history of Western culture might be thought and represented. The possibility of contextualizing such events as either historical or fictional narratives that are part of an ongoing progressive, narrative project of European culture has been called into question. The event of the Shoah, then, has become a break or a fissure with past forms and practices of historical representation. One divides European history into a before and an after. What we are left with are fragments and signs that something happened without a clear narrative sense of what they refer to. What remains are indeterminate and contested meanings, opacities, and eventually silence, since there can be no representational consensus about exactly what occurred. In other words, in its unspeakability, its obscured visibility, and gaps in narration, the Shoah has rendered the limits of its representability. It would therefore be impossible to accurately explicate such an event without including these silences, opacities, and gaps, which have no apparent content, as part of the fabric of the telling. For artists and historians sensitive to representational aporias, such an event not only creates philosophical and ethical problems but also presents new formal and aesthetic ones as well. How does one speak the unspeakable, make clear what is opaque, understand what is not understandable, when the limits of linguistic and representational forms are the only thing that *is* clear? It is here that the search for adequate strategies that could take into account the aporias of such an event becomes necessary.[1]

Artists for whom taking into account the aporias in an event like the Shoah is essential start from the position of silence and incomprehension and work within it rather than trying to overcome it. Their work raises more questions than it answers.

Lanzmann's ten-hour film is one of the few on the Shoah that include, as part of their content, the process of finding a form for representing the unrepresentable nature of the event. The film's process reveals the limits of what can be known. What gets thoroughly undermined in this sprawling investigation is the possibility of the closure of an event through the catharsis of its telling. In *Shoah,* Lanzmann makes the possibility of a seamless passage through the material so difficult (both emotionally and intellectually) that we come to see that no matter how hard we study and investigate these circumstances, we end up only with more questions. After all, how can one understand the murder of six million Jews, or twenty-five million Africans in the slave ships of the Middle Passage, or countless indigenous people during the colonization of the Americas? *Shoah* is about these limits. It is a ten-hour process that works against the very possibility of being able to gather enough information to draw conclusions about occurrences whose implications continue to reverberate well beyond the event itself. This shows that any attempt to understand it is a process that continually opens onto itself rather than forming closure. In fact, Lanzmann, a European Jew, who spent over eleven years of his life plumbing the depths of the event called the Jewish Holocaust, puts it in even stronger terms when he talks of the "obscenity of understanding." He says:

> Is it enough to formulate the question in simplistic terms—Why have the Jews been killed?—for the question to reveal right away its obscenity. There is an absolute obscenity in the very project of understanding. Not to understand was my iron law during all 11 years of the production of *Shoah.* I clung to the refusal of understanding as the only possible ethical and at the same time the only possible operative attitude. This blindness was for me the vital condition of creation. Blindness has to be understood here as the purest mode of looking, of the gaze, the only way to not turn away from a reality which is literally blinding. (Quoted in Caruth, *Trauma,* 204)

For Lanzmann, it is the acknowledgment of the opacity of his subject that allowed him to try to make something out of nothing. It allowed him to confront the silences and fragmented memories of the witnesses who experienced the Shoah in ways that someone with a preconceived concept of what happened would not be able to do. The structure of the film moves from fragments of testimonies of the perpetrators to the victims and bystanders whose experiences of the same events are so different as to be incommensurable. It is due to Lanzmann's acknowledgment of the opacity of what is said and heard that, even after ten hours of this kind of fragmented testimony, the film does not yield any totalizing truths, or even any theories, about what happened.[2]

Signal—Germany on the Air

Another, and perhaps more radical, approach to the limits of representability of an event like the Shoah is the film *Signal—Germany on the Air* by Ernie Gehr (1982–85). In this film, Gehr has moved his cinema away from traditional conventions and

languages of cinematic signification such as storytelling, drama, autobiography, and documentary forms. For him the drama of cinema occurs in the way the camera and lens system sensitizes light on the film stock, and in the way the projector transforms these traces into recognizable—and often unrecognizable—reflections. This process of transformation presents philosophical questions about the limits of meaning and of what can be seen. As the film historian Tom Gunning writes:

> As full of surprise and energy [as his films are] . . . Gehr accesses it [meaning] through acts of *ascesis,* refusing the immediate possibilities of representation the motion picture camera delivers. The discoveries Gehr offers are purchased by acts of constriction, a focusing of attention through techniques of discipline, a concentration and silence. Infinity is only reached by a thorough mining of the finite. ("Perspective and Retrospective," 4)

In many of his films, Gehr limits the visual and sonic to just a few elements in order to make each element's relationship to another distinct. This allows the viewer to focus more deeply on the workings of the cinematic and the ways in which it acts on the body. As Gunning suggests, Gehr's films discipline the body to focus on what normally are the most transparent elements of the film experience: the passing of time, light, filmically created movement, as opposed to real-time movement, among others. This is a rigorous process that strips away any extraneous elements. It produces a form of *attention* that heightens our awareness of what we are seeing and hearing, bringing us to the point of sensing what is *not* being seen as much as what is.

Producing this kind of extreme attention in the viewer is central to the formal processes of *Signal—Germany on the Air.* The film begins as a study of an intersection—where four or five streets converge—in contemporary West Berlin (Figure 26). The intersection is rendered as a series of short shots that cut between different positions around it. Each cut is separated with a white flash frame, turning each shot into a distinct entity. This is not montage, which works to connect the shots through juxtaposition; rather, Gehr keeps them separate, making a visible gap between them, allowing the light of the projector to create a space between the shots. This forms a catalog of shot groupings rather than a sense of shot fragments adding up to a whole or singular impression of the street. As the shots accumulate, they begin to create a multifaceted portrait of the intersection. The effect is crystal-like, each shot its own facet. Some shots combine movements that come from the camera panning horizontally. Other movements are from cars, buses, and people moving in the frame. Sometimes movement is created from a combination of both. The ambient sound comes from the street. As the film continues, we become more familiar with this intersection and its contents, the signs, the shops, the trees, and so on. Since we are not deliberately guided to specific sights as a form of explication or narration, our senses, out of a desire to create meaning, become sharpened by the absence of specific direction about how to read these scenes.

Through this kind of stripping away of context, a viewer is able to think about not only what is being seen and heard but also what is not. One becomes aware that despite the lack of action there is much to consider about what is represented in the frame: the weather, the time of day, the quality of light falling on the street, and the way it changes as the sun moves behind a cloud. There are signs and billboards that begin to place the space: this is a city in Germany. Conversely, with such prosaic renderings, it is also possible for boredom on the part of the viewer to set in. If one stays with the film as it unfolds, however, it is possible that this boredom can cause the viewer to become curious about why this intersection is being studied. As time passes, with the viewer watching, contemplating the images of the street, a sense of possibility of a particular meaning that this place might have begins to assert itself. There is a new sense of "eventness"; one may become aware that these images are generating thoughts that are attaching themselves to these images. But we see nothing of any significance. Perhaps the street corner is slow to give up its secrets. But *nothing* becomes *something* in the film's refusal to give up the nothing as something significant to the making of meaning. This emptying out of specific signification defies traditional forms of representation, which usually insist on the clarity of the meaning produced.

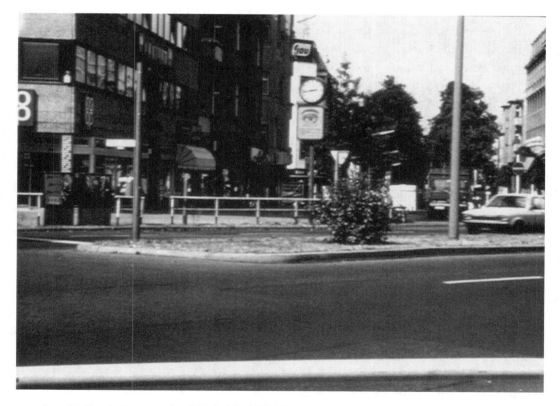

Figure 26. *Signal—Germany on the Air* (Ernie Gehr, 1982–85). Photograph courtesy of Ernie Gehr.

In *Signal,* the viewer slides into moments when the images and sounds of the film may be meaningless. But one can also experience a sense that meaning is being made of what is being seen and heard. Here clarity and opacity are not simply opposites but rather components for the production of meaning. Gehr insists that both be part of the experience of the film. In these moments, one is left to confront the bodily experience of the cinematic. This sensuousness is experienced largely through the film's duration. *Signal* contains a dialectic between the real time of the film's viewing and the constructed movement of time within the film, which is nonlinear and fragmented. The real time of the film passing through the projector *is* real time passing for the viewer. There is no diegetic time. Rather, time is observed in the lengths of individual shots and the changes in light. There is no indication that time is moving from a present to a past or a future; instead, the fragmentation produces a sense of the present in each image as it appears on the screen. At times there is boredom; at other times the temporal relationships between past and present—which must be deciphered—can be experienced as drama. Both are given equal importance.

The film cuts to another site. We see an open field, large buildings in the background. There is a similar visual style of non-match-cutting exploration of this site, though there is no sense of its spatial relationship to the streets that form the intersection. There is a large sign. Eventually we are able to read it in three different languages: "This was the site of a Gestapo torture chamber" (Figure 27). But in the context of the exploration of the site, the sign is decentered, a part of the landscape. Gehr places the sign in the frame in such a way that it is no more or less emphasized than any other aspect of the shot. But once we have read the sign, instantly everything is different. Now the landscape has a history; it has moved from being an empty *space* to a *site*. For me the film evokes a feeling that although it is the same space as before the sign was seen, everything about it is different. Like Srebnik's empty field in *Shoah,* it is the disparity between the inert quality of the space and the traumatic past to which the billboard refers that raises a specter of that past for which there is no image. There is no image for the indescribable acts once performed on this site, no image of those lost. The sense of a quotidian into which past and present flow is disrupted because a gap now exists between the familiar everydayness of life in the present and everydayness of a past now unimaginable. The billboard bears witness to the past of this site, which cannot be fully integrated into the present. The sign signifies something that is absent, opening a gap from which the specters of the dead emanate. The intangible presence in this gap creates an insistence that there *is* something that inheres in this site—a "signal on the air." That is to say, the gap signals the need for a new reading or interpretation of the space.

Again the film returns to the original street intersection. Now the sound track has moved from the sounds of the site to another space altogether. We hear the sound of a shortwave radio with the channels being changed, moving from one station to the next. This "signal—on the air" also removes us from the confines of a spatial site to a completely deterritorialized out-of-field position beyond it. The limitation of what

is seen created by the edges of the frame is overcome by the sounds of the radio and gives a sense of another space beyond. The constant changing of the channels moves us sonically through different spaces and times. As the channels change, we hear different European languages being spoken. Often the words locate us in different countries, or a piece of music will indicate a specific culture or place. At times we hear snippets of news reports that locate this out-of-frame space in history. It is not so much what the event is as the sonic timbre of the radio news report that creates the impression of an important event. Still the exploration of the street corner continues in the same manner as in the beginning. Moving away from the purely visual, the sound track places the viewer in several different spaces and moments in time simultaneously and starts a process of possible readings between image and sound. This, too, produces a gap out of which the specters of the past are thought and felt. The quality of the image changes from a view that is purely observational, which privileges visual relationships between objects within the frame, and also between shots, to moments in which what is heard is inscribed on the image. A piece of music changes the scene into a lyrical series of movements between cars and the lines and grid patterns of the street scenes.

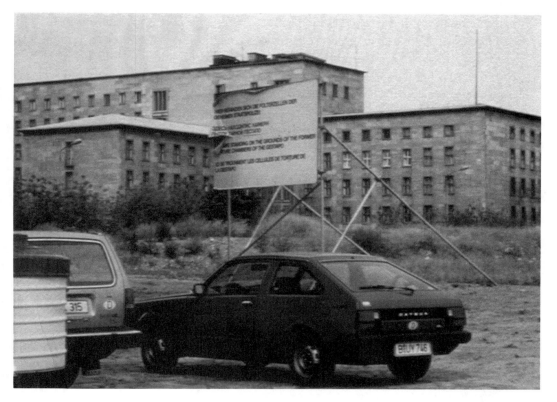

Figure 27. *Signal—Germany on the Air*. The sign reads in German, Russian, English, and French: "You are standing on the grounds of the former torture chambers of the Gestapo." Photograph courtesy of Ernie Gehr.

In another moment, a news report recontextualizes the city as a site that was once of global importance. At yet another moment there is a scene from an old British radio melodrama in which a couple discusses issues of guilt and blame. We hear the couple talking about some betrayal or crime having been committed, but it is not clear what. The relationship between this found narrative and the mundane scenes on the street begins to create a powerful interplay between the way one engages with the highly wrought elements of the radio drama and the quotidian nature of the street corner.

Again the disparity between what is heard on the sound track and what is seen in the image produces a spectral gap. Image and sound are fractured and do not add up, leaving the narrative incomplete and unable to cohere. The juxtaposition of the image and sound tracks raises questions of guilt and blame and infects the images of old people walking down the Berlin streets, which now seem poisoned by the specter of an unspeakable past (Figure 28). A discourse begins to emerge between three moments in time: the present of the street scene, its past as the site of a historical event, and finally the out-of-field moment of the radio drama. The visual and conceptual space of the film opens out onto vast possibilities for thought.

The film cuts away from the intersection to an old railroad yard. We see boxcars and railroad tracks leading away from the city. Railroad tracks and boxcars, once the figuration of modernity and industrialization in Europe, now evoke for many the mass deportations to the concentration camps. The train is now nearly anachronistic, a sign more of the past than of the present. These images of boxcar trains have become signs that can evoke the specters of those deportations and lead our thoughts along pathways to other moments in time. The meaning of the sounds and images emerges from the interplay between what the film offers and what the viewer knows of the present in regard to the past. At other times there is no meaning to be made. The film

Figure 28. *Signal—Germany on the Air*. Photograph courtesy of Ernie Gehr.

returns to the original intersection of streets and its jump-cutting exploration of the space. It is raining. The same cars are in the road, and the same faceless people are walking, but now carrying umbrellas. The streets are wet, creating a different quality of light. The textural dynamic of the image has changed. Light reflects differently off objects. Even the moisture in the air refracts the light differently, rendering a softness to the image. Again these images are familiar, and yet they are now different. Gone is the out-of-field world of the shortwave. Now the sounds are of rain falling on the streets and cars moving through the puddles. There is a sensuousness to these images and sounds. Thunderclaps are heard, and they continue over the images of the street. There is a cleansing quality to the rain. Is it, perhaps, washing the streets clean of the past? The flatness of the image calls attention to the surface of the film onto which the film's emulsion has been laid. Like the emulsion into which the image is inscribed by the light and chemical processes that form this image of the street, there is now also a sense that a specter of an unrepresentable event has been inscribed in the image during the course of the film. Can the rain wash away this unseen specter, like the final washing of the film strip as it is processed to remove all unnecessary emulsion? Can images be cleansed of the past? Can the name "Germany" ever be spoken without its history of catastrophe being evoked? Could this intersection ever become an intersection in any city? Despite the persistence of this past, the rain and ominous sound of the thunder also evoke the future. This calls to mind Walter Benjamin's famous image of a "storm blowing in from paradise."

Gehr's rainstorm, also a "signal on the air," propels us into the future not as a chain of events but as a series of gaps, elisions, and specters of a past that always returns to the same place. What is coming? Is this image the foreshadowing of further catastrophe? It is the ability of this image of the street to be at once a Berlin intersection *and* a deterritorialized "any-intersection-anywhere" that is silencing, since it cannot be said with any certainty what happened—or did not happen. The film ends with a final clap of thunder, the image dissolves into an end-of-roll flare of red and black, and finally the screen is flooded with the clear white light of the projector. The viewer is returned to the space of the room where the film is being projected. The thunderclaps continue and the screen goes black.

The film has ended, but the sound of thunder persists for another minute or so. In these last minutes of the film, Gehr has elegantly created an overlapping of the possibility of history *and* its opposite, amnesia, the past *and* the present, the illusionistic space of the film image *and* the present of the viewing of the film. Finally, the thought of redemption coupled with the ominous possibility of catastrophe is evoked in both the image of the rainstorm and the final white light of the projector. The contradiction evoked in the ending to the film, combined with what is already known by the viewer, adds further to the inexplicability of the film's images. They seem so mundane in their inexpressiveness, and at the same time, the images say so much, giving the film its sense of limitless disparities. Like *Shoah,* all of this mitigates against the possibility of any kind of totalizing or monolithic reading of what the film's images and sounds show and imply.

As in Simon Srebnik's (failure of) words, "No one can describe it," the experience of *Signal—Germany on the Air* is in the gaps between what is shown and what can only be sensed, between what is understandable—readable—as an effect of a catastrophic past and what is not. These gaps render palpable the limits of what can be placed into familiar narrative form. The film thus embodies a moment in the present in which the impact of events exceeds the means to represent it. This can be seen as an aspect of the Lyotardian *differend,* in which "something 'asks' to be put into phrases, and suffers from the wrong of not being able to be put into phrases right away" (Lyotard, *The Differend,* 13). The film can be experienced as the search for another way to approach such events using what is available to the filmmaker in the present: an accumulation of sound fragments that suggest different moments in time, images of the quotidian in the random street scenes shown of present-day Berlin, the name "Germany." None of these add up to a story, but they cause the spaces of the city to reverberate with the power of an event that cannot be seen but nonetheless demands attention.

There has been much debate over the philosophical and ethical problems of using the events of the Shoah as the basis for works of art and entertainment and the ways such works are used as history. As early as 1949, as part of his now famous remark about barbarity and poetry after Auschwitz, Theodor Adorno warned of the dangers of the exploitation of the suffering and murder of the Shoah's victims through the reification, commodification, and appropriation of such imagery by the culture industry.[3] There is also the discussion of the redemptive nature of art in which the skilled narrativizing and emotional intensities in the transformation of such impossible subjects into those beautiful/horrible works of art reinscribes a notion of essential humanity—even in our most barbaric and inhumane actions—rather than questioning it. In the words of Leo Bersani, this can create the condition for "the catastrophes of history to matter much less if they are somehow compensated for in art, and art itself gets reduced to a kind of superior patching function" (*The Culture of Redemption,* 1). Alternatively the insistence on events remaining unspeakable in the face of exploitation can render the Shoah as another kind of aesthetic experience in the form of the sublime, in which historical events become so "awe-ful" that contemplation takes on the quality of a sacred experience beyond human agency. The insistence on such unspeakability can work to mystify this past, creating the sense of the Shoah as a religious or metaphysical occurrence beyond the control of the human beings who perpetrated it and those who might prevent it from occurring again.[4]

Signal—Germany on the Air resists the trap of aestheticized historicism by insisting on the present both in the cityscape of Berlin and in the experience of viewing the film itself. Both work to embody past events as if they were apparitions whose presences one feels and occasionally glimpses out of the corner of one's eye, which can never fully be apprehended. Although the film is only thirty-five minutes long, it is the experience of duration in the film that reveals the process of an effort to find a way to understand

an event like the Shoah, and how that effort falls back into inexplicability and silence. But the effort to say *something* in the face of inexplicability and silence is there. This effort is the poignancy and the risk of Gehr's attempt. His unique cinematic approach to this history is at once a continuation of his aesthetic explorations of the material nature of cinema, now tempered by a personal relationship to the history of Berlin (his own family fled the city to escape Nazi persecution), and is also an act of transgression. Berel Lang understands the notion of transgression as "a *condition* for representation . . . [in which there] 'is no possibility of arriving at a representation of the limit without transgressing it; yet the limit is indeed posited—thus however without representation'" (Friedlander, *Probing the Limits of Representation,* 303). Gehr performs this doubling in the film in an attempt to interrupt the silence that surrounds an event like the Shoah, by simultaneously creating the conditions for representation and revealing its limits.

In *Signal—Germany on the Air* Gehr has risked taking the responsibility of trying to engage with the silence of unspeakable events. In doing so, he takes up the challenge of trying to move away from the purely visualizable as the basis for knowledge toward an encounter with the vast emptiness produced by the Shoah. He confronts us with the immaterial but nonetheless relentless present tense of such events in our lives.

Killer of Sheep

The need to confront those specters of a past that, though unseen, still powerfully impacts the present becomes even more necessary as the events themselves recede into a distant past. Whereas the events of the Shoah lasted less than ten years and occurred sixty years ago, the catastrophe of African American slavery, on the other hand, lasted for hundreds of years and visibly ended generations ago. How to understand the ways in which events long past continue to inhere in the present becomes even more difficult to pinpoint and harder to represent visually. It has been the challenge for some artists to find different ways to speak about the spectral nature of such events in an attempt to produce more complex and deeply felt representations of people as beings who are affected and transformed by the movement of time.

The film *Killer of Sheep* by Charles Burnett (1977) reveals the ways in which legacies of events from the past actually inhere in the present, invisibly inflecting daily life with a force that is powerfully tangible. This film can be seen as an attempt to understand how elements of a past come to bear on the present in ways that are not always identifiable. These are the "hauntings" of the present, which, although invisible in positivist social science notions of historicism, when given close attention, begin to reveal just how dynamic the relationships are between past and present. As Avery F. Gordon suggests, "'Invisible things are not necessarily not-there' [and] encourage the complementary gesture of investigating how that which appears absent can indeed be

a seething presence" (*Ghostly Matters,* 17). This suggests a need to refocus attention away from what is simply visible toward the temporal as the meanings of an event, its legacies and effects, transform in time. For a medium like film, in which its indexical literalness is the basis for its historiographic authority, conventions of historical narrative are harnessed to that of the seeable. The larger problem of narrating the history of African American slavery is compounded not only by the formal problems of how to show it but also by American society's reluctance to integrate its history of slavery into narratives of the present. This is why these histories tend to produce such powerful boundaries that close off the past. The insistence on closure limits the complex ways that different moments of time commingle, inscribe, and inflect each other. This often forecloses possibilities of understanding the continuing effects of such a past as they impact the present. To take up daily life in the present in relation to the specters of the past is to counter the notion that African slavery is a closed chapter in American history, and to show that its haunting legacy continues to be a powerful part of the present—a force that continues to brutalize black America and unsettle the entire nation.

The vision of a life and a community haunted by the cultural inheritance of the catastrophe of slavery and hundreds of years of racist brutalization permeates the images in *Killer of Sheep.* While it is one of the only films I have taken up that is an entirely dramatic film, and does not appear to fit into many of my criteria for materialist avant-garde film practices, I find that the film's formal and aesthetic style not only is cinematically innovative and perhaps unique but also reflects—as the only culturally specific African American film in this study—an aesthetic designed to evoke the haunting legacy of American slavery. As does Gehr in *Signal—Germany on the Air,* Burnett uses cinematic duration, especially the continuous take and long shot, as the central formal element of the film's visual style, allowing viewers to engage their own thoughts in relation to what is seen and heard. But while *Signal* remains staunchly materialist, *Killer of Sheep* produces both a representation of a state of being in the film's fictional characters and a concrete real-time experience for the viewer. The film evokes, rather than represents, the daily rhythms and psychological conditions of the film's central character and community. A good deal has been written about the emerging Pan-African cinema of the last thirty years. Much of this writing has focused on the social and political contexts of these films, either as artifacts of marginalized cinematic practices or as communities within a larger context, as does Thomas Cripps, for example, when he writes about African American cinema as a genre within the larger context of American film:

> We shall seek to define black genre film through social and anthropological rather than aesthetic factors. In this light, films are different from those fine arts in which the artist and his audience share a fund of common knowledge and experience. Rather, films bridge the gap between producer and mass audience, not through shared arcane tastes, but because a team of filmmakers shares a knowledge of genre formulas, more than an artistic tradition with its audience. (*Black Film as Genre,* 9)

Here Cripps implies that because African American cinema is specifically a minority cinema, the films should largely be understood in sociological terms or as artifacts because marginalized black sensibilities and "tastes" are inaccessible to wider audiences outside black culture, or worse, that the only ground black filmmakers and their audiences share is the knowledge of cinematic genre formulas. The danger with Cripps's contention is that it implies that black cinema is simply a subgenre working off the dominant ones, rather than a dynamic and innovative cinema capable of creating complex and nuanced expressions of an individual filmmaker and his or her community in the context of other advanced work in contemporary world cinema.

In *Killer of Sheep,* Burnett innovatively uses the cinematic element of duration instead of literary elements of emplotment to show the intimate details of the daily lives encountered in the film's characters. He has also pared down plot elements to the barest minimum in order to reveal other elements within the film as complex components in the production of the film's meanings. In *Killer of Sheep* the depiction of place as opposed to events is foregrounded. The characters' interaction with the environment in which they live reveals their psychological or emotional condition rather than the forward movement of melodramatic conflict-resolution forms so common to conventional dramatic films. The film places the main characters' psychological states in the context of larger social conditions, suggesting that it is social contexts that have produced the characters' personal condition. *Killer of Sheep,* however, is not a sociological study. Rather, the attempt is to produce the experience of the characters' conditions as cinematic experience for the viewer. To do this, the film departs radically from the cinematic conventions of film melodrama, such as the continuity constructions of the classical Hollywood form with its seamless flow of time moving from one scene to the next according to the dictates of plot requirements. The film has reduced to a minimum spoken dialogue between the characters as a way of propelling the narrative forward. Rather, the film shows the characters in detailed visualizations of their daily activities and their physical relationships to the people around them.

The narrative form of the film's story is more typically modernist than classical. The story in *Killer of Sheep* is episodic and fragmentary, constructed through a series of loosely knit sequences depicting the daily life of this working-class African American family, each separate scene a self-contained narrative with its own formal logic. While the accumulation of these sequences produces specific meaning as a whole, each shot has its own integrity temporally and compositionally. Narrative time is constantly being constructed within each shot and then broken by colliding with another. As in the films of Benning and Godard discussed in the previous chapter, the narrational intensity comes from the accumulation of discrete shots, each succesive one deframing the next. This is a quintessentially anti-illusionist gesture that fractures narrative continuity and repeatedly throws the viewer back into the context of his or her own present by constantly having to work to reconnect one sequence to another.

In *Killer of Sheep,* the formal style is constructed around two major kinds of shots: the long shot, in which the entire object shown is contained in the frame; and the

long take, in which the duration of the shot is continuous. These shots emphasize complete actions and images of whole objects. These types of shots emphasize the real-time continuity of an action rather than the expansion or elision that results from putting together individual shots to make up a whole action. These two shots are deviated from in the occasional use of the close-up or moving camera. The long shot and the continuous take, however, create the rhythms of the film, which are languid and produce a contemplative relation to the events in the story.

Killer of Sheep produces interesting tensions between traditional modes of storytelling and more purely visual and experiential modes of filmmaking. It shows, through a loosely connected string of sequences, elements of daily life in a working-class black community. The story is structured in alternating sequences between the activities and interactions of the adults in the family and neighborhood and the play of the children in its streets and buildings.

The film centers on Stan, who has a wife and two kids and works in a slaughterhouse. We see him interact with family members and friends. We see him involved in different activities that show the uneventful, prosaic quality of his life. He is repairing the kitchen sink, cashing a check, disciplining his son, going through the routinized activities at work. The adults talk to each other about their lives either in stammering, soul-searching discussions or by arguing. In both cases they seem to be trying to articulate their emotional condition, but with little success. Through objective positioning of the film's mostly static camera and long takes, the viewer is given the time to see the characters' eyes, expressions, and bodies. We see what cannot be expressed verbally. In contrast to the adults, we see the children of the neighborhood playing in the streets, in vacant lots, and in buildings. The children are pure motion, like kinetic apparitions who are defined by movement. There is little for them to do or play with, so they play with each other, inventing games, running and biking around the neighborhood. Their youthful energy and constant invention of activities keep them in motion and occupied. No one, adult or child, is doing anything out of the ordinary, and nothing particularly dramatic happens, again emphasizing the prosaic nature of life in this neighborhood. Intermittently we see Stan at work, herding the sheep to slaughter. These moments at the slaughterhouse that show the sheep unknowingly being led to slaughter are placed in relief against the activities of the adults and children. The metaphor of the archetypal image of the innocent lamb being led to slaughter is the only specific comment the director makes about the condition of his characters. Otherwise the activities of the people are recorded objectively with a static camera shot largely in a series of long shots with the occasional cut to a close-up of a face. Burnett rarely leads the viewer to specific conclusions through conventional master shot–close-up combinations but rather lets his or her eye wander through the details of a shot's richly composed framing.

Killer of Sheep creates rhythms rather than stories. It is in the contrast between the alternating rhythms created by the kinetic energy of the children at play and the slow movements of the quietly serious adults placed in the unremarkable, crumbling

environment of South Central Los Angeles that the condition of many African Americans in the late-twentieth-century United States is most profoundly articulated. These rhythms emerge as the central element of the film, giving *Killer of Sheep* a strange, otherworldly quality. While the film is located specifically in South Central Los Angeles, in the present day, the highly formalized rhythms render the place and time slightly unfamiliar and ephemeral. Rather than being realistic, the film produces a spectral-like aura around the characters that makes them appear to be slightly out of time.

In his essay "New Black Cinema," Clyde Taylor, who has emphasized the realism and documentary quality that characterizes the visual style of *Killer of Sheep,* writes:

> The basic palette of the indigenous Afro-screen is closer to that of Italian Neo-realism and third world cinema than to Southern California. Charles Burnett, in *Killer of Sheep* for instance, makes effective use of the open frame, in which characters walk in and out of the frame from the top, bottom and sides—a forbidden practice in the classical mode of Hollywood. (47)

The realism of the film's mise-en-scène, with its unadorned locations and real interiors instead of sets, is unmistakable. The film, however, is also a tightly controlled and formally rigorous construction, which defies the documentary-like quality associated with early neorealist cinema such as *The Bicycle Thief* by Vittorio De Sica (Italy, 1948) or *Rome, Open City* by Roberto Rossellini (Italy, 1945). Rather, *Killer of Sheep* can be seen more productively in relation to later highly formal and stylized modernist films that grew out of neorealism such as *L'eclisse (The Eclipse)* by Michaelangelo Antonioni (Italy, 1962). *L'eclisse,* while using real locations, also expresses the traumatized, out-of-time quality of its characters, who in the wake of World War II are no longer able to express a sense of personal agency. As with Stan in *Killer of Sheep,* they seem to be disconnected from the lives they lead and are seen in rigorously composed shots existing in depersonalized urban landscapes.

Unlike the more spontaneous style of neorealism, in *Killer of Sheep* every shot is formally composed using the graphic elements of the frame to compositionally foreground the interplay between characters and their environment. This relationship can be seen in one paradigmatic sequence of four shots, which opens as a deep-focus long shot of children playing in the stairwell of an apartment building (Figure 29). Far in the background we see three boys on a bicycle. In the foreground there are more kids wrestling each other. The bicycle approaches the stairs. The boys dismount and walk the bike down the stairs. The camera is static and holds its fixed position. The boys remount the bike and proceed to ride forward toward the camera. Shot 2 is a medium shot reframing from the same camera angle. All the boys are still in full frame. The bike and riders continue to move toward the camera. The scale changes, with the wrestling kids now in the background, and the new angle emphasizes the narrowness of the walkway, while the bikers are getting larger as they approach the camera and finally

Figure 29. *Killer of Sheep* (Charles Burnett, 1977). From top to bottom, shots 1–4. Photograph courtesy of Charles Burnett.

ride out of frame left. Shot 3 is a reverse shot of the bike now in a different location, on a large boulevard on which the boys are riding away from the camera. This is a long shot in which we see a car approaching. Then two dogs enter frame left and start chasing the bike. The boys swerve into the car's path to avoid the dogs. As they are about to run into the car, they all jump off the bike and leave it lying in the street and run out of frame left. Shot 4 follows the boys running down the street.

In the case of the first three shots, the static full frame reveals the intricacies of being a child in an urban environment. Shot 1 uses a wide-angle lens that accentuates the narrowness of the walkway through which they must ride. Shots 2 and 3 use a telephoto lens, which flattens the space, collapsing the elements of the mise-en-scène together and emphasizing the lack of open space in the city. Even children at play are constantly being forced to negotiate the constricting reality of inner-city life with its buildings, narrow stairways, sidewalks blocked with other children, dogs running uncontrolled, and boulevards filled with cars. In these tightly composed framings—rather than documentary spontaneity—we see the thwarted desire for the freedom of open spaces that characterizes inner-city life. This becomes a graphic cinematic metaphor for the African American lives that are filled with compromise, the negotiation with a hostile environment, and the ultimate inability to live the way one wants.

The high-contrast black and white used in the film emphasizes the graphic compositional elements of the shots as opposed to the use of black and white to heighten a sense of realism, another element often ascribed to early neorealism. From the beginning of the film, the black and white is used to create contrasts, producing otherworldly spaces and separations between people and cultures. From the opening, the images of a father chastising his son are shot in low-key expressionist lighting in which space is deterritorialized, as in a dream. The next sequence begins with the screen literally divided between black and white. It is a rock fight in a sandlot, and a boy is using a sheet of plywood as a shield. By framing the plywood to completely cover half the frame, Burnett uses the flatness of the screen to create divisions between dark and light. Throughout the film, the high contrasts of the black and white make palpable the sense of claustrophobia and frustration of daily life in this ghetto. In this sense, the black and white of the film creates a much more abstract and metaphorical world than a realistic one. There is no clearer instance of this than the graphic quality of the white sheep disappearing into the black space of the chute in the slaughterhouse. The contrast between black and white is made even more potent when the image of the white sheep going to slaughter is reversed in the viewer's mind—through the film's central metaphor—into the black skins of the film's subjects.

The metaphor of innocence then continues as the sheep silently go off to slaughter, intercut with images of the also innocent Stan, helplessly watching the neighborhood children. Stan, as the killer of sheep, is at once murderer and victim as he bears witness to the trauma of the African American experience. Stan's silence comes from the slow and steady diminution of a sense of self through the lack of control over his life. As the killer of sheep, he kills, as he himself is being killed by the lack of possibilities

and his lost dreams. In *Killer of Sheep,* this can be seen as his trauma—and also the collective one—embodied by his silence and listless gaze.

In his essay "Notes on Trauma and Community," Kai Erikson describes traumatized subjects as those who "look out at the world through a different lens. And in this sense they can be said to have experienced not only changed sense of self and changed way of relating to others but a changed *worldview*" (Caruth, *Trauma,* 194). Looking out at the world through a different lens is an apt way to describe a film like *Killer of Sheep.* It is one that presents a completely different image of the black experience in America, by looking closely, carefully, and intimately at the rhythms of daily life in an African American community. In the film, Stan's silent gaze can be seen as that of the traumatized subject, through whom the viewer bears witness both to the spirit of endurance and to the abjection in African American life. Through Stan's silence, the film privileges the visual over the written, opening the film and its viewers to insights and modes of expression perhaps not possible by literary means. Because of the film's prosaic and quiet qualities, we are able to see the world around him. Nothing much happens to Stan, and he does little besides his job. This invites us to move beyond the actions of the protagonist and to look at the world around him.

In one of the most moving scenes in the film, Stan tries to speak in a way that reveals his deep sensitivity, however clotted and sedimented under his silence it may be. Late one night, he is sitting at the kitchen table playing dominoes with a friend; they are drinking tea out of china cups. Stan has the friend put the hot teacup against his cheek and asks what it reminds him of. The friend says he has no idea. Stan ventures that it feels like a woman's forehead while making love. The friend bursts out laughing incredulously. We see in the background his longing wife in the darkness of the hallway, silently observing this exchange. The camera holds on Stan as he rubs the cup against his cheek; we see him struggle with his emotions as if he is using the hot cup to evoke the memory of another world now inaccessible to him (Figure 30). Throughout the film, despite the advances of his wife and other women, he shows little interest in sex, or sensual experience of any kind. So the realization of the warm cup as something connected to pleasure takes on much larger symbolic proportions than a sexual fantasy. In the disparities between his quietly reflective attempt to describe an ephemeral sensation, the boisterous ridicule of the uncomprehending friend's laughter, and his wife's silent presence, the viewer can see evidence of Erikson's notion of a worldview changed by trauma. All bear witness to Stan but are unable to perceive as he does the memory evoked by the heat of the teacup, thus separating Stan from his wife, his friend, and the viewer, isolated as he is in his own world.

The relationship between a traumatized subject of catastrophe and the act of witnessing is central to understanding this reading of the film's form. The fixed camera quietly records these poignant moments in Stan's domestic life in which his wife and children try to find ways of crossing into the isolated world that surrounds Stan. In a single fixed-camera shot, Stan and his wife are seen alone in their darkened living room. She is trying to get him to dance with her. They are in silhouette, framed by a

window in which nothing can be seen in the window but the bright white light of the overexposed outside world. In this heartbreaking scene, he spurns her attempts at love-making and walks away. Like a moth to the light, she rushes to the window, throwing her body against it as if she might crash through (Figure 31). Such otherworldly images graphically open the film beyond the present. In Burnett's formal style of real time observed through the continuous take, we are able to sense the specters of past trauma that creates such affect in the present.

The African American community is haunted by the specter of the trauma of slavery. As Avery Gordon writes:

> Slavery has ended, but something of it continues to live on, in the social geography of where peoples reside, in the authority of collective wisdom and shared benighted-ness, in the veins of the contradictory formation we call New World modernity, pro-pelling, as it always has, a something to be done. Such endings that are not over is what haunting is about. (*Ghostly Matters,* 139)

Figure 30. *Killer of Sheep.* Depressed and estranged from his wife and family, Stan holds a teacup to his cheek. Its smooth warmth reminds him of a woman's forehead while making love. Photograph courtesy of Charles Burnett.

The profound accomplishment of *Killer of Sheep* is its quiet construction of the rhythms of the quotidian. It creates the sense of the wavering present by asking the viewer to think beyond what is represented and perhaps opens up a space where one can experience the ways in which ephemeral and ungraspable elements of the past are always present and inflect daily life. Through the long and lingering shots of his camera pointed at his own community, Burnett creates a conjuring tool with which to witness a present that evokes a past far from over.

Killer of Sheep reflects a vastly different culture and social reality than the other avant-garde films discussed in this study; their connection, however, lies in the way they all use time as the central formal element to move viewers away from the specificity of stories told, toward the experience of the temporal rhythms of daily life lived. Burnett is committed to an image of time as a way of exploring a prosaics of the quotidian that might sensitize the viewer to the complexity and richness of African American cultures past, present, and future. Certainly *Killer of Sheep* is a politically situated expression of the African American reality in the late twentieth century—coming at the end of the civil rights and Black Power movements of the sixties. The film can

Figure 31. *Killer of Sheep*. Stan spurns his wife's affections, and she is helpless to reach him. Photograph courtesy of Charles Burnett.

even be seen as social realist in the ways some critics have cited. As I have argued, however, the film's power lies in what remains unseeable, but felt, through Burnett's use of the formal elements of duration, composition, and the contrasts of black, whites, and grays that evoke in the present the specters of the catastrophic past of slavery that continues to haunt America.

Witnessing

The cinematic experience of both *Signal—Germany on the Air* and *Killer of Sheep* renders palpable the limits of that which, in a catastrophic event, can be visually represented once it has passed out of the present. Central to these films is the attention paid to the elements that continue into the present as forces that defy assimilation into a coherent image of that past. This gap is the limit of historical knowledge. To fill it with the testimony of people who have witnessed or have themselves gone through such limit experiences is often considered the most accurate accounting of such events.[5] Unlike traditional historical narrative, which elides such gaps, it becomes clear from listening to the testimony of such witnesses that a similar lacuna exists as part of their inability to put those experiences into words. Here the witness is a displaced person between two worlds: that of the event he or she has survived, and that of the place in which the survivor finds himself or herself afterward. One world bears no resemblance to the other, leaving few tools to translate the experience. As the novelist and Shoah survivor Aharon Appelfeld writes:

> Everything that happened was so gigantic, so inconceivable, that the witness even seemed like a fabricator to himself. The feeling that your experience cannot be told, that no one can understand it, is perhaps one of the worst that was felt by the survivors after the war. . . . The inability to express your experience and the feeling of guilt combined together and created silence. (*Beyond Despair*, 31–32)

This silence in the face of such personal and social incredulity begins to raise the question even about the possibility of the witness. For many survivors, the sense of their experience as being unbelievable was inculcated in the midst of the experience itself. As Primo Levi writes, many survivors remember that the SS militiamen enjoyed cynically admonishing the prisoners: "And even if some proof should remain and some of you survive, people will say the events you describe are too monstrous to be believed" (*The Drowned and the Saved*, 11).

Not only were survivors stripped of their personhood, but their captors tried to convince them that the very experience of their bodies was not to be believed. As Fela Ravett says about her own survival of Auschwitz: "When you recall that and you are thinking how a person is able to overcome that, I can't believe it . . . how it was possible to overcome that, is unbelievable."[6] This sense of self-doubt, coupled with the need for the survivor to reintegrate into a "normalized" society, produced the need to

forget in order to be able to function. This begins to define the notion of the witness as traumatized subject. In psychoanalytic terms, trauma is "an event in the subject's life defined by its intensity, by the subject's incapacity to respond adequately to it, and by the upheaval and long-lasting effects that it brings about in the psychical organization" (Laplanche and Pontalis, *The Language of Psycho-Analysis,* 465). While the wish to forget such experiences through silence is understandable for the subject trying to rebuild his or her life, the effect of such a repression of memory "serves as a perpetuation of its tyranny." The memory becomes so distorted in the "survivor's conception of it . . . that the survivor doubts the reality of the actual events" (Felman and Laub, *Testimony,* 79). An important part of what defines an event such as the Shoah is that it becomes "an event without witnesses." In such a catastrophe there is the knowledge that something happened, but according to the psychiatrist Dore Laub: "Not only in effect, did the Nazis try to exterminate the physical witnesses of their crime; but the inherently incomprehensible *and* deceptive psychological structure of the event precluded its own witnessing, even by its victims" (80). Laub suggests that in the overwhelming intensity of the experience of the event, an annihilation of the subject's identity occurs, at least temporarily. The event contains so few reference points to the experience of the rest of the subject's life—both before and after the event—that it cannot be fully understood and therefore raises the question, What was experienced and by whom? This gives rise to a notion of trauma created from the force of an experience never fully had. The result, as Cathy Caruth suggests, "is a gap that carries the force of the event and does so precisely at the expense of simple knowledge and memory. The force of this experience would appear to arise precisely, in other words, in the collapse of its understanding" (*Trauma,* 7). The viability of such witnessing is called into question not only as a result of the crisis of memory lost over time but also as a result of the loss of identity in relation to the veracity of one's own experience. This produces a crisis not only for the individual but also for the larger historical accounting of such events. As the philosopher Giorgio Agamben writes, "The aporia of Auschwitz is, indeed, the very aporia of historical knowledge: a non-coincidence between facts and truth, between verification and comprehension" (*Remnants of Auschwitz,* 12). How does one put into language all the gaps in knowledge and what is left unsaid? How to speak what is unspeakable and to listen to what is unsayable?

Testifying

The sound film is a unique medium because it can record the speech act in real time. Sound film gives us the ability to see, literally, words forming at the tip of the tongue. The advent of the sound film was perhaps as radical a development in the history of photographic vision as was Eadweard Muybridge's realization that serial photography gave us the ability to study the movement of living creatures. Muybridge was the first to prove photographically that a horse does actually lift all four legs off the ground while running.[7] Similarly, with the ability to synchronize sound and image, it becomes possible to see the process of thought turned into language. The ability of the

motion picture camera to record the face and body in real time allows viewers to see subjects in the process of thinking as we hear them speaking. This makes thought both a physical and visualizable process and an integral part of how what is being said is understood.

Much of the use of sync sound has been for dramatic film to record actors speaking written lines, and for journalistic purposes in which statements or opinions are expressed in the form of direct address to the camera or interviewer.[8] For many, this talking-head form has come to embody an uncreative solution to the problem of how to make television journalism visually engaging. From the talk show format to the evening news and investigative documentary journalism, sync sound and image are generally used to authorize the veracity of a statement, because we see it actually coming from the mouth of the speaker. As Bill Nichols writes of this kind of exposition: "[It] usually makes a tacit proposal to the viewer as part of its contract negotiations: the invocation of, and the promise to, gratify a desire to know" (*Ideology*, 205). In conventional documentary journalism, the authority of the speaker is verified by his or her particular expertise as stated at the outset of the interview or by the fact that he or she has been selected to be on camera. The interviewee is often used as a rhetorical substitute for the authorial position of the filmmaker, who is able, through editing, to fashion a statement to meet the expository needs of the story or report.

This kind of direct-address interview style is a staple of the contemporary historical documentary, in which witnesses are shown reciting their own experiences and experts are seen narrating events in coherent ways. "The exposition begins [verified by the image of the talking head]; it proposes an ending: the temporal trace of the film will provide the arena within which we are led to believe we can possess the truth" (Nichols, *Ideology*, 205). The emphasis here is on retrospective statement that produces a sense of pastness in which the speaker, now safely in the present, can reflect on past events from the perspective of a narrativized beginning-to-end structure. Major historical films such as Marcel Ophuls's *Hotel Terminus: The Life and Times of Klaus Barbie* (France, 1988) or Henry Hampton's *Eyes on the Prize* (1987–90) use testimony to authorize the filmmaker's position and temporal perspective. In *Hotel Terminus* we see and hear victims and perpetrators of Nazi and French collaborationist crimes. The fragmentary, cut-up style of the interviews works to slowly and inexorably verify the complex history that Ophuls is constructing. Here the testimonies are fashioned into knowledge that has come from direct experience. Ophuls uses combinations of the experiential testimony of witnesses and the expert testimony of scholars, researchers, and investigators to verify and validate the narrative of Nazi-instigated crimes. These are woven in and out of the perspectives of Jewish victims, French Resistance fighters, Vichy collaborationists, U.S. government officials, South American government officials, and scholars of the history of that period. The result is a document of an investigation that has taken place already and is then performed and structured for the camera. The intent is to represent a coherent narrative history already arrived at before the film was made. The filmmaker uses the witnesses as a form of rhetoric to authorize and build his or her argument. Something similar takes place in *Eyes on the Prize*.

This is a redemptive narrative in which relationships of past and present are produced by the intercutting of archival news footage of the events of the civil rights struggle in the United States from the 1950s through the 1980s with present-day reflections on the depicted events by those who were involved.[9] In a "sound bite" style of cutting, these first-person interviews, shot in color, are woven into the usually black-and-white footage of the past events, all of which are contextualized with voice-over narration, binding these disparate elements into a single narrative that moves inexorably into the present. The chaotic struggles shown in the archival footage are given narrative form with the testimonies of the participants, whose very presence on camera verifies the moral and political victory of the struggle. This is a history that had already been narrativized before the film was made, and the film and the testimonies that are seen in it authorize a complex, carefully crafted narrative that says what the filmmaker has intended.

I have tried to demonstrate the rhetorical formal style that contemporary historical documentaries use to construct their histories, and my use of these particular films is not an attempt to mitigate their enormous value and complexity as visual and oral histories, or the public impact they have had as a result of their wide viewership. I am using these important and well-known documentary histories heuristically to demonstrate a particular formal technique that has become part of the genre of television documentary. I also use them as a way to throw into relief my descriptions of the interviewing technique in *The March* and *Un vivant qui passe* to follow, which have a different form and intention.

In contrast to the interview cinema I have just described is an extraordinary body of films and videotapes that I link more closely with certain avant-garde strategies that come as much out of poetry and conceptual art as from the documentary film genre.[10] These experimental films and videos consist almost entirely of people testifying based on questions asked of them. There is, however, a subtle but important distinction I want to make between the kinds of testimonial works that I describe and another significant body of work called confessional video art.[11] For the most part, these works also use direct-address formats in which the artists appear to be alone and speak directly to the camera about themselves. The confessional video centers on the act of self-disclosure as a form of catharsis. The use of the video medium offers the ability to film oneself while alone, making possible the intimacy required to create a document of the confession. In such works the act of confession often comes more out of the maker's own needs than for the needs of history or other people; but even here the confession is documented with the knowledge that in some later moment, others will be in the position of witnessing it.

The private confession implies the possibility of relief or self-improvement through the act of self-revelation. Implicit to this is a desire for the vulnerability of self-exposure and the possibility of being anonymously judged. Such works set up a highly complex form of spectatorship that creates intricate relationships between notions of what is public and private, in which the confessor is seen alone in the act of confession, and

the viewer becomes voyeuristically implicated in the process through the act of witnessing a private moment being performed without having any direct engagement with the confessor.[12] In testimony, on the other hand, the witnessing of self-revelation is not as much the point as is the interaction between a speaker and a listener in which the dynamic of telling is inextricably linked to the listener. Unlike confession, which is about a confrontation with the self that may or may not have been witnessed, testimony takes place in relation to another person or other people and is intended for other people. The testimony is often made out of a sense of duty with the implication that what will be revealed is necessary for others to know. In *Shoah,* for example, the barber Abraham Bomba is testifying in the presence of the filmmaker and a barbershop full of men about cutting the hair of people about to be gassed at the Treblinka concentration camp. He is testifying not for himself but out of a sense of duty as a witness to an event despite his own ambivalence and personal discomfort. At one point he is momentarily unable to continue:

> BOMBA: I can't it's too horrible. Please.
> LANZMANN: We have to do it. You know it.
> BOMBA: I won't be able to do it.
> LANZMANN: You have to do it. I know it's very hard. I know and I apologize.
> BOMBA: Don't make me go on please.
> LANZMANN: Please we must go on.
> BOMBA: I told you today it's going to be very hard. (Lanzmann, *Shoah,* 117)

The dynamic in this harrowing scene is one in which the testifier has chosen to tell his story despite knowing how hard it will be to do so. The relationship between speaker and listener is one of mutuality in which the listener is in the position of assisting the speaker, and together they complete the process of the testimony.

What separates the testimony film from a journalistic interview is the emphasis on speaking as a process of coming to knowledge rather than giving a statement. Like the psychoanalytic process, the events spoken about are of occurrences that have not yet been understood in ways that create coherent narratives. Often the speaker has not allowed himself or herself to put into words certain experiences, and so the speaker's testimony is the very process of finding the words. In other cases, in what could be a process of self-protection, the one testifying says one thing in order not to say another; speaking becomes a process of avoidance, rather than a confrontation with the memory of something too difficult to deal with.

Two paradigmatic films that perform this process are *The March* by Abraham Ravett (1999) and *Un vivant qui passe* (*A Visitor from the Living*) by Claude Lanzmann (France, 1998). In these films, viewers become witnesses to the process of people struggling with events that occurred in their lives, which, despite their pastness, continue to exceed the frame of reference of their current daily lives and therefore cannot be integrated. The people speaking in these films are not being interviewed but are testifying

about their experiences. The two films do not offer, as Shoshana Felman has suggested in her definition of testimony, "a completed statement, a totalizable account of those events. In the testimony, language is in process, and in trial, it does not possess itself as a conclusion, as the contestation of a verdict or the self-transparency of knowledge" (Felman and Laub, *Testimony,* 5). Hence what makes this kind of testimony film a unique form of historiography is its emphasis on the present. Not necessarily the present day or time, but rather the present moment of the speech act, since what is revealed about the past only becomes known—both to the speaker and to the listener—at the moment it is said. The other important aspect of this kind of film is the inclusion of the questioner and listener in the process of the testimony and the way the viewer is allowed to see how new knowledge is shared between them. Often it is the listener who is responsible for the emergence of such new knowledge. "The testimony to the trauma thus includes its hearer, who is, so to speak, the blank screen on which the event comes to be inscribed for the first time" (57). In both *The March* and *Un vivant qui passe,* we see the evolving state of the filmmakers as they listen, question, and respond to the subjects who are testifying; and through this, Ravett, like Lanzmann, "comes to be a participant and co-owner of the traumatic event: through his very listening, he comes to partially experience the trauma in himself" (57). Although the films are about the subjects' testifying, they also come to be about the maker and his subjective relation to the unfolding trauma. In this sense, these films can be seen as a form of personal and autobiographical filmmaking.

In *The March,* through a series of sync-sound interviews done over a thirteen-year period, we see Ravett repeatedly asking his elderly mother, Fela Ravett, who was interned in Auschwitz during World War II, to speak about her experience on the forced "death march" evacuation of Auschwitz in the winter of 1945.[13] *Un vivant qui passe* is an hour-long testimony of Maurice Rossel, who worked for the International Red Cross Committee during World War II. His job was to inspect German military and civilian internment camps and, as a Swiss national, report his findings to the Swiss government. Lanzmann questions him specifically about what he saw and thought while visiting the concentration camps at Auschwitz and Theresienstadt. While both *The March,* twenty-five minutes long, and *Un vivant qui passe,* sixty minutes, use the lip-sync sound film technique, the films are markedly different in their formal structures. The former is fragmented, using many short scenes; the latter, a nearly continuous single interview intercut only with cutaways of Lanzmann looking at Rossel and several long tracking shots through the streets of present-day Theresienstadt. *The March* also differs from *Un vivant qui passe* in its approach to these filmed testimonies in the ways they are or are not transformed into aestheticized works. In *Un vivant qui passe,* Lanzmann deliberately eschews any kind of aesthetic gratification, using the camera largely as a recording device, allowing all meaning to emerge from the discussion and the mise-en-scène of the fixed shot. In contrast *The March* is a fragmented work that mixes different registers of materials from sync-sound testimony to poetically abstract imagery.

Un vivant qui passe

Un vivant qui passe (A Visitor from the Living) is based on the real-time sync-sound recording of Rossel's testimony. Its simple structure is formed by a series of long continuous shots of its talking subject that reveal the unconscious motivations in the conclusions to which Rossel came in his reports to the International Red Cross after visiting two German concentration camps in 1944. This one-hour-long single interview was conducted in 1979 during the making of Lanzmann's film *Shoah,* which consists of many testimonies complexly intercut with each other, and for reasons of length was not included in that film.[14]

In *Un vivant,* Lanzmann continues to work to undermine the testimonial authority of the eyewitness, this time by focusing on a single witness and showing in a sustained testimony how the conclusions that were reached by this witness were, as we shall see, determined more by his negative predisposition toward European Jews than anything he saw (or did not see) while visiting the camps. (As is indicated in the film, Rossel's reports were used by the International Red Cross to determine the legality of prisoner treatment in prisoner-of-war and civilian concentration camps and influenced Allied policy toward such camps.)

Unlike Fela Ravett, Maurice Rossel is not a traumatized victim of Nazi crimes but a bystander whose recorded assessment of what he saw when visiting Auschwitz and Theresienstadt was that there was no evidence of mistreatment or systematic killing of Jews, thus reinforcing the Nazi claims that these were deportation and work camps, not extermination camps. In his interview with Rossel, Lanzmann is not so much interested in disproving Rossel's claims with what are now known facts so much as he is trying to find out how, in the midst of such mass murder, Rossel saw or suspected nothing. Rossel's testimony, then, becomes the performance of his wish to justify his conclusions in the face of the now overwhelming historical facts about what went on in these camps. In doing this, Rossel reveals much about the nature of the complicity of non-Germans and those who claimed neutrality. When we find out through Rossel's testimony that even Swiss Red Cross inspectors were predisposed to the German deportation of the Jews, we begin to discover how such an enormous crime was carried out under the nose of the world.

Like Ravett, Lanzmann does not exclude his own direct involvement in the testimony, speaking, interrupting and correcting Rossel, and expressing his outrage at what went on in the camps. If there is a traumatized victim in this testimony, it is Lanzmann himself, who, as a listener to hundreds of hours of testimonies during the making of *Shoah,* has come "to partially experience trauma in himself" (Felman and Laub, *Testimony,* 57). In this sense Lanzmann becomes a surrogate, bearing witness to the testimony of Rossel for the victims who might have been saved if he had "seen" what was occurring in the extermination camps.

After a first-person written introduction that crawls across the screen for nearly five minutes in which Lanzmann fills in the historical details of what went on at Auschwitz

and Theresienstadt, he explains that Theresienstadt was a show camp that the Nazis used to demonstrate to the outside world that interned Jewish prisoners were being treated well and had adequate living conditions. The film opens with the single camera angle on Rossel that (except for close-ups) is held on him throughout the interview. Rossel is seen as an aging, silver-haired patrician sitting in his library with books, a fireplace, and dark hardwood paneling. He is the image of the quintessential civilized bourgeois European. His demeanor as he begins speaking is that of a rational, enlightened humanist; he seriously tries to answer everything Lanzmann asks. There is a strong sense of duty in the way he attempts to answer, as if he understands the importance of creating a historical record if society is to learn from its past. Lanzmann allows him to reminisce about his days living in luxurious accommodations in Berlin at the height of the war, socializing with the Swiss and German elite at night and inspecting the German prisoner-of-war camps by day. Rossel doesn't indicate that he sees any conflict of interest in this. Lanzmann's questioning steers him toward his inspection of Auschwitz. He went there of his own accord and without Swiss protection, which Rossel indicates was a dangerous thing for him to do. But once there, he gained entrance with surprising ease. He says he saw nothing unusual, just a prison camp with barracks. Rossel says he met with the camp *Kommandant,* whose name he cannot recall, but speaks admiringly of him as a "young, elegant man with blue eyes, distinguished, friendly,"[15] and remembers small talk about bobsledding in the Alps. Lanzmann keeps asking Rossel what he saw, and if he had any sense that mass exterminations were occurring just yards from where he had been standing. Lanzmann asks, "Did you ask the *Kommandant* about the rumors of such exterminations?" Rossel says he saw nothing and asked nothing. He says that at first he saw just a few groups of prisoners marching on the grounds—nothing unusual. Lanzmann continues to question him about his feelings about being there and asks him to describe in detail what he saw. As the camera rolls, under the careful questioning of his experience, Rossel begins to reveal the subtle ways in which he was predisposed to see no evidence of the Nazi extermination of the Jewish prisoners.

After much probing by Lanzmann, Rossel finally says he does remember that he saw large groups of four to five hundred prisoners whom he describes as "skeletal," "clearly starving," as if they were the "walking dead." Lanzmann asks if these were what became known as the camp *Muselmanner.* In concentration camp jargon, the *Muselmanner* were considered the camps' living dead. Named for their dark, sunken eyes, blank stare, and listless walk, they had lost the will to survive. The *Muselmann* (literally, Muslim, in the Arabic meaning of the word) is, according to the philosopher Giorgio Agamben,

> the one who submits to the will of God. It is this meaning that lies at the origin of the legends concerning Islam's supposed fatalism, legends which are found in European culture starting with the Middle Ages (this deprecatory sense of the term is present in European languages, particularly in Italian). But while the Muslim's resignation

consists in the conviction that the will of Allah is at work every moment and in even the smallest events, the *Muselmann* of Auschwitz is instead defined by a loss of all will and consciousness. (*Remnants of Auschwitz*, 45)

These men, who through starvation, illness, and physical and emotional trauma were no longer able to maintain any visible affect of human behavior or consciousness, were described as all looking the same and silently shuffling through the camps, nearly dead.

In his essay on the figure of the *Muselmann,* Agamben describes him as the embodiment of the limit of the human, "marking the moving threshold in which man passed into non-man and in which clinical diagnosis passed into anthropological analysis" (47). For Agamben, what is lost at Auschwitz is the concept of the human as defined by a limit across which is the inhuman. But what occurred there shows instead "the insufficiency and abstraction of the limit" (63). The *Muselmann* is no longer seen as Jew or human being, but something nonhuman. This makes it possible to consider such beings as life that is "no longer truly life," and "whose death cannot be called death, but only the production of a corpse" (81). In this sense what Lanzmann reveals is not an inconsistency in Rossel's story but the deepest accomplishment of Auschwitz, which was to make the notions of the human and nonhuman interchangeable and contingent; it made Rossel's claim that—despite seeing hundreds of *Muselmanner* in the camp—he saw no evidence of extermination technically, if not literally, correct. So powerfully had the figure of the Jew been placed in the now blurred line between the human and nonhuman that Rossel, even in the face of Lanzmann's incredulous questioning and the well-documented activities of what went on in the camps, still maintained that he would not change anything in his reports.

Lanzmann goes on to question Rossel about his visit to Theresienstadt near Prague in June 1944. This camp, which housed many elderly and so-called prominent Jews, business leaders, artists, doctors, and war veterans, became the model "show camp" to which the Nazis brought international inspectors to judge their treatment of civilian prisoners. Although Rossel claims he had heard that Theresienstadt was considered a show camp, he still insists that he saw nothing that would cause him to suspect anything unusual about the camp that might indicate harsh treatment of prisoners by the Nazis. He speaks of being allowed to wander around the camp freely and take photographs of everything. Although he says he felt as if things were being staged, he wrote his report uncritically, describing children's fake nurseries (procreation was illegal and abortion compulsory) and what he saw as the high quality of life there with playgrounds, park benches, and a bandstand with a staged orchestra.

Up to this point, Lanzmann has created an interaction with Rossel that seems to make him feel free enough to express his opinions in an unguarded way. While having little to say about the Nazis' running of the camp, Rossel instead begins to talk about what he found most disturbing about his visit to Theresienstadt: "the unpleasant attitude of the Jews." He begins to speak with disgust about how the camp seemed to be filled with "rich Jews" who were able to buy themselves into a model camp like

Theresienstadt "to save their own skins." He goes on to talk about what he "could not stomach," which was the Jewish servility and passivity he saw. He sees this as a character flaw rather than a response to Nazi terror. He describes as "mankind sinking to its lowest level" the Jews' willingness to carry out Nazi orders—even to the point of sending their own to their deaths. Here he reserves his harshest criticism for the Jews themselves, indicating that somehow they were responsible for their own demise. In a sense, Rossel has blamed the victims of Theresienstadt for his positive assessment of the camp. He says that had they not been so passive, they might have made indications to him that things were not as they seemed. He continues, "How easy it would have been to slip a note to him or any member of the inspection team." He testifies with passion about this Jewish lack of initiative, his face filled with disgust.

As Rossel free-associates, he is unaware that he has begun to express his deep-seated anti-Semitism and hatred for the Jewish prisoners. What has begun as a cooperative interview with an aging Swiss gentleman in his library is transformed into a "horror film" in which the mask of gentility is peeled off, revealing the face of the anti-Semitic European bourgeoisie, unchanged, unrepentant, and unself-conscious (Figure 32). His constant characterizations of Jews as rich, self-serving, servile, and passive invoke the typical anti-Semitic stereotypes of prewar Europe.[16] These kinds of images, which were central to the campaign to dehumanize the Jews and to define them as something apart from the rest of Europe, are so internalized that we see how they continue into the present day. Now talking freely, Rossel not only begins to reveal his unconscious anti-Semitism but seems to indicate no awareness even that he is talking to a Jew, and that he has lost track of the reason for the interview in the first place. So deep is Rossel's continuing sense of Jewish otherness that as he speaks he refers to Jews as "Israelites"—as if the Nazi victims were not natives of Europe but from elsewhere. It becomes excruciatingly telling that after a twenty- to forty-five-minute meeting, Rossel is able to remember a lot about the Auschwitz camp *Kommandant* (elegant,

Figure 32. *Un vivant qui passe* (Claude Lanzmann, 1998).

blue-eyed, etc.), but when asked about his meeting with Dr. Epstein, the Jewish leader of Theresienstadt, who showed Rossel around the camp for eight hours, he says he remembers nothing about Epstein other than his indicating that nothing was amiss. In contrast to the German *Kommandant,* it is clear that Rossel can't remember Epstein because he regards the Jewish internees as insignificant and forgettable.

At this point in the interview, Lanzmann changes tactics and attitude. Having exposed Rossel's true feelings, Lanzmann begins to refute, line by line, Rossel's favorable report, which mentions all the positive things the Nazis wanted noticed, but raises no questions about the staged quality of the camp. Using found Nazi records, Lanzmann reports that overcrowding at Theresienstadt was so great that prisoners slept four or five to a bed. The records show that to alleviate the sense of overcrowding in preparation for Rossel's visit, five thousand Jews were sent to Auschwitz, and ten thousand more were sent away after the visit. Lanzmann suggests that the Jews lived there in "absolute terror" for their lives, and this might explain their silence to the inspection team. Lanzmann refutes Rossel's claims that people were well fed and "getting 2,500 calories a day, when in fact they got 1,200 and were starving to death. . . . Your report says four hundred deaths per month; there were five thousand."

Lanzmann tells him that Theresienstadt had a crematorium as big as the one at Auschwitz, but Rossel didn't report its existence. As he goes on with this refutation, the camera holds in close-up on Rossel's face, impassive and stony, as Lanzmann, barely able to contain his anger, goes on. The testimony shifts from Rossel to Lanzmann, who is now doing all the speaking and has become Rossel's accuser and judge. Finally Lanzmann asks if Rossel regrets his report today, knowing everything Lanzmann has told him. Rossel responds defiantly, "I'd sign it again."

The film ends with Lanzmann raising the specter of the lost of Theresienstadt by reading to Rossel the speech Dr. Epstein gave to the Jewish prisoners there three months after Rossel's visit. Epstein exhorts the prisoners to be "totally dedicated to work and not to talk or speculate on our future." In the poetic speech, it is clear that Epstein still believes that there are people working to save them. Using the metaphor of a boat that is waiting to dock but cannot enter the harbor because of minefields, Epstein says, "You must trust your captain, who is doing everything humanly possible to ensure the security of our lives." While Lanzmann is reading, the image cuts from Rossel to the filmmaker. He finishes reading, is visibly moved, and says, "He was executed three days later with a bullet in the back of the head." We see Lanzmann closing the notebook from which has just read; he says, "The speech is heartbreaking." The film ends.

Lanzmann has gone from being interviewer to accuser, and finally to being a medium through which Epstein is able to speak from the dead. Lanzmann shows how despite the utter cruelties to which Epstein had been exposed, he still maintained a faith in the humanity of the world, a belief that there were people actually working to rescue the Jews from their annihilation. What is heartbreaking is not just Epstein's naive faith but that it gives rise to an even more frightening realization that it was not just global indifference to the situation of the Jews but the ways in which, through

their passage toward the camps, they became invisible. They achieved nonexistence in their own catastrophe.

The cinematic power of *Un vivant qui passe* lies in the way the long-take interview with Rossel creates an embodied image of the deep-seated hatred that many Europeans—even those who claimed strongly neutral positions—had toward the Jews. Despite a convulsive war and revelations of unspeakable crimes, Rossel's testimony suggests just how little self-reflection or reevaluation there has been on the part of many of the generation who were involved in the war. Unlike Fela Ravett, who, as we will see, fifty years after her experience at Auschwitz went to her grave still trying to find the language to speak of her experience, Rossel has remained unchanged in his assessment of the events that took place and his own role in them. It could be argued that Rossel must maintain his position, that to admit he was wrong about what was occurring in the camps would acknowledge his complicity in the crimes perpetrated there.

The March

In contrast to the long, uninterrupted shots of Rossel's continuous testimony, Abraham Ravett's *The March* is made up of a series of fragmented utterances of the filmmaker's mother, Fela Ravett, who, over the course of the twelve years in which the film was shot, moves inexorably toward silence. Also in contrast to *Un vivant qui passe, The March* is a highly aestheticized work, at once a poetic rendering of the fragility of memory, a son's desire to know and understand the experiences of his mother, and a materialist exploration of the process—and its limits—of what it is to represent such memories. The film emphasizes process over statement in its formal structure, which is predetermined by being divided into seven sections, each marked by year. Each year, from the first interview in 1986 to the last in 1997, we hear Ravett asking his mother the same question, "Mom, what do you remember about the march?"[17] Formed around these yearly interviews, the film's structure can be seen in relation to earlier avant-garde film practices such as the structural film. Structural filmmaking was defined by P. Adams Sitney "as a cinema of structure in which the shape of the whole film is predetermined and simplified, and it is that shape which is the primal impression of the film" (*Visionary Film,* 369). In most of the works that Sitney gathered under this rubric, representational elements such as mise-en-scène and profilmic events were stripped down to a minimum. This turned purely formal and cinematic elements such as shot duration, repetition, rhythmic structures, and specific camera movements and editing constructions into the film's content.[18] Structural films also emphasized film's materiality as a way to subvert the highly illusionistic elements of cinematic representation in favor of the *presentational* and therefore experiential aspects of the cinematic. Peter Gidal has defined such a film by its

> development towards increased materialism and materialist function [which] does not *represent,* or document anything. The film produces certain relations between segments

between what the camera is aimed at and the way that "image" is presented. (*Structural Film Anthology,* 1)

While *The March* does emphasize its own shape and materiality through the repetitive structure of the yearly filming, its subject matter also insists on a more complicated relationship to signification than the structural film, which is, for the most part, according to Sitney, "minimal and subsidiary to outline" (370). In contrast, *The March,* as well as Ravett's other films that take up his parents' experience in the Shoah,[19] use the presentational elements of the film's materiality to signify an outside or limit of what in their experience can be represented and what Ravett himself can ever know about his parents' past. These elements of filmic material are experienced as actual gaps in the process of trying to put the history of his family trauma into cinematic form. Similarly, in *Cooperation of Parts,* Daniel Eisenberg uses the material elements of film as a way to produce the experience of the gaps and fragmentation in his own struggle to come to know his parents' experiences of the Shoah.[20] In both films these sons of survivors work formally with the material elements of cinema to reflect the fragmented, incomplete, and unnarrativizable knowledge based on the bits and pieces they have received from their parents. Rather than creating an illusionary "whole story" from their fragmented knowledge, they emphasize the gaps in what they can know or comprehend through the use of cinematic material elements, much in the way the restorer of old mosaics will leave blank spaces of lost sections, rather than replacing them.[21]

Throughout *The March,* Ravett introduces each new section by using different elements of the filmmaking process normally rendered invisible, such as head and tail leadering with handwriting on it, holes punched into the film stock, end-of-roll flares, and flash frames; often we see him setting up a shot, turning the camera on and off at the beginning and end of each shot. The film's temporal construction is revealed in its cataloging form, in which each interview is marked by the year. This kind of filmic cataloging creates meaning from the accumulation of fragments of images and information through the repetition of the yearly interview format. In this way the film's formal structure is strongly linked to Gehr's *Signal—Germany on the Air* with its accumulation of repetitive explorations of a street intersection in Berlin. The emphasis on process is built into the film's fabric as we see Ravett each year setting up the interview microphone and asking his mother to clap her hands to mark image and sound sync. We hear Ravett, who is running the camera, asking questions out of frame. At times Fela Ravett can be seen asking if the camera is running (Figure 33).

Each year the mother does her best to cooperate with her son's desire to film these interviews, and she is seen attempting to answer his questions as best she can, despite her obvious discomfort at having to dredge up such memories on command; at one point she says, "Don't ask me anymore, because I start feeling bad." But still wanting to accommodate even at the expense of her own well-being, she attempts to continue: "I just remember one thing. . . ." The repetition of the interviews reveals the incessant

nature of Ravett's questioning. His growing obsession to know his mother's experience becomes central to the film's process as he pushes her to talk more. That he returns to the same question year after year, insisting that his mother revisit her experience whether she seems interested or not is at the core of the film as Ravett shows what Laub has suggested, that he too has come to experience the trauma himself. The repetitive structure of the film reveals the way in which the trauma continues to return as a second wounding—the wounding of the son. As Caruth states: "Trauma is not locatable in the simple violent or original event in an individual's past, but rather in the way it was precisely *not known* in the first instance—[it] returns to haunt the survivor later on" (*Unclaimed Experience,* 4). The idea that trauma is not locatable spatially or temporally makes the event an experience of the present, implicating not only the survivor but others who become involved with the person or people. In this case, the mother

Figure 33. *The March* (Abraham Ravett, 1999). The filmmaker sets up the microphone to interview his mother, Fela Ravett, in 1997. Photograph courtesy of Abraham Ravett.

is haunted not only by her own trauma but also now by that of her son, for whom she feels an obligation to repeat her experience each year. The son's desire to revisit her experiences appears to be more powerful than the mother's desire not to. At first he even starts questioning her in Yiddish—the language she spoke in Europe—until she confusedly asks, "Why are you speaking in Yiddish? I am more comfortable speaking in English." Here the multiple temporalities of the trauma reveal themselves in language as we see the mother's desire to push forward beyond her European experiences as the son attempts to move back toward that past.

Each year Ravett asks the same question, and she answers with fragmented anecdotes about having little food to eat on the march; she mentions bread and tins of meat that no one dared to eat because the meat couldn't be digested by those starving without killing them. She speaks of the road being littered with corpses of those who could not keep walking. She remembers the German soldiers asking them, "Can you walk quickly?" and shooting those who could not. Each year she reprises the same anecdotes, adding little that is new. She mentions that there were some who had the courage to escape—including a man who would later become her husband and the filmmaker's father. She speaks of the prisoners being treated like animals, forced to sleep in barns and pigsties. She speaks with amazement and a sense of detachment— as if she were recounting someone else's story—about finding a few pieces of sugar meant for the local pigs and how the sugar gave her energy to continue walking, thus saving her life. None of these anecdotes amount to a whole story, and she repeats many of them in different combinations each year. Others, after much prompting from her son, she alludes to only vaguely, such as a beating in which she sustained permanent internal organ damage, or her finally succumbing to illness on the march. Always speaking anecdotally, rather than descriptively, she is never able to give her telling a coherent narrative with a linear progression. Despite the suggestions that Ravett makes off camera at interpreting her memories to make the anecdotes cohere, they never do. The gaps become too big, and the repetitions too frequent. The memories are out of time, and there is never a clear sense of the temporal order of her narrative. She mentions that she finally got sick and could no longer walk, but she cannot remember or will not say what happened to her. Ravett asks leading questions in an attempt to prod her memory, but she has little to say. There is a sense that she doesn't recognize the experience to which she is testifying as her own. With each reply, we see in her face not just the emotional toll of her testimony but also the struggle to make words and to say something useful. The activity of testifying opens a gap between what she went through and what she is saying. What is so moving about Fela Ravett's testimony is that she is trying so hard, but each time she speaks, she has less and less to say. Agamben writes movingly on this point:

> Not even the survivor can bear witness completely, can speak his own lacuna. This
> means that language, in order to bear witness, must give way to a non-language in
> order to show the impossibility of bearing witness. The language of testimony is a

language that no longer signifies and that, in not signifying, advances into what is without language, to the point of taking a different insignificance—that of the complete witness, that of he who by definition cannot bear witness. (39)

Agamben suggests that the language of testimony itself is its own undoing, moving the witness toward the limit of what can be expressed. The trope of the "complete witness" indicates the unique paradox of one who can neither bear witness to his or her own destruction, since he or she survived, nor speak for the experience of those who did not, also because he or she survived. The testimony thus is the impossibility of speaking. In this paradox, it is the lacuna created by Fela Ravett's horrible experiences in the camp *and* her miraculous survival that makes her unable to put her experience into language, becoming one who cannot bear witness—or for Agamben, the "complete witness."

Ravett treats the slipping away of signification through language as central to the problem of bearing witness throughout the film. Creating epigraphic breaks between each year's testimony, he precedes each interview with several words written on the screen. Some are typeset; others are handwritten, at times by Ravett, and at other times, having asked her to write certain words from her testimony, in his aging mother's hand. She usually speaks these words in the interview that follows. We see words such as *Trepches* (wooden shoes), "blanket," "bread," "sardines," "Estusha was her name," the rivers Odra, and Nysa. The words return in the context of her talking—sometimes they are understandable; at other times, they slide by, barely comprehensible. Ravett uses the words as a repetitive device to call attention to certain parts of Fela's testimony, and they also work to pull the viewer into her process of speaking. We wait attentively to hear her say the word that was written, hoping it doesn't slide by. This use of visual and then spoken language asserts the temporal quality of narrative formation, making the written word a foreshadowing of Fela's performance of it. Conversely, when spoken, her speech is not only her memory of her experience; it also becomes the viewer's memory of what was read. All parties, from witness to listener to viewer, are involved in a return to an image from her past: the wooden shoes, a blanket, a German soldier threatening a young girl. In these black frames with the handwritten words, Ravett often includes an image fragment of Fela that is repeated in two separate frames. These are frames within the larger frame, words next to images. In these frames, the top one is usually recognizable, and the second an optically abstracted (blurred or lost loop) double of the first (Figure 34). These are the most enigmatic parts of the film, silent images that offer a different space from either the interviews or the written text. They are painterly in their color and abstract quality. As Ravett himself writes of these images:

[They] resonate not only with its representation but with its tonality, color and rhythm. Perhaps that puts some of the footage in the realm of abstraction but for me the border between what is "real" and "abstracted" is at times, indistinct.[22]

These intangible images are traces of the limit: of a moment, the impossibility of a memory, the limit of what can be held onto as it is fading into the past. Perhaps this tripartite frame—word, image, repeated image, surrounded by black—is what Agamben describes when he writes:

> The trace of that to which no one has borne witness, which language believes itself to transcribe, is not the speech of language. The speech of language is born where language is no longer in the beginning, where language falls away from it simply to bear witness: "It was not light, but was sent to bear witness to the light." (39)

The blackness around the frame testifies to the impossibility of witnessing. The words and the images are the trace that shows what "no one has borne witness to"; the blackness that surrounds everything in the frame is that which cannot be put into language. The emptiness of the frame, what is not there, bears witness (Figure 35).

As the yearly interviews go on, Fela Ravett becomes more enfeebled, her ability to write clearly—as seen in the intertitles—lessens as well, her ability to speak clearly

Figure 34. *The March.* Fela Ravett recalls the name of the person she walked with during the months of the forced march from Auschwitz. Photograph courtesy of Abraham Ravett.

gets worse. Here language and memory seem to become intertwined. Is she losing memory or language? Or is the loss of one, the end of another? Each year as they return to the question about "the march," Fela has visibly aged. At times the gap of a year has changed her face and body dramatically, and in one year the interview is given from a wheelchair. On the one hand, what we are seeing is the natural aging process of the elderly, for whom such dramatic changes are inevitable. On the other, in the context of the disjointed testimony, one cannot help but feel that the talking of such experiences is making her age so dramatically. One cannot help but sense that the rigors of the "march" of her testimony, which the son is insisting on, begin to seem like a repetition of the forced march she was made to do fifty years earlier. Has her ability to make sense through language begun to weaken from the years of telling and retelling? She begins to falter, as she did on the march, her body weakened from the months of endless walking.

By 1997, the titles over black simply say, "repeat-repeat." We see that Fela Ravett has lost her health. She is seen finally in a hospital, shot in extreme close-up, with oxygen tubes in her nose and without teeth; her eyes are moving wildly, seemingly in a state of confusion. Her speech is now barely comprehensible: mumbling words and other sounds. Ravett asks her if she has anything to say to her grandson. What she tells him is barely comprehensible, although she tries to communicate with the urgency of someone who has little time. She tells her grandson to "be a *mensch*" (an honorable and responsible human being); she says something about being a help to other people, and to keep his identity. To be a man and to have an identity were exactly the elements of selfhood that the Nazis worked to strip the Jews of, as part of the process of their extermination. The frame cuts to black. Ravett again asks her if she remembers anything about the march. The mother's voice is so enfeebled that what she says is repeated in subtitles for it to be understood:

> No I don't want to talk about that.
> Enough my son!
> You have enough there.
> They say in German, English . . .
> Overdo
> I just had a stroke.
> Do I have to remember?
> Think about it.

It is now clear that this film has been the testimony of Ravett's obsession to know, more than it is Fela's desire to tell. He chuckles embarrassedly, perhaps recognizing the extent of his obsessiveness at the idea of having asked once more. This film has been about the son all along. Finally Fela Ravett can only say, "Enough!" We see that she has cooperated with his need, and she tells him, "You have enough there—don't overdo." As remarkably heroic as Fela Ravett has been at surviving the Auschwitz death

march and Ravett's yearly attempts to have her recall it, she no longer has the strength. Her march finally ends here, her body calling a halt. "I just had a stroke," she pleads. "Do I have to remember?" But for the son, the trauma continues. He is no longer able to separate the mother's trauma from his own. As his mother is dying, it is through the shared experience of her trauma that Ravett can be seen to be holding on to her as she is slipping into oblivion. For Ravett, the pain of the trauma of his mother's experience, which they both had to repeat each year, is now coming to an end. The constant questioning that at first seems perverse or even cruel has actually been a shield for something even more horrible: the death of his mother.

The film ends in silence with the title "1998." There are now only words on the screen, written in Fela Ravett's enfeebled handwriting, which Ravett has collected while she was in the hospital: the name of a long-lost friend, a river in Poland, misspelled words, the German word for walking quickly—all fragments of an experience that could never become a story told. But while we are confronted with an event without a witness, we are also confronted with the real of the event (which, as Lacan suggests

Figure 35. *The March*. Photograph courtesy of Abraham Ravett.

in a different context, "always returns to the same place" [42]) that happened fifty years earlier: the death of Fela Ravett.

In her death, she has at last become the "complete witness," permanently silent, returning to those who were lost. Her son, however, remains. Ravett's very existence continues to bear witness to his mother's experience. As a filmmaker, Ravett invents a language in which to speak from this place between the two. "To bear witness is to place oneself in one's own language in the position of those who lost it," writes Agamben (161). Ravett's film is a remnant—what cannot be said. The remnant is not something that is left over from an event but something created from the "aporia of testimony" (163)—between what is unsayable by the mother and the son's attempt to bear witness to her incapacity to speak.

Both films, *The March* and *Un vivant qui passe,* have been made in the disjunction between what was witnessed and what cannot be told. They are figurations of this aporia. In these films, such figurations are never static or binary but rather dynamic and shifting. The activity of witnessing constantly moves from the witness, as the one who attempts to speak, to the listener, who bears witness to this process as one who is between the survivors and the dead, and ultimately to the viewer, who becomes a part of the process. The viewer also becomes a remnant of this event despite the impossibility of fully comprehending the limits of what can and cannot be known of the past traumas that inhere in the present. The creation of this dynamic relationship between past and present links *Signal—Germany on the Air, Killer of Sheep, The March,* and *Un vivant qui passe.* The formal procedures of each film allow for the gaps in knowledge and narrative coherency usually suppressed in conventional historical narratives and give them play in these works. This lets the specters of the past that cannot (yet) be put into language—either as image or as word—manifest themselves in the present through the mediating force of images of place, as in *Signal* and *Killer of Sheep.* In *The March* and *Un vivant qui passe,* it is language in which such specters of the past arise through the interactions between filmmaker and witness, and always in the mind of the viewer. As works of history, the processes that these films place in motion defy the closure of the pastness of conventional historical narratives. They also show how the ongoing nature of an event such as the Shoah not only redefines our notion of what an event is as it moves through time but shows, as well, how our notion of what constitutes the human is constantly being defined and redefined.

5. Obsessive Returns: Filmmaking as Mourning Work

Mourning without solidarity is the beginning of madness.
—ERIC L. SANTNER, *Stranded Objects*

The point of departure for this chapter was a recent experience of re-viewing my own film *Nicaragua: Hear-Say/See-Here* (1986) with a small group of people. The film, a portrait of daily life in Nicaragua during the Sandinista Revolution, at the height of the United States–Contra war, is a one-hour travelogue in which I explored the country, looking at the ways the revolution was transforming the society. The film makes the point that behind all the cynical Cold War propaganda, what was being destroyed was the sense of idealism and possibility that the revolution had created in the daily lives of some of the poorest people in the Americas. Years later, long after the defeat of that revolution by the United States and long after the useful life of that kind of topical film, a few friends and I sat in my living room watching this artifact from what seemed like an ancient past. But our response to the film was eye opening. Several of us, who had been deeply involved in work to support the revolution during that time, were silent, reflecting on the images and remembering the place the Sandinista Revolution had in forming our relation to the world. The muralist who painted murals all over Nicaragua at the invitation of the Sandinista cultural organizations and the Mexican American chemist who did Latin American solidarity work throughout the eighties were teary eyed when the film ended. We spoke about how the images evoked such powerful memories of our hopes and aspirations for social transformation that revolutions like the Sandinista embodied. On the other side of the room were a couple of younger friends in their twenties, who found our melancholic reminiscences

149

rather annoying and roundly criticized the film and our response to it as being nostalgic, naive, and sentimental. They maintained that the past we were trying to hold on to had produced little enduring social change and a great deal of carnage. In effect, they saw the film as an evocation of failure. Their sense was that valorizing these images confined the utopian imaginary to a set of past images and events that could yield nothing productive in the present and even restrained the current generation's ability to imagine a utopian present on its own terms. What was so striking about this conversation was the way in which the images from my film had moved from being images of success to images of failure. The larger question that arose from that evening was the fate of utopian thought at the end of the twentieth century, particularly as it is expressed in the cinema, whose development almost from its origins has been inextricably linked with the utopian impulses of modernist social transformation. What happens to those same images of success when they, because of historical forces, transform into images of failure? What is to become of such images whose meanings become unmoored by the shifting currents of history? "Stranded objects" is a term used by Eric L. Santner to describe "the labor of recollecting a cultural inheritance fragmented and poisoned by an unspeakable horror" (*Stranded Objects,* xiii). The question is, How do such stranded objects become part of a narrative of past struggles for social change in positive and productive ways in the present?

Furthermore, if twentieth-century socialist movements have failed, as it has been claimed, do the events and their varied iconography of this passing age of revolution continue to contain—even if failed—the potential for inspiration by connecting the present with an idealistic past? Or has such a history and its artifacts become so much cultural detritus, exhausted, now merely nostalgic, thus preventing us in the present from rethinking the past critically and imagining the future in new and original ways?

Leandro Katz's *El día que me quieras* (*The Day You'll Love Me*) (1997, 30 mins.) and Patricio Guzmán's *Chile, la memoria obstinada* (*Chile, the Obstinate Memory*) (1997, 58 mins.) are two works that focus on the fate of Latin American revolutionary movements of the past forty years. Though very different kinds of works aesthetically and perhaps politically, each takes up the fate of radical utopian social experiments in the twentieth century—specifically Che Guevara's final revolutionary campaign in Bolivia (Katz) and the Popular Union Movement of Salvador Allende in Chile (Guzmán). Katz, who began his career as a poet in his native Argentina, is a filmmaker long associated with avant-garde art movements in both North and South America. He has been living and working in the United States for the last thirty years and has made numerous films, photographic works, and installations focusing on the problem of historical memory, particularly as it relates to Latin America. Guzmán also began as a writer[1] and is the director of the film *The Battle of Chile* (1975–79), a six-hour documentary about the rise and fall of Chile's Popular Union Movement, in which Allende became the first democratically elected Marxist head of state. Internationally renowned as one of the masterpieces of the documentary film genre, *The Battle of Chile* had nonetheless never been shown in Chile until Guzmán's return in 1996. Both films are

radically unconventional and take up the problem of representing a transitional political moment as it is expressed in, by, and through the art forms of photography and film. Through the act of each filmmaker's return to the site of a failed revolutionary struggle, their films self-reflexively investigate and implicitly raise the question of what to do with the "stranded objects" that are part of the legacy of twentieth-century movements in Latin America. Both filmmakers are obsessively interested in the experience of returning to the exact locations of past events. Katz finds the laundry room in Vallegrande, Bolivia, where Che Guevara's corpse was displayed after he was murdered by the Bolivian army in 1967, and Guzmán returns to the football stadium in Santiago, Chile, where he was interned along with thousands of others during the coup of 1973. The making of each film involved the activities of excavating and examining lost images and narratives, finding and getting people long silent to speak the memories of their experiences, and even re-creating past moments as a way to conjure up memory. Rather than analytical or chronological historiography, both films might be described as archaeological. That is to say, both films can be seen as twentieth-century fin de siècle works of art that were made as part of the task of mourning a moment in Latin American history that has just passed.

El día que me quieras

For Latin Americans who came of age in the 1950s, the Summer of Love wasn't San Francisco, circa 1967, but winter 1959, when the dashing, long-haired Fidel Castro and Los Barbudos—like rock stars from the future—marched victoriously into Havana. From the vantage point of the cynical twenty-first century, it is hard to understand just how romantic and full of meaning the victory of the Cuban Revolution was for young Latin Americans. After a century of brutal imperialist domination there was now the sense of possibility for progressive social change—not just in Latin America but throughout the developing world.

Nearly forty years later, Katz, an Argentinean who left an increasingly repressive Argentina soon after Che, his fellow countryman, took up residence in Havana, has produced a beautiful and moving series of artworks collectively entitled *Proyecto para El día que me quieras* (The Project for *The Day You'll Love Me*). (The title is taken from the famous Argentinean tango of the same name.) The image of Che is at the center of all the pieces. This body of work can be seen as an elegy to a lost moment when love, youth, and revolution seemed synonymous. As part of an ongoing series of artworks that include gallery installations, photo series, and a film, Katz meditates on the strong relationships between the romance of liberation struggle and the violence and death that have surrounded the history of Latin American revolutionary movements. Like Benning in his film *Utopia*, Katz also focuses on Che's ill-fated revolutionary campaign in Bolivia, but to very different ends. As we have seen, Benning's interest is not so much in looking at Che's failure in Bolivia as it is in evoking the idea of its success—which stands as a virtuality—outside Latin America by connecting it

to the situation of Mexican undocumented workers in Southern California.[2] Katz, by contrast, uses the reality of Che's failure as a way to work through the meaning of that failure psychologically, historically, and perhaps politically from within the context of Latin America. In *El día* Katz uses the legacy of Che's failure in Bolivia to stand metaphorically for the failures of the larger revolutionary endeavors within the Latin America of the last forty years. With this understanding, *El día* can be seen as a work of mourning. It is an attempt to work through the trauma of a lost moment, of the horror of the dead bodies piled up throughout the continent in the struggles for justice and self-determination, of youth and the romance of heroes, and the possibility of progressive utopian transformation so central to the 1960s. In keeping with this sense of the infinite possibility that seemed to define those years, Katz focuses on Guevara's final ill-fated revolutionary campaign in Bolivia. In early 1965, with a group of seventeen followers, he left Cuba and his position as hero of the Cuban Revolution for Bolivia to organize the peasantry and overthrow the military regime of General René Barrientos. Two years later—aided by the CIA—Che and his small band of guerrillas were captured in the mountains of Bolivia and executed.

In *El día,* Katz contemplates the last photograph of Guevara's body surrounded by the Bolivian military officers who captured and killed him (Figure 36). The photograph

Figure 36. *El día que me quieras* (Leandro Katz, 1997). Ernesto Che Guevara. Photograph by Freddy Alborta. Copyright 1967.

was published in newspapers around the world to prove that his ill-fated campaign to continue fomenting revolution beyond Cuba had ended in defeat. The photograph showing Che's corpse laying prone, beatific, with eyes open gazing skyward, had, in fact, the opposite effect. Bearing an uncanny resemblance to past images of Jesus Christ, the photograph embodied Che as the Christlike martyr of international liberation struggles; his image has become a link to ideas of social justice for the poor, so significant to both Latin American revolutionary struggle and some Christian theologies. Throughout Latin America, it is still not uncommon to see Che's photograph hanging on a wall next to images of Christ or the pope. Also, this photograph has long fascinated the international cultural Left, linking contemporary revolutionary iconography to traditional Christian religious and messianic imagery in Western art. John Berger, for example, wrote an essay soon after the photograph's publication comparing it to Mantegna's *Dead Christ* and to Rembrandt's *The Anatomy Lesson of Professor Tulp*.[3] More recently there was the exhibition Che Guevara: Icon, Myth and Message,[4] which looked at the myriad ways Che's image has been used politically, in fine art and in pop culture as well.

El día que me quieras continues to engage the fascination that this photograph still holds as a central image in modern Latin American history. The film is a work of mourning in the form of an investigative elegy, not just to raise an image of the dead but as a way to work through the memory of a period of history that has just passed. The film is structured around a range of materials, from Katz's original footage shot in the mountains in present-day Bolivia, talking-head interviews, newspaper clippings, archival photos and film footage, as well as a reading of a poem by Borges. Katz explores the image of the dead Che not only as a symbolic icon but, more important, as a document of a moment that took place in real time and in a specific place. The film, then, becomes an investigative report on how this photo came to exist and examines it closely as a document of the brutality of the Latin American past. Katz relentlessly examines this photograph by using extreme close-ups and masking off sections of the image. In addition, he returns to the site in Vallegrande where the photographs were taken, exploring with his own camera the room itself and then the landscape around the building. For the self-exiled Katz, the central action in the film is one of obsessive return. He returns again and again to the photograph of Che, returns to Latin America and the site where the photograph was taken, and to the lost promise of revolution that marked his youth. Katz's return to this photograph of the dead body of Che in the late 1990s is an effort to contemplate the ways in which the hopes and promises of revolutionary social movements of the century as a whole turned out. It is a story of loss. The act of making this film becomes the work of mourning that loss. Using Freud's notion of *Trauerarbeit,* or mourning work, Santner has aptly defined it as "a process of elaborating and integrating the reality of loss or traumatic shock by remembering and repeating it in symbolically and dialogically mediated doses; it is a process of translating, troping and figuring loss" (Santner, "History," 144).

In the film, Katz uses repetition as a process of elaborating loss by showing the photo of Che's corpse again and again through different discourses. This is his way of trying to understand the continuing mythic power of Che and the photograph. He begins by tracing the image to its origins. It was originally published as a UPI wire photo credited to the photographer Hal Moore, but Katz discovers that the photo was actually taken by a young Bolivian photographer named Freddy Alborta. Now in his sixties, Alborta is a soft-spoken, elegant man who begins to remember that central moment in his life when he was called on to be a part of a defining moment in Latin American history. He remembers every moment. He describes how the journalists were taken to a small laundry room near a hospital in which Che's body was laid out on a sink. He remembers the smell of rotting bodies. Despite the intensity of the moment, Alborta immediately understood the mythological dimensions of Che's body. When asked how he felt when he saw the body, Alborta answers:

> I had the impression that I was photographing a Christ, I had in fact entered that dimension. It was not a cadaver that I was photographing but something extraordinary. That was my impression, and that is perhaps why I took the photographs with such care: to demonstrate that it was not a simple cadaver.[5]

In his questions to Alborta, Katz tries to tease out what seems to be a particularly ironic conjunction of the reality of Ernesto Che Guevara's life as a freewheeling Communist adventurer and revolutionary and the iconography of the Catholic Church. Questions hover. Is Che's visage a predestined immanence of Christ revealed in the photograph, like sightings of the Virgin Mary's shadow appearing on a wall as the moon casts its light through some tree? Or is Che-as-Christ a set of formal constructions that a young photographer from a Catholic culture has created? Katz asks about why Che's eyes were left open. Alborta suggests that the military kept his eyes open to better identify him; "However," he remembers, "that helped me to photograph not a common cadaver but a person who seemed to be alive and gave the impression of being a Christ." Katz asks Alborta if he was aware of past paintings using Christian iconography such as Mantegna's *Dead Christ*. Alborta replies:

> No, I did not know them. When I took these pictures, I really did not want to make photographs for the press only, but in looking for angles and composition, I tried to do something artful in each one of them.

What is uncanny in Alborta's photograph is the way it repeats and returns the image of Christ to Che's political legacy—a discourse that was deeply critical of such religious traditions. The film scholar Tom Gunning has suggested that in photography, the uncanny has to do with a notion of the double and, in particular, doubling as part of a fascination with repetition. Gunning theorizes that historically this has been central to the power of photography itself. He writes that photography was also

experienced as an uncanny phenomenon, one which seemed to undermine the unique identity of objects and people, endlessly reproducing the appearances of objects, creating a parallel world of phantasmatic doubles alongside the concrete world of the senses verified by positivism. ("Phantom Images," 42–43)

The Alborta photo, then, identifies the physical body of Che, proving that he is dead, and at the same time opens onto a dematerialized world of the phantasm of a Christ. The figure of Che is uncanny as he evokes the discourse of the double: Che/Christ, Communism/Catholicism, living/dead, tradition/innovation, all of which make him at once familiar and strange despite one's ideological proclivities. This produces one of the central ironies of Che's legacy, that by the year 2000, with his image being repeated and recirculated everywhere from art films to T-shirts and advertising campaigns, consumer capitalism has claimed Che as an icon for freedom, rebellion, and nonconformity, and the socialists have worked to legitimize him by connecting him to traditional religious iconography.

Katz, however, tries to undermine the religious mythos surrounding the photo by showing many of the other photos that Alborta took in the laundry room during the press conference. In a wide-angle shot, we see that, in fact, Che's is not the only corpse in the room. This is a charnel house, and bloody corpses of several other guerrillas from his army are strewn around the floor in various states of decomposition. It is a horrifying scene in which generals and journalists are stepping around these bodies to see Che. Through these shots, we see that behind the beatific image of a Christ figure there is horrible brutality and carnage. Rather than focusing on Che's spiritual aura, we must speculate on the horror of the last hours of these men. Clearly, the Alborta photos are a document of the aftermath of unspeakable torture and execution (Figure 37).

Still, much of the poetic power of the film comes from the uncanny doubling of images and the layering of representations on representations to the point where any sense of an original body becomes obscured. As time passes, the image of Che continues to be appropriated for any ideological purpose; Katz makes these photographic objects—in their textures and reproducibility—as concrete as possible. We see the negatives and proof sheets of the famous photographs; Alborta is shown in his darkroom printing new copies of them—the images miraculously appearing in the developing tray. Throughout the film, the photographs are constantly being reformed, cropped, and segmented. There are even photos within photos. In one shot the generals are holding a magazine with photographs of Che alive next to the corpse to prove that it is the same person (Figure 38). In another picture, Che's corpse is almost obscured by all the photographers and cinematographers hovering over the body to photograph it.

Katz begins to intercut motion picture footage (which was shot at the same moment as the stills) with Alborta's still photos. It is a startling transition. Suddenly there is movement as the motion picture camera pans down the length of the body. There is a momentary sense that the body has come alive as we are moved from the

frozen time of the stills to the real time of the movie footage. While the photos give a sense of death as frozen in time, the moving pictures show the body lying in real time as life around it continues. The still photo is frozen time—"*flat Death*" (Barthes). On the other hand, the film footage gives an eerie sense of presence; Che's eyes, wide open, staring into the camera as we see people moving around, open up a space between the living and the dead. More powerfully than in the still photos, the shaky movements of the handheld movie camera give Che, with his still-piercing eyes, the appearance of being at once alive and dead, as if he had not yet completely passed into

Figure 37. *El día que me quieras*. Soldiers and reporters step over the bodies of the dead guerrillas to touch Che Guevara. Photograph by Freddy Alborta. Copyright 1967.

the past tense, suggesting a liminal space between life and death. In this footage we can perceive glimpses of a living world around the frozen corpse. Some peasants can be seen in the background moving cautiously in relation to the generals who surround the body. The film footage exposes the awe with which the generals regard Che's body. They are constantly touching the body, pointing at it, hovering over it as one might examine a fallen angel or a mythic creature always known of but never actually seen. Despite the fact that they have killed him, it can be seen in this footage how Che's charisma and its threat are still very powerful in that tiny room. By cutting between the still and moving pictures, Katz shows how differently each medium evokes a sense of how death is part of a temporal continuum.

Katz chooses to embody the present of this continuum by intercutting breath-takingly filmed shots of the Bolivian landscape and villages in the mountainous region in which Che fought. Here Katz suggests the persistence of life through images of these vital landscapes. Despite the traumas of human history, perhaps a sense of potential for transformation lies in the ability of nature to constantly renew itself. Katz has also staged several scenes showing Bolivian peasants carrying red flags through the land-scape and others in which peasants wearing traditional costumes dance and play music. In this context they seem to stand in homage to Che, but their anonymity lends a

Figure 38. *El día que me quieras.* Ernesto Che Guevara: a Bolivian general holds a magazine image of Che next to his body to prove they really caught him. Photograph by Freddy Alborta. Copyright 1967.

childlike purity to their activity, as if in their innocence they—like nature—stand outside time. The film positions them as exotic bystanders in their own land, while somehow the workings of history are left to others from the outside such as Che, arriving from Cuba to organize them in 1966, or even Katz himself, flying in from New York to eulogize them as part of a failed movement. While it was necessary to create an image of the people for whom Che was fighting, the peasants remain at a distance, simply an abstraction—a criticism that was also made of Guevara's own relation to Bolivia, which, it has been claimed, contributed to his failed campaign. At this point in the film, Katz's work of mourning is overtaken by a sense of moral outrage. An intertitle appears quoting from a passionate Latin American text condemning the cold-blooded execution of Che after he was captured:

> Shot, executed, murdered or finished off—whatever particular personal interpretation one gives to the facts—there is a human truth which gives rise above any subjectivism: A man, a sick and wounded prisoner, was killed without any semblance of justice when he was in the hands of those whose duty it was to rigorously guard his physical safety. Beyond any moral law and above any legal principles, the truth is that an elementary rule of war had been violated: A prisoner is always sacred.

These words raise the specter of the brutality and the moral bankruptcy of the forces of repression in the history of Latin American politics in the face of Che and his comrades' mythic purity of purpose—fighting for social justice. Ending the film with this quote also indicates that the work of mourning is not yet complete. The sense of moral outrage evident in the quotation has not yet been fully integrated into Katz's otherwise mythic memory. There is still no proper contextualization or closure despite the film's postscript stating that in 1997 Guevara's remains were finally found in Bolivia and returned to Cuba.

The final image is a photograph from an earlier moment. We see a dashingly handsome Che standing and gazing into the camera, replete with his battle fatigues, red-starred beret, a warm smile, and twinkling eyes. The title song, "The Day You'll Love Me," sung by the Argentinean singer Carlos Gardel, is heard telling of a love fantasy that brings about an almost biblical transformation. Through the song and image, Katz ends his film by evoking a generation's lost romance of the passing age of revolution in Latin America. From photographs, bits of film, a corpse, a landscape, a poem, the reminiscences of an elderly man, the film becomes a time-image that opens onto a virtuality: that of the still as-yet-unrealized revolution in Latin America. Despite the failures, one can sense in these stranded objects the idealism, passion, humanity, and desire for justice and self-determination that transformed a generation. These are the shards of a romance that remain as a force perhaps to blossom again. The song and the film's title—*The Day You'll Love Me*—speaks to this future, not only to the redemption of the failures of a beatific hero, but also for those who imagined and struggled with him.

Chile, la memoria obstinada

In *Chile, la memoria obstinada*, Patricio Guzmán's return is to Chile for the first time since he went into exile after the coup d'état of 1973, bringing with him his film *The Battle of Chile*, which had never been seen in that country. *Chile, la memoria obstinada* is structured by a mix of first-person narration and the intercutting of archival footage—largely from *The Battle of Chile*—with contemporary interviews and film footage shot by Guzmán. As much about individual subjectivity and the ephemeral quality of the *feeling* of memory as the earlier film was resolutely analytic and descriptive, *Chile, la memoria obstinada*, focuses on first-person testimony, through which Guzmán structures the film.[6] He returns to present-day Chile, visiting many of the sites and people he knew before the coup. Many of those interviewed are former activists or members of Allende's administration, and the now-elderly parents and spouses of those killed or disappeared; several are Guzmán's old friends and colleagues who are now artists, doctors, filmmakers, and college professors, among others. Some recall their experience of the Allende years, while others reflect philosophically on the nature of memory, and still others testify to the horrors they experienced during and after the coup. Guzmán also speaks to younger Chileans who have little or no memory of the coup. It is here that he begins to construct Chile as a split world. One Chile is that of the older people for whom the coup and the subsequent silence during the dictatorship have been central to the structure of their lives. The other is the Chile of the young who have been brought up in the silence and rationalizations of the brutality in the coup's aftermath. Many of these young people were not yet born or seem to have only vague memories from childhood of the day of the coup, or had a family member who was killed, but have little knowledge of why. In this way, Guzmán begins to reveal two Chiles in the same space. This doubling of the Chilean present goes on throughout the film and creates an uncanny sense of a place that is at once familiar and strange. Throughout, Guzmán produces doublings of past/present, memory/ignorance, youth/middle age, exile/home. Through this doubling there is a feeling that something unseen inheres in all these people and places, but one doesn't really know what it is. The film introduces the possibility of *feeling* rather than chronology as a mode of historiography.

In Freud's essay on the uncanny, rather than defining it as a phenomenon, he shows us instead that it is a feeling that is nearly impossible to define except through description and illustration that usually produce a feeling of dread. Indeed, in the first part of the essay, Freud explores dictionary definitions of the word in several different languages, none of which add up to much more than the idea of dread. Freud finally returns to his native German, and the word for uncanny—*unheimlich*, or literally "unhomely"—for which he gives a long etymology and then concludes:

> Among its different shades of meaning the word *heimlich* exhibits one which is identical with its opposite *unheimlich*. What is *heimlich* thus comes to be *unheimlich* . . .

which without being contradictory are yet very different: on the one hand, it means that what is familiar and congenial, and on the other, that which is concealed and kept out of sight. ("The Uncanny," 129)

As Freud suggests, this doubling of the familiar and the concealed produces the feeling of the uncanny. Guzmán, who returned to Chile after thirty years of exile, rather than giving a conventional report of past events, tries to capture this uncanny feeling in his film to reveal the past through the repressed silence that has been created by time, ignorance, and trauma.

Guzmán creates situations that produce uncanny moments when the repressed memories from the past return and, at times, "awaken" in a subject in the film—and often in the viewer himself or herself—"an uncanny feeling, which recalls that sense of helplessness sometimes experienced in dreams," as Freud puts it (143). In one crucial scene, he has hired a marching band to play the anthem of the former Popular Union as it marches through the crowded streets of present-day Santiago. He focuses his camera on the people in the streets; as the older people stop in their tracks, we see in their faces a sense that the dailiness of the city street has been momentarily transformed into something at once familiar and strange. We perceive in their faces a sense of anxiety from the repressed memory of the experience of the coup. At this moment, the *Heimlich,* as Freud describes it, turns into the *Unheimlich,* "for this uncanny is in reality nothing new or foreign but something familiar and old—established in the mind that has been estranged only by the process of repression" (148). This theatrical tactic of restaging a parade produces a purely cinematic form of historiography in which the photographic image in time documents that history through a visual examination of people's expressions of confusion and mixed emotions of a moment long ago that returns in the midst of their everyday lives. In contrast, the younger people in the crowd react with a bemused noncomprehension that shows the gap in knowledge between the generations. The swirling handheld camera intensifies the sense of strangeness, as the force of time unleashed in the street through the music. The scene produces a time of memory and "a feeling which recalls that sense of helplessness sometimes experienced in dreams" (143). As a form of historiography, this can be seen as a kind of doubling of the visual narrative that produces a multiplicity of relations to the trauma of the failed experience of the coup. What we are seeing is not just the image of a remembering but a feeling of ambivalence that pushes the feeling of the familiar (*heimlich*) into its opposite. As Freud writes: "Thus *heimlich* is a word the meaning of which develops toward an ambivalence, until it finally coincides with its opposite *unheimlich*" (131). Guzmán's use of the uncanny changes the idea of home (or what is familiar) from a static and fixed relationship of causal events into something that is fluid and ephemeral.

In another sequence, Guzmán returns to the National Stadium, which was used as an internment camp during the coup, and recalls his own internment. A doctor who was administering first aid to the prisoners speaks of the torture, murder, and

mock executions that went on. Guzmán elides past and present through a series of lap dissolves between archival footage and photographs taken during the coup and present-day images of the bowels of the stadium to produce another uncanny moment. In both past and present footage, we see soldiers preparing for military-style crowd control in full riot gear. They are in formation, preparing to take to the field. The image dissolves into the present: the crowds are screaming, there are billows of smoke, soldiers rush at the young people, who are chanting and waving banners as if protesting the soldiers' presence (Figure 39). There is a strong feeling of violence, and the

Figure 39. *Chile, la memoria obstinada* (Patricio Guzmán, 1997). The filmmaker returns to the stadium in Santiago, haunted by the memory of his internment along with thousands of others, many of whom were tortured or killed by the military during the 1973 coup. For the younger generation of Chileans, the stadium is a place to celebrate soccer, while the soldiers posted there to maintain order look on. Photograph courtesy of First Run/Icarus Films.

situation again seems to be moving toward total chaos. But this time it is only a football game. For the filmmaker, whom we see gazing out onto the stadium where he was held prisoner, it is uncanny to see the same kind of violence and militarism still directed at unarmed young people. But today these youths are only cheering on a football game. Freud continues his description of the uncanny:

> Many people experience the feeling in the highest degree in relation to death and dead bodies, to the return of the dead, and to spirits and ghosts. As we have seen, many languages in use today can only render the German expression "an *unheimliches* house" by a *haunted* house. ("The Uncanny," 149)

For Guzmán and others of his generation, the stadium can be seen only as a haunted house, no longer simply as a sports arena where aggression and competition between groups are symbolically acted out; for them it is a site where unspeakable violence was actually done. We see a shot of Guzmán's octogenarian uncle gazing skyward at a wall on which is inscribed the thousands of names of those killed or disappeared during the coup. As Guzmán and the older people in the film attest, the whole country has become an *unheimliches* house in which the dead are everywhere, but still not at rest. The youths chanting and rioting during the football game are unaware of the irony of the nature of their activity in relation to what went on nearly three decades ago in the same spot. This scene in the stadium visually embodies the sense of two Chiles split generationally by the memory of the coup.

In *Chile, la memoria obstinada*, Guzmán returns to Chile as a kind of third term between the generations. By making the film, he becomes a catalyst creating situations in which mourning work that has yet to take place can begin and to which he comes to bear witness. In another such situation, Guzmán is showing old photographs to a group of men and women who worked as bodyguards, maids, and secretaries for Allende while he was president. We see a photograph of Allende in his car, surrounded by crowds. Several of the people looking at the photo are also seen in it, walking alongside the car as bodyguards. Guzmán then reenacts, in the present, the same scene from the photograph with the same men. He has someone drive an empty car with the former bodyguards stationed at each corner of the car, as they were in the past when protecting Allende. Guzmán focuses on their faces as they silently walk alongside the car down an empty street. The car is no longer a limousine, and there are no people cheering. There is an eerie silence as the camera focuses on the men. Through the repetition of this once-familiar action, Guzmán evokes a sense of the uncanny for the men. Through the gait of their walk and close-ups of their faces and hands, we see them experiencing themselves as they once were (Figure 40). The reenactment opens onto a virtual scene of them protecting Allende in his car as he moves through cheering crowds. This activity allows these men to experience themselves in the present as the people they once were, and through that to reconnect—even for a moment—with how meaningful what they were involved with was in the face of the silence that has

covered over such memories. Rather than illustrating this as a fictional scene from the past, Guzmán has created a situation in which the viewer can see the men as their memories become palpable. The force of the past is experienced physically as body memory in this uncanny moment in which the past and present commingle on the empty street.

After focusing on ways in which the older generation begins to experience their repressed memories through Guzmán's process of making this film, the last part of the film takes place in classrooms where he shows his earlier film *The Battle of Chile* to different groups of young college students. Some sit stunned by what they have just seen. Others weep uncontrollably and cling to each other. The confused responses of the students after the screenings make clear how little they have known of their own country's history, or even the reasons for the kinds of melancholy and nihilism that seem to pervade their lives. One young man whose brother was killed by the dictatorship speaks to the ways in which he believes in nothing and has been living a life of darkness. On the other hand, there are others who continue to defend the coup, accepting the rationalizations of the dictatorship and their claims that they needed to bring order to the country. It becomes evident that they themselves have become part of the silence that has permeated the last thirty years of Chilean life. Here we can see

Figure 40. *Chile, la memoria obstinada*. Experiencing themselves as the people they once were, Allende's former body-guards demonstrate how they protected the president in his car. Photograph courtesy of First Run/Icarus Films.

the students consciously experiencing themselves as having been "stranded objects" in the years of silence during the dictatorship, which has suffused their lives with the melancholy of an unmourned past. In discussing Freud's notion of mourning work in relation to postwar generations in Germany, Santner writes:

> The postwar generations face the complex task of constituting stable self-identities by way of identifications with parents and grandparents who in the worst possible cases, may have been directly implicated in crimes of unspeakable dimensions. . . . But even where direct culpability is absent, these elders are individuals whose own self-structures are likely to have been made rigid by a persistent core of repressed melancholy as well as the intense aggressions associated with unmourned narcissistic injuries. (*Stranded Objects,* 35)

While comparing the Nazi Holocaust to the Chilean coup may be a leveling out of the uniqueness of each event, the task of mourning for the Chilean second and third generations can be understood as analogous. Their sense of self in relation to the larger society can only be formed, as Santner suggests, in relation to the gap that was created by a prior traumatic social upheaval. Their integration into that history is a necessary part of the work of mourning if they are not to absorb unconsciously the melancholy and cynicism of an unmourned past.

The young whose families were victims of the dictatorship also become witnesses to their parents' mourning work in their effort to reintegrate into the Chilean present their parents' memory of the failure of the Allende movement and the experience of the repression after the coup. The film shows how the two generations are inextricably tied to each other if the events of the past are to be productively integrated into the present. As Santner puts it: "Mourning without solidarity is the beginning of madness. . . . Mourning if it is not to become entrapped in the desperate inertia of a double bind, if it is to become integrated into a history, must be witnessed" (*Stranded Objects,* 28). It is not only the knowledge of past events that must be understood; if the younger generation is to mourn with the older generation, they must also experience the feeling of how a home that was once familiar (*heimlich*) becomes strange (*unheimlich*). For this reason, as a follow-up to *The Battle of Chile,* Guzmán makes *Chile, la memoria obstinada,* a personal film (which he dedicates to his two daughters) about the quality of ephemeral feelings of memory evoked by the experience of the uncanny.

Now to return to my earlier question of what to do—in the present—with the problem of an image of success that becomes an image of failure. The melancholy air that permeated my living room on the evening I showed my film about the Sandinista Revolution holds within its very sadness—a form of self-consciousness—a certain kind of awareness of possibility, with all its potential, as the other side of total loss. Just as Katz takes up the image of Che Guevara's body as the figuration of the lost idealism of past pan–Latin American liberation struggles in *El día que me quieras, Chile,*

la memoria obstinada is also an attempt to find a way back to the possibility of the idealism of revolutionary transformation among the shards and stranded objects of the failed Allende revolution. The active brooding (Benjamin) over these fated struggles that characterizes both Katz's and Guzmán's process of film making raises once again, within the melancholic aura of failure, an awareness of the intensity of the idealism and hope that infuse these histories.[7]

The existence of these films as a phenomenon of the present articulates a dialectic between loss and recovery that revitalizes an apparently stagnant image of revolutionary struggle in the current context. Films such as *El día que me quieras* and *Chile, la memoria obstinada* produce possible counterhistories that reconsider historical opportunities—such as these failed revolutionary movements—that are left unrealized, but within which there is a latent energy that can provide the spark for thinking anew the possibility of progressive social transformation in Latin America and elsewhere.

Coda: Notes on History and the Postcinema Condition

All of old. Nothing else ever. Ever tried. Ever failed. No matter. Try again. Fail again. Fail better.

—SAMUEL BECKETT, *Worstward Ho*

Throughout this book I have worked to acknowledge the expanding possibilities for contemporary avant-garde film practice by making a case for a wide range of aesthetic approaches to the imaging of history. In the final two chapters, I paired films from more typically avant-garde film contexts such as Ernie Gehr's *Signal—Germany on the Air* and Abraham Ravett's *The March* with films more commonly classified as dramatic narrative or social documentary such as Charles Burnett's *Killer of Sheep* and Patricio Guzmán's *Chile, la memoria obstinada*. By making the claim that these and several other works can be construed as avant-gardist, I have shown ways in which avant-garde practice in cinema arises not simply out of a desire for stylistic innovation but, more deeply, through a profound engagement with the changing nature of contemporary thought. As such, stylistic innovation becomes a necessity in order to express ideas and experiences that can no longer be contained by defined genre forms. In this sense, current postmodern discourses that are blurring traditional separations between disciplines and cinematic genres have their basis in the desire to use cinema as a medium through which to think. Such an aspiration embodies the utopian belief that has surrounded film culture since its beginning, that the deepest, most relevant questions about our world could be raised, and that the medium of film would actually be capable of answering them.

Not content to allow sedimented genre forms to contain their explorations of the

world and its ideas, filmmakers continue to trespass the borders of given genres and are making new connections between forms and techniques, creating new hybrids and shifting the terms that classify them. The nature of genre classification often makes it difficult to recognize how filmmakers are revitalizing the art of cinema through the subtle ways in which different forms envelop each other. This is particularly true for avant-garde film, which is often perceived to be made for a closed and impenetrable community of cognoscenti more interested in making and showing films to each other than in joining larger conversations. The idea that there could be a need to struggle against the "genrefication" of avant-garde and experimental film seems ironic given its ideal of radical openness and free-form exploration. But to be fair, this impression of a closed-circuit community only interested in talking to itself is intensified by a larger sense of invisibility owing to the lack of economic support for the production, exhibition, and distribution of experimental media, on the one hand, and the limited critical engagement with contemporary avant-garde cinema by film and art critics and scholars, on the other. This is true particularly in the United States, in which support for nonprofit and noninstrumentalized art has become nearly nonexistent.

Like other forms of historical narrative, film history must also resist linearity and closed systems to define itself. By making the case for an avant-garde and experimental cinema that has moved beyond its roots in formalist abstraction and the mythopoetics of the first-person cinema, I have challenged some of the more established aesthetic criteria for what has traditionally constituted these practices.

To foreground the social and intellectual discourses occurring within avant-garde films, I have assiduously resisted technologically deterministic rationales as a basis for understanding the changing forms within avant-garde practice of the last twenty-five years. It is for this reason that all the works I have discussed have been films. This is not to say that I don't believe electronic image making has not transformed the ways historical representation in avant-garde film is being made and used. It is hard to assess the extent to which the changing technologies of cinema have transformed avant-garde film from an important and influential counterpractice within contemporary media into what is often seen as an anachronistic and boutique genre of little consequence. While not a quantifiable fact, it is nonetheless a general feeling within the academic, art, and media worlds interested in avant-garde and experimental media that the most important experimentation and conversation is currently taking place with video and digital technologies. So it is clear that changing technologies do determine the ways filmmakers make, distribute, and exhibit their work. The expense of working with photographic motion picture film has made it nearly impossible for avant-garde filmmakers to sustain the expensive and unprofitable practice invaluable for the ambitious experimentation necessary to develop an advanced, socially engaged art.

But perhaps more profound than all the technological shifts in the way films are made are the technologies that have transformed the ways cinema is watched and, hence, used as a social practice. The movement away from cinema as a group-oriented

theatrical viewing experience toward increasingly varied cinematic experiences, from the art gallery to the living room to the personal computer, has inflected older discussions such as site specificity and interactivity in exciting new ways. The following are a looser set of musings and arguments I have been thinking about in relation to the present and future transformations of avant-garde film practices and the ways they have created new possibilities for historiographic representation. As with all my theoretical thinking about cinema, I have grounded them in actual practice. I continue to connect even my speculations with the generative discussions of recent work that pushes against the boundaries I have set up for this book.

From Public to Private: The VCR

The emergence of the home VCR, and with it low-cost video (and now DVD) rental in the mid-1980s, has transformed the ways film is used in daily life. The urgency that surrounded film viewing has changed. No longer is it necessary to integrate going to the movies into the complexities of life in the world. "We gotta get to the 7:30 screening" has given way to the more detached "I'll catch it on video." Part of the energy produced by cinephilia is the way in which one has to organize one's life around the time and place of a screening. For those who take film to be a contemporary medium through which contemporary ideas circulate, seeing the rare film that is being shown only for a day or two—with no other screening date in sight—becomes an essential way of organizing one's life. As such, theatrical film viewing is a deeply social practice: the arrangements with others, the subway-ride encounters, meeting friends before and after to share the experience and reactions together. Creating such an experience is an important part of what movies in public theaters do. To paraphrase Godard, when watching films in a theater, we are alone together. Thinking, talking, arguing, and lovemaking after going to a film become an extension and a layering of the cinematic experience. In this way, theatrical film viewing can be understood to be a unique event, each screening different from another, each containing its own dynamics and relationship to daily life that powerfully inflects the experience of cinema.

Perhaps in this era of film viewing in one's living room, media library cubicle, and personal computer, the public theatrical experience of a film has become the "auratic" (in the Benjaminian sense of the aura of an artwork) element of cinema, which, in the shift toward the more private, small-screen experience, has begun to wither. If, as Benjamin argued, the decay of the aura comes from a desire to "get hold of an object at very close range by way of its likeness" (*Illuminations,* 223), the VHS or DVD creates an object that can be bought, sold, and copied out of the immaterial experience that a movie ticket once purchased. Like "a mountain range on the horizon or a branch which casts its shadow over you" (223), the VHS or DVD transforms the projected film image once seen at a distance, its size measured in feet and yards, into something that is now measured in inches and brought so close it can even be held in the palm of one's hand.

From the appearance of the DVD "collector's edition" with high-quality restorations, director's cuts, outtakes, historical documentation, and commentaries by filmmakers and scholars to low-cost DVD reissues sold at Wal-Mart, the cinematic experience is now placed in the realm of shopping and owning rather than in the realm of provocative anxiety where the ephemerality of an image is continually slipping away just out of reach. The success of the DVD as something to be bought and collected is transforming the notion of the cinephile from the passionate filmgoer to film collector and with it has created a new consumer market.[1]

Similarly, the development of the DVD has finally succeeded in transforming cinema-based art into collectible objects. How to sell easily reproducible artworks like film prints to an art market where the singularity of original objects turns them into profitable investments vexed many of the pioneers of avant-garde cinema. In the 1960s and 1970s, some filmmakers, such as Stan Brakhage, Larry Jordan, Paul Sharits, and others, spoke about their attempts to find ways, with little success, to convince collectors, galleries, and museums that their films could be collectible.[2] At the time, the idea of collecting artworks that were contained in heavy tin cans filled with endless ribbons of film, the images of which could be accessed only through the use of awkward mechanical projection machines, played little part in the imaginary of cultural connoisseurship.

By the 1990s, however, with the development of easily usable compact DVDs, smartly packaged in containers—often designed by the artists themselves—and sold in limited editions, artists' film and video have become reimagined as salable and collectible objects like fine art photographs, prints, or the artifacts of conceptual artworks. This has been the case not only for single-screen work but also for the more elaborate film installations that frequently use the most advanced electronic equipment (often sold as part of the installation) and are now regularly sold in contemporary art galleries. The interest in the collectibility of media art has led to the next step in the art world's commodification of film, in which museum curators and gallerists have become film producers, often putting up hundreds of thousands of dollars for production costs. The films of contemporary artists such as Matthew Barney, Shirin Neshat, Sharon Lockhart, and William Kentridge are often high-budget productions that fetch high sale prices for installations and limited editions of DVD copies. Frequently emulating Hollywood film merchandizing strategies, art world producers sell spin-off objects that are often unique elements used in making the films, from the handmade props used in Barney's *Cremaster* cycle to Kentridge's drawings made from his animations. These extend even further the possible profitability of art world film production. The centrality of film and video art in the contemporary art scene not only reflects a recognition of the importance of film and video as contemporary cultural expression but also coincides with its technological ability to be reified in new ways, to be bought, sold, and collected.

Ironically, avant-garde film, like much conceptual art that emerged in the 1960s, grew out of a political and philosophical impulse to move away from object-based art

as a way to undermine or critique the commodification of art. That there are now new possibilities for wider access to once-hard-to-see fine art films—and that some avant-garde film and video artists are actually making money from the sale of their work—is a cause for celebration. At the same time, the very ephemerality of the film image that has been at the center of avant-garde film's spirit of resistance is now called into question as buying and owning such images becomes a major part of the experience of cinema today. This also underscores the relationships between the drive toward increased commodification of everything in today's consumer culture and the increasing solitariness of cultural experience, from movies on Palm Pilots to music on iPods.

I am not interested in mourning the loss of earlier modes of cinematic spectatorship or nostalgically wishing for a return to older possibilities for collective uses of cinema—the intimacy of individualized viewing, of course, has its own pleasures and, as we will see, its aesthetic possibilities. Rather, I want to indicate a powerful change in the ways cinema is used that perhaps accounts for the enormous transformation of film culture at the turn of the century. There is something about the ethos of the fin de siècle that brings out claims for the endings of things, in particular the ends of the forms we use to organize and structure our lives, along with the ideas we use to explain ourselves to ourselves. I, like others, am trying to understand the complex nexus of material conditions for a changing film culture, and I find it is important not to confuse the evolution of an art form with its demise.[3]

Rather than lamenting that cinema is not what it used to be, the more exciting question is, to what extent do changing technologies such as the VCR extend our engagement with other aspects of cinema that are accessed in the undistracted context of private viewing? Many of the claims for the benefits of VCR/DVD viewing are that it promotes analytical viewing habits by allowing the viewer to watch a film or sequence repeatedly, or view it in slow motion, or freeze a frame, or hear the director narrate his or her intentions as a voice-over, thus transforming "the cinema" into something else. The VCR/DVD turns the entire history of cinema into an artifact in which people watch a small-screen reproduction of a work that has transcended its limited life on the "big screen" and now exists as a scaled-down version, a trace of the original in its low resolution. The films appear on the video screen as reconstituted, in apparition-like form, referring to their past life on the large screen. The video store becomes a kind of cine-mausoleum. People walk through it, looking at the walls of videotape and DVD boxes as if they were tombstones, in order to find more information about a past that was already ephemeral to begin with.

For those interested in the history of cinema beyond the canonical works shown in repertory houses and classrooms, there were only the unwieldy, incomplete fragments of cine-detritus found in the trash or attic, as with the film material Ernie Gehr used in *Eureka*. Since the 1980s, the VCR has given rise to a whole new industry of video rental, inventing the video rental store and making available all manner of filmic material from early cinema to newsreels to TV commercials and cult cinemas. In short, the ephemera of film industry product that lost its use value once it played the movie

house circuit has now become recommodified as easily obtainable artifacts rented and purchased in convenient cassettes that can be watched repeatedly at any time. The VCR offers unique possibilities for revisiting whole realms of once popular, now forgotten and useless films that, in their rereading, hold the opportunity of creating counter-histories, not only of the cinematic canon but also of revisionist cultural histories using the accumulation of artifacts from the mass culture of the twentieth century.

Rock Hudson's Home Movies

For some avant-garde film artists, the emergence of home video technologies has opened up new relationships between the cine-connoisseur, the collector, and the textual analyst to create new forms of cultural history. Paradigmatic of such historical work are the videotapes of filmmaker Mark Rappaport. Among the most important filmmakers associated with the "new narrative" avant-garde feature film of the 1970s and 1980s,[4] Rappaport has also made a body of video histories that integrate semifictional or speculative narrative elements with an encyclopedic use of Hollywood film clips as a way to reconsider and revise the histories of Hollywood icons lost as much because of their social and political nonconformity as because of their limited talents. These include *Rock Hudson's Home Movies* (1993), *From the Journals of Jean Seberg* (1995), *Silver Screen/Color Me Lavender* (1997), and *John Garfield* (2003). *Rock Hudson's Home Movies* is part revisionist history, part speculative archaeology, and part queer fantasy. In response to Hudson's revelations of his homosexuality shortly before he died of AIDS in 1985, Rappaport combs through Hudson's huge body of films to find evidence of his desire to reveal who he was to the public through the unconscious of the films themselves. Rappaport begins with a fictional conceit, a ghost story in which a young actor plays Hudson speaking directly to the viewer from the afterlife. He explains that his true sexual proclivities were always evident if people had watched the films carefully enough. Rock invites us to rewatch his old movies with him, thus transforming them from hack industry product into the personal testimony of self-revelation. As in the conventions of home movie screenings, the maker narrates his or her experiences around the edges of the frame, expressing personal thoughts and feelings about the images and the people and places in them. Rappaport expertly weaves together clips from over thirty-five different films, appropriating not only the images but the dialogue as well. These clips offer a wide range of scenes depicting the sexually charged nature of Hudson's films and showing how his characters are constantly spurning the sexual advances of women, trying, on the one hand, to convince potential suitors that he is not marriage material and, on the other, showing his relationships to men to be sexually charged, filled with flirtation and innuendo, sometimes subtle and at other times staggeringly overt. Shots of Tony Randall lighting his cigarette seductively and asking, "Need a light, cowboy?" lead to shots of them lying in bed together. Hudson's metanarration reframes the shot–reverse shot of a threatening confrontation between Hudson and Kirk Douglas into an ogling match filled with sexual tension. The

accumulation of clips begins to reposition Hudson from the paradigmatic image of American masculinity of the 1950s and 1960s into a counterimage of a closeted gay man's desperate and ultimately tragic attempt to assert his true sexuality. Of Hudson's screen persona, Rappaport explains:

> Rock Hudson was a prisoner, as well as a purveyor, of sexual politics and stereotypes. He is a prism through which sexual assumptions, gender-coding, and sexual role-playing in Hollywood movies and, therefore, by extension, America of the 1950s and 1960s can be explored. ("Mark Rappaport's Notes," 16)

Throughout the film, the narration by Hudson's ghost positions him to be speaking—posthumously—as an insider in the gay community that grew up around him, making the case that although he could not say so back then, he was actually "one of us" all the time. Here Rappaport begins to insist on the possibility that speculative fantasy, based on his own desire, becomes integral to the notion of revisionist history. In the privacy of his home *and* in the afterlife, Hudson can finally admit that he was an outsider to his own screen persona while actually understanding himself to be an insider among those whom his screen persona found abhorrent. In this way, Rappaport shows the true dimensions of Hudson's tragedy. Once he is "outed" by his illness, the shambles of his image as the paradigmatic straight man who lived a lie can only be redeemed by his posthumous embrace of the gay community. As the video progresses, Rappaport begins to include clips from different films in which Hudson played characters who were made vulnerable by being sick, dying, and aging, thus creating parallels between what becomes a more complex screen persona through the compressed juxtaposition of the wide range of characters he played and his actual life experience. As a work about the present, these recontextualized film clips become the missing images of Hudson that link his experience as a gay man dying of AIDS with his long career as a closeted sex symbol, with the gay community and the catastrophe that has ravaged it. As a work of history, *Rock Hudson's Home Movies* expands the long story of American celebrity culture and the ways that many gays and lesbians in Hollywood suffered the pain and humiliation of having to lead closeted lives to maintain their careers. The images, recontextualized in this way, cause one to experience them moving back and forth between past and present, making them at once horrifying, prophetic, and humanizing. Through this, the ghost of Rock claims himself to be a latent insider of a community to whom he leaves the task of revealing that his image as straight male sex symbol was a masquerade—but a masquerade that could actually produce a mobile image of masculinity.

Feminist film theorist Mary Ann Doane has argued that in classical cinema, in addition to reinforcing patriarchal notions of femininity, the image of the woman also functions as a masquerade, which in "flaunting femininity, holds it at a distance . . . femininity which itself is constructed as a mask—as the decorative layer which conceals a non-identity" (*Femmes Fatales,* 25). For Doane, womanliness, with its

overproduction of the signifiers of femininity, "is a mask which can be worn or re-moved" (25). This notion of a highly codified image of gender covers for something that is far less fixed, much more mobile, revealing the constructed nature of a female sexuality that contains no essential properties. Likewise in *Rock Hudson's Home Movies,* Rappaport is not simply queering the text by reediting Hudson's movies into gay/straight double entendres. Rather, he reveals Hudson's image of hyperheterosexual masculinity to have been a masquerade for a male nonidentity that is capable of being constructed and reconstructed in multiple ways, perhaps generating a more complex notion of masculinity; it is a masculinity that is more mobile, less stable, more equivocal, and belies the one-dimensional image that Hollywood constructed for him.[5] Through Rappaport's montage, the images of Hudson become part of a free play of signs, the meanings of which are transformed into multiple possibilities for thinking about masculinity that are more permeable and malleable than the films that created them. Creating a historical narrative, Rappaport uses video montage of the film clips to render actual what could only remain virtual in Hudson's performances: an image of his own desire.

While Rappaport's use of found footage has its roots in avant-garde antecedents of the found-footage films of Joseph Cornell, Jack Smith, and Bruce Conner discussed in earlier chapters, Rappaport's tapes are more essayistic and polemical than poetic. Though Rappaport does not use the language of poststructural critical discourse, *Rock Hudson's Home Movies* is clearly informed by and extends strategies of deconstruction in which images are torn from their original contexts to be examined and repositioned, as it were, in the historical and political context of Rappaport's present.

> In reality, *Rock Hudson's Home Movies* is a child of 15 or 20 years of critical theory . . . indebted to theoretical approaches that have subsequently reached deep into our culture—questions of gender stereotyping, feminist and gay concerns about modes of representation, what an image means and the different ways in which an image or words, or an image *combined* with words, can be read. Nor could *Rock Hudson* have been made before the invention of that quintessential surplus capital leisure-time appliance, the VCR. ("Mark Rappaport's Notes," 21)

Rappaport links postmodern critical modes with new film-viewing technologies that at once allow for the obsessional private viewing of cultural surplus such as outdated middlebrow cinema but also make it possible to transform such guilty pleasures into critical public dialogues with the material itself. Rather than the fragmented scraps of discarded film strips that earlier cinematic brooders found, from which they teased new meanings through reprinting and frame-by-frame analysis or allegorical juxtapositions of temporal moments, Rappaport builds a case for his arguments through the accumulation of evidentiary material from an encyclopedic storehouse of films from which clips can be used for any rhetorical need.

To return to the question of how technology has transformed the ways cinema is used and seen through the VCR/DVD, Rappaport has rethought its figuration from the proverbial couch potato sitting passively, watching endless movies, into a context that allows for the possibility of an even more actively engaged spectatorship.[6] He finds that

> in the privacy of my living room I can speak my mind aloud and at the same decibel level as the film I am watching. The invention of the VCR turned this active approach to film criticism into an indoor sport. . . . You could rollback and rewrite your barbs until you got it just right, until you found the perfect retort, *le mot juste.* (17)

As Rappaport suggests, the invention of the VCR transforms passive film viewing into the practice of active film criticism and, when in the hands of an artist, has the potential to become a public voice. More talmudic than allegorical, the VCR allows for the film text to be read and reread, argued with, and endlessly commented on. In this sense, Rappaport's revisionist history of Rock Hudson's life through the film clips becomes a cinematic writing in the margins of the original texts. While the video is highly worked, the editing and writing carefully wrought, the visual quality of the tape suggests the spontaneity of talking back and writing in the margins with its patchwork image textures resulting from the low resolution of consumer VHS tapes. Rappaport uses the varying degrees of image degradation of the different clips, caused by the differing quality of the film-to-tape transfers and multiple generations of copying. He also uses effects that are particular to video, mainly blue-screen techniques, to key the actor playing the ghost of Rock over the film images. Rappaport asserts the materiality of the video process to emphasize the transposition from the filmic experience of the clips into video much in the same way that filmmakers often use the scratches, dirt, and high-contrast graininess of found materials—as in Gehr's *Eureka* and Gianikian and Ricci Lucchi's *Dal polo all'equatore*—to turn the copy into both an aesthetic and analytical distancing device.

The home video aspects of *Rock Hudson's Home Movies* also take on a metaphoric quality that links the technology of the home VCR to AIDS. The irony that the rise of the VCR was concurrent with the worldwide spread of AIDS and other immune system disorders is not lost on Rappaport. He writes of his own realization that he was making this tape in the midst of a growing homebound population of gay men suffering from the illness who were "being comforted to the hum of best selling video hits" (19). In this nexus, my earlier contention that the rise of private home viewing of film has truncated the social and communal aspect of film spectatorship takes a deeply redemptive turn into a medium through which people who can no longer physically participate in the public sphere can continue engaging with the aesthetic and intellectual world of cinema. From the sickbed they/we can go on being critically responsive to what is being experienced.

The Mobile Spectator: The Film/Video Installation

The emergence of the portable VCR, videocassette, and DVD also expanded other non-traditional viewing contexts, deepening connections between cinema and art-gallery-based sculptural forms in particular. What was once an occasional foray out of the movie theater and into the gallery or performance space by experimental filmmakers has given way to the category of "film/video installation artist." In the 1960s and 1970s, filmmakers such as Paul Sharits, Carolee Schneeman, Michael Snow, Ken Jacobs, Malcolm Le Grice, and Tony Conrad, among others, experimented with elaborate variations on the traditional viewing context, creating "paracinema" events using multiscreen projection, film loops, and performance—often transforming the projector, light beam, and screen into sculptural objects. These works were often unwieldy and labor intensive. Projectors for 16 mm film were often large and not made for the continuous looping of motion picture film, which was fragile and would quickly scratch and break under continuous projection. Three minutes of 16 mm film is one hundred feet of film that requires close attention if it is to run continuously throughout the day without breaking down. Filmmakers often modified and built their own projection and looping systems that only they themselves could operate. Synchronized multiscreen projections were difficult to orchestrate, since film projectors rarely ran at exactly the same speed. Projection light source intensities often varied and required properly darkened spaces for the images to be seen. All of this was changed by the VCR, with which many problems of mechanical projection were overcome by the ease of operation and electronic programming of video decks. Worn-out videotapes, are easily replaced, and smaller, brighter video projection has made it more feasible to adapt projection to irregular gallery conditions.[7]

The mainstreaming of film and video installation in the 1990s as a gallery-based form has also raised questions about how such works are replacing more traditional experiences of cinema art. It has been argued that the emergence of the gallery and museum-based film/video installation has created a new kind of social space for cinema in which spectatorship is open-ended and mobile; viewers wander in and out of darkened installation spaces at will, according to their own interests, rather than in the restrictive context of the traditional theatrical film's insistence on an immobilized spectator who enters and exits according to a timetable. Many installations are multichannel works such as *Sip My Ocean* by Pipilotti Rist (Switzerland, 1996) and *Stasi City* by Jane and Louise Wilson (U.K., 1997), or single-screen works such as Neshat's *Pulse* and *Passage* (2001) that run continuously, often as loops, with no set starting and ending times. Such installations create less of an emphasis on narrative development than on the physical and environmental encounter with the projected image in the museum or gallery space that viewers walk into, as they happen upon them. The curators Chrissie Iles and John Ravenal have both suggested that film/video installations break with the illusionistic imperative of traditional cinema by redirecting the viewer's attention "from the illusion on the screen to the surrounding space, and to the physical

mechanisms of the properties of the moving image . . . [creating] an analytical, distanced form of viewing" (Iles, *Into the Light,* 34). Unlike the immobile conditions of traditional cinema, viewers become "active participants who move through the surrounding space. . . . The heightened awareness of the conditions of spectatorship . . . resists easy consumption by the viewer's gaze as the artist irreverently stares back" (Ravenal, "Curatorial Introduction," 2).

Here contemporary video installation is seen at once as a postmodern spectacle, a display of new media technologies, and a hybridized postmedium art form combining many different technologies, viewing conditions, and aesthetic forms. Isles and Ravenal argue that video installation also embodies the aspirations of earlier political modernism, in which the viewer's critical awareness is heightened by choosing his or her own degree of attentiveness. Moreover, active spectatorship is externalized through physical engagement: walking in, out, and through the work at will. This notion of active participation, in which the viewer can choose what, where, and how long to engage with a given installation, is seen to mitigate against the tyranny of aesthetic pacification, as embodied by the physically immobilizing context of the bolted-down seat in the movie theater. The integration of the discourse of personal choice and free will into the gallery installation also implies a democratization of the experience of film art that is subversive and liberating in a larger struggle against the overpowering manipulations of mass-media forms while maintaining the consumerist ethos that the customer is always right. However much the decentered activity of wandering rather than attending may create a self-consciousness through the fragmentation of linear cinematic experience, it does not necessarily create the context to address the larger problem of narrative duration as a material basis for the complexities of time-based visual art.

As I have maintained in these pages, it is the relationship between duration and image in film that creates complex experiences of temporality. The immediacy of physical encounter in installation art as part of the movement through museum galleries can discourage the viewer from having to confront the ideas generated as an inherent part of narrative development because durational viewing of individual pieces is rarely understood to be a part of the gallery experience. While such pieces are often beautiful in their sculptural quality, the context of installation exhibition often reproduces the distracted quality of fast-paced, media-saturated contemporary life, in which images and ideas are apprehended as they pass in and out of the movement of daily life. There is so much to see in the jam-packed contemporary museums and on the gallery-lined streets of, say, Chelsea in New York City. Rather than cinematic time being used as a subversive space outside the overflow of modern experience in which images can open into the flow of time as an engaged reflective experience of thought, the museum exhibit connects cinema with the video arcade, in which viewers drift from installation to installation guided by the length of time their interest lasts. Such a shift from the theatrical context to the gallery has made it more difficult for filmmakers working with extended durational elements to have their work viewed in the concentrated

ways necessary for them to be experienced fully. As a result, film/video installations have become shorter, duration becoming more of a conceptual reference to time than its actual experience. In this sense, it is interesting to consider a work like Shirin Neshat's eight-minute-long single-screen gallery installation, *Pulse,* from 2001 in relation to a film like Michael Snow's forty-five-minute *Wavelength* from 1967. *Pulse* is a continuous tracking shot across a room to a woman listening to a man's voice on a radio. The continuous movement through the room references the woman's desire, her waiting, the sense of her life being highly controlled, as we watch her private moment of listening. But since the duration is so short, the evocation of her isolation and longing as a temporal condition has little formal power to make it more than a representation; the moving camera does little more than emphasize the exotic quality of the mise-en-scène. In contrast, the forty-five-minute duration of the zoom across a room in *Wavelength* confronts the viewer with his or her own senses, boredom, and memory. Through the duration of the film, space—and the events that occur in it—is experienced as multidimensional, at once actual and virtual, in constant transformation, existing as real time, in memory, and as graphic representation. Without the material confrontation with duration, film/video installation becomes more purely imagistic, a subset of traditional forms of painting emphasizing the spectacle of surface rather than the transformational becomings of time.[8]

Snow's recent digital transfer of his landmark film *Wavelength,* now called *WVLNT (Wavelength for Those Who Don't Have the Time)* (1967/2003, video, Canada), is a sardonic commentary on contemporary art audiences' limited willingness to engage with long-form works of film art in which duration is the central medium and a material experience of consciousness. In *Wavelength,* the slow, inexorable zoom across the space of an open loft becomes a meditation on the transformation of space in the movement of time. In the digital version, Snow has reduced the viewing time of his original film from forty-five minutes to fifteen by dividing the film into three equal sections and superimposing one strip on top of another. The entire film is seen, but in one-third of the time. Of course, except for the recognizable location, sounds, and events, the original film is nonexistent precisely because the experience of the space transforming over the duration of the piece was its subject. While a witty gesture, the redux is clearly an admonition and an indication of Snow's concern about the ways in which the emphasis of experimental time-based media has become focused on the image rather than on the movements of time.

As I have argued, avant-garde cinema's approach to history is through evocation rather than representation in the ways it opens onto the virtual coexistence of past, present, and future through duration. The challenge of representing history though film/video installation whose form emphasizes site specificity over narrative duration presents an interesting problem when confronting the complexity of historical narrative. Nonetheless, with the strengths of installation calling attention to relationships between image and environment, there have been gallery-based installations that have productively engaged aspects of political history through the evocation of place. Jane

and Louise Wilson's *Stasi City* (U.K., 1997) is a five-minute double-screen loop projection that was filmed in the former East German Stasi secret police headquarters in Berlin. It is now abandoned, and the institutional rooms, colorless office furniture, and old surveillance equipment are shown in various states of ruin. A uniformed female is seen walking through the space. The camera follows her moving as if under surveillance. The disembodied view coupled with sounds of footsteps is creepy and coolly unsettling. It evokes the feeling of power and fear that the institution of the East German secret police held over its population, who were both victims and perpetrators of the Stasi's vast network of control. At one point another figure literally levitates and floats in space like a ghost of the lives ruined by such a repressive apparatus. Another installation, *Gamma* (U.K., 1999), explores the deserted spaces at Greenham Common, a decommissioned American military base in Berkshire, England, housing nuclear missiles. Both spaces are experienced as haunted houses. Both installations become unsettling archaeologies of the kinds of resources that were used to maintain the high levels of military power and social control exerted by both sides during the Cold War. The faceless power of the modern state is made physically palpable as the cameras glide slowly through these unseemly edifices. Seeing such images in the present, now housed in an art gallery or state-run museum, another particular kind of highly institutional setting, makes them all the more unsettling. The installations leave unaddressed, however, crucial questions about how images of spaces that were historically used for such tyrannical purposes have been transformed into highly aestheticized works, unproblematically situated within the commodifying contexts of high culture.

Dichotomy

The history of changing forms for representing landscape in art is also reflected in the shift from the use of the gallery as a neutral space that has traditionally exhibited static paintings into a historically situated neocinematic space that presents images and sounds moving in time. The artist and filmmaker Tony Sinden's video installation *Dichotomy* (U.K., 2000) takes up shifting meanings of the landscape painting tradition by creating allusive relationships between nineteenth-century American landscape painting and the modern video installation. *Dichotomy* is an image of the landscape of the American West in which its changing meaning is contemplated from multiple moments in time. The experience of the installation exists as a dichotomy between the possibility of landscape as a timeless manifestation of a divine order as it was allegorized in nineteenth-century landscape painting and the notion that the meaning of that landscape is produced as a phenomenon of history in which its meaning lies not in physical place but as a constantly transforming idea.

Sinden's installation is a twenty-minute DVD loop that is encountered in the middle of a darkened gallery space. Recalling the large-scale panoramic landscape paintings by artists such as Frederic Edwin Church (1826–1900), Albert Bierstadt (1830–1902), Thomas Moran (1837–1926), and Thomas Hill (1829–1908) from a century earlier, the

images are seen on a large panoramic screen, suspended in the middle of the space, allowing the viewer to walk around the image, which can be seen from both sides of the screen. Although no longer in the traditional screening space of the movie theater, *Dichotomy* is still very much a montage film in which the singularity of each image is at once a sign to be read and contemplated as each image appears—one after another—on the screen, and also to be read associatively in their juxtaposition to one another. The piece is structured around a series of long and static wide-angle shots of scenes from California's Yosemite Valley that are composed in direct reference to the earlier landscape paintings. These video landscape shots can be characterized by their stillness, in which one gradually notices a waterfall or flowing river in the frame of each shot, making the viewer subtly aware of the continuous movement of the landscape in time. The tension in these images is created in yet another dichotomy between stillness and movement: between the static language of traditional landscape painting, whose stillness enhances the idea of nature as a timeless entity far from man, and an image of constant movement in which the landscape is in flux. Sinden's images at once evoke and destroy the auratic experience of earlier landscape paintings, by recreating in video both an image of the transcendental language of nineteenth-century landscape painting and its easy reproduction electronically. While compositionally the shots mirror the earlier paintings, many dissolve into medium and close-up shots of the waterfalls that often fill the screen with rushing water, breaking up the sublime, distanced quality of the earlier paintings. The extreme close-ups of the rushing water abstract the image, transforming the screen from static representational views at a distance to an image of pure movement. Sinden creates compositional abstractions throughout the piece by using extreme close-ups of water, the textures of the trees, and the rock formations in the streams, and at times even tinting the images and altering their colors. The patterning and abstractions are purely cinematic elements of the close-up, bringing the scenes closer to our grasp and fulfilling our desire for cinema to bring things closer. But more importantly, Sinden has placed these images in history as constructed views that are in a constant state of reproduction and transformation by the artist and the medium used.

Throughout, the empty landscapes are interrupted with shots of a man standing in the landscape next to a flowing river looking out at the distance. Over the course of the piece, the figure appears several times, changing his position until he is gazing directly into the camera. The presence of the figure with his modern hiking boots and bright red hunting jacket interrupts the nineteenth-century image of untouched nature by placing the landscape in a particular moment in the history of man. The figure staring at the camera mirrors the viewer's own gaze, reflecting the present moment in time back onto the screen. Sinden makes the act of looking at the landscape the subject of the installation. There are other shots that interrupt the timelessness of the landscape with human history. In one shot, we see an image of a journey, of hands on the steering wheel of a modern car. The side-view mirror reflects the image of the desert highway as the car speeds ahead. At the center of the steering wheel, embossed

in the plastic, is the famous image of a mustang horse in full gallop, once a symbol of the free-spiritedness of the American West, now appropriated by the Ford Motor Company for its most famous sports car. Sinden creates multiple ironies regarding the notion of progress. The mustang, once an icon of the pioneer spirit of the nineteenth century, when people on horse and wagon slowly crossed the continent, is now the trademark for a gas-guzzling, high-style sports car with the power of dozens of horses, crossing the country on roadways blasted into the landscape. The mass-produced, embossed plastic image of the mustang in full gallop, an image of a real animal stuck in frozen motion, is now a trademark that recalls Frederic Remington's paintings of horses, cowboys, and Indians: America has turned its own myths into monochrome plastic kitsch.

A darker side of technological progress is woven into the montage of *Dichotomy* with images of bombs falling on the jungle landscapes of Vietnam. The documentary images are filmed from the air, showing napalm exploding with flowerlike white plumes of smoke billowing above burning palm trees. There are other images of bright orange firebombs exploding in the forests that are at once shocking, horrifying, and unsettlingly beautiful in their devastation. The destructive power of the bombs is unmistakable both as a historical figuration of the bombs that have been dropped in the great wars of the twentieth century and as a prefiguration of the bombs that will be dropped. The images of the bombs dissolve back to the close-up of the Yosemite waterfall, which at times has been tinted blood red, directly connecting the American landscape with the horrors of the 4.5 million tons of bombs the United States dropped on the Vietnamese landscape. As Sinden has written of his own piece, "*Dichotomy* debates the sublime experience and paradox of memory: reflecting the history and bloody human costs embedded in a landscape, something that is often forgotten."[9] Rather than being timeless, the quiet imagery of *Dichotomy* becomes an occasion for the contemplation of history. The mythic hand-painted image of nature as untrammeled frontier has given way to the image of polluted urban sprawl and SUV-clogged freeways that connect suburbanized wilderness regions now filled with housing tracts and shopping malls. In the year 2004, the pastoral, hand-painted nineteenth-century panoramas have given way to terrifying photographic and televisual images of lush tropical landscapes and jungle warfare in the highlands of Vietnam, the rugged mountains of Central America, or the desert moonscapes of the Middle East. Awful nature, no longer divine, is seen burning and wilting from the bombs dropped by high-tech jets on faraway places, the apocalyptic visions of burning oil wells in the deserts of Kuwait, and the collapse of the burning towers of the World Trade Center. In *Dichotomy*, Sinden connects past and present, reconfiguring the landscape within history. Yosemite, a symbol of the American West as the figuration of the utopian promise of a limitless future, has given way to a landscape that can only be contemplated in relation to a past of two centuries of continental expansionism and the violence of U.S. imperial conquest. With images of the modern automobile, of carpet bombing, man is not simply a part of the American landscape; man *is* the landscape, which is now

understood as a series of expanding borders that are not only physical but economic and cultural. The modern legacy of U.S. "manifest destiny" consciousness can be seen to be embodied in its man-made, high-tech economic and military power rather than in the reflective figurations of the divinely given grandeur of nature of an earlier period. The contemporary image of the untamed wilderness of the West is no longer one of limitlessness, but rather one that must be contained, as the neoracist imagery of the American landscape is now seen to be overrun with blighted American inner cities, with free-range gang violence, illegal immigrants clogging the U.S. borderlands, and now unidentifiable terrorists effortlessly passing through the landscape to destroy our cities.

While Sinden's installation is in no way a work of documentary journalism or political commentary, the contemplative play of highly wrought signifiers invites this kind of historiographic reading. The televisual experience of history is central to contemporary image making, and to disconnect it from image-making practices and technologies from other periods of history is to keep the past at a distance, to be gazed at passively rather than actively interrogated. In *Dichotomy*, the connections between changing technologies of aesthetic reproduction and the ways in which the past comes to have meaning in the present are of central concern. Throughout the piece, as the infinity of the black screen and darkened room gives way to the pixilated snow of video noise—moving white specks on a black background—Sinden asserts the materiality of the images and technologies he is using. After a time the video snow dissolves into an image of a phonograph on which a revolving long-playing record is seen. The haunting, dissonant sounds of Oliver Messiaen's modernist religious organ composition *Diptych* are heard. Sinden has sampled the final split second of the music and then repeated it continuously throughout the installation. The chords change occasionally and fade in and out among the sounds of the waterfalls, video static, and car engine sounds. As the image of the revolving record continues, there is a slow dissolve back to the Yosemite landscape of Bridal Veil Falls. Like the ships that transported Europe to the New World, and the books that carried its ideas, the phonograph and record are transporters of culture, portable, installed at will. Overpowering in its mass reproducibility and dissemination, the revolving record can repeat endlessly until the sounds are learned by heart. This sonic revolver opens onto the memory of another revolver: the Colt .45 handgun. A mythic repeater—the six shooter—was also another technology that "won the West," teaching and insisting that lessons be learned and laws obeyed—or else! The repetitive sampling of organ music creates an eerie apocalyptic quality when heard over the images of Yosemite, in which the landscape is seen at the end of history rather than the beginning. Its repeating high-pitched strain becomes a metaphor for the ways in which European culture moves from continent to continent. Again Sinden is mixing technologies and historical moments: the digital sampling of an analog recording of a mechanical pipe organ. The present-day Yosemite landscape as an image of the nineteenth-century sublime juxtaposed with Messiaen's modernist reworking of traditional religious organ music with his ghostly postholocaust

dissonance digitally sampled in the same way horn licks from a James Brown tune are sampled in a contemporary hip-hop scratch mix. The mixing of the material textures of each of these technologies is mirrored by the white noise of the amplified sounds of the waterfalls themselves.

With these three images, the video snow, the anachronistic phonograph, and the video re-creation of nineteenth-century landscape painting, Sinden has elegantly moved between three modes of reproduction—artisanal, mechanical, and electronic. He engages these technologies to create a play between the differing aesthetics of nineteenth-century naturalism, modernism, and postmodern hybridization. *Dichotomy* causes us to periodize the development of technologies of reproducibility in relation to social and aesthetic transformation, with each one having a historical context that is inflected by each of the others. In *Dichotomy*, Sinden allows the images and sounds to hang in the air of the gallery, to float, constantly generating meanings and relationships between past and present, between personal memory and historical artifact. The installation itself—the screen, the gallery, the images and sounds—becomes a landscape in which viewers encounter and conjure a history of their own moment in time.

Further Thoughts on Interactivity

The interactive CD-ROM and Web-based artwork are other posttheatrical cinematic forms in which the shift toward the experience of spectatorship as a private activity, physically isolated from others, has become even more intensified. With PC-based "desktop cinema," spectatorship is largely a solo activity in which the viewer sits in front of a computer screen large enough for only one person. Unlike the theatrical cinema, which creates an embodied interactive social dynamic with others, computer interactivity shifts the emphasis to one of direct interaction with or through the machine itself. With new digital technologies, the question of what constitutes interactive viewing becomes a more complex question for a posttheatrical avant-garde cinema filled with new possibilities.

Throughout this book, I have made the case that nearly all the films I have written about are interactive in the ways meaning and thought are activated through duration and formal structures such as allegory, virtuality, and evocation. Here interactivity is understood to be connections between images and ideas is an abstract, subjective experience that occurs in the mind of the engaged viewer or in conversation with others. In CD-ROM and Web-based artworks, like video installations, interactivity becomes externalized by one's physical interaction with the pieces. While the relationships to installation art shift through physical movement around a piece, computer interactivity externalizes such active engagement through concrete, physical interaction with computer hardware. The CD-ROM gives the viewer certain choices about how to move through materials by touch screen or mouse clicking on chosen buttons, panning across or zooming into images and texts in order to move around and between different kinds of materials at will. Hence what constitutes an immersive

experience begins to take on new meanings. In traditional cinema, the sensation of immersion is constituted by the projection of the subject *into* the film text through the disappearance of the theater space around the viewer, heightening a psychological identification with the internal world on-screen. In contrast, immersion by means of computer interactivity is constituted by the viewer's physical involvement with the transformation of the image. The mind's operations are thus externalized, objectified, and metaphorized.

The new-media scholar Lev Manovitch has argued that this contemporary notion of interactivity literalizes a larger drive to externalize mental life in modern society already begun with the advent of film and photographic technologies. He suggests that this is "related to the demand of modern mass society for standardization. . . . The subjects have to be standardized, and the means by which they are standardized need to be standardized as well" (*The Language of New Media*, 60). As cinematic spectatorship becomes a more solitary activity in the move from the social space of the movie theater to the individual space of the PC, interiority itself is reconstituted from something that occurs within the mind of the viewer to something that occurs outside through bodily interaction with the computer. While the activity of following links, clicking to new images and scenes, foregrounds the idea of individual choice, it also standardizes it by insisting on specific modes of interaction as specified by the hardware and software created to make the piece work.

As with video installations it has been argued that this kind of computer interactivity works to undermine the illusionistic transparency of conventional forms of cinematic narrative construction. It forces the viewer to move between passive spectatorship and active participation in the piece's construction. The constant shift from spectating to physically collaborating holds the possibility that the viewer can become aware of meaning making as a mental and physical material process. Such a claim suggests that computer interactivity is a medium that is inherently anti-illusionist because it never allows the viewer to be fully absorbed into a seamless flow of narration. Manovich has argued, however, that rather than breaking the illusion of seamlessness, by means of the shifts between illusion and its suspension through the clicking, linking, and choosing among images, the viewer is actually "interpolated in it" (208).[10] The imperative to participate naturalizes relationships between subject and object rather than disrupting them. Not unlike classical cinematic continuity systems, the subject becomes a part of the apparatus rather than being alienated from it. I would also add that the solitary quality of the human/machine interaction creates a closed circuit between them. This further distances the experience of the piece from a larger social context, which must be acknowledged for any kind of materialist relationship to meaning making.

The CD-ROM continues the consumerist metaphor of interactivity in which choice of buttons and the "click" are predicated on the guarantee of a return. While one may not know what connections will be made, still, the motivation is to see the result of one's choice—with the guarantee that something will happen. This model of

choice and instant return short-circuits a critical interrogation of a formally fixed text, out of which the notion of interaction arises from an objection or a need to talk back, leading to creative rereading, active appropriation, and deconstruction as forms of engagement (as in films such as *Rock Hudson's Home Movies, Tribulation 99,* and *Utopia*). Interactivity in this sense holds the possibility for a boundless collaborative reproduction of textuality in which the viewer or reader must produce his or her own relationships between images and sounds within the formal context the filmmaker has created and without the automatic guarantee of meaningful connection. With choose and click, in contrast, computer interactivity becomes a desire-and-fulfillment loop that continues until the viewer is satiated or bored (whichever comes first). This notion of interactivity implies a less-hierarchical aesthetic experience in which the viewer is invited to "help" construct the work and is liberated from the univocalism of traditional filmmaking, sharing with the artist the privileged position of authorship. On the other hand, the open-ended quality of the artwork that allows for shared authorship can also be seen as a form of aesthetic "repressive tolerance" in which interactivity, now structured by a set of preconstituted options already provided by the artist and computer program, actually conceals the limited nature of the terms for interaction. The viewer's desire for agency is addressed but is channeled through a narrow set of interventions that are both expected and encouraged, short-circuiting the potential for an unruly, active, critical engagement with the artwork on the viewer's terms, as part of a struggle for a place in the work.[11]

To critique the pleasures of a "desire-and-fulfillment loop" in favor of the hard work of critical deconstruction sounds rather moralistic. The interactive labor of slogging through opaquely structured works of interminable duration that are humorlessly critiquing the ideologies of representation smacks of modernist Puritanism (one thinks of the films of Mulvey and Wollen, such as *Riddles of the Sphinx* [1977], or Straub and Huillet's *History Lessons* (1973), or the "not fun" films of Godard after 1968 such as *Ici et ailleurs* [1974]). In today's postcinema, where random-access interactivity blurs lines between the video game and fine art to form a new digital pop art, it is clear that kids just want to have fun. Fine-art CD-ROMS, however, rarely generate the kinds of playful suspense and competitive tensions of video gaming devices to which they are often compared. The pleasures of engagement with the computer game often have to do with the development of analytic or hand-eye skills to beat the game. Games like *Mario Brothers* and *Diablo* motivate engagement through the rewards of personal accomplishment by allowing the player to progress to more difficult levels of the program as each succeeding level opens onto the excitement of new environments and new sets of problems and skill requirements. But unlike much CD-ROM art, the formal structures of these interactive games are anything but random or open ended; rather, they are straightforward narratives that propel the participant forward through a story to deeper involvement in the game.

Claims for postcinema interactivity have been concerned with freeing the viewer from the tyranny of the fixed impositions of the filmmaker's sensibility, to create more

open forms while motivating the viewer to participate in shaping his or her own cinematic experience. I would suggest, however, that it is not openness or ability to choose that encourages active engagement, but rather the confrontation with the ways that the strong sensibility of artists articulate their ideas through formal aesthetic structure. This is where the pleasures of engagement reside. Formal structures, how a filmmaker activates images and sounds in relation to one another, not only create the limits for involvement but produce the tensions of limitation that forces the viewer to push beyond them. This is what, in the aesthetic experience, is generative. A question I have not resolved, however, is whether or not choice and random access are form.

The CD-ROM *Immemory* by Chris Marker (France, 1997) is a personal archive of Marker's creative life that can be randomly accessed as the viewer clicks on designated buttons that open onto different "zones" of the disc. Like a file cabinet with drawers marked with general subject headings (Travel, Museum, Memory, Poetry, War, Photo, Cinema), the piece contains an encyclopedic compendium of artifacts of Marker's travels—postcards, handbills, posters, quotations, portraits of women whom he has known. His photographs from the countries he has visited and favorite works of painting, sculpture, poetry, and cinema are all referenced. There are his own image and text meditations on war, cinema, memory, and art interspersed with quotations by others. Through all of this, the viewer randomly clicks. As Marker writes, *Immemory* "is a guided tour of a memory" of the filmmaker/photographer who "has left traces with which one can work, contours to draw up his maps."[12] He suggests that the activity of "haphazard navigation" allows the viewer-participant to create the contours of Marker's memory, thereby drawing a mental map through the random juxtapositions of material included in the CD-ROM. The sense that the viewer is participating along with the maker in producing a map of his memory is implicit to the rhetoric of democratic aspiration of this new form of interactivity. Marker asserts: "That the subject of this memory should be a photographer and filmmaker [himself] does not mean that his memory is more interesting than that of the next man (or woman)." But in fact, it is the completely unstructured openness of the interaction that causes the associative power of the images to remain inert. There is no formal structure through which Marker articulates levels of importance in the relationships between images. In this way he has abdicated the power of his own insight, which makes his earlier montage films, especially *Le fond de l'air est rouge* (*A Grin without a Cat*) (France, 1977) and *Sans soleil* (France, 1982), such profound essays. Rather than a frisson created through the viewer's encounter with the power of Marker's ideas, in *Immemory* there is simply randomness. In the end the motivating interest that is generated by the piece is the fact that the subject "Marker" *is* actually more interesting than most. It is my interest in the history of the life, personal obsessions, and travels of this enigmatic master filmmaker that impels me to continue to point and click on one random image after another until satiated and bored.

The ability to create a personal archive like *Immemory,* however, raises interesting possibilities for CD-ROM art as a medium for creating cinematic histories. The ability

of the CD-ROM to store large amounts of audio, visual, and textual information that can be accessed in nonlinear ways, as Marker's piece does, suggests new possibilities for the storage and retrieval of objects and documents not yet historically validated or given the importance of archival status. The physical space of the library or archive is no longer a determining factor in the value of what at a particular moment in history is preserved and what is discarded as unimportant, since so much material can be stored digitally. For better and worse, digital random access also increases the speed with which one can wander through vast networks of materials and emphasizes the discursive and intertexual relationships within an archive. Moving across materials, the meanings of which are transformed through the endless production of virtual connections, holds the potential to create new and dynamic links between past and present: new histories.

Here in the new random-access digital technologies we sense the phantasm of Walter Benjamin's figure of the brooder from an earlier moment in history, whose memory ranges over the indiscriminate mass of material from the past without knowing beforehand that any of it will constitute a coherent meaning. Still, he continues to hold one piece next to another to see if they fit together. (*The Arcades Project*, 368).[13] The actualization of a random-access digital archive reconnects the postcinema present most powerfully with the phantasmagoria of its past technologies, always with the hope that the present is capable of actualizing the unrealized dreams of the past. As Benjamin wrote:

> The utopian images which accompany the emergence of the new always, at the same time, reach back to the primal past. In the dream in which each epoch entertains images of its successor, that latter appears wedded to elements of primal history. (*The Arcades Project,* "Expose of 1935," 893)

In this sense, whenever a new technology emerges, it is as history, causing the past to return as the present. The possibility that a new technology might actualize what was already imagined at the birth of cinema reconnects us with the most idealistic hopes for the medium that were lost or discredited and remain unfulfilled. It is not the technology that is utopian, but rather the dreams onto which the technology is cathected. Here lies the definition of a contemporary avant-garde media practice—one that can demystify the claims of the new by creating new temporal forms that reveal interrelationships between past and present. Such a practice must be willing to take up the most idealistic possibilities of new technologies in the context of a *critical* practice that places them within the historical continuum from which they were created. In this coexistence between the dream life of technology and the realities of how they function socially, politically, and culturally, they fold into one another. Such a practice neither holds on to the past, face in the wind, nostalgically clutching forms and aesthetics lost in the changing technologies of cinema, nor invests in the emerging ones as if there were a historical rupture with those past forms.

I have tried to enumerate a dialectic of the dream life of technology: the possible losses as cinema moves away from the limitations of its traditional theatrical roots on the one side, and, on the other, the new possibilities for postcinema technologies as something infinitely more flexible with a multitude of new ways of using cinematic material for making histories.

Beyond

I am sitting alone at the kitchen table in front of a laptop computer. At the center of the screen I am watching a tiny image, the famous newsreel footage of the zeppelin *Hindenburg* gliding through the air over New York City, filmed moments before it exploded in a fireball over the airport in Lakehurst, New Jersey, on May 6, 1937. There is an extraordinary sense of temporal self-consciousness as I use this state-of-the art personal computer to contemplate the images of the archaic, balloonlike airship, once an emblem of the most advanced technological developments of Nazi Germany on the eve of World War II. This 35 mm film footage, originally projected to hundreds of people in giant movie theaters, now appears as a two-inch QuickTime image that begins the filmmaker Zoe Beloff's interactive CD-ROM *Beyond* (1997). At first, the black-and-white, grainy, scratched, postage-stamp-size image of this archaic object has an alien quality, like something sent from another realm. The potency of the image lies in the way the *Hindenburg,* with giant swastikas on its wings floating over New York City, foreshadows Germany's mobilization of advanced technology to begin the second global war of the century. The zeppelin is flying over lower Manhattan above the site where the towers of the World Trade Center will be built some thirty years later. With the image of Manhattan without the towers, I think of the jet planes that will destroy them thirty years after that, plunging the world into another devastating global crisis. Between the electronic box sitting before me and the image of this giant mechanical flying machine from seventy years earlier, I am caught between past and present through the extraordinary technological advances between early flying balloons and personal computers that allow me to link to a global web of images, sounds, and texts. This reverie of continuous technological progress that moves from the New York skies of 1937 to my kitchen table in 2004 sits uncomfortably alongside the wreckage of unending human conflict.

This same sense of technological and historical dislocation lies at the center of *Beyond,* in which Beloff explores the thought, fantasies, and mechanical technologies at the start of the modern period beginning around 1850 through today's electronic imaging technologies. Guided by the excitement of the social and intellectual trans-formations of emerging technologies at both ends of cinema's history, Beloff causes those earliest moments to be reanimated through the most recent ones. In *Beyond,* she explores the emergence of modernity by conjuring the earliest history of the cinemat-ograph and with it a sense of the blurred lines between the fantastic and the scientific that surrounded the dazzling phantasmagoria of those emerging technologies. In

making a work of creative history, Beloff reanimates, through the digital computer, their protocinematic forms, such as the magic lantern, the cinematograph, the panorama, and spiritualist photography. Along with the machinery and images, historical figures and their ideas reappear as ghosts in the digital machine: the writers Baudelaire and Roussel, the philosophers Benjamin and Bergson, the psychologists Freud, Charcot, and Pierre Janet, and inventors like Thomas Alva Edison. In true Benjaminian fashion, the world of early modernity is a ruin. Death permeates all, only to be reanimated as the specter of cinema, which hovers over everything.

In many ways, as an artist, Beloff herself exists as the consummate time traveler, floating between the two eras of cine-technology, freely moving back and forth between traditional photographic filmmaking and the most recent digital technologies. Though she was trained as a filmmaker, with strong roots in experimental film, Beloff's movement toward new technologies grew out of her interest in the history of the rapidly changing cine-technologies and the ways they were transforming the current cinema around her. Much of her film work incorporates found images and sounds from earlier periods, as well as obsolete machinery such as the gramophone, hand-cranked projectors, and 3-D slides. These are usually woven into bizarre historical narratives concerning the obscure histories of parapsychology. All of this work reflects her interest in relationships between technologies of the visible and parapsychologies as they intersected in the late nineteenth century and the early twentieth.[14] *Beyond* is constantly crossing lines between the hard sciences of light and optics and the metaphysics of the unseen worlds of spiritualism, time travel, somnambulism, psychology, and in this new form of digital interactivity. The piece has an encyclopedic quality. It makes reference to a wide range of materials that become markers for ideas linking past and present. After the ominous prelude of the *Hindenburg* in New York, *Beyond* begins its loose narrative with a cut to a still picture of an empty street corner with what appear to be several nineteenth-century buildings in various states of decay. There are a few strange objects lying around. A globe, a bag of paper strewn on the ground. A bird frozen in flight. Where I am in time is still unclear. Like an early film that begins with a still picture that jumps to life as the projectionist begins to turn the hand-cranked projector, this image starts moving as the touch of my mouse pushes at the edges of the tiny image. At once archaic and high-tech, the QuickTime VR program transforms this static image into a moving panorama that I begin to explore by panning in and out, tilting up and down, and zooming into the buildings to see if there is anything in them to look at. Though I am sitting in front of the computer, I hear footsteps accompanying the movements, my body is somewhere between the fixed gaze of the traditional movie, the mobility of a gallery installation, and what one might imagine it was like walking around nineteenth-century panorama paintings. I realize I am at the corner of "Einbahnstrasse" (perhaps the One-Way Street of Benjamin's famous essay) and the "Cité pleine de réves" ("city gorged with dreams / where ghosts by day accost the passer-by") from a poem in Baudelaire's *Les fleurs du mal*. This corner is at once a street and a sort of virtual bibliography, composed of remnants of the

birth of modernity. In addition to Benjamin and Baudelaire, there is a door on which is the title of Roussel's book *Locus Solas* from 1914, a building named L'Eve Future for Villiers de Isle-Adam's proto–science fiction novel about androids from 1886. Lying on the ground is a bag with pages spilling out, and beneath it a caption: "The Arcade." Each building has a series of interactive "hot spots" to click on. The computer screen itself becomes an entrance that opens onto a different time and place. As the mouse pointer is passed over the hot spots, voices call out, enticing one to click. The technology of digital interactivity becomes the rabbit hole into which we enter past worlds. All the elements and ideas contained within the piece itself become hard to describe because with each mouse click there are so many different places the viewer can access and aimlessly wander through in what Beloff calls an "exercise in digital flaneurie."[15] Though the selection of hot spots is random, they are thematized by ideas that are suggested by the books. Upon entering, the work takes on a massive detail as one randomly navigates through a series of twenty-two VR panoramas, each with about five hot spots to choose from. Moving through the tiny panoramas, I am either in the wrecked rooms of a once great edifice, littered with broken windows, furniture, paintings, and other discarded objects, or in burned-out and overgrown lots. The panoramas appear to be the wreckage of a civilization fallen into ruin. Strewn about the rooms are objects, drawings, scientific diagrams, and detritus from another time (Figure 41). These hot spots, when clicked, open onto a series of eighty small-size Quick-Time movies that vary in length from forty-five seconds to two minutes. There is a wonderland quality in seeing these two-inch black-and-white movies accompanied by voices, eerie music, and the sounds of things that go bump in the night. Seen on my high-tech computer monitor, it is not so much a "kingdom of shadows," as Maxim Gorky ominously described the emerging cinema in 1902; it is rather like a doll's house filled with miniatures. In these movies, one is introduced to many historical figures—both real and fictional—their writings read by a hypnotic voice-over as if from another dimension. They explain Bergson's theories of duration, the experiments of Pierre Janet,

Figure 41. *Beyond* (Zoe Beloff, 1997). A digital panorama: exploring the ruins of nineteenth-century thought and technologies. Each object is a hot spot, which when clicked opens to a different moment in time. Photograph courtesy of Zoe Beloff.

case histories of paranormal experiences, and explications of Benjamin's Arcades Project, among other subjects. We hear fantastic theories of memory and time travel. Some of the tiny movies are found films made in the earliest days of cinema, from images of city streets to pornography, and even home movies from the 1920s. Some of the images are recognizable artifacts, such as Edison's films or the paper print collection of the Library of Congress. Beloff has collected all of it in flea markets over the years. There are handmade puppets, drawings, still photographs. Written texts on long strips of transparent film snake their way through the images and objects. The movies have the quality of collage, fragments, and bits and pieces stuck together to create fantastic worlds. Rather than using digital compositing technologies, Beloff has created them as real-time performances. Using a low-resolution QuickCam that is plugged directly into the computer, she films on small sets created in her apartment; 16 mm movie projectors are stacked on top of each other to superimpose film loops. The music heard is played in the room as the film is being shot, Beloff narrating and quoting texts at the same time. She uses her own body to brood over the materials, sometimes passing the shadow of her hand and face over images of people who were once alive walking down the street. At other times she inserts herself into the film as a character responding to what is happening in the scene, inscribing her own image in the present into the images from the past. These movies are at once documents of performances in the present, historical texts reanimated, and visions of the inner lives of those long dead.

Because all the movies are so short, coupled with the arbitrary clicking in the panoramas to get to them, they do little to create a narrative context for the material. The materiality of all the elements, which barely seem to hang together at all, nonetheless creates a history—but one as fragmented and enigmatic as the material itself. As in Marker's CD-ROM and many others, the problem of the motivation for random hotspot clicking as more than just busy work, as a form of interaction with the piece, is still not solved. The problem returns once again to the earlier tensions within historical construction between the need to shape materials from the past into narrative forms that create meaningful relationships between past and present and an open field that allows for unpredictable connections.

Still, the cumulative aesthetic of this unique admixture of performance, music, early cinema, photography, and contemporary digital technology is one of roughhewn, handmade discovery. Beloff's play with these images and texts from the earlier period through her artisanal working methods and low-tech digital tools creates a historical continuum in which the inventive nature of emerging technologies from all periods in the history of avant-garde cinema reverberates back and forth in time. Some of the short movies have the quality of the earliest films of Lumière, Edison, and Méliès. Others seem to connect to the early modernist cinema experiments of Leger, Moholy-Nagy, and Dulac, and still others to the more contemporary works of Brakhage, Deren, and Conner. The aesthetics of *Beyond* can no longer be seen simply as a product of new technology or the appropriation of older ones. Rather, *Beyond*

reaches back to move forward. In this sense it is a phenomenon of history as a doubling of past and present, using today's still-primitive digital technology and appropriating cinema's history to explore the dream life of contemporary technology. Beloff herself is not just an allegorist or pasticheur commenting on one period of time from the vantage point of another. She is an inventor connecting with the spirit of those artists from the past who also created new aesthetics from the emerging technologies of their day. From both points in time, all are working to expand the possibilities of perceiving life in new ways. All are working to reenchant the world. This is the promise of the ongoing odyssey of avant-garde cinema. It continues to be necessary.

Notes

Introduction

1. Here I am referring to two contemporary historical dramas that can be seen as paradigmatic: *Amistad* by Steven Spielberg (1997) and *Kuroi ame* (Black Rain) by Shohei Imamura (Japan, 1989).

2. Since his "cinema" books appeared in English in the late 1980s there have been several book-length studies devoted to Deleuze's cinematic philosophy and its relation to film studies. These include *Gilles Deleuze's Time Machine,* by D. N. Rodowick; *The Brain Is the Screen: Deleuze and the Philosophy of Cinema,* especially editor Gregory Flaxman's excellent extended introduction; *The Skin of the Film: Intercultural Cinema, Embodiment, and the Senses,* by Laura U. Marks; and *Deleuze on Cinema,* by Ronald Bogue. All provide in-depth discussions of Deleuzian cinematics and are helpful supplements to Deleuze's primary texts.

3. A detailed definition and explication of the histories of the modernist avant-garde cinema are outside the scope of this study; see P. Adams Sitney, *Visionary Film: The American Avant-Garde, 1943–1978;* Gene Youngblood, *Expanded Cinema;* David Curtis, *Experimental Cinema: A Fifty Year Evolution;* Peter Wollen, "The Two Avant-Gardes"; D. N. Rodowick, *The Crisis of Political Modernism: Criticism and Ideology in Contemporary Film Theory;* Malcolm Le Grice, *Abstract Film and Beyond;* Peter Gidal, *Materialist Film;* David James, *Allegories of Cinema: American Film in the Sixties;* James Peterson, *Dreams of Chaos, Visions of Order: Understanding the American Avant-garde Cinema.*

4. For a sense of the plurality of the histories of independent and experimental media that include film, video, and new media see Coco Fusco, *Young, British and Black: The Work of Sankofa and Black Audio Film Collective;* Martha Gever, John Greyson, and Pratiba Parmar, eds., *Queer Looks: Perspectives on Lesbian and Gay Film and Video;* Lynn Hershman-Leeson, ed., *Clicking In: Hot Links to Digital Culture;* Laura U. Marks, *The Skin of the Film: Intercultural Cinema, Embodiment, and the Senses;* Michael Renov and Ericka Suderberg, eds., *Resolution: Contemporary Video Practices;* Catherine Russell, *Experimental Ethnography: The*

Work of Film in the Age of Video; Ella Shohat and Robert Stam, *Unthinking Eurocentrism: Multiculturalism and the Media;* Chris Straayer, *Deviant Eyes and Deviant Bodies: Sexual Re-orientation in Film and Video.*

5. See Wollen's essays "The Two Avant-Gardes" and "Ontology and Materialism in Film" for his illuminating and complex distinctions between these two approaches to materialist filmmaking.

6. For the most comprehensive critical explication of the theories and polemics around political modernism in cinema, see D. N. Rodowick, *The Crisis of Political Modernism.*

7. See Michaelson, ed., *Kino-Eye: The Writings of Dziga Vertov.*

8. For an expanded analysis and critique of structural/materialist film, see chapter 5 in Rodowick, *Crisis of Political Modernism,* 126–46.

9. For studies of this varied body of work from this period, see Malcolm Le Grice, *Abstract Film and Beyond;* Peter Gidal, *Materialist Film;* Colin MacCabe, *Godard: Images, Sounds, Politics;* James Roy MacBean, *Film and Revolution;* Julianne Burton, *Cinema and Social Change in Latin America.*

10. For an important case study of the ways in which forms and conventions of an older aesthetic and medium are appropriated as part of the aesthetic development of new technologies, see Lev Manovich, *The Language of New Media.* Manovich convincingly traces the ways in which cinematic language and other modernist visual forms are the basis for much of what he calls the "computer interfaces" of the digital era. This includes the moving camera, spatial and temporal montage, collage, compositing, looping, and so forth.

11. See Marc Ferro, *Cinema and History;* Vivian Sobchack, ed., *The Persistence of History: Cinema, Television and the Modern Event;* Robert Burgoyne, *Film Nation: Hollywood Looks at U.S. History;* Marcia Landy, ed., *The Historical Film: History and Memory in Media;* Robert A. Rosenstone, ed., *Revisioning History: Film and the Construction of a New Past;* Mimi White, *An Extra Body of Reference: History in Cinematic Narrative;* and Pierre Sorlin, *The Film in History: Restaging the Past.*

12. See Yosefa Loshitsky, ed., *Spielberg's Holocaust: Critical Essays on "Schindler's List";* Burgoyne, *Film Nation.*

13. The proliferation of such theatrical and television Holocaust dramas since 1990 alone has been staggering. The following is a small sampling of the most widely acclaimed: *Triumph of the Spirit,* Robert M. Young (1990); *Europa Europa,* Agnieszka Holland (1990); *Schindler's List,* Steven Spielberg (1993); *In the Presence of Mine Enemies,* Joan Micklin Silver (1997); *Life Is Beautiful,* Roberto Benigni (1998); *The Devil's Arithmetic,* Donna Deitch (1999); *Jakob the Liar,* Peter Kassovitz (1999); *Anne Frank—The Whole Story,* Disney (2001); *The Grey Zone,* Tim Blake Nelson (2001); *Uprising,* Jon Avnet (2001); *The Pianist,* Roman Polanski (2002).

14. Here I am invoking the literary critic Harold Bloom's psychoanalytic explanation for much aesthetic innovation in the arts in his book *The Anxiety of Influence: A Theory of Poetry.*

15. Such films include *Bilder der Welt und Inschrift des Krieges* (Images of the World and the Inscription of War), Harun Farocki (West Germany, 1988); *The Communists Are Comfortable and Three Other Stories,* Ken Kobland (1984–88); *Daughters of the Dust,* Julie Dash (1992); *Die Macht der Gefühle* (The Power of Emotion), Alexander Kluge (West Germany, 1983); *Journeys from Berlin/1971,* Yvonne Rainer (1979); *Handsworth Songs,* Black Audio/Film Collective (U.K., 1986); *History and Memory: For Akiko and Takashige,* Rea Tajiri (1991); *The Last Angel of History,* John Akomfrah (U.K., 1996); *Liberators Take Liberties,* Helke Sander (Germany, 1992); *Looking for Langston,* Isaac Julian (U.K., 1989);

Nitrate Kisses, Barbara Hammer (1992); *Nostalgia (Hapax Legomena I),* Hollis Frampton (1973); *The Passion of Remembrance,* Sankofa Collective (U.K., 1986); *The Pharaoh's Belt,* Lewis Klahr (1993); *Reminiscences of a Journey to Lithuania,* Jonas Mekas (1972); *Sans soleil,* Chris Marker (France, 1982); *The Society of the Spectacle,* Guy Debord (France, 1973); *Surname Viet Given Name Nam,* Trinh T. Minh-ha (Vietnam/United States 1989); *War Stories,* Richard Levine (1983); *Maelstrom,* Peter Forgacs (Netherlands, 1997); *What Farocki Taught,* Jill Godmilow (1998); *The Zapruder Footage: An Investigation of Consensual Hallucination,* Keith Sanborn (1999).

16. For an expanded explication of the concept of sideshadowing, see chapter 2, "Shadows." Also see *Foregone Conclusions: Against Apocalyptic History,* by Michael André Bernstein, on which this formulation is based.

17. See Bergson's writings on duration in *Matter and Memory* and *Time and Free Will: An Essay on the Immediate Data of Consciousness.*

18. For broader studies of the philosophical problems and aesthetic strategies of representing catastrophe in contemporary visual art, architecture, and literature, see in particular James E. Young, *At Memory's Edge: After-images of the Holocaust in Contemporary Art and Architecture,* and Saul Friedlander, ed., *Probing the Limits of Representation: Nazism and the Final Solution.*

1. Shards

1. For expanded discussions of the Benjaminian figure of the brooder and his thinking about surrealism, see Pensky, "Tactics of Remembrance," and Cohen, *Profane Illumination.*

2. For more detailed histories of Cornell's film work and his relationship to, and influence on, the postwar American avant-garde cinema, see Sitney, *Visionary Film;* and Keller, *The Untutored Eye;* also see the detailed notes on Cornell's films in the New York Filmmaker's Co-op *Catalogue 7,* 117–19.

3. See Sitney, *Visionary Film;* and Leffingwell et al., *Jack Smith: Flaming Creature.*

4. Quoted from program notes in "Ken Jacobs' Nervous System," a British Film Institute touring retrospective of Jacobs's work, October–December 2000.

5. A comprehensive study of the mutual influence of avant-garde cinema and twentieth-century visual art practices is yet to be done and is certainly outside the scope of this study. There is Malcolm Le Grice's *Abstract Film and Beyond,* a history that connects avant-garde film to modernist visual arts movements, largely in European art. Also, the 1996 exhibition "Art and Film since 1945: Hall of Mirrors" at the Museum of Contemporary Art, Los Angeles, was an attempt to show the cross-fertilization between the visual arts and cinema; Ferguson, *Art and Film since 1945.*

6. For a multifaceted history of the "actuality," see Elsaesser, *Early Cinema,* esp. 56–86.

7. In conversation with Gehr, he expressed discomfort with the term "actuality" when referring to this piece of film. Instead he prefers to use his own term "moving panorama." This makes reference to an even earlier protocinema form, the panorama. These were immense static wall murals housed in their own building that surrounded the viewer, realistically depicting a changing landscape as the viewer walked around its 360-degree expanse. This and all information about the making of *Eureka* is based on unpublished conversations with the filmmaker.

8. The persistence of vision is a physiological phenomenon of the human eye in which light hitting the retina remains for a fraction of a second before it fades. This produces the illusion of movement in motion pictures when successive frames flashed onto the movie screen become superimposed as the not-yet-faded frame is replaced by the next.

9. The phi phenomenon is the apparent movement of successive still frames. This phenomenon is a result of the brain's ability to retain images for a short period of time, forming patterns from them. The patterns fill in the gaps of missing movement (time) between each frame, thus creating the illusion of temporal continuity and consistent movement between frames.

10. All the background information regarding Comerio's original footage and how the filmmakers found it and rephotographed it comes from an interview with Gianikian and Ricci Lucchi in Scott MacDonald, *A Critical Cinema 3: Interviews with Independent Filmmakers.*

11. The viewing of *Dal polo* in a graduate seminar at the School of the Art Institute of Chicago (spring 2000) demonstrated just how much the reading of the film reflected the social identity of the students. Some students of color saw the film as an uninteresting rehearsal of stereotypical images of the white colonial gaze that was neither informative nor entrancing. On the other hand, many white students felt that seeing the images in such a heightened aesthetic state did challenge their ideas of racial otherness by implicating their own whiteness in the gaze of the camera.

12. See especially Fatimah Tobing Rony, *The Third Eye: Race, Cinema, and Ethnographic Spectacle;* and Elsaesser, *Early Cinema.*

13. The production facts are taken from printed publicity materials for the film.

14. Quotes are taken directly from the videotape's sound track; italics mine.

15. All quotes from the film are taken directly from the sound track.

16. See Gidal, *Materialist Film;* Le Grice, "Towards Temporal Economy"; and Sitney, "Structural Film," in *Visionary Film.*

17. See Brecht, *Brecht on Theatre,* for his theory and practice of epic theater. Also see "The Two Avant-Gardes," by Peter Wollen, for an in-depth discussion of the relationships between Brechtian and structural materialist approaches in avant-garde filmmaking.

18. As conceived of by Guy Debord and the Situationists, whose techniques of the *détournement* of mass culture are very much part of Baldwin's aesthetic and political heritage. See Debord, *The Society of the Spectacle;* and Ken Knabb, *Situationist International Anthology.*

19. In this case, I am thinking not only of the structural/materialist films of Le Grice, Gidal, Sharits, and Frampton but also of the films by Straub-Huillet, Godard of the Dziga Vertov Group period, and Ackerman. This reiterates the connection and distinction that Peter Wollen makes in his essay "The Two Avant-Gardes" between the strategies of the image-based work of the former and the language-based work of the latter.

2. Shadows

1. I thank Michael André Bernstein for introducing me to his concept of sideshadowing. The formulations of fore-, back-, and sideshadowing that I use here come from his important study. For the complete discussion of his concept of shadowing and its literary implications, see his *Foregone Conclusions: Against Apocalyptic History.* For a parallel formulation of literary sideshadowing, also see Gary Saul Morson, *Narrative and Freedom: The Shadows of Time.*

2. For complete descriptions and in-depth discussions of Antin's work, see the catalog for her 1999 retrospective at the Los Angeles County Museum of Art (Fox, *Eleanor Antin*).

3. From unpublished conversations with the artist.

4. "The authenticity of a thing is the essence of all that is transmissible from its beginning, ranging from its substantive duration to its testimony to the history which it has experienced" (*Illuminations,* 221).

5. As the society moves away from photographically based filmmaking to electronic digital technologies, the viewing of a restored classic film on photographic film—with its frescolike dimensions and uniquely photographic textures—in a traditional large-screen theater, takes on the aura of a high-art experience such as attending the opera. Often these screenings become heightened events, since the film may only be shown in this form several times before disappearing into home-video format. This was the case with the restored version of Hitchcock's *Vertigo* (1958), when after years of being unavailable, it was released in the United States as a limited run in commercial art houses. Similarly, the revival of Able Gance's *Napoleon* (France, 1928) was shown in its original form as a three-screen film with live orchestra at the San Francisco Opera House as a limited event, never to appear there in this form again.

6. See also the book *The Seventh Million* by the Israeli historian Tom Segev, who traces the ways Holocaust narratives were appropriated for political ends in the development of Israeli nationalism.

7. For example, *Perfect Film* (1985) is a reel of outtakes of a news report on the assassination of Malcolm X that Jacobs found in a bin on Canal Street in New York City. After viewing the material, Jacobs decided that it needed no further alteration and reprinted the reel as he had found it. The outtakes were reassembled randomly by the editor of the news report once the shots that were used in the report were removed. *Perfect Film* shows shots of the streets of Harlem around the Audubon Ballroom where Malcolm X was shot, people milling around, and bits of interviews with witnesses and bystanders. The chance arrangement of this material reveals a sense of loss and confusion around this event that is poetically and poignantly moving. Jacobs has written of this practice in the program notes to his 1989 retrospective: "A lot of film is perfect left alone, perfectly revealing in its un- or semi-conscious form. . . . I wish more stuff was available in its raw state, as primary source material for anyone to consider, and to leave for others in just that way, the evidence uncontaminated by compulsive proprietary misapplied artistry. 'Editing,' the purposeful 'pointing things out' that cuts a road straight and narrow through the cine-jungle; we barrel through thinking we're going somewhere and miss it all. Better to just be pointed to the territory, to put in time exploring, roughing it, on our own. For the straight scoop we need the whole scoop, no less than the clues entire and without rearrangement." Ken Jacobs, "Films That Tell Time: A Ken Jacobs Retrospective" (American Museum of the Moving Image, 1989).

8. These films in Jacobs's large and multifaceted oeuvre include, most famously, *Tom, Tom, the Piper's Son* (1969–71), as well as *Opening the Nineteenth Century: 1896* (1990), *Keaton's Cops* (1991), *Disorient Express* (1996), and *Georgetown Loop* (1996).

9. These works are known as "Nervous System Performances," in which Jacobs uses a modified projector to project two strips of the same film over each other, usually a frame or two apart. He performs live with the two projectors, subtly changing their speeds, moving the images backward and forward, moving the two strips of film in and out of phase with each other. The projection creates new perceptual and physical experiences of the footage, unlocking entirely different aspects of the film frames impossible to see in normal projection.

10. See J. Hoberman's acknowledgments in his important study of Yiddish cinema, *Bridge of Light*.

11. All text transcribed directly from the audiocassette sound track supplied with the film.

12. For in-depth discussions of relationships between the Jewish American community and the Shoah in postwar American life, see Peter Novak, *Holocaust in America;* and Peter

Hayes, *Lessons and Legacies: The Meaning of the Holocaust in a Changing World;* see also the controversy surrounding the exhibition "Mirroring Evil" at the New York Jewish Museum (spring 2002).

13. In his brief but helpful essay from 1989, "The Appearance of History in Recent Avant-Garde Film," published in *Frame/work,* the critic Paul Arthur has argued similarly that the emergence of a historicizing tendency was in reaction to "an unspoken [and utopian] desire in earlier American avant-garde film to exist outside History in a realm of aesthetic experience and expression that elided any recognition of a socially-shared past" (39). With the emergence of postmodern aesthetics, such positions became untenable for many artists, giving rise to a cinema "increasingly infused with a historicizing energy, a need to counterpose private and public accounts of everyday life or make connections between contemporary and 'primitive' cinematic practices" (40). Arthur identifies three separate categories or strategies for such work. The first is the so-called new narrative feature, which often focuses on genres and conventions of mass-culture cinema and uses spoof, parody, and pastiche. The second is the use of artifacts from film history, where "the home movie and other found materials deemed unimportant or thoroughly transparent are treated as documents engendering rich speculation about the nature of historical evidence" (42). The third category is the "collusion of autobiography and social history," in which the filmmaker's subjectivity is explored in the context of larger social forces and mediated through the forms of representation that produce limits to what can be expressed or known.

14. See Vertov's essays on the kino-eye in Michaelson, *Kino-Eye: The Writings of Dziga Vertov,* and Brakhage's writings on closed-eye vision in *Metaphors on Vision* and *The Essential Brakhage: Selected Writings on Film.*

15. For an important theoretical discussion of the lyrical camera style, see Sitney, *Modernist Montage,* esp. 196–210.

16. While Brakhage's immense body of work is based on the promise of revelation through vision, his film *Visions in Meditation 2: Mesa Verde* (1989) seems to be an exception to this idea and is a meditation on the limits of vision as knowledge. In the film, Brakhage takes up one of the great mysteries in Native American history and visits the Mesa Verde plateau in New Mexico to try to understand the mystery of the disappearance of the ancient Anasazi Indians. Like Eisenberg, Brakhage uses his handheld camera as a tool to conjure the past. In the film, he feverishly zooms in and out while focusing on the mountainside and skyline. It seems as if Brakhage, by this action, is trying to crack open the image of the landscape in the hope of revealing its mysteries. The camera movements try to conjure the lost, but such revelation is impossible, and the landscape can reveal little of its past. In this late film, Brakhage seems to be using the film images less to express his own vision of this mythic location than to explore the limits of vision as a form of knowledge or discovery. For a more in-depth discussion of this extraordinary film, see John Pruitt's very different reading of it in his essay "Stan Brakhage and the Long Reach of Maya Deren's Poetics of Film," in "Stan Brakhage: Correspondences," a special issue on Brakhage and his work in the *Chicago Review* (2002).

17. The issue of the use of testimony and personal experience is taken up in more depth in chapter 4 in my discussion of *The March* and *Un vivant que passe.*

3. Virtualities

1. Andreas Huyssen's book *Twilight Memories: Marking Time in a Culture of Amnesia* explores the cultural impact of the division and reunification of Germany. See especially section 1, "Time and Memory."

2. Two examples of historicist constructions of conventionally linear Berlin Wall narratives are *The Promise* by Margarethe von Trotta (Germany, 1995), a dramatic film; and a documentary, *Something to do with the Wall* by Ross McElwee (1992).

3. Here I am paraphrasing the Deleuzian notion of an "any-space-whatever," which he describes as a space represented in modern cinema that is no longer a particular determined space: "It is a perfectly singular space, which has merely lost its homogeneity . . . so that linkages can be made in an infinite number of ways. It is a space of virtual conjunction, grasped as pure locus of the possible" (*Cinema 1*, 109).

4. All quoted material from the film is taken directly from the film.

5. See the discussion of Trinh's notion of the "interval" in the previous chapter on Daniel Eisenberg's film *Cooperation of Parts* and in her essay "Documentary Is/Not a Name."

6. See Huyssen's essay "Escape from Amnesia: The Museum as Mass Medium," in *Twilight Memories: Marking Time in a Culture of Amnesia.*

7. Daniel Eisenberg, director's statement for the forty-seventh Berlin Internationale Filmfestspiele catalog, February 13–24, 1997.

8. Because *Persistence* also maps across discontinuous moments in time in the ways I have described, it also introduces the possibility of a temporal dimension to Jameson's largely spatial notion of cognitive mapping. For Jameson, cognitive mapping refers to cultural, aesthetic, and epistemological shifts that occur as a result of the rise of late capitalism with its attendant postindustrial, globalized economy. In this new context he calls for the invention of radical new aesthetic forms to represent these new spatial relationships. It would also be logical to add to Jameson's formulation the question of new forms for mapping time in relation these social, cultural, and aesthetic changes, particularly in relation to time-based forms such as film. Though outside the scope of this study, this could provide a crucial link between Jameson's cognitive mapping and Deleuze's time-image.

9. For a detailed history of some of the major artists' projects on homelessness and gentrification in New York City, see Gregory Sholette, "Nature as an Icon of Urban Resistance: Artists, Gentrification and New York City's Lower East Side, 1979–1984."

10. For a more comprehensive look at activist video on urban housing struggles, see Ernest Larsen, "Who Owns the Streets."

11. In *The Logic of Sense,* Deleuze uses the example of Jorge Luis Borges's story "The Garden of Forking Paths" to demonstrate his notion that incompossible worlds become variants of the same story: "Fang, let us say, has a secret. A stranger knocks at his door. Fang makes up his mind to kill him. Naturally there are various possible outcomes. Fang can kill the intruder, the intruder can kill Fang, both can be saved, both can die and so on and so on. In Ts'ui Pen's work all possible solutions occur, each one being the point of departure for other bifurcations" (114).

12. Here are Deleuze's words: "The sound image is born, in its very break, from its break with the visual image. There are no longer even two autonomous components of a single audio-visual image . . . but two heautonomous [i.e., autonomous] images, one visual and one sound, with a fault, an interstice, an irrational cut between them" (*Cinema 2*, 251).

13. For one of the best investigations into the lives of "illegal" Mexican workers in Southern California, see filmmaker Louis Hock's epic videotape *The Mexican Tapes: A Chronicle of Life outside the Law* (1986). The tape is an intimate day-to-day chronicle of the lives of three families of undocumented Mexican workers over a five-year period. The tape shows that although these people are an integral part of the Southern California workforce, they are criminalized and exploited without the protection and benefits of basic U.S. labor laws, and this takes a heavy toll on these families psychologically and physically as they try to make a life in the United States.

14. I take this from David Harvey, who writes about paraphrasing the title of Raymond Williams's book *Resources of Hope: Culture, Democracy* for the title of his own book, *Spaces of Hope* (17).

4. Specters

1. Jean-François Lyotard has written in depth about this problem, in which an event or situation arises that destabilizes language to the point where something that must be "put into phrases cannot yet be." He calls this instability of language "the differend." He writes: "In the differend, something that 'asks' to be put into phrases . . . and suffers from the wrong of not being able to be put into phrases right away. This is when human beings who thought they could use language as an instrument of communication learn through the feeling of pain which accompanies silence . . . that they are summoned by language, not to augment to their profit the quantity of information communicable through existing idioms, but to recognize that what remains to be phrased exceeds what they can presently phrase, and that they must be allowed to institute idioms which do not yet exist" (*The Differend*, 13).

2. For one of the most theoretically informed and in-depth readings of this extraordinarily complex work, see Shoshana Felman, *Testimony: Crises of Witnessing in Literature, Psychoanalysis and History*, especially chapter 7, "The Return of the Voice: Claude Lanzmann's *Shoah*," 204–83.

3. Adorno, "Cultural Criticism and Society."

4. Many of these complex discussions surrounding the exploitation, redemption, and sublimity of Holocaust representation are powerfully rehearsed in Adorno, Agamben, Bernstein, Caruth, Friedlander, LaCapra, Lanzmann, and Young.

5. The authority of the personal testimony of the eyewitness sits at the core of modern legal systems, centering society's notions of truth and justice around the articulation of individual experience and perception. Similarly, within the discipline of history, the genre of "oral history" has emerged as a more direct and democratic notion of historical inquiry than third-person interpretive history. Like the legal system, it also privileges direct experience as a less-mediated form of documentation, since it presumes that the witness is deciding what is important in an event and is unencumbered by the interpretation and perspectives of the professional historian. See Paul Thompson's study of oral historiography in *The Voice of the Past: Oral History*, as well as Studs Terkel, *Hard Times: An Oral History of the Great Depression*.

6. Quoted directly from the film *The March*.

7. See Hendricks, *Eadweard Muybridge;* and Manes, *Pictures of Motion and Pictures That Move.*

8. For a detailed analysis of uses of interview formats in nonfiction film contexts, see in particular Bill Nichols, "The Voice of Documentary" and *Ideology and the Image: Social Representation in the Cinema and Other Media.*

9. The backshadowed knowledge of the moral victories of the civil rights movement is what redeems the horrors and misery of the struggles that the film explores for viewers in the present.

10. Films such as these include *Portrait of Jason* by Shirley Clarke (1967); *Soft Fiction* by Chick Strand (1979); *Pierre Vallieres* by Joyce Wieland (Canada, 1972); the video series *France/Tour/Detour/Deux Enfants* by Jean-Luc Godard (France, 1978); *The Word Is Out: Stories of Some of Our Lives* by Peter Adair et al. (1978); and Claude Lanzmann's *Shoah* (France and Israel, 1986) and *Sobibor, October 14, 1943, 4 P.M.* (France, 2001).

11. Examples of this kind of work include *The Red Tapes* by Vito Acconci (1976); *The Electronic Diary Series* by Lynn Hershman (1986–95); *Joan Does Dynasty* by Joan Braderman (1986); and *If Every Girl Had a Diary* by Sadie Benning (1990).

12. For an excellent discussion of confessional video art, see Michael Renov, "Video Confessions," in Renov and Suderburg, *Resolutions*.

13. The following description of this event is an intertitle seen at the opening of the film. It is taken from the film's publicity material: "As WWII was coming to a close, Soviet troops were about to liberate several of the concentration camps located in Poland. On January 18, 1945, the German high command ordered the evacuation of Auschwitz, Birkenau, and Monowitz. Inmates were forced to march in midwinter, either to a nearby railway junction from which they would be taken to subcamps in western Germany or for hundreds of miles—on foot—to other destinations. Those who were too weak to march away were shot in the camps prior to evacuation. Testimonies from survivors indicate that tens of thousands were shot and killed along the way. During the Eichmann trial, Israel Gutman stated that "anybody who had to sit down for a few minutes, was shot at" (Gilbert, *The Holocaust*, 772).

14. Lanzmann gives this background to the Rossel interview in the long written text that opens *Un vivant qui passe*.

15. All quotes come directly from the film's sound track.

16. For in-depth studies of Jewish stereotyping, see Gilman, *Freud, Race and Gender* and *The Jew's Body;* and Brienes, *Tough Jews*.

17. All quotes are taken directly from the film unless otherwise noted.

18. The artist Michael Snow's three films *Wavelength* (1967), <—> (*Back and Forth*) (1969), and *La Région Centrale* (1971) can be seen as paradigmatic of this definition of structural film. Each focuses on a single kind of camera movement from a fixed point in a single space. *Wavelength* consists of a slow zoom across the space of a nearly empty loft, showing how the image changes as the focal length of the lens is increased. <—> is filmed in an empty classroom as the camera is panned back and forth and tilted up and down at varying velocities over a forty-five-minute duration. *La Région Centrale* uses a machine invented for the film, which could be preprogrammed to move a mounted camera in any direction—up, down, side to side, and in circles. The apparatus was used to explore a Canadian mountain range in a series of continuous shots for three and one half hours. See Sitney's chapter entitled "Structural Film" in his *Visionary Film*.

19. *The March* can be seen as part of a stylistically similar series of films that Ravett has made to explore his struggle to know about his parents' experiences of the Shoah, and the impact this history has had on his family, especially *Everything's For You* (1989), a postmortem meditation on Ravett's relationship to his father, in light of his father's experience in Auschwitz and the destruction of his family there. Ravett explores the ways these experiences impacted his father's subsequent relationship to him. Ravett knew nothing of his lost family until after his father's death. In another film, *Half Sister* (1985), Ravett contemplates the only remaining photograph of his father's daughter—Ravett's half sister, who was killed in Auschwitz. Like *The March*, these films are highly fragmented works that the reveal the son's desire to know and understand the experiences of his parents. They show Ravett struggling with the limits and gaps in his own knowledge, which is manifested in his imploring his parents to tell him of their experiences.

20. See the detailed analysis of Eisenberg's *Cooperation of Parts* in chapter 2 of this book, which takes up his different but related strategies for representing the gaps in his understanding of his own history.

21. A similar example of the children of Shoah survivors trying to understand the

experiences of their parents as fractured knowledge can be found in Art Spiegelman's protocinematic graphic memoir *Maus: A Survivor's Tale*. Spiegelman's fragmented comic book style embodies the incomplete narrative form of the son's attempts to clarify his father's recounting of his story. It is also worth noting that filmmakers Ernie Gehr and Ken Jacobs are acknowledged in *Maus*, indicating the connection between avant-garde film and Spiegelman's experimental reconception of the comic book form and its narrative possibilities.

22. An unpublished letter from Ravett to the author, June 8, 2000.

5. Obsessive Returns

1. As stated by Guzmán's friend Professor Ernesto Malbran in the film *Chile, la memoria obstinada*.

2. See my discussion in chapter 3 of James Benning's *Utopia*.

3. See John Berger, "Che Guevara Dead."

4. See David Kunzle, *Che Guevara: Icon, Myth and Message*.

5. All quotations from the film are taken from a translated screenplay provided by the filmmaker.

6. In an interview, Guzmán recalls how he structured the material used for *The Battle of Chile*: "We needed to use a wide-angle lens and to situate ourselves at as great a distance as possible from events while still being able to record them. . . . We realized that it would be a mistake to analyze events from a single perspective. . . . The theoretical outline we developed was divided into three major areas: ideological, political and economic. Our point of departure was a Marxist analysis of reality" (Burton, "Politics and the Documentary," 50).

7. Here I am invoking a distinction between Freudian and Benjaminian notions of melancholia. For Freud, melancholia is an immobilizing condition of sadness characterized by an inability to recover from the loss of a love object or ideal. Structured by withdrawal, the ego turns back on itself, introjecting the loss as a way to hold on to the object. In its preoccupation with its own sadness, the subject's engagement with the outside world recedes. Benjamin sought a more redemptive notion of melancholia, in which the turning back on the self holds the potential for creativity and a heightened awareness of one's present position in the activity of brooding over one's condition: "He broods—not so much over the matter itself as over his past reflections on it" (*The Arcades Project*, [J79a,1], 367). For Benjamin, the dialectics of melancholia exist in the possibility that one's preoccupation with what is lost or failed can open onto a rebellion against the conditions that precipitated the loss. True to his dialectical thinking, however, Benjamin also warned against what he called "left-wing melancholy," in which leftists hold on to past political attachments and ideas as if they were cryogenically preserved objects to be reconstituted at a later moment, while refusing to accede to the shifting conditions of the present. The left-wing melancholic withdraws from the "time of the now" to "what is left . . . the empty spaces where, in dusty heart-shaped velvet trays, the feelings—nature and love, enthusiasm and humanity once rested" ("Left-Wing Melancholy," 425).

Coda

1. See Elvis Mitchell, "Everyone's a Film Geek Now," *New York Times*, August 17, 2003.

2. See, for example, Larry Jordan's essay "Survival in the Independent-Non-Commercial-Avant-Garde-Experimental-Personal-Expressionist Film Market of 1982," *Millennium Film Journal*, no. 12 (fall/winter): 1982.

3. For other attempts to understand the change in contemporary film culture with varying degrees of insight, nostalgia, and mourning, see Camper, "The End of Avant-Garde Film"; Sontag, "The Decay of Cinema"; Lopate, "When Foreign Movies Mattered."

4. Those filmmakers associated with the "new narrative" avant-garde feature film in the 1980s include Yvonne Rainer, James Benning, Chantal Ackerman, Bette Gordon, Jon Jost, and Derek Jarman, among others. Rappaport's feature films include *Local Color* (1977), *The Scenic Route* (1978), *Imposters* (1979), *Chain Letters* (1985), and *Exterior Night* (1994).

5. For a more detailed discussion of this complex theory of the masquerade in cinema, see Doane's essays in *Femmes Fatales,* "Film and the Masquerade: Theorizing the Female Spectator" and "Masquerade Reconsidered: Further Thoughts on the Female Spectator." For its cogent critique in relation to queer cinema, see Straayer, "Queer Theory, Feminist Theory: Ground for Rhetorical Figures," in *Deviant Eyes,* 102–59.

6. Rappaport named his production company Couch Potato Productions.

7. For historical overviews of film installation, see Iles, *Into the Light;* Ferguson, *Art and Film Since 1945;* Le Grice, *Abstract Film and Beyond;* and Hayward Gallery, *Film as Film.*

8. While contemporary film and video installations do vary widely in their running times, it is my observation that they are rarely longer than ten minutes. For example: Shirin Neshat's *Fervor* (2000), 11 mins., *Possessed* (2001), 11 mins., and *Pulse* (2001), 8 mins.; Pipilotti Rist's *Sip My Ocean* (1996), 8 mins.; Jane and Louise Wilson's *Stasi City* (1997), 5 mins.; Gillian Wearing's *Prelude* (2000), 4 mins.; Rodney Graham's *City Self / Country Self* (2000) 4 mins.; Rosemary Trockel's *Manu's Spleen 1–5,* 1:30 to 7:20 mins.; Stan Douglas's *Nu*tka** (1996), 6 mins.

9. Tony Sinden, "Artist Statement: Durham Cathedral Residency," 2002.

10. For more complete discussions of the notion of interactivity as it relates to new media, see Manovich, *The Language of New Media,* esp. 55–61, 205–11. See also Manovich, "From the Externalization of the Psyche to the Implantation of Technology"; and Rokeby, "Transforming Mirrors."

11. Here I polemically adapt Herbert Marcuse's notion of "repressive tolerance" to complicate the notion of participatory aesthetics in media. Marcuse argues that built-in forms of participation and dissent within liberal society, which are understood to allow for change, actually have a repressive function by creating the false sense that all groups within society carry equal power to transform it. Tolerance becomes a controlling structure that conceals the unequal power that the established social order has to repress actions and discourses that threaten it. Prescribed modes of acceptable critique and dissent become the naturalized terms for participation and make others appear unreasonable, unacceptable, and unimaginable. See Marcuse, "Repressive Tolerance."

12. All Marker citations are from the liner notes of the CD-ROM case for the English edition of *Immemory* (Cambridge, Mass.: Exact Change, 2002).

13. For a more detailed discussion of Benjamin's figure of "the brooder," see chapter 1.

14. Beloff's extraordinary range of work in film, sound, performance, theater, and digital forms includes long-form 16 mm single-screen films such as *A Trip to the Land of Knowledge* (1995), *Lost* (1997), and *Shadow Land or Light from the Other Side* (2000). She has done multimedia collaborations with artists from other disciplines in music and theater including the composers Ken Montgomery and John Cale and the Wooster Group theater company. In addition to *Beyond* there are several other interactive films, the CD-ROM *Where Where There There Where* (1998), and the installation *The Influencing Machine of Miss Natalija A.* See Beloff's Web site, also a varied artwork that contains clips of her

media work, historical research into protocinema machines, and writings on her own work: Zoe's World at http://zoebeloff.com.

15. Throughout my reading of *Beyond,* I am aided by Beloff's own writing on the piece that can be found on her Web site, http://www.zoebeloff.com/ideas.html, and by unpublished letters from the artist.

Bibliography

Adorno, Theodor. *Aesthetic Theory.* Trans. C. Lenhardt. New York: Routledge, 1986.

———. *Prisms.* Trans. Samuel Weber and Shierry Weber. Cambridge: MIT Press, 1981.

———. *Minima Moralia.* Trans. E. F. N. Jephcott. London: Verso, 1978.

Agamben, Giorgio. *Remnants of Auschwitz: The Witness and the Archive.* Trans. Daniel Heller-Roazan. New York: Zone Books, 1999.

Appelfeld, Aharon. *Beyond Despair: Three Lectures and a Conversation with Philip Roth.* Trans. Jeffrey M. Green. New York: Fromm International, 1994.

Arthur, Paul. "The Appearance of History in Recent Avant-Garde Film." *Frame/work* 2, no. 3 (1989):39–45. Los Angeles: Los Angeles Center for Photographic Studies.

Bad Object-Choices, eds. *How Do I Look? Queer Film and Video.* Seattle: Bay Press, 1991.

Bakhtin, M. M. *The Dialogic Imagination: Four Essays.* Trans. and ed. Michael Holquist and Caryl Emerson. Austin: University of Texas Press, 1981.

Barthes, Roland. *Camera Lucida: Reflections on Photography.* Trans. Richard Howard. New York: Hill and Wang, 1981.

———. *Image, Music, Text.* Trans. Stephen Heath. London: Fontana/Collins, 1977.

———. "The Discourse of History." In *The Rustle of Language.* New York: Hill and Wang, 1986.

———. *S/Z.* Trans. Richard Miller. New York: Hill and Wang, 1974.

Baudelaire, Charles. *Les fleurs du mal.* Trans. Richard Howard. Boston: David R. Godine, 1983.

Baudrillard, Jean. *Simulacra and Simulation.* Trans. Sheila Faria Glaser. Ann Arbor: University of Michigan Press, 1994.

Bazin, André. *What Is Cinema?* Vol. 2. Trans. Hugh Gray. Berkeley: University of California Press, 1972.

Beckett, Samuel. *Krapp's Last Tape.* New York: Grove Press, 1960.

———. "Not I." In *Ends and Odds.* New York: Grove Press, 1976.

———. *Worstward Ho.* New York: Grove Press, 1983.

Bellour, Raymond, and Mary Lea Bandy, eds. *Jean-Luc Godard: Son + Image.* Trans. Georgia Gurrieri. New York: Museum of Modern Art, 1992.

Benjamin, Walter. *The Arcades Project.* Trans. Howard Eiland and Kevin McLaughlin. Cambridge: Harvard University Press, 1999.

———. "Central Park." Trans. Lloyd Spencer. *New German Critique* 34 (winter 1985): 32–58.

———. *Charles Baudelaire: A Lyric Poet in the Era of High Capitalism.* Trans. Harry Zohn. London: New Left Books, 1973.

———. *Illuminations.* Trans. Harry Zohn. New York: Schocken Books, 1969.

———. "Left-Wing Melancholy." In *Selected Writings,* vol. 2, *1927–1934,* ed. Michael Jennings. Cambridge: Harvard University Press, 1999.

———. *The Origin of German Tragic Drama.* Trans. John Osborne. London: New Left Books, 1977.

———. *Reflections.* New York: Harcourt, Brace Jovanovich, 1978.

———. "The Work of Art in the Age of Mechanical Reproduction." In *Illuminations.* New York: Schocken Books, 1969.

Benning, James. *Fifty Years to Life: Texts from Eight Films by James Benning.* Madison, Wisc.: Two Pant Press, 2000.

Berger, John. "Che Guevara Dead." *Aperture* 13, no. 4 (1968).

Bergson, Henri. *Matter and Memory.* Trans. N. M. Paul and W. S. Palmer. New York: Zone Books, 1991.

———. *Time and Free Will: An Essay on the Immediate Data of Consciousness.* Trans. F. L. Pogson. New York: Macmillan, 1959.

Bernstein, Michael André. *Foregone Conclusions: Against Apocalyptic History.* Berkeley: University of California Press, 1994.

Bersani, Leo. *The Culture of Redemption.* Cambridge: Harvard University Press, 1990.

Bloch, Ernst. *The Utopian Function of Art and Literature: Selected Essays.* Trans. Jack Zipes and Frank Mecklenburg. Cambridge: MIT Press, 1988.

Bloom, Harold. *The Anxiety of Influence: A Theory of Poetry.* New York: Oxford University Press, 1973.

Bogue, Ronald. *Deleuze on Cinema.* New York: Routledge, 2003.

Bourdieu, Pierre. "The Field of Cultural Production, or The Economic World Reversed." In *The Field of Cultural Production: Essays on Art and Literature.* New York: Columbia University Press, 1993.

Brakhage, Stan. *The Essential Brakhage: Selected Writings on Film.* New York: McPherson, 2001.

———. *Metaphors on Vision.* Ed. P. Adams Sitney. New York: Film Culture, 1963.

Brecht, Bertolt. *Brecht on Theatre: The Development of an Aesthetic.* Ed. and trans. John Willett. New York: Hill and Wang, 1964.

Breton, André. *What is Surrealism?* Trans. David Gascoyne. London: Faber and Faber, 1936.

Brienes, Paul. *Tough Jews: Political Fantasies and the Moral Dilemma of American Jewry.* New York: Basic Books, 1990.

Buck-Morss, Susan. *The Dialectics of Seeing: Walter Benjamin and the Arcades Project.* Cambridge: MIT Press, 1989.

Bürger, Peter. *Theory of the Avant-Garde.* Minneapolis: University of Minnesota Press, 1984.

Burgoyne, Robert. *Bertolucci's 1900: A Narrative and Historical Analysis.* Detroit: Wayne State University Press, 1991.

———. *Film Nation: Hollywood Looks at U.S. History.* Minneapolis: University of Minnesota Press, 1997.

Burton, Julianne, ed. *Cinema and Social Change in Latin America.* Austin: University of Texas Press, 1986.

———. "Politics and the Documentary in People's Chile: An Interview with Patricio Guzmán." In *Cinema and Social Change in Latin America,* ed. Julianne Burton. Austin: University of Texas Press, 1986.

Cadava, Eduardo. *Words of Light: Theses on the Photography of History.* Princeton: Princeton University Press, 1997.

Camper, Fred. "The End of Avant-Garde Film." *Millennium Film Journal,* nos. 16–18 (fall–winter 1986–87).

Caruth, Cathy, ed. *Trauma: Explorations in Memory.* Baltimore: Johns Hopkins University Press, 1995.

———. *Unclaimed Experience: Trauma, Narrative, and History.* Baltimore: Johns Hopkins University Press, 1996.

Cohen, Margaret. *Profane Illumination: Walter Benjamin and the Paris of Surrealist Revolution.* Berkeley: University of California Press, 1993.

Cowie, Elizabeth. *Representing Women: Cinema and Psychoanalysis.* Minneapolis: University of Minnesota Press, 1997.

Crary, Jonathan. *Techniques of the Observer: On Vision and Modernity in the Nineteenth Century.* Cambridge: MIT Press, 1994.

Cripps, Thomas. *Black Film as Genre.* Bloomington: Indiana University Press, 1979.

Curtis, David. *Experimental Film: A Fifty Year Evolution.* New York: Dell, 1971.

Debord, Guy. *The Society of the Spectacle.* Detroit: Red and Black, 1979.

de Certeau, Michel. *Heterologies: Discourse on the Other.* Trans. Brian Massumi. Minneapolis: University of Minnesota Press, 1986.

———. *The Writing of History.* Trans. Tom Conley. New York: Columbia University Press, 1988.

Deleuze, Gilles. *Cinema 1: The Movement-Image.* Trans. Hugh Tomlinson and Barbara Habberjam. Minneapolis: University of Minnesota Press, 1986.

———. *Cinema 2: The Time-Image.* Trans. Hugh Tomlinson and Robert Galeta. Minneapolis: University of Minnesota Press, 1989.

———. *Difference and Repetition.* Trans. Paul Patton. New York: Columbia University Press, 1994.

———. *The Logic of Sense.* Ed. Constantin V. Boundas, trans. Mark Lester. New York: Columbia University Press. 1990.

———. *Proust and Signs.* Trans. Richard Howard. New York: George Braziller, 1972.

———. "Three Questions about 'Six Fois Deux.'" In *Jean-Luc Godard: Son + Image, 1974–1991,* ed. Raymond Bellour and Mary Lea Bandy. New York: Museum of Modern Art, 1992.

Deleuze, Gilles, and Félix Guattari. *Kafka: Toward a Minor Literature.* Trans. Dana Polan. Minneapolis: University of Minnesota Press, 1986.

———. *A Thousand Plateaus: Capitalism and Schizophrenia.* Trans. Brian Massumi. Minneapolis: University of Minnesota Press, 1987.

Derrida, Jacques. *Archive Fever: A Freudian Impression.* Trans. Eric Prenowitz. Chicago: University of Chicago Press, 1996.

———. *Writing and Difference.* Trans. Alan Bass. Chicago: University of Chicago Press, 1978.

Doane, Mary Ann. *Femmes Fatales: Feminism, Film Theory, Psychoanalysis.* New York: Routledge, 1991.

Durham, Scott. *Phantom Communities: The Simulacrum and the Limits of Postmodernism.* Stanford: Stanford University Press, 1998.

Eisenberg, Daniel. Filmscript of *Cooperation of Parts* and commentaries. *Kinemathek* 77. Berlin: Freunde der Deutschen Kinemathek, 1992.

Eisenstein, Sergei, *Film Form: Essays in Film Theory*. Ed. and trans. Jay Leyda. New York: Harcourt, Brace, 1969.

Elsaesser, Thomas, ed. *Early Cinema: Space, Frame, Narrative*. London: BFI, 1990.

Federman, Raymond. "Displaced Person: The Jew / the Wanderer / the Writer." *Denver Quarterly* 19, no. 1 (1984).

Felman, Shoshana, and Dori Laub. *Testimony: Crises of Witnessing in Literature, Psychoanalysis and History*. New York: Routledge, 1992.

Ferguson, Russell, ed. *Art and Film since 1945: Hall of Mirrors*. Exhibition catalog. New York: Monacelli, 1996.

Ferro, Marc. *Cinema and History*. Trans. Naomi Greene. Detroit: Wayne State University Press, 1988.

Flaxman, Gregory, ed. *The Brain Is the Screen: Deleuze and the Philosophy of Cinema*. Minnesota: University of Minnesota Press, 2000.

Foster, Hal. *The Return of the Real: The Avant-Garde at the End of the Century*. Cambridge: MIT Press, 1996.

Foucault, Michel. "Nietzsche, Genealogy, History." In *Language, Counter-memory, Practice: Selected Essays and Interviews,* ed. Donald F. Bouchard, trans. Donald F. Bouchard and Sherry Simon. Ithaca, N.Y.: Cornell University Press, 1977.

———. *The Order of Things: An Archaeology of the Human Sciences*. New York: Vintage Books, 1973.

Fox, Howard, L., ed. *Eleanor Antin*. Los Angeles: Los Angeles County Museum of Art and Fellows of Contemporary Art, 1999.

Frampton, Hollis. *Circles of Confusion: Film, Photography, Video, Texts, 1968–1980*. Rochester: Visual Studies Workshop, 1983.

Freud, Sigmund. *Moses and Monotheism*. Trans. Katherine Jones. New York: Vintage Books, 1967.

———. "The Uncanny." In *On Creativity and the Unconscious: Papers on the Psychology of Art, Literature, Love, Religion*. New York: Harper, 1958.

Friedberg, Anne. *Window Shopping: Cinema and the Postmodern*. Berkeley: University of California Press, 1994.

Friedlander, Saul, ed. *Probing the Limits of Representation: Nazism and the Final Solution*. Cambridge: Harvard University Press, 1992.

Fusco, Coco. *Young, British and Black: The Work of Sankofa and Black Audio Film Collective*. Buffalo: Hallwalls, 1988.

Gever, Martha, John Greyson and Pratiba Parmar, eds. *Queer Looks: Perspectives on Lesbian and Gay Film and Video*. New York: Routledge, 1993.

Gidal, Peter. *Materialist Film*. London: Routledge, 1989.

———, ed. *Structural Film Anthology*. London: BFI, 1976.

———. "Technology and Ideology in/through/and Avant-Garde Film: An Instance." In *The Cinematic Apparatus,* ed. Stephen Heath and Teresa de Lauretis. New York: St. Martin's, 1980.

Gilbert, Martin. *The Holocaust: A History of the Jews of Europe during the Second World War*. New York: Holt, 1987.

Gilman, Sander L. *Freud, Race, and Gender*. Princeton: Princeton University Press, 1993.

———. *The Jew's Body*. New York: Routledge, 1991.

Godard, Jean-Luc. "Godard Makes [Hi]stories: Interview with Serge Daney." In *Jean-Luc*

Godard: Son + Image, ed. Raymond Bellour and Mary Lea Bandy. New York: Museum of Modern Art, 1992.

Gordon, Avery. *Ghostly Matters: Haunting and the Sociological Imagination.* Minneapolis: University of Minnesota Press, 1997.

Grafe, Frieda. "Whose History: Jean-Luc Godard between the Media." Trans. Stephen Locke. In *Documenta Documents 2.* Kassel: Documenta GmbH, 1996.

Gunning, Tom. "Perspective and Retrospective: The Films of Ernie Gehr." In *Films of Ernie Gehr.* San Francisco: Foundation for Art in Cinema, 1993.

———. "Phantom Images and Modern Manifestations: Spirit Photography, Magic Theater, Trick Films and Photography's Uncanny." In *Fugitive Images: From Photography to Video,* ed. Patrice Petro. Bloomington: Indiana University Press, 1995.

———. "Signaling through the Flames: Ernie Gehr's *Signal—Germany on the Air.*" *Millennium Film Journal.* ed. Noel Carroll, Grahame Weinbren, and Tony Pipolo. 16–18 (fall–winter 1986–87): 169–73.

Hall, Doug, and Sally Jo Fifer, eds. *Illuminating Video: An Essential Guide to Video Art.* New York: Aperture, 1990.

Harvey, David. *Spaces of Hope.* Berkeley: University of California Press, 2000.

Hayes, Peter, ed. *Lessons and Legacies: The Meaning of the Holocaust in a Changing World.* Evanston: Northwestern University Press, 1991.

Hayward Gallery, South Bank London, ed. *Film as Film: Formal Experiment in Film, 1910–1975.* London: Arts Council of Great Britain, 1979.

Hendricks, Gordon. *Eadweard Muybridge: The Father of the Motion Picture.* New York: Grossman Publishers, 1975.

Hershman-Leeson, Lynn, ed. *Clicking In: Hot Links to Digital Culture.* Seattle: Bay Press, 1996.

Hoberman, J. *Bridge of Light: Yiddish Film between Two Worlds.* New York: Schocken Books, 1991.

———. *Vulgar Modernism: Writing on Movies and Other Media.* Philadelphia: Temple University Press, 1991.

Huyssen, Andreas. *Twilight Memories: Marking Time in a Culture of Amnesia.* New York: Routledge, 1995.

Iles, Chrissie, "Between the Still and Moving Image" In *Into the Light: The Projected Image in American Art, 1964–1977.* Exhibition catalog. New York: Whitney Museum of American Art, 2001.

———. *Into the Light: The Projected Image in American Art, 1964–1977.* Exhibition catalog. New York: Whitney Museum of American Art, 2001.

James, David. *Allegories of Cinema: American Film in the Sixties.* Princeton: Princeton University Press, 1989.

Jameson, Fredric. *The Geopolitical Aesthetic: Cinema and Space in the World.* Bloomington: Indiana University Press, 1992.

———. *Postmodernism, or The Cultural Logic of Late Capitalism.* Durham: Duke University Press, 1991.

Jordan, Larry. "Survival in the Independent-Non-Commercial-Avant-Garde-Experimental-Personal-Expressionist Film Market of 1982." *Millennium Film Journal,* no. 12 (fall–winter 1982): 4–7.

Kaes, Anton. *From Hitler to Heimat: The Return of History as Film.* Cambridge: Harvard University Press, 1989.

Katz, Joel. "From Archive to Archiveology." *Cinematograph: A Journal of Film and Media Art* 4 (1991): 96–102.

Keller, Marjorie. *The Untutored Eye: Childhood in Films of Jean Cocteau, Joseph Cornell and Stan Brakhage.* Rutherford, N.J.: Associated University Press, 1985.

Knabb, Ken, ed. and trans. *Situationist International Anthology.* Berkeley: Bureau of Public Secrets, 1981.

Koselleck, Reinhart. *Futures Past: On the Semantics of Historical Time.* Trans. Keith Tribe. Cambridge: MIT Press, 1985.

Krauss, Rosalind. "The Originality of the Avant-Garde: A Postmodern Repetition." In *Art after Modernism: Rethinking Representation,* ed. Brian Wallis. New York: New Museum of Contemporary Art, 1984.

————. *A Voyage on the North Sea: Art in the Age of the Post-medium Condition.* New York: Thames and Hudson, 1999.

Kruger, Barbara, and Phil Mariani, eds. *Remaking History.* Seattle: Bay Press, 1989.

Kunzle, David. *Che Guevara: Icon, Myth and Message.* Los Angeles: UCLA Museum of Cultural History, 1997.

Lacan, Jacques. *The Four Fundamental Concepts of Psycho-Analysis.* Ed. Jacques-Alain Miller. Trans. Alan Sheridan. New York: Norton, 1978.

LaCapra, Dominick. *History and Memory after Auschwitz.* Ithaca: Cornell University Press, 1998.

Landow, George P., ed. *Hyper/Text/Theory.* Baltimore: Johns Hopkins University Press, 1994.

Landy, Marcia, ed. *The Historical Film: History and Memory in Media.* New Brunswick: Rutgers University Press, 2001.

Lang, Berel. "The Representation of Limits." In *Probing the Limits of Representation,* ed. Saul Friedlander. Cambridge: Harvard University Press, 1992.

Lanzmann, Claude. "From Holocaust to 'Holocaust.'" *Dissent* 28, no. 2 (1981): 188–94.

————. "Seminar with Claude Lanzmann, 11 April 1990." *Yale French Studies* 79 (1991): 82–99.

————. *"Shoah": An Oral History of the Holocaust.* New York: Pantheon, 1985.

Laplanche, J., and J.-B. Pontalis. *The Language of Psycho-Analysis.* Trans. D. Nicholson-Smith. New York: Norton, 1973.

Larsen, Ernest. "Who Owns the Streets?" *Art in America* 78, no. 1 (January 1990): 55–61.

Leffingwell, Edward, Carole Kismaric, and Marvin Heifman, eds. *Jack Smith: Flaming Creature; His Amazing Life and Times.* London: Serpent's Tail, 1997.

Le Grice, Malcolm. *Abstract Film and Beyond.* Cambridge: MIT Press, 1977.

————. "Towards Temporal Economy." *Screen* 2, nos. 3–4 (winter 1979): 58–79.

Leutrat, Jean-Louis. "The Declension." In *Jean-Luc Godard: Son + Image,* ed. Raymond Bellour and Mary Lea Bandy. New York: Museum of Modern Art, 1992.

Levi, Primo. *The Drowned and the Saved.* Trans. Raymond Rosenthal. New York: Vintage International, 1989.

Levin, Kim. *Beyond Modernism.* New York: Harper, 1988.

Lopate, Phillip. "When Foreign Films Mattered." *New York Times,* August 13, 2000.

Loshitsky, Yosefa, ed. *Spielberg's Holocaust: Critical Essays on "Schindler's List."* Bloomington: Indiana University Press, 1997.

Lu, Alvin. "Situationist 99: Craig Baldwin's Eagerly Anticipated *Spectres of the Spectrum* Opens the Film Arts Festival." *San Francisco Bay Guardian,* November 3, 1999.

Lyotard, Jean-François. *The Differend: Phrases in Dispute.* Trans. Georges van den Abbeele. Minneapolis: University of Minnesota Press, 1988.

————. *The Postmodern Condition: A Report on Knowledge.* Trans. Geoff Bennington and Brian Massumi. Minneapolis: University of Minnesota Press, 1984.

———. *The Postmodern Explained: Correspondence, 1982–1985.* Ed. and trans. Julian Pefanis and Morgan Thomas. Minneapolis: University of Minnesota Press, 1992.

MacBean, James Roy. *Film and Revolution.* Bloomington: Indiana University Press, 1975.

MacCabe, Colin. *Godard: Images, Sounds, Politics.* Bloomington: Indiana University Press, 1980.

MacDonald, Scott. *A Critical Cinema 2: Interviews with Independent Filmmakers.* Berkeley: University of California Press, 1992.

———. *A Critical Cinema 3: Interviews with Independent Filmmakers.* Berkeley: University of California Press, 1998.

Manes, Stephen. *Pictures of Motion and Pictures That Move: Eadweard Muybridge and the Photography of Motion.* New York: Coward, McCann and Geoghagan, 1982.

Manovich, Lev. "From the Externalization of the Psyche to the Implantation of Technology." In *Mind Revolution: Interface Brain/Computer,* ed. Florian Rotzer. Munich: Akademie Zum Jahrtausend, 1995.

———. *The Language of New Media.* Cambridge: MIT Press, 2001.

Marcuse, Herbert. "Repressive Tolerance." In *A Critique of Pure Tolerance,* ed. Robert Paul Wolf, Barrington Moore Jr., and Herbert Marcuse. Boston: Beacon Press, 1969.

Marks, Laura U. *The Skin of the Film: Intercultural Cinema, Embodiment, and the Senses.* Durham: Duke University Press, 2000.

Martin, Michael T., ed. *Cinemas of the Black Diaspora: Diversity, Dependence and Oppositionality.* Detroit: Wayne State University Press, 1995.

McElhatten, Mark. "Dan Eisenberg's *Cooperation of Parts.*" *Kinemathek* 77 (January 1992): 26–32.

Mercer, Kobena. "Skin Head Sex Thing: Racial Difference and the Homoerotic Imaginary." In *How Do I Look? Queer Film and Video,* ed. Bad Object-Choices. Seattle: Bay Press, 1991.

Michelson, Annette, ed. *Kino-Eye: The Writings of Dziga Vertov.* Trans. Kevin O'Brien. Berkeley: University of California Press, 1984.

Mitchell, Elvis. "Everyone's a Film Geek Now." *New York Times,* August 17, 2003.

Morson, Gary Saul. *Narrative and Freedom: The Shadows of Time.* New Haven: Yale University Press, 1994.

New York Filmmakers Cooperative. *Catalogue 7.* New York, 1989.

Nichols, Bill. *Blurred Boundaries: Questions of Meaning in Contemporary Culture.* Bloomington: Indiana University Press, 1994.

———. *Ideology and the Image: Social Representation in the Cinema and Other Media.* Bloomington: Indiana University Press, 1981.

———, ed. *Movies and Methods. Vol .2.* Berkeley: University of California Press, 1985.

———. "The Voice of Documentary." In *Movies and Methods,* vol. 2, ed. Bill Nichols. Berkeley: University of California Press, 1985.

Novak, Peter. *The Holocaust in American Life.* New York: Houghton Mifflin, 1999.

Oettermann, Stephan. *The Panorama: History of a Mass Medium.* Trans. D. L. Schneider. New York: Zone Books, 1997.

Pensky, Max. *Melancholy Dialectics: Walter Benjamin and the Play of Mourning.* Amherst: University of Massachusetts Press, 1993.

———. "Tactics of Remembrance: Proust, Surrealism, and the Origin of the Passagenwerk." In *Walter Benjamin and the Demands of History,* ed. Michael P. Steinberg. Ithaca: Cornell University Press.

Peterson, James. *Dreams of Chaos, Visions of Order: Understanding the American Avant-Garde Cinema.* Detroit: Wayne State University Press, 1994.

Petro, Patrice. *Fugitive Images: From Photography to Video*. Bloomington: Indiana University Press, 1995.

Prelinger, Rick. "Archival Footage: Its Past and Future." *The Prelinger Archive Web Site,* June 23, 2000, http://www.tanmedia.co.uk/prelinger.htm.

Proust, Marcel. *Swann's Way. In Search of Lost Time*. Trans. C. K. Scott-Moncrieff and Terence Kilmartin. Rev. D. J. Enright. Vol. 1. New York: Modern Library, 1992.

Pruitt, John. "Stan Brakhage and the Long Reach of Maya Deren's Poetics of Film." In "Stan Brakhage: Correspondences," special issue, *Chicago Review* (March 2002).

Rappaport, Mark. "Mark Rappaport's Notes on Rock Hudson's Home Movies." *Film Quarterly* 49 (summer 1996): 16–22.

Ravenal, John. "Curatorial Introduction." In *Outer and Inner Space: Pipilotti Rist, Shirin Neshat, Jane and Louise Wilson, and the History of Video Art*. Exhibition catalog. Richmond: Virginia Museum of Fine Arts, 2002.

Renov, Michael. ed. *Theorizing Documentary*. New York: Routledge, 1993.

Renov, Michael, and Ericka Suderberg, eds. *Resolutions: Contemporary Video Practices*. Minneapolis: University of Minnesota Press, 1996.

Rich, B. Ruby. *Chick Flicks: Theories and Memories of the Feminist Film Movement*. Durham: Duke University Press, 1998.

Ricoeur, Paul. *Time and Narrative*. Vol. 1. Chicago: University of Chicago Press, 1984.

Rodowick, D. N. *The Crisis of Political Modernism: Criticism and Ideology in Contemporary Film Theory*. Berkeley: University of California Press, 1988.

———. *Gilles Deleuze's Time Machine*. Durham: Duke University Press, 1997.

Rokeby, David. "Transforming Mirrors: Subjectivity and Control in Interactive Media." In *Critical Issues in Electronic Media,* ed. Simon Penny. New York: State University of New York Press, 1995.

Rony, Fatimah Tobing. *The Third Eye: Race, Cinema and Ethnographic Spectacle*. Durham: Duke University Press, 1996.

Rosenstone, Robert A., ed. *Revisioning History: Film and the Construction of a New Past*. Princeton: Princeton University Press, 1995.

———. *Visions of the Past: The Challenge of Film to Our Idea of History*. Cambridge: Harvard University Press, 1995.

Roth, Philip. *Goodbye Columbus*. New York: Houghton Mifflin, 1959.

———. *Operation Shylock: A Confession*. New York: Simon and Schuster, 1993.

Russell, Catherine. *Experimental Ethnography: The Work of Film in the Age of Video*. Durham: Duke University Press, 1999.

Santner, Eric L. "History beyond the Pleasure Principle: Some Thoughts on the Representation of Trauma." In *Probing the Limits of Representation,* ed. Saul Friedlander. Cambridge: Harvard University Press, 1992.

———. *Stranded Objects: Mourning, Memory and Film in Postwar Germany*. Ithaca: Cornell University Press, 1990.

Segev, Tom. *The Seventh Million: The Israelis and the Holocaust*. Trans. Haim Watzman. New York: Hill and Wang, 1993.

Shohat, Ella, and Robert Stam. *Unthinking Eurocentrism: Multiculturalism and the Media*. New York: Routledge, 1994.

Sholette, Gregory. "Nature as an Icon of Urban Resistance: Artists, Gentrification and New York City's Lower East Side, 1979–1984." *Afterimage* 25 (September–October 1997): 18–20.

Silverman, Kaja. *The Threshold of the Visible World*. New York: Routledge, 1994.

Sitney, P. Adams, ed. *The Avant-Garde Film: A Reader of Theory and Criticism.* New York: New York University Press, 1978.

———. *Modernist Montage: The Obscurity of Vision in Cinema and Literature.* New York: Columbia University Press, 1990.

———. *Visionary Film: The American Avant-Garde, 1943–1978.* 2nd ed. New York: Oxford University Press, 1978.

Skoller, Donald. "Aspects of Cinematic Consciousness: 'Suspense' and Presence/Dis-Illusion/Unified Perceptual Response, Part One." *Film Comment,* September 1972, 41–51.

———. "The Fisher Phenomenon: Aspects of Cinematic Consciousness, Part Two." *Film Comment* 9, no. 2 (March–April 1973): 58–63.

Skoller, Jeffrey, ed. *Cinematograph Volume 4: A Journal of Film and Media Art.* San Francisco: Foundation for Art in Cinema, 1991.

———. "Sublime Intensity: An Interview with Ernie Gehr." *Release Print* 20, no. 4 (May 1997): 18–20.

Sobchack, Vivian. *The Address of the Eye: A Phenomenology of Film Experience.* Princeton: Princeton University Press, 1992.

———, ed. *The Persistence of History: Cinema, Television and the Modern Event.* New York: Routledge, 1996.

Sontag, Susan. "The Decay of Cinema." *New York Times Magazine,* February 25, 1996.

Sorlin, Pierre. *The Film in History: Restaging the Past.* Totowa, N.J.: Barnes and Noble Books, 1980.

Spiegelman, Art. *Maus: A Survivor's Tale and Here My Troubles Began.* New York: Pantheon Books, 1991.

Stam, Robert. *Subversive Pleasures: Bakhtin, Cultural Criticism and Film.* Baltimore: Johns Hopkins University Press, 1989.

Steinberg, Michael P. "Benjamin and the Critique of Allegorical Reason." In *Walter Benjamin and the Demands of History,* ed. Michael P. Steinberg. Ithaca: Cornell University Press, 1996.

———, ed. *Walter Benjamin and the Demands of History.* Ithaca: Cornell University Press, 1996.

Straayer, Chris. *Deviant Eyes and Deviant Bodies: Sexual Re-orientation in Film and Video.* New York: Columbia University Press, 1996.

Syberberg, Hans-Jurgen. *Hitler: A Film from Germany.* New York: Farrar, Straus and Giroux, 1982.

Taylor, Clyde. "New Black Cinema." *Jump Cut: A Review of Contemporary Media* 28 (April 1983): 46–48.

Terkel, Studs. *Hard Times: An Oral History of the Great Depression.* New York: Pantheon Books, 1970.

Thompson, Paul. *The Voice of the Past: Oral History.* 2nd ed. New York: Oxford University Press, 1990.

Trinh T. Minh-ha. "Documentary Is/Not a Name." *October* 52 (spring 1990): 76–98.

———. *The Framer Framed.* New York: Routledge, 1992.

———. *When the Moon Waxes Red: Representation, Gender and Cultural Politics.* New York: Routledge, 1991

———. *Woman, Native, Other: Writing Post-coloniality and Feminism.* Bloomington: Indiana University Press, 1989.

Turim, Maureen. *Flashbacks in Film: Memory and History.* New York: Routledge, 1989.

White, Hayden. *The Content of the Form: Narrative Discourse and Historical Representation.* Baltimore: Johns Hopkins University Press, 1987.

———. "Historical Emplotment and the Problem of Truth." In *Probing the Limits of Representation,* ed. Saul Friedlander. Cambridge: Harvard University Press, 1992.

———. *Metahistory: The Historical Imagination in the Nineteenth Century.* Baltimore: Johns Hopkins University Press, 1973.

———. "The Modernist Event." In *The Persistence of History,* ed. Vivian Sobchack. New York: Routledge, 1996.

———. *Tropics of Discourse: Essays in Cultural Criticism.* Baltimore: Johns Hopkins University Press, 1978.

White, Mimi. "An Extra Body of Reference: History in Cinematic Narrative." Ph.D. diss. University of Iowa, 1981.

Williams, Linda, ed. *Viewing Positions.* New Brunswick: Rutgers University Press, 1995.

Williams, Raymond. *Resources of Hope: Culture, Democracy.* Ed. Robin Gable. NewYork: Verso, 1989.

Wollen, Peter. "Ontology and Materialism in Film." In *Readings and Writings: Semiotic Counter-Strategies.* London: Verso, 1984.

———. *Readings and Writings: Semiotic Counter-Strategies.* London: Verso, 1984.

———. "The Two Avant-Gardes." In *Readings and Writings: Semiotic Counter-Strategies.* London: Verso, 1984.

Young, James E. *At Memory's Edge: After-images of the Holocaust in Contemporary Art and Architecture.* New Haven: Yale University Press, 2000.

———. *The Texture of Memory: Holocaust Memorials and Meaning.* New Haven: Yale University Press, 1993.

Youngblood, Gene. *Expanded Cinema.* New York: E. P. Dutton, 1970.

Zimmerman, Patricia R. *States of Emergency: Documentaries, Wars, Democracies.* Minneapolis: University of Minnesota Press, 2000.

Filmography and Distributors

Distributors for the particular films are given in parentheses after each entry. A list of distributors and their contact information appears at the end of the filmography.

Allemagne année 90 neuf zéro (*Germany Year 90 Nine Zero*), Jean-Luc Godard (France, 1991).

The Battle of Chile, Patricio Guzmán (Chile and Cuba, 1975–79) (FRIF).

B/Side, Abigail Child (USA, 1996) (CAN; NYFC; LC).

Beyond, Zoe Beloff (CD-ROM, USA, 1997) (Zoe Beloff).

Chile, la memoria obstinada (*Chile, Obstinate Memory*), Patricio Guzmán (Chile, France, Canada, 1997) (FRIF).

Cooperation of Parts, Daniel Eisenberg (USA, 1987) (CAN; NYFMC; LC).

Corporation with a Movie Camera, Joel Katz (USA, 1992) (CG).

Dal polo all'equatore (From Pole to Equator), Yervant Gianikian and Angela Ricci Lucchi (Italy, 1986) (MOMA; BFI).

Dichotomy, Tony Sinden (video installation, UK, 2000).

Displaced Person, Daniel Eisenberg (USA, 1981) (CAN; NYFMC; LC).

El día que me quieras (The Day You Love Me), Leandro Katz (USA and Argentina, 1997) (FRIF).

Ernesto Che Guevara, the Bolivian Journal, Richard Dindo (Switzerland, 1994).

Eureka, Ernie Gehr (USA, 1974) (CAN; NYFMC).

Eyes on the Prize, Henry Hampton (USA, 1987–90).

Gamma, Jane Wilson and Louise Wilson (UK, 1999).

Germany Year Zero, Roberto Rossellini (Italy, 1946).

The Gringo in Mañanaland, Dee Dee Halleck (USA, 1995) (Dee Dee Halleck).

Hotel Terminus: The Life and Times of Klaus Barbie, Marcel Ophuls (France, 1988).

Immemory, Chris Marker (CD-ROM, France, 1997) (EAI).

Keaton's Cops, Ken Jacobs (USA, 1991) (NYFMC).

Killer of Sheep, Charles Burnett (USA, 1977) (TWNR).

La dialectique peut-elle casser des briques? (Can Dialectics Break Bricks?), René Viénet (France, 1973) (Not Bored!).

Le fond de l'air est rouge (A Grin without a Cat), Chris Marker (France, 1977) (FRIF).

The Man without a World, Eleanor Antin (USA, 1991) (Milestone).

The March, Abraham Ravett (USA, 1999) (CAN; NCJF; LC).

Nicaragua: Hear-Say/See-Here, Jeffrey Skoller (USA, 1986) (CAN).

No President, Jack Smith (1968) (CAN).

¡O No Coronado! Craig Baldwin (USA, 1992) (CAN).

The Pawnbroker, Sidney Lumet (USA, 1965).

Persistence: Film in 24 Absences/Presences/Prospects, Daniel Eisenberg (USA, 1997) (CAN).

Passage, Shirin Neshat (USA, 2001).

Pulse, Shirin Neshat (USA, 2001).

Rock Hudson's Home Movies, Mark Rappaport (USA, 1993).

Ruins, Jesse Lerner (USA, 1998) (VDB).

Schindler's List, Steven Spielberg (USA, 1993).

Shoah, Claude Lanzmann (France, 1986) (NYR).

Signal—Germany on the Air, Ernie Gehr (USA, 1982–85) (CAN).

Sip My Ocean, Pipilotti Rist (Switzerland, 1996).

Stasi City, Jane Wilson and Louise Wilson (UK, 1997).

Tom, Tom, the Piper's Son, Ken Jacobs (USA, 1969) (NYFMC; CFNDC; LC).

Too Early, Too Late, Jean-Marie Straub and Danièle Huillet (West Germany and France, 1981) (NYR).

Tribulation 99: Alien Anomalies under America, Craig Baldwin (USA, 1991) (CAN).

Un vivant qui passe (A Visitor from the Living), Claude Lanzmann (France, 1998) (NYR).

Urban Peasants, Ken Jacobs (USA, 1975) (NYFMC; CFNDC).

Utopia, James Benning (USA, 1998) (CAN; CFNDC).

Wavelength, Michael Snow (Canada, 1967) (CAN; CFDC; NYFMC)

WVLNT (Wavelength for Those Who Don't Have the Time), Michael Snow (video, Canada, 1967/2003) (CFDC).

Distributors

BFI	British Film Institute, Stephen Street Office and BFI National Library, 21 Stephen Street, London W1T 1L. www.bfi.org.uk.
CAN	Canyon Cinema, 145 Ninth Street, Suite 260, San Francisco, CA 94103. Telephone and fax: (415) 626-2255. E-mail: films@canyoncinema.com. www.canyoncinema.com.
CFDC	Canadian Filmmakers' Distribution Centre, 37 Hanna Avenue, Toronto, Ontario, Canada M6K 1W8. Telephone: (416) 588–0725, fax: (416) 588-7958. E-mail: cfmdc@cfmdc.org. www.cfmdc.org.
CG	Cinema Guild, 130 Madison Avenue, 2nd floor, New York, NY 10016-7038. Telephone: (212) 685-6242, fax: (212) 685-4717. www.cinemaguild.com.
EAI	Electronic Arts Intermix, 535 West 22nd Street, 5th floor, New York, NY 10011. Telephone: (212) 337-0680, fax: (212) 337-0679. E-mail: info@eai.org.
FRIF	First Run/Icarus Films, 32 Court Street, 21st floor, Brooklyn, NY 11201. Telephone: (718) 488-8900, fax: (718) 488-8642. E-mail: mailroom@frif.com. www.fwww.frif.com.

LC Light Cone, 12 rue des Vignoles, 75020 Paris, France. Telephone: 33 (o) 1 46 59 01 53; fax: 33 (o) 1 46 59 03 12. E-mail: lightcone@lightcone.org. http://fmp.lightcone.org:8000/lightcone.

LUX LUX Distribution, 18 Shacklewell Lane, London E8 2EZ, UK. Telephone: 44 (o) 20 7503 3980; fax: 44 (o) 20 7503 1606. E-mail: info@lux.org.uk. www.lux.org.uk.

Milestone Films, P.O. Box 128, Harrington Park, NJ 07640-0128. Telephone: (800) 603-1104; fax: (201) 767-3035. E-mail: info@milestonefilms.com. www.milestonefilms.com.

MOMA Museum of Modern Art, 11 West 53rd Street, New York, NY 10019.

NCJF National Center for Jewish Film, Brandeis University, Lown 102 MS053, Waltham, MA 02454-9110. Telephone: (781) 899-7044, fax: (781) 736-2070. E-mail: ncjf@brandeis.edu. www.brandeis.edu/jewishfilm.

NYFMC New York Film-Makers' Cooperative, c/o Clocktower Gallery, 108 Leonard Street, 13th floor, New York, NY 10013. Telephone: (212) 267-5665, fax: (212) 267-5666. E-mail: film6000@aol.com. www.film-makerscoop.com.

NYR New Yorker Films. Telephone: (212) 645-4600, (212) 677-2431; fax: (212) 645-3030. E-mail: info@newyorkerfilms.com. www.newyorkerfilms.com.

Not Bored! P.O. Box 1115, New York, NY 10009–9998. www.notbored.org.

TWNR Third World Newsreel, 545 Eighth Avenue, 10th floor, New York, NY 10018. Telephone: (212) 947-9277, fax: (212) 594–6417. E-mail: twn@twn.org.

VDB Video Data Bank, 112 South Michigan Avenue, Chicago, IL 60603. Telephone: (312) 345-3550, fax: (312) 541–8073. E-mail: info@vdb.org. www.vdb.org.

Zoe Beloff, 504 Grand Street, Apt. A35, New York, NY 10002. Telephone: (212) 677-2431. www.zoebeloff.com.

Dee Dee Halleck, P.O. Box 89, Willow, NY, 12495. Telephone: (845) 679-2756, fax: (845) 679-7535. E-mail: dhalleck@ucsd.edu. www.deedeehalleck.org.

Tony Sinden, Chapel, Star Corner, Colerne, Chippenham, North Wilts, SN 148DG, England. Telephone: 44 1225 743 213. E-mail: TonySinden@aol.com.

Permissions

A different version of chapter 2 was first published as "The Shadows of Catastrophe: Toward an Ethics of Representation in Films by Antin, Eisenberg, and Spielberg," *Discourse: A Journal for Theoretical Studies in Media and Culture* 19, no. 1 (fall 1996): 131–59. Reprinted with the permission of Wayne State University Press.

Parts of chapter 3 first appeared as "Reinventing Time, or the Continuing Adventures of Lemmy Caution in Godard's *Germany Year 90 Nine Zero,*" *Film Quarterly* 52, no. 3 (spring 1999): 35–42, and "The Man without a World," *Film Quarterly* 49, no. 1 (fall 1995): 28–32. Copyright by the Regents of the University of California. Parts of this chapter were also previously published in "Reconstructing Berlin," *Afterimage: The Journal of Media Arts and Cultural Criticism* 26, no. 1 (July–August 1998): 12; and "Home Sweet Home," *Afterimage: The Journal of Media Arts and Cultural Criticism* 26, no. 3 (November–December 1998): 15. Published by the Visual Studies Workshop, Rochester, New York; reprinted by permission.

Chapter 5 was first published as "The Future's Past: Re-imaging the Cuban Revolution," *Afterimage: The Journal of Media Arts and Cultural Criticism* 26, no. 5 (March–April 1999): 13–15. Published by the Visual Studies Workshop, Rochester, New York; reprinted by permission.

Passages from the coda were previously published in "Landscapes for the End of History: Tony Sinden's Video Installation *Dichotomy,*" in *Tony Sinden: Everything Must Go—Installation, Video, and Film,* ed. Judith Winter (Sunderland, Australia: Reg Vardy Gallery, School of the Arts, Design, Media, and Culture, University of Sunderland, 2003). Copyright 2003. Reprinted by permission.

Index

Jeffrey Skoller is a filmmaker, writer, and associate professor of film, video, and new media and of visual and critical studies at the School of the Art Institute of Chicago.